Pastimes

Pastimes

From Art and Antiquarianism to Modern Chinese Historiography

Shana J. Brown

University of Hawai'i Press
Honolulu

Library of Congress Cataloging-in-Publication Data
Brown, Shana Julia
Pastimes : from art and antiquarianism to modern Chinese historiography /
Shana J. Brown.
p. cm.
Includes bibliographical references and index.
ISBN 978-0-8248-3498-2 (hardcover : alk. paper)
1. China—Historiography. 2. Historiography—China. 3. Art—Collectors
and collecting—China—History. 4. Antiquarians—China—History. 5. Art
dealers—China—History. I. Title.
DS734.7.B76 2011
951.0072—dc23
2011021438

Designed by Wanda China

Contents

Preface

It has been more than a decade since I was introduced to Chinese practices of collecting and studying ancient artifacts. As a graduate student in Taiwan, I was lucky to be hired as a part-time translator for the antiquities department at the National Palace Museum. For the better part of a year, I rendered into English the captions and catalog texts for exhibits of ancient bronze vessels and Buddhist sculpture. In the dim workrooms of the museum, I watched curators in white gloves gingerly examine Zhou Dynasty (c. 1100–221 BC) bronze vessels, and benefited immeasurably from their patient tutelage. But I was equally intrigued by an exhibit of Qing Dynasty (1644–1911) archaistic jades—shiny, pastel-colored stones, carved to imitate bronzes—that were a particular favorite of the Qianlong emperor (1711–1799). Seen in proximity, the two sets of materials documented a complex array of meanings that the study of antiquity evoked for Chinese scholars, suggesting that antiquarian practice remained in constant evolution over the centuries, up to and including the present day.

A project that began in a museum basement in Taipei has come to light only with the support of many individuals and institutions, starting with the staff of the antiquities department, especially Chang Li-tuan, Ch'en Hui-hsia, and Director Chang Kuang-yuan. After circulating versions of this work in various guises, I received astute comments from the late Frederic E. Wakeman, Jr., as well as from Andrea Goldman, Michael Nylan, and Amina Steinfels. Exceptionally useful and generous critique was provided by the anonymous readers for University of Hawai'i Press; I am very grateful for their efforts, as I am for the gracious help of my editor, Patricia Crosby. Most important, this

project would never have reached book form without Wen-hsin Yeh's unwavering support and inspiring conversation across three continents.

For help with research materials, K.T.Yao and other librarians at Hamilton Library at the University of Hawai'i at Mānoa have been extremely generous, as have Peter Zhou and his staff at the East Asian Library at the University of California, Berkeley. My research was conducted at the Number One Historical Archives in Beijing, the Beijing National Library, the library of the Chinese Academy of Science, and the libraries of Renmin University and Peking University, with the kind assistance of their staff and faculty. Thanks also are due to Michael Knight at the Asian Art Museum of San Francisco for access to the Avery Brundage papers; and the curators and staff at the Honolulu Academy of Art, the Bodleian Library, the Staatsbibliothek Berlin, and the École des Hautes Études en Sciences Sociales.

Funding was provided by a Fulbright-Hays Doctoral Dissertation Fellowship, and generous grants were received from the University of California, Berkeley, and the University of Hawai'i at Mānoa. A year as part of the "Common Languages of Art and Science" working group in Lorraine Daston's department at the Max Planck Institute for the History of Science in Berlin provided a stimulating environment to pursue many of the themes in this book.

Some of the material in these chapters has been considered in earlier publications. Chapter Five touches on issues discussed in "What Is Chinese About Ancient Artifacts? Oracle Bones and the Transnational Collectors Hayashi Taisuke and Luo Zhenyu," in *Collecting "China": The World, China, and a Short History of Collecting*, edited by Vimalin Rujivacharakul (Newark: University of Delaware Press, 2011): 63–72. Portions of Chapter Six elaborate on topics considered in "Archives at the Margins: Luo Zhenyu's Qing Documents and Nationalism in Republican China," *The Politics of Historical Production in Late Qing and Republican China*, ed. Robert Culp and Tze-ki Hon (Leiden: Brill, 2007): 249–270.

In all phases of the project, many scholars offered generous feedback and encouragement, among them Stanley Abe, Iwo Amelung, Julia Andrews, Patricia Berger, Arianne Chernock, Robert Culp, Nixi Cura, Jerry Dennerline, Joshua Fogel, Luca Gabbiani, Qitao Guo, Yuming He, Larissa Heinrich, Christian Henriot, David Keightley, Martin Kern, Luo Shaodan, Rui Magone, Rana Mitter, Susan Naquin, Joshua Rosenzweig, Kuiyi Shen, Su Rongyu, and John Williams. My friends and colleagues at the University of Hawai'i have been wonder-

ful, particularly Roger Ames, Poul Andersen, Helen Baroni, Rosita Chang, Cathy Clayton, Marcus Daniel, Ned Davis, Peter Hoffenberg, Karen Jolly, Daniel Kwok, Vina Lanzona, Frederick Lau, Matthew Lauzon, Kate Lingley, Mark McNally, Richard Rapson, Matt Romaniello, Giovanni Vitiello, and Wensheng Wang. This project also has benefited in innumerable ways from the pioneering research of several scholars on Chinese historiography and antiquarianism, particularly Craig Clunas, Benjamin Elman, Thomas Lawton, Sang Bing, Q. Edward Wang, and Wu Hung.

There are many dear friends and family members, near and far, who have been patient over the years as this book took shape pixel by pixel. It is impossible to thank every one of you individually, but please know that I greatly appreciate your presence in my life. To my parents and grandfather, my sisters and their families, my in-laws and Hawai'i *'ohana*, I wish to convey my affection and humble thanks. This work is dedicated to my pirate captain and his crew—Danno, Dash, and River. Your love is inscribed on every page.

Introduction

If you love ancient inscriptions, then gather them,
judge them, contemplate them, and transmit them.
Seek ancient calligraphy; seek examples of the con-
cerns of the ancients; seek forms of lost ancient
characters.

— Chen Jieqi, 1875 letter to Wang Yirong

THE GREAT EIGHTEENTH-CENTURY NOVEL *A Dream of Red Man-sions* begins with a curious episode. A monk discovers a stone dropped from heaven and, instead of feeling satisfied with its unadorned beauty, wants to "engrave some characters" on it so "people can see at a glance that you're something special."[1] This preference animated many forms of Chinese connoisseurship, including the desire to possess ancient objects. Indeed, in the discourse of the eighteenth century, artifacts without texts hardly merited collecting.

A century or so later, another fantastic, perhaps apocryphal, discovery seemed to affirm this preference. In 1899, the paleographer Wang Yirong (1845–1900) fell ill with malaria in Beijing. An expert in *jinshi* (the study of bronze vessels and stone steles; the word rhymes with "insure"), Wang purchased some medication from a nearby pharmacy. The packet contained a variety of natural and exotic ingredients, including, most astonishingly, shards of bone engraved with unusual characters.[2] As was later determined, these were pieces of ancient divination implements dating to the Shang Dynasty (c. 1600–1100 BC). Now called oracle bones in English, they contain some of the earliest examples of written Chinese, and their chance—yet momentous—discovery exhilarated specialists in history and paleography worldwide.[3]

1

Both stories are animated by appreciation for ancient texts and objects, but in fact the tale of the heavenly stone and the discovery of the oracle bones took place in different conceptual worlds. During the eighteenth century, the prevailing hermeneutics of classical texts emphasized *kaozheng* (the school of textual criticism or philology), which privileged etymology and phonology while reading bronze and stele inscriptions. Late-Qing scholars, in contrast, embraced the concept of artifact studies, an approach suggested by natural science that persuaded them to research a far more diverse set of sources, including materials without inscriptions. Their studies of antiquity also reflected the desire to solve the unique political and social problems of the day. In combination, these factors weakened the importance of *kaozheng* and encouraged antiquarians to apply their insights to other fields, including history, that were believed to have great practical relevance at the turn of the century.

The group of men who led this transformation included several members of Wang Yirong's social circle, such as Wu Dacheng (1835–1902), a renowned specialist in ancient calligraphy, and the political reformer and educator Sun Yirang (1848–1908). In turn, their antiquarian activities influenced two of the most famous scholars of the early twentieth century: the philosopher and literary critic Wang Guowei (1877–1927), and his mentor Luo Zhenyu (1866–1940), an art dealer and publisher as well as expert on antiquities. Wang and Luo showed historians how to research oracle bones and bronzes, demonstrating how they could supplement literary sources in describing China's ancient politics and society. They used the methods of traditional Chinese antiquarianism or *jinshi* as the starting point for a new form of research that came to dominate the modern historiography of ancient China.

Why Antiquarianism?

Antiquarianism is a way to understand the past through the systematic investigation of material artifacts and one-of-a-kind inscriptions. For Chinese scholars, this form of research is almost as ancient as the source materials themselves. For millennia, rulers and elites preserved important documents by recording them on durable surfaces like stone steles. Often colossal in size, these plinths were embellished with ornate carvings and affixed to bases in the shape of turtles or other animals that symbolized longevity. Chinese rulers also forged important texts onto the interiors of bronze vessels, like *ding* (tripods), whose outside

surfaces were decorated with *taotie* (mythical beast designs) or shaped in the form of fantastic creatures. By the Warring States period (476–221 BC), these texts were collectively referred to as "bronze and stone" inscriptions, or *jinshi*. The philosopher Mozi (470–c. 391 BC) possibly made the earliest use of the phrase when he spoke of the words of the philosophers "written on bamboo and silk, and engraved on bronze and stone"; another early reference is found on a Qin Dynasty (221–206 BC) stele that refers to political documents copied onto bronze and stone for preservation.[4]

By the Northern Song (960–1127), *jinshi* no longer referred simply to durable writing surfaces but to a scholarly field whose practitioners used inscriptions as evidence for the ritual ceremonies, language, calligraphy, and politics of the past.[5] Song elites considered this form of research a creative and pleasurable activity—a way to "pass the days" in retirement, according to Ouyang Xiu (1007–1072).[6] But *jinshi* was not trivial; on the contrary, it was a pastime in the sense that Wang Guo-wei intended when he defended leisure pursuits like literature and art as potent tools to demonstrate one's intelligence and stature—essentially, the Nietzschean will to power.[7] And between the publication of the first surviving *jinshi* catalog in 1092 and the 1920 discovery of the first Stone Age archaeological sites—temporal bookends suggested by the archaeologist K.C. Chang (1931–2001)—the field was more than prestigious—it was venerated.[8] Inscriptions preserved words, and *jinshi* preserved inscriptions. Safeguarding history with their research, antiquarians were the guardians of China's cultural patrimony.[9]

But the field's longevity and pedigree should not be confused with stasis. Although Song antiquarians were revered by successive generations of specialists, the pastime continued to develop. There was particularly dramatic change in the nineteenth century, when a diverse group of scholars entered the field and altered its purpose and methodologies through their concerns with educational reform, foreign learning, and visual culture, contributing to a "revolution in traditional linguistics" observed by the journalist and historian Liang Qichao (1873–1929) in the study of bronze inscriptions.[10] The adoption of antiquarian methodologies by Chinese historians in the 1920s was just another phase in a field under evolution for centuries.

One thing about the pastime, however, remained constant—notably, its name. The field continued to be referred to as *jinshi* even after its actual focus came to encompass many more kinds of artifacts than bronzes and stone steles, including artifacts without texts.[11] The term

has a complex emotional valence as well. Often accompanied by terms like *kaogu* (the systematic investigation of antiquity) or *haogu* (the love for or affinity with antiquity), *jinshi* evokes the proud mastery of syntactically difficult documents, as well as a bittersweet longing for the vanished past they represent. Because of the range of meanings that the pastime evoked for Chinese scholars as well as the diversity of research materials and methodologies that it could encompass, I have chosen to translate *jinshi* as "antiquarianism" rather than relying on more literal or narrow renderings such as "bronze-and-stele studies" or "epigraphy."[12] And of course, using antiquarianism is also a useful way to suggest common features and differences between *jinshi* and its European counterparts.

European antiquarianism is arguably of more recent vintage than *jinshi*, but it was just as vital to the development of history and empirical studies. Derived from *Antiquitates*, the study of Roman history and culture, antiquarianism expressed an admiring attitude towards the past and its material remains.[13] The field bloomed after the sixteenth century when a robust consumer culture (partly fueled by colonial empires) encouraged scholars to demonstrate wealth, cosmopolitanism, and intelligence by collecting exotic artifacts, artworks, and objects of scientific wonder.[14] As a subset of this larger phenomenon, the connoisseurship of Roman and Greek relics became a way to express support for the values of the classical world, the essence of Renaissance humanism.[15] Much of the resulting research on coins, statues, and vessels established the groundwork for the rediscovery of the classical world. Yet, as Arnaldo Momigliano (1908–1987) argued, this research did not count as academic history because it did not articulate a particular narrative. When scholars like the English historian Edward Gibbon (1757–1794) finally began to reference nonliterary sources, it was considered a profound innovation.[16]

The European tradition is a helpful comparison as we consider the popularity of antiquarianism in China. The economic boom times of the late-Ming and mid-Qing periods also made possible a robust consumer culture, which encouraged scholars to demonstrate taste and status through the collection of ancient artifacts.[17] Artifacts like bronze vessels symbolized the centralization of the cultural heartland by the Shang and Zhou, analogous to the classical world admired by the humanists. Similar to their Renaissance counterparts, *jinshi* scholars invoked a vision of antiquity to justify innovation, whether in the guise of political reform, new learning, or novel calligraphic forms.[18] In addi-

tion, Chinese scholars had increasing contact with Europeans and other foreigners, comparable perhaps to the Western imperial reach, which whetted their appetites for the exotic, including unusual artifacts from their own domain.[19] Finally, in both contexts there was a research tradition focusing on nonliterary sources, which was gradually integrated into historical practice.

Yet, just as in Europe, the path uniting antiquarianism and historiography meandered—far more than is commonly recognized. Song antiquarians like Ouyang Xiu remained justifiably famous for using stele inscriptions in historical research. But over the centuries, historiography was only a part of *jinshi*. Ritual studies were also significant, particularly when it came to studying bronze inscriptions and other artifacts that predated the Han Dynasty (206 BC–220 AD). These were prized for their capacity to illuminate passages in the classics that described ancient ceremonies.[20] Furthermore, not all antiquities were of use in studying history, anyway—they were too recent. As Craig Clunas reminds us, Chinese connoisseurs used the word *gu*, meaning old or ancient, to refer to something made millennia ago or just a few decades ago.[21] In *jinshi* practice, this meant that some catalogs of antiquities began with Zhou bells, while others included stele inscriptions carved only decades earlier.

By the nineteenth century, even old steles were not always valued for historical research—not because they were unimportant sources, but because philology in general had come under attack. Up to that point, most Qing antiquarians were allied with the *kaozheng* movement, whose principal goal was to examine the language of Confucian texts in order to determine their meaning and authenticate their age. This kind of research was considered a form of *kaoju*, a more broadly defined process of "exegetical learning," or interpreting and comparing texts. But whereas these related approaches were dominant in *jinshi* and historiography for more than a century, by the late eighteenth century there was a notable cooling of enthusiasm. Philosophers like Zhang Xuecheng (1738–1801) charged that the *kaozheng* approach to reading ancient texts was little more than "compiling and preparing documents and calling it historical editing, collecting and referencing documents and calling this historical research."[22] If that were not enough, several centuries of enthusiastic but sloppy research further discredited *jinshi*. Zhu Yixin (1846–1894) cautioned that there were so many mistakes in catalogs of inscriptions that they were valuable only to connoisseurs of calligraphy and not for their factual contents.[23] At

the very moment when European historians were beginning to utilize nonliterary sources, their Chinese counterparts were drawing back in distrust of the field.

As a consequence, for most of the nineteenth century *jinshi* enthusiasts did not consider themselves historians, but rather proponents of the art movement known as the Epigraphic School. They collected hundreds of artifacts and studied their physical properties with exacting devotion, using their inscriptions as inspiration for calligraphy and antiquarian painting. But even without being labeled history, their scholarship encouraged an approach towards antiquities as material artifacts, an approach that was later essential to historians. They emphasized the study of excavated materials long before the introduction of Western archaeology. And for scholars coming of age in the late nineteenth century, their purpose in researching antiquity was to establish an ethical foundation to debate contemporary political affairs. A methodological revolution was under way, and the study of antiquity was about to enter one of its most dynamic periods.

Art and Science

Chinese antiquarianism was much more than paleography. It was an important corollary to art practice and the connoisseurship of calligraphy, all fuelled by the passion for accumulation for which Chinese scholars are justly famous. As a consequence, the history of the field entails many issues related to art and visual culture, including the production of images and the circulation of artifacts. Indeed, the very modernity of the field grew out of this complex interplay between art, antiquarianism, and historiography.

To begin, *jinshi* was always allied with art and other forms of visual culture. Indeed, some of the earliest Chinese antiquarian texts are pictorial catalogs of artifact collections. Produced by individual scholars as well as the imperial court since the Song Dynasty, these albums are made up of a distinct intellectual lineage, with conventions of representation that endured for centuries. Although their usefulness for archaeology is limited, they eloquently document an extraordinary passion for building collections of artifacts as both status items and objects of historical and ritual research, for rulers and courtiers and scholars. However, just as the persistent use of the term *jinshi* can mask dramatic changes in methodologies over time, so too can the sustained collection of artifacts and their representation in catalogs camouflage consider-

able changes in collecting practices, research methodologies, and aesthetic taste; this is particularly true during the nineteenth century.

Art historians have been arguing for some time that the nineteenth century represented a turning point in Chinese art and visual culture. Not only were fresh styles of portraiture and perspective popular among Chinese artists but also there was a boom in media culture and a proliferation of print images, thanks to the introduction of technologies like photolithography. As photographic processes became more common, Chinese readers were offered a feast of representations whose range of subject matter—old and new, foreign and domestic—encouraged a corresponding sense of "multiplicity, fluidity, and internal alterity," in Laikwan Pang's phrase.[24] Particularly in metropolitan centers such as Shanghai and the capital (modern-day Beijing), pictorial literacy was increasingly significant to botany and medicine.[25] In their quest for visual mastery or world-picturing, Chinese intellectuals participated in a broader moment, experienced in many parts of the world, when the reproduction of images made possible by industrial technologies—such as in the print medium, with posters, postcards, and magazines, to name just a few examples—became inexorably linked to claims of political, cultural, and social authority.[26] The scopic experiences made possible by mechanical technology in the nineteenth century are crucial signifiers of modern life. They outline that critical caesura between a world dominated by customary social and cultural practices, typically paced by preindustrial technologies, and the faster, more chaotic, and more fractured world that replaced it.

It is not a coincidence that *jinshi* was in transition precisely at the moment when Chinese visual culture and its technologies, and other markers of political and cultural modernity, were in critical flux. Nineteenth-century antiquarians developed their own pictorial styles, such as three-dimensional epigraphic rubbings, that took advantage of new technologies like photolithography. Even when they studied ancient calligraphy—a form of research enjoyed by antiquarian scholars from Ouyang Xiu to Wu Dacheng and his mentor Chen Jieqi (1813–1884)—they cultivated unorthodox script forms and linked their appreciation for exotic and unorthodox styles to their increasingly cosmopolitan worldview and desire for political reform. At the same time, antiquarianism, which had generally been a hobby for the wealthy and politically exalted, began to appeal to a social stratum that was increasingly important in the nineteenth century—those who were less well-heeled, hungry for social and political connections, and eager for re-

form of the educational and political systems. These new connoisseurs and collectors demanded new kinds—and greater numbers—of artifacts, pushing the commercial antiquities market into uncharted waters and encouraging the establishment of entirely new classes of artifacts. In turn, this led to a broadening of antiquarian methodologies, further testing the boundaries of the concept of *jinshi*.

My emphasis on the importance of visual culture to *jinshi* indicates how my approach differs from some earlier accounts of Chinese antiquarianism. Benjamin Elman, in his first study of Chinese eighteenth-century philology, for example, acknowledged "the inseparability of technical and artistic interests" among Qing antiquarians, but still argued that the revival of stele-style calligraphy was "stimulated by epigraphical studies," rather than the other way around.[27] Although his research brilliantly situates the mid-Qing revival of antiquarianism in relation to *kaozheng*, Elman's relative disinterest in visual culture unintentionally reflects prejudices among Chinese archaeologists, who criticized connoisseurs for overvaluing the calligraphic beauty of ancient inscriptions.[28] Many Chinese historians in the early twentieth century also downplayed the art-historical elements of *jinshi*, preferring to emphasize aspects of the pastime that appeared more "cool and systematic" or scientific, like philology.[29] At the time, they were obsessed with proving to themselves (and to the outside world) that there was an indigenous scientific tradition in China. But a century later, we should no longer feel the same need to denigrate visual culture in order to elevate science.

Indeed, recent research on the history of science suggests that we should take precisely the opposite approach. From the perspective of the Western natural sciences, for example, the production of visual culture, along with the collector's passion for material artifacts, helps explain which objects were chosen as suitable for systematic research, as well as the qualities that were valued by scientists.[30] It is indeed relevant that *jinshi*, particularly in the eighteenth century, was one of the "precedents of modern scientific practice" that existed prior to the arrival of Western learning in China.[31] But Chinese antiquarians were systematic in their appreciation for antiquities as historical sources *and* obsessed with the aesthetic, monetary, and ritual values that they represented. Furthermore, to consider art and collecting invites us to think beyond the motivations of individual collectors and to consider the institutional contexts—both formal and informal—in which collecting and the production of visual culture occurred, including the commercial market

in antiques and the then-nascent Chinese museum system.[32] Indeed, the topic of antiquarianism at the turn of the century leads to the intriguing question of why museums were not always favored by Chinese scholars, and helps explain the preference for private libraries and artifact collections long after government and university institutions could presumably have taken the lead.

The comparison of *jinshi* and science does point to an important methodological quandary, however. What is the best way to discuss the persistence of traditional learning in the twentieth century without either disregarding or giving too much importance to the disdain of modernists? As the debate over science suggests, Republican intellectuals were very opinionated about the shortcomings of their predecessors. Although it is important to "decenter" the critiques of iconoclastic scholars in hopes of achieving a more balanced perspective, historians of the period should take their concerns seriously; after all, when it comes to the advantages and disadvantages of traditional fields, they were in a good position to know.[33] Otherwise, one risks resembling Rey Chow's sketch of "the great Orientalist, [who] blames the living Third World natives for the loss of the ancient non-Western civilization."[34] And despite its innovations, late-Qing *jinshi* included many practices that are uninformed or mistaken from the perspective of present-day historiography and archaeology. Nonetheless, we need not adopt the opinions of early twentieth-century intellectuals reflexively. There were reasons to find fault with *jinshi* in the modern era, but, as we will see, not all of these reasons were related to the actual practices of *jinshi*.

In this vein, Foucault cautioned against overestimating the significance of any previously unappreciated narrative in intellectual history when he mused, "Is it perhaps not the case that these fragments of genealogies are no sooner brought to light…than they run the risk of recodification, re-colonization?"[35] Heeding his warning, my goal is not to overcompensate for the disdain of modernists by elevating antiquarianism over all other forms of historical knowledge. Still, though, we must appreciate that *jinshi* remained relevant decades after one might predict its obsolescence. Its influence includes persistent attitudes towards the uses of history, the meaning of pictorial images and the value of material artifacts, and the complex relationship between public institutions and private scholars. That these issues touch on the experience of modern life more broadly simply suggests that in China as well as in many parts of the world nothing was so modern as antiquity.

Antiquity and Modern History

To appreciate why the ancient past so fascinated late nineteenth-century scholars, we should bear in mind the temper of that era as a whole. History was crucial for a generation of Chinese intellectuals who were desperate to comprehend their country's weaknesses—military, economic, discursive—relative to the imperialist powers. Indeed, if the experience of modernity is, as Marx described it, the disorienting sense that "all that is solid melts into air," then late-Qing intellectuals were walking on ether. Well aware of the empire's waning prestige and affluence and eager to reverse its decline, they tried to find lessons in the experiences of more powerful nations, particularly Western countries then at the zenith of their imperial reach.

The didactic authority of history was certainly not new. The annals, chronological tables, and biographies included in the *Shiji* (Records of the historian) by Sima Qian (145–c. 86 BC) were meant to give scholar-officials easy access to the political and ethical lessons of the past. But by the late nineteenth century, Chinese historians were restless with Sima Qian's "case history" approach.[36] In 1902, Liang Qichao argued that national (as opposed to dynastic) histories, with their narratives of social transformation, helped the West and Japan to modernize by encouraging readers to identify with the state and their fellow citizens. Indeed, Liang's vision of history as a "mirror reflecting the nation" and a "source of patriotism" was an important prelude to anti-Qing revolutionary discourse.[37] Historical writing that lacked these qualities was disparaged as tacitly promoting political stasis.

During the often politically chaotic Republican Period (1911–1937), the nature of good historical writing and the status of ancient history remained vital. Many scholars hoped to establish ethnic, linguistic, and religious linkages with foreign nations, creating a sense of global interconnectedness. Others stressed the indigeneity of their own traditions. A third group argued that literary sources were so tainted by mythologizing that the ancient period could scarcely be researched, at least based on available accounts. The solution was to turn to artifacts and inscriptions, and *jinshi* scholars could demonstrate how to use these sources. But they did not promote age-old methodologies: instead, they recommended approaches that were propelled by artifact studies and other late-Qing innovations, and reflected the dynamism of *jinshi* overall.

To understand the persistent vitality of *jinshi*, we begin by con-

sidering the roots of the pastime in the Song, Yuan (1271–1368), and Ming (1368–1644); its Qing revival; and its ongoing concerns with language, ritual, and visual representation. During the late Qing, groups of elite scholars reengaged with antiquity, using *jinshi* as the starting point for an art movement as well as a vehicle for reform. As we see in the example of Wu Dacheng, late-Qing collecting practices and technologies of visual representation helped create a new form of artifact studies and provided the necessary preconditions for the discovery of the oracle bone inscriptions in 1899. Turn-of-the-century pioneers in oracle bone studies like Sun Yirang and Luo Zhenyu found these methodologies particularly useful as they looked for analogies between ancient history and modern politics. But after the 1911 Revolution, Luo's views became increasingly conservative. Despite his success as an independent publisher and art dealer, he was marginalized in historical circles. It was left for his protégé Wang Guowei in the 1920s to harmonize *jinshi* with emerging scholarly discourse, and to persuade young historians that ancient artifacts were still critical to their research.

Indigenous fields like *jinshi* survived into the twentieth century because their practices were resilient despite changing values in other areas of culture and society. And rather than obviating the usefulness of antiquarianism, foreign learning brought its advantages into sharper relief. Of course, those advantages were multifaceted, as was *jinshi* itself. Its persistence in the twentieth century illustrates the importance of hybrid discourses, which combine traditional and iconoclastic elements, scientific and humanist approaches, textual and visual modalities. By integrating art and antiquarianism into historical studies, Chinese scholars forged precisely this kind of modern amalgam.

1

Antiquarianism and Its Genealogies

> Bronze vessels embody ritual. When we wish to be-
> hold the Way [*dao*] and physical material [*qi*] of the
> Three Dynasties, outside of the Nine Classics, where
> can we find this other than with bronzes?
> —Ruan Yuan, *Jiguzhai zhongding yiqi kuanzhi*, 1883

SINCE THE QING DYNASTY, scholars have insisted that *jinshi* began
with Northern Song historians, who are praised for integrating inscrip-
tions into historical research and establishing a tradition of empiricist
scholarship. Yet since its inception, the pastime incorporated many
other important elements, particularly ritual studies and calligraphy.
Indeed, the great collector and *jinshi* scholar Ruan Yuan (1764–1849),
who started a new trend in appreciating stele calligraphy, admired not
only the historical research of Northern Song antiquarians but also
their attitude of ritual orthodoxy.[1] A full understanding of modern *jin-
shi* requires us to consider art, ritual, and historiography simultaneous-
ly in order to understand the complex, ever changing, and sometimes
conflicting ways in which *jinshi* specialists comprehended the material
remains of the ancient past.

Ritual and Politics

Antiquarianism was born in a contentious era. The period that fol-
lowed the Tang Dynasty (618–907) was characterized by violence
and disunity, as well as by the popularity of Buddhism, whose Indian
origins forever marked it as foreign in the eyes of orthodox Confu-

cians. Once the Song consolidated its empire, Confucian reformers like
Ouyang Xiu tried to revive supposedly more indigenous forms of poli-
tics and scholarship, those untainted by Buddhism.[2] Their search took
them back to the Three Dynasties period, encompassing the legendary
Xia (c. 2100–1600 BC), Shang, and Zhou dynasties, when, according to
Ouyang Xiu, "the rites and music united all under heaven."[3]

Proponents of the Song *fugu* (return to antiquity) movement ad-
vocated ancient-style prose and reprinted newly annotated works of
Confucius and Mencius. Although the idea of purifying politics and
culture through a return to antiquity was popular in the late Tang as
well, it became a particular obsession of eleventh-century intellectuals,
who urgently sought a way to perpetuate the empire by consolidating
its moral principles. To do this, they not only explored textual significa-
tions of culture but also immersed themselves in the material culture of
the ancients.[4] The politician and historian Sima Guang (1019–1086)
lounged in his garden wearing clothes made according to the ancient
Liji (Record of ritual).[5] And if even garden attire was modeled after
antiquity, then how much more important was it to perform imperial
rituals with the proper apparatus? Around 960, Nie Chongyi (fl. 10th
c.) presented the court with an illustrated catalog of the musical in-
struments, clothing, altar vessels, and other objects required for state
ceremonies. With its exacting measurements derived from references in
classical texts and the contents of the imperial collection, Nie's hand-
book was intended to standardize the manufacture of new ritual imple-
ments by the court.[6]

These new, archaistic pieces soon drew criticism from purists who
decided that only ancient bronzes counted as authentic ritual imple-
ments. But before it was possible to use antiquities correctly, it was nec-
essary to better understand their types and purposes.[7] For Ouyang Xiu's
friend Liu Chang (1019–1068), this research enabled "ritual specialists
to understand how vessels were used, etymologists to decipher their in-
scriptions, and genealogists to confirm the posthumous titles of their
ancestors."[8] Song Confucians believed the decorations on bronze ves-
sels embodied the ethics of antiquity in much the same way that a piece
of calligraphy expressed the moral essence of the artist who held the
brush.[9] As the painter Li Gonglin (1049–1106) explained, "The sages
adorned their vessels with images to convey the Way and hand down
admonishments [i.e., correct behavior]. These were skillfully conveyed
in both the physicality and use of the vessels, and otherwise could not
have been passed down to successive generations."[10] Three centuries

later, a Ming connoisseur asserted that the cultural characteristics of the Three Dynasties—for the Xia, loyalty; for the Shang, honesty; for the Zhou, elegance—were "shown in the designs of their vessels."[11] By studying the physical dimensions of bronzes and categorizing them according to their ritual uses, scholars venerated the corporeal expressions of antiquity.

The Song Confucian revival animated almost two centuries of avid bronze collecting. Hundreds of vessels were unearthed and eagerly discussed among coteries of antiquarian friends. Li Gonglin painted a mountain retreat, showing a seated semicircle, including a young boy, facing a bronze tripod resting on a large flat rock. Another Li Gonglin painting shows a bronze tripod used as a cooking vessel over an open fire, consistent with the purists' desire to return to the original purposes of bronzes, such as preparing and serving food.[12]

Proud of their growing expertise regarding ancient ritual artifacts, collectors produced pictorial catalogs with line-drawn images like Nie Chongyi's handbook. Unfortunately, most of these texts have been lost. Only the preface to Liu Chang's *Xian-Qin guqi ji* (Records of pre-Qin vessels) survives, embedded in a twelfth-century encyclopedia. Another lost text is the *Kaogu tu* (Illustrated investigations of antiquity) by Li Gonglin, who may have misattributed the ages of artifacts in order to make them appear more important.[13] The first surviving illustrated catalog was produced by Lü Dalin (1044–1093). His *Kaogu tu* (the name is the same as Li Gonglin's catalog) highlights the ceremonial use of some two hundred vessels by organizing them according to type. His philological study of their inscriptions made it possible to compare their contents to literary sources, but overall there is scant discussion of the historical, political, or philosophical meaning of the texts. Indeed, even esteemed linguists like Ouyang Xiu and Liu Chang had extreme difficulty deciphering bronze inscriptions.[14]

One of the most significant and influential attributes of these catalogs is their approach towards pictorial representation of artifacts. As best we can judge from Ming versions (no Song editions survive), the line-drawn illustrations in these catalogs were intended primarily to depict the essentials of the artifacts, outlining their shapes and sketching in their *taotie* decorations. The absence of detail—not to mention the strange errors like mismatched finials—can seem puzzling, although it is highly likely that the artists who created the images had little chance to see the objects in person and were instead drawing from memory or from other forms of description and representation.[15] An-

other curious detail is the nonexistence of any impurities such as patina, corrosion, or damage, which one would expect to see on bronzes after a millennium or more in tombs, underwater, or in other environmentally stressful locations. Given Confucian purposes of antiquarian collecting, however, this purified quality is particularly appropriate: since bronzes embodied ritual, their forms should be depicted as perfect in every respect. Indeed, bronze albums were intended to allow readers to see the "face of the ancients," while reciting inscriptions allowed them to "hear their voices."[16] In other words, early bronze catalogs were devotional implements, allowing Confucians to enjoy "a direct, bodily connection," in Christian De Pee's phrase, "between themselves and the ancients."[17]

The bond with antiquity had important political overtones. After all, King Yu of the Xia ordered the forging of the magical nine tripods, one to represent each province. By using ancient bronzes to conduct ceremonies, the Song court asserted its cosmological prerogative to represent the empire.[18] Emperor Huizong (1082–1135), a legendary collector of art and antiquities of all kinds, ordered his court officials to study the records of ancient ceremonial bells and commanded that new versions be cast for use in state ritual.[19] This project was so successful that Huizong next ordered his officials to collect other types of authentic ancient vessels from across the empire, hoping to use them as models to cast new vessels for other ceremonial purposes. The poet Ye Mengde (1077–1148) described the consequences as courtiers eagerly complied with the emperor's request:

> Literati families did not dare hide any of the Three Dynasties, Qin, and Han Dynasty vessels they had inherited, but had to present them all to the emperor. Antiquarians vied to obtain them, without concern for their actual value, so that the cost of one vessel could reach a thousand strings of copper coins. People fished them out of water and excavated tombs without any restraint. In total several thousand were collected, all appearing at once, in uncountable numbers.[20]

In various counties, local magistrates "ordered people to atone for crimes by paying in ancient vessels," some large enough to hold a young child.[21] Huizong's utilization of authentic ancient vessels in court ceremony was praised by officials; Zhai Qinian (fl. 1142) wrote, "with one stroke, he wiped away the vulgar speculations of the scholars of the Han and the Tang" regarding vessels and their uses.[22] Having creat-

ed an awesome collection of almost nine hundred artifacts, Huizong ordered his official, Wang Fu (1079–1126), to produce an illustrated catalog, the *Xuanhe bogutu* (Illustrations of broad antiquity from the Xuanhe palace) that was intended not only to document the court collection but also to standardize the manufacture of new vessels.[23] Other bronze items with cosmological significance, such as mirrors decorated with auspicious symbols, trigrams, and deities, also became popular with the emperor and his ministers.[24]

The Song reverence for bronze bells, ceremonial vessels, and mirrors as symbols of Confucian moral principles and cosmological significance reverberated until the end of the Qing Dynasty. In the mid-eighteenth century, the Qianlong emperor—another ruler with vast collecting appetites as well as a concern for both temporal and cosmological authority—ordered pictorial catalogs of his own considerable collection of bronzes. The introduction to his bronze catalog praised the artifacts for "expressing virtue in their firm nature and substantial forms," which made apparent "the models and manners of the Three Dynasties and earlier."[25] Qianlong also used ancient bronzes as models to produce porcelain and jade replicas, which were employed in court ceremonies.[26] Even at levels far removed from the exalted altars of the imperial court, bronzes and other artifacts—both ancient pieces and more modern replicas—continued to accompany Confucian, Buddhist, and Daoist ceremonies of all kinds well into the twentieth century.

And this ritual meaning of antiquities still resonated for the Qing official Duanfang (1861–1911), who credited antiquarians not only with "improving classical commentaries" but also with "transmitting ancient texts and ceremonies."[27] In 1901, a famous set of eleven bronzes and a bronze altarpiece was discovered in Shaanxi; Duanfang acquired the set and made it the showpiece of his album of bronzes, which was illustrated with line-drawn images of artifacts and printed by woodblock. Just like Song bronze catalogs—albeit with far more detailed attention to *taotie* decorations—Duanfang's album showed the bronzes in a highly idealized form, with no suggestions of damage or corrosion. The Shaanxi bronzes were also the focal point of a photograph of him and his colleagues commemorating his acquisition. In both images, the bronzes are displayed on top of the bronze altar that was part of the archaeological find, emphasizing their ritual purpose (see Figure 1.1).[28] The placement of the artifacts in these representations does not mean that Duanfang used them in actual ceremonies; their arrangement echoes his continuing respect for vessels as ritual implements, however.

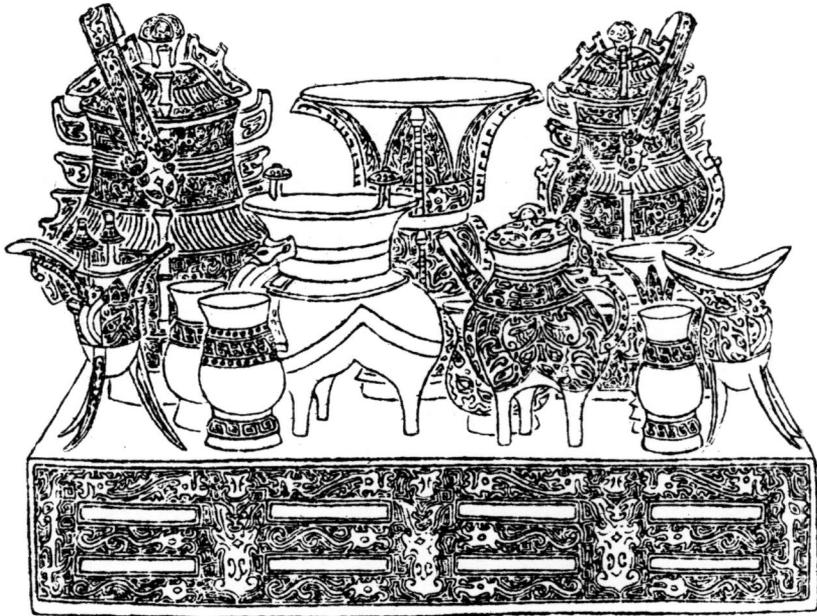

Figure 1.1. Line-drawn, woodblock-printed illustration of a set of ritual bronzes excavated in Shaanxi in 1901 and collected by Duanfang. This image is from Duanfang's bronze album (*Taozhai jijinlu,* 1908), where they are shown arranged on an original matching altarpiece.

Indeed, bronze vessels or their replicas continue to be used as both altar implements and political symbols—along with other national treasures, they appear on stamps and floats in National Day parades as synecdoches for the longevity of Chinese civilization.[29] In this way, popular discourse continues to honor the original politico-ritualistic associations of bronzes, refracted through highly motile definitions of national and cultural identity.

Inscriptions as Art and History

Only a few years after Huizong produced his artifact catalog the empire fell to the invading Jurchen Jin Dynasty (1115–1234). The imperial art collection was dispersed, although some artifacts were later recovered by private agents and sold to Southern Song (1127–1279) elites. The fact that the ethnically foreign conquerors were uninterested

in keeping the vessels for themselves underscored, of course, their general ignorance of ritual and ethics.[30]

One of the most esteemed private collections of art and books destroyed during the conquest belonged to Zhao Mingcheng (1081–1129)—a devotee of Ouyang Xiu—together with his wife, the talented poet Li Qingzhao (1084–c. 1151), avid collectors of bronze vessels, paintings, and stele inscriptions. As a young married couple, they delighted in a mutual passion for antiquities, particularly rubbings of stele inscriptions.[31] Like most antiquarians, they preferred texts taken from commemorative steles or *beitie,* whose inscriptions, such as epitaphs and dedicatory monuments at temples, often were created specifically to be inscribed on stone. These steles were "intended for public readership," expressing "orthodox visions of history, religious doctrine, and self-generated records of genealogy and ancestral achievement," in Robert Harrist's words.[32] They stood in contrast to the other principal form of stele inscription, namely the model-letters or *fatie* type, which reproduced calligraphy originally done on silk or paper. For example, during the Song, a famous set of *fatie* steles was created to safeguard examples of calligraphy by classical masters like Wang Xizhi (303–361).

The two types of steles differed in appearance as well as in purpose. *Fatie* steles were generally created to showcase cursive script styles. In contrast, *beitie* steles customarily used older script styles like *zhuanshu* (seal script), *lishu* (clerical script), and *kaishu* (regular script).[33] These styles were more rectilinear in shape, and were formed by heavier strokes of more consistent width, each graph distinct and separate. Antiquarians preferred *betie* scripts in part because Confucian art criticism valued calligraphy as the expression of an artist's education, political views, and inner character. They criticized Wang Xizhi and other model-letters masters because their ornate and mannered calligraphy symbolized political decadence. In contrast, regular-script masters such as the Confucian paragon Yan Zhenqing (709–785) had "firm, strong, and individual" brush strokes that reflected an upright moral character.[34] Song scholars emphasized the calligraphy of inscriptions while generally ignoring their pictorial carvings, as was the case with their research of the Han Dynasty Wu Liang shrine, for example.[35]

In his pursuit of Confucian calligraphy models, Ouyang Xiu collected hundreds of inscriptions in the form of rubbings. His original catalog of these materials is lost, but some four hundred of his colophons and commentaries to the inscriptions survived and were published by his son. From these we know that, with help from friends like

Liu Chang, he had rubbings of a few bronze vessels like the Maobai *dui* (a kind of covered food vessel), the stone drum inscriptions (inscribed boulders that narrate a hunting party by the king of Qin during the Spring and Autumn period, 770–476 BC), and inscriptions from Qin weights and measuring devices. But fewer than twenty items in his collection were taken from bronzes, which he could scarcely read in any case.[36] The overwhelming majority were *beitie* inscriptions created by Yan Zhenqing and other Confucians from more recent periods. Their connoisseurship allowed Ouyang Xiu to criticize the court-sponsored "Wang style" and challenge not only the aesthetic but also the political judgment of the emperor.[37] When the study of inscriptions was revived in the Qing, Ouyang Xiu's example encouraged them to venerate stele calligraphy, and to associate Confucian attributes—moral fiber, discipline of character, and honesty in politics—with practitioners of the script styles most commonly found on dedicatory steles.

Hence, Ouyang Xiu's interest in inscriptions was deeply entangled in his desire to revive orthodox Confucianism via a promotion of calligraphy styles. But from the perspective of Qing scholars, his most lasting contribution was his use of steles for historical research. During the years he collected rubbings, he was active with several historical projects, including writing a history of the Five Dynasties (907–960) and serving as editor of a new, imperially sponsored history of the Tang. Given his expertise in stele calligraphy, it is not surprising that Ouyang Xiu enjoyed using stone monuments as historical material. For example, he rewrote the Tang imperial genealogy after consulting a temple inscription created by Prince Li Yuanyi (d. 673), which listed the names of his ten sons.[38] He believed that the material in stone inscriptions was more factually reliable than were literary sources, and he enjoyed the sense that he was helping to preserve their contents for future generations.[39] When working with literary sources, in contrast, he felt less reverence; his history of the Tang modifies the flowery language of original documents to produce more austere, ancient-style prose, and ignores reports of supernatural events like the auspicious omens that reportedly accompanied the births of the first Tang emperors.[40]

The idea that inscriptions were more trustworthy than literary sources gained wide currency in the Song. Zhao Mingcheng argued that, when comparing stele texts to histories, "bronze and stone inscriptions contradict [mistaken] information three or four times out of ten"; they were "created at the time, and can be believed without doubt," in contrast to literary sources, which were "produced by the hands of later

generations, so they must have omissions."[41] While this approach has been cited as evidence of the strict empiricism of Song historians, these men were well aware that not all inscriptions were accurate or contemporaneous with the events they describe. Indeed, steles with important political texts could be created, destroyed, and recreated using rubbings from earlier versions, without diminishing (although qualifying) their appeal for collectors.[42] Their respect for nonliterary sources was colored by the special consideration given to bronzes and steles as Confucian artifacts, whose contents expressed more than mere empirical information.[43] As Li Qingzhao commented, only lesser scholars studied inscriptions simply to correct historical mistakes: true antiquarians wanted to harmonize with the *dao* (the Way) of the sages.[44]

Nonetheless, Ouyang Xiu's use of inscriptions, particularly stone monuments, as historical sources was profoundly influential on subsequent research. During the heyday of Qing philology, he was credited with creating the field of *jinshi* precisely because of his ability to utilize steles in order to correct mistakes in literary sources. His empiricism stood in stark contrast to the controversial legacy of Ming antiquarianism, which by the Qing had unsettling connotations of decorativeness, playfulness, and social striving.

Ming Antiquarianism and the Problem with Play

The Jin conquest did more than disperse artifact collections: it signaled the waning of an entire attitude towards antiquities as Confucian and historical artifacts. Southern Song elites still venerated bronzes and steles, but primarily for their calligraphy. The few *jinshi* works produced during the dynasty, like the *Lidai zhongding yiqi kuanshi fatie* (Model letters of ancient inscriptions on bells, cauldrons, and wine vessels) compiled by Xue Shanggong (fl. 12th c.), were esteemed not for philology or ritual acumen, but as studies of bronze-vessel calligraphy forms. Ming collectors once again prized examples of cursive texts over standard-script masters like Yan Zhenqing. When they appraised bronzes, they focused on their decoration and usefulness in interior decoration. This physically attuned style of antiquarianism was articulated in a thirteenth-century connoisseurship text by Zhao Xigu (fl. 1180–1240), who paid particular attention to physical properties like coloring, texture, and even smell. He informed collectors, "Ancient vessels of the Xia, Shang and Zhou dynasties do not have the slightest rank odor, though those that are newly excavated have an earthy smell that disap-

pears in time. If a vessel is a fake and is rubbed in the warmed palms of the hands a terrible stink of bronze arises."[45] In the early Ming, the *Gegu yaolun* (Essential criteria of antiquities, 1388) by Cao Zhao (fl. 14th c.) begins with a section on bronzes but focuses on their color— "the color of a bronze vessel which has been buried under the soil for a thousand years is pure turquoise, like the blue feather of the kingfisher; when it has lain in water for a thousand years, [it is pure] green like the skin of a melon"—and designs, not inscriptions.[46] It also discusses the value of bronzes as incense burners, flower vessels ("heavily imbued with the spirit of the earth," an ancient bronze will keep flowers as fresh "as if they were still growing on the trees"), and even their usefulness in dispelling malevolent spirits.[47]

Appreciative of patina, coloration, smell, and other tactile qualities, Yuan and Ming antiquarians focused their attention on a wider variety of artifacts than did Song antiquarians. Although Lü Dalin included some fourteen jade artifacts in his catalog, no one else produced a text dedicated solely to jades until the painter Zhu Derun (1294–1365) compiled some thirty-nine artifacts in his *Guyu tu* (Illustrated ancient jades), detailing their measurements, coloration, and provenance. Zhou Mi (1232–1298) also included jade pieces in his catalogs of art and artifacts. In the Ming, Cao Zhao, the poet Yang Shen (1488–1559), and the playwright Gao Lian (1573–1620) all wrote texts discussing the types, inscriptions, and areas of production of ancient jades. Another innovation was the treatment of seals, with the first works dedicated specifically to the study of seal-carving, like the *Yinshi* (History of seals) by the painter and calligrapher Zhao Mengfu (1254–1322), and the *Xuegu bian* (Compiled studies of antiquity) by Wu Qiuyan (1272–1311). (Not surprisingly, pioneering Yuan seal carvers discovered the artistic possibilities of soft soapstone.)[48]

An even more striking departure from Northern Song antiquarianism was the attitude towards antiquity as a source of both status and pleasure, and the collection of artifacts as a form of play. Yuan Xie (1144–1224) noted the "considerable enjoyment in playing with ancient paintings, books, and artifacts" felt by contemporaries like Yuan Wen (1119–1190), who "constantly spread out and played with the things he particularly loved."[49] This pleasure-seeking attitude reached its zenith in the late Ming, when ancient artifacts were "objects of connoisseurly enjoyment" that could decorate a study, an ancestral shrine, or both.[50] Scholars from the Jiajing era (1522–1566) combined collecting art and antiquities with constructing gardens and mentoring troops of

singing girls.[51] A few decades later, Wu Qizhen (1607–c. 1678) probably referred to paintings when he remarked, "the difference in taste or vulgarity lies in whether or not one has antiques," but his insights apply equally well to rich families who sought a reputation for elegance through their purchase of bronzes.[52] Tellingly, ancient artifacts were not always valued above more modern pieces, like model-letters calligraphy or Yuan paintings.[53] Indeed, by the Wanli reign (1572–1620), collectors were obsessed with modern curios, like paintings, incense burners, and objects of foreign origin.[54] They hunted bronzes inlaid with gold and silver (probably archaistic pieces rather than genuine ancient artifacts) and used them to store ink, weigh down papers, burn incense, and, of course, display flowers.[55]

To be sure, Ming antiquarians were not the first to express delight in studying antiquities. Even Ouyang Xiu collected rubbings of inscriptions to "please himself" and experience "great pleasure when I am old." He compared ancient artifacts to "ivory, rhinoceros horn, gold and jade," materials that were just as valuable and durable as bronze and stone.[56] Robert Harrist relates, "So widespread was the passion for collecting antiques [in the Song] that some serious-minded scholars found it necessary to proclaim that they bought their treasures not with a fondness for playthings to 'dazzle the eye,' but with a true love of antiquity."[57] Li Gonglin warned that since the sages created bronzes to carry admonishments and transmit ethical principles, they were not merely things of beauty or enjoyment.[58] Lü Dalin was more severe, instructing fellow antiquarians that they "must not take vessels as curios. Observe their uses, read their texts aloud, describe their similarities, in order to pursue the winds coming from the Three Dynasties and meet the ancients."[59]

And many Ming collectors were profoundly interested in inscriptions and antiquities. A connoisseurship text on antique ink by Ma Sanheng (fl. 1640s), for example, includes the invention of ink among other legendary feats by the ancient sages.[60] And by the end of the dynasty, there was renewed interest in the epigraphic study of steles. Members of this group included Guo Zongchang (c. 1570–1652), who collected stele inscriptions in North China. Their writings were republished by antiquarian scholars in the Qing, who admired their use of steles in historical research.

Guo Zongchang and his friends notwithstanding, Ming antiquarianism was still generally criticized for its lack of philological rigor. The historian and antiquarian Qian Daxin (1728–1804) charged, "From

the Yuan to the Ming Dynasties, scholars talked emptily about famous theories, and ignored etymology. They seemed scholarly, but were just flapping their mouths in ignorance."[61] Tao Zongyi (1329–c. 1412) was praised for including rare stone monuments in his *Guke congchao* (Collected copies of ancient inscriptions), but was criticized for not re-searching inscriptions more systematically.[62] A 1920 history of *jinshi* concluded, "the Yuan Dynasty found it difficult to succeed upon the flourishing [of antiquarianism] during the Song Dynasty, because their prevailing customs did not emphasize concrete learning, and therefore few bronzes and steles were discovered....Being even more appreciative of non-empiricism, and unable to distinguish between real and coun-terfeit, but still flaunting their subjective talk with virtually no textual research, was the failing of Ming literati scholarship."[63] As we shall see, the sensuality expressed by Ming connoisseurs remained unsettling.

Indeed, by the late Qing period, even Song contributions were downplayed. A nineteenth-century *jinshi* study lists almost 150 Qing antiquarians, while only seventeen combined were from the Jin and Yuan dynasties and forty-four were from the Ming. The Song is cred-ited with slightly more than sixty scholars.[64] A guide to the field by Rong Yuan (1904–?), whose brother was the famous archaeologist Rong Geng (1894–1983), lists fewer than thirty authors and works from the Song.[65] Although Liu Chenggan (1882–1963) admitted that *jinshi* began with Ouyang Xiu and Zhao Mingcheng, he argued that the field really developed during the mid-Qing, when "the multitudes immersed themselves in studies of antiquity, and those who studied bronzes and steles were harnessed together in one ambition, to confirm the classics and correct the histories. They resumed making rubbings of inscriptions, and in this way there gradually developed a specialized discipline."[66] In the new genealogy of *jinshi*, philological research was paramount.

Stele Inscriptions and Han Learning

Regardless of the value of Yuan and Ming antiquarianism, it is undeni-ably the case that the popularity of antiquarianism declined after the Song. When it did revive, it had been transformed again. Qing scholars used inscriptions to confront a fundamental (and recurrent) anxiety that the classics had been corrupted over the millennia. As a consequence, they believed philological research was required to judge which por-

tions were authentic. After a text had been verified, they could interpret its meaning more accurately and apply its wisdom more confidently. Particularly following the Qing conquest, the philological study of the classics was seen as far superior to what was considered the decadent philosophical interpretations of the Ming. Looking to explain the fall of the previous dynasty, they faulted the Ming craze for metaphysical speculation, sparked by the teachings of the philosopher Zhu Xi (1130–1200) and hence labeled Song Learning. As an antidote, they championed Han Learning, which emphasized *kaozheng* or textual research. Han Learning adherents like Dai Zhen (1724–1777) particularly valued etymology and phonology, summing up the relationship between classical texts and philological research this way: "The essence of the Classics is the Way. The meaning of the Way is found in its language, which is clarified through the study of linguistics and etymology."[67]

Song antiquarians were suspicious of Han scholars, who venerated the ancients insufficiently.[68] But Qing classicists sought particular guidance in Han commentaries to ancient texts. Like the antiquarian Lu Wenchao (1717–1796), they believed, "Han people were not far from antiquity, saw more ancient characters, and were accustomed to their ancient pronunciations."[69] Accordingly, the study of ancient inscriptions was a critical part of the Han Learning movement from its inception. Some of the most famous early-Qing antiquarians were members of a coterie of Han Learning adherents surrounding Gu Yanwu (1613–1682), a highly respected polymath.

Deeply critical of Ming scholarship, Gu and his associates focused on phonology to understand how the ancients had literally spoken their words and to recover the meaning of their texts.[70] They turned to stele inscriptions to interpret variant graphs found in early texts and to clarify etymology. Han Learning proponents later emphasized the empiricist, "seek truth from facts" components of *kaozheng* discourse, as in the admonition of the late-Qing official Zhang Zhidong (1837–1909) to "know what an object is, what an event was, and who someone was, and only afterwards understand the meaning of the sages."[71] But the original goal was not so much a desacralization of the classics as it was an attempt to maintain their ethical authority and, in Kai-Wing Chow's words, "reaffirm the core values of Confucian ethics."[72] Armed with a better understanding of how ancient language was constructed and sounded, Gu Yanwu and other Han Learning proponents hoped to secure a more pristine classicism and metaphysi-

cal foundation for a better age. As Gu wrote, "By preserving these [ancient] writings, Heaven has demonstrated that the sages will one day return and restore the pronunciation of today to the clarity and purity of ancient times."[73]

One of Gu's closest friends was the brilliant Yan Ruoqu (1636–1704), author of the *Shangshu guwen shuzheng* (Evidential study of the Old Text Documents). In this work, Yan investigated the transmission of the *Shangshu* (Documents), a compilation of Shang and Zhou texts including legal codes, conversations between kings and ministers, prayers, and imperial gifts. During the Han Dynasty, a version of the *Documents* that included several new chapters and that was written in an archaic script form, the so-called Old Text, was discovered in the walls of Confucius' home. This version was copied into standard script and included in the canonical edition. According to Yan, however, these new chapters were not Shang- and Zhou-period texts. In fact, they were simply reedited fragments from other sources. From the perspective of Han Learning adherents, his unmasking of this centuries-old forgery was particularly important because it rendered irrelevant certain Ming metaphysical claims.[74]

Other members of Gu Yanwu's circle expressed an interest in Han Learning through their appreciation for ancient calligraphy. Fu Shan (1607–1684) specialized in Han clerical script, paring down the character variations in his artwork in order to avoid anachronistic graphs.[75] The models for his artwork were primarily found on steles, and these became newly important to Gu and his friends for their artistic value. Furthermore, as men of the "conquest generation," their loyalty to the Qing was tempered by nostalgia for the Ming. Often their love of antiquarianism was expressed through travel, in what was referred to as *fangbei* or searches for steles. While late-Yuan painters like Wang Lü (1332–c. 1391) traveled to sacred mountains to experience sublime scenery, Gu Yanwu and his friends scoured remote regions for historical steles, with particular excitement if they found materials that documented the recently fallen dynasty.[76] Their *fangbei* were emotional peregrinations—wistful reencounters of the vanished past, particularly since their travels took them to remote regions, where the rugged landscapes embodied their feelings of political alienation.[77]

Of all the steles he pursued, Gu Yanwu considered the most valuable to be monuments dating from the most recent dynasties—the Song, Yuan, and particularly the Ming. After finding a Ming stele on a mountain in Anhui, for example, Gu wrote,

It is a small stele with just one face, on the Western wall of the marketplace temple on Mount Huo. When I travel around the country, texts on ritual ceremonies and other steles are very common from the Hongwu (1368–1398) and Yongle (1402–1424) periods, but few from the Jianwen period (1399–1402), perhaps because it was brief, or because the flattery offered by officials to the emperor during his reign has all been rooted up. This text was mixed in among several dozens of steles, but its characters were perfectly complete without any flaws, and I was anxious to record it.

Future scholars may mourn that Ming history does not contain any traces of the Jianwen reign, and hence nothing to compare to for evidence. If I can encourage elegant scholars to brave the deep mountains and wretched valleys to come find this stele, if this stele or one or two others still exist (not just on the Mount Huo temple) and not just the poem on the Luoyong Shrine, then the accounts of [the Hongwu Period officials] Cheng Ji and Shi Bin cannot be easily falsified. Thus I copied it, to ensure that future generations can trust antiquity.[78]

Gu Yanwu emphasized the need to travel to remote areas, as he himself did; indeed, early Qing scholars scorned Ming antiquarians who traveled in excessive comfort, and then indolently delegated the collection of inscriptions to subordinates.[79] Once he found this stele, Gu's primary goal—like Ouyang Xiu's—was to preserve its contents for future generations because such sources would someday allow historians to verify other historical accounts. Hence, the early-Qing revival of stele inscriptions as tools for linguistic research and art connoisseurship helped spark their rediscovery for historiography.

Antiquarianism and Eighteenth-Century Historiography

Gu Yanwu's revival of stele inscriptions in historical research, and his calls for their preservation, launched a new antiquarian movement that persisted for the next two centuries. During the eighteenth century, there was a particularly famous incident when a set of Liao Dynasty (915–1125) stele inscriptions regarding the layout of the medieval capital were unearthed by the Qing official Zhu Yun (1729–1781). After similar discoveries of previously unknown inscriptions by himself and his friends, Zhu Yun became convinced of the need to preserve these steles across the empire. In 1772, when serving as Educational Com-

missioner of Anhui, he petitioned the throne to compile a new impe-
rial library, which would include catalogs along the lines of the works
composed by Ouyang Xiu, Zhao Mingcheng, and Lü Dalin. Zhu Yun
argued that the court should also commission an empire-wide survey of
stone monuments—i.e., the imperial library should include nonliterary
material—to pull together, for the first time, thousands of inscriptions
from all periods strewn across the empire.[80]

Alas, an empire-wide directory of steles was never compiled. Per-
haps the court was reluctant to encourage the strong connotations of
localism already present in *jinshi* research.[81] But the idea of an expand-
ed library did find favor in the imperial ear, and soon Qianlong autho-
rized the Ground Council and the Hanlin Academy to pursue several
ambitious book-compilation projects. Most impressively, the massive
Siku quanshu (Complete library of the four treasuries) project repub-
lished thousands of titles, gathered by officials and donated by biblio-
philes from across the empire, including hundreds of Song, Yuan, and
Ming texts that were believed lost. An accompanying catalog, which
included many more works than the actual library could encompass, set
standards of bibliographic classification for almost two centuries. But it
also sparked a debate over the proper classification of nonliterary ma-
terials, which ultimately helped articulate why the study of inscriptions
should be considered part of history, and not of linguistics.

Given the use since Ouyang Xiu of stele inscriptions as historical
sources, the inclusion of *jinshi* in history might have seemed obvious
to the *Siku quanshu* editors. In fact, they were perplexed as to its proper
classification within the *sibu* (four branches, namely classics, history,
masters, and belles lettres) bibliographic system. This is because, as we
have seen, not all antiquities were used in historical research. If a work
clarified etymology and hence aided in interpreting literary sources, the
editors believed it should be considered part of the classics. But this
made it difficult to assign a location for pictorial catalogs of bronzes
and other artifacts, which often included facsimiles of inscriptions—
and hence had value for etymology—but were not necessarily philo-
logical studies. The editors ultimately placed antiquarian studies into
three separate sections: works like Ouyang Xiu's that focused on stele
inscriptions and their historical significance were placed in history;
pictorial catalogs that were organized according to artifact type (and
hence denoted their ritual use) were considered part of the Masters
branch, which included philosophy; and finally, philological works were
placed in linguistics, a subfield of classics.[82]

But some scholars disagreed with this splintering. Qian Daxin spoke for many eighteenth-century scholars who valued inscriptions primarily for their contemporaneity and who believed they should be considered tools for historical research. "Writings on bamboo and silk [i.e., early texts written on ephemeral materials] have long been corrupted by hand-copying and woodblock printing, so that they lost their truth bit by bit," he wrote, echoing Zhao Mingcheng. "Only on bronze and stone inscriptions, conveyed from centuries in the past, can one behold the true face of the ancients, their language and their affairs."[83]

It is not entirely the case that eighteenth-century antiquarians "challenged historians to respect facts," as Edward Wang suggests, but they certainly championed *different* facts.[84] Stele inscriptions were still the most commonly used nonliterary sources, but now stele inscriptions from the edges of empire were newly foregrounded. For example, Qian Daxin, who helped rescue the stele studies of Guo Zongchang, referenced the information contained in a Dunhuang inscription in his account of the Han Dynasty defeat of the Huyan (one of the largest tribes in the nomadic Xiongnu alliance on the northern frontier).[85] Elsewhere, he cited an inscription to document maritime journeys to the West by the Yuan navigator Yang Shu (1283–1331), a century before the more famous Ming admiral Zheng He (1371–1433).[86] Zhu Yun's friend Wang Chang (1725–1806) researched Song, Liao, and Jin steles in order to correct the dynastic histories composed during the Yuan under the leadership of the Mongol historian Toktoghan (1314–1355).[87]

These studies departed from previous forms of antiquarianism because they paid so much attention to inscriptions from conquest dynasties, as well as those from Buddhist temple sites. But in an age of increased contact with foreign nations, including the Western powers (Russia, in particular, which was putting pressure on Qing frontiers), it is not surprising that conquest dynasties and frontier affairs seemed important. An accomplished mathematician and astronomer, Qian Daxin wrote extensively about the challenges posed by the West and expressed his support for the "Chinese origins of Western learning" *(Xixue Zhongyuan)* theory, which posited that European science was derived from principles already known to ancient Chinese innovators.[88] He also learned Mongolian and was an expert on Yuan history.[89] Confronting foreign power and discursive authority on an unprecedented scale, Qian and his contemporaries articulated a legacy of triumph over foreign invasions and cultural influence, and stressed the importance of

historical research in providing a sense of national cohesion. Gong Zi-
zhen (1792–1841), for example, authored several essays on Mongolian
Buddhism, language, and geography, and claimed, "to extinguish a na-
tion, you first get rid of their historians." Conversely, historians were es-
sential to the functioning of the state: "as long as its historians survived,
the Zhou survived; the Zhou perished when its historians perished,"
Gong cautioned.[90]

This emphasis on conquest dynasties and frontier nations meant
that, for virtually the first time, inscriptions from Buddhist sites and
non-Han dynasties were considered *jinshi* materials. This discov-
ery energized the field, particularly for artists who were interested in
nonorthodox styles. No longer attracted to stele inscriptions as the
embodiment of orthodoxy, they used unusual inscriptions to contex-
tualize China's aesthetic and textual traditions within a new global
consciousness.

New Visions of Stele Calligraphy

As the example of Fu Shan demonstrates, the role of art practice and
connoisseurship was central to the Qing revival of *jinshi*. Qianlong's
decision to publish pictorial albums of his collection of art and antiq-
uities came after a number of high officials, like the calligrapher and
poet Liang Shizheng (1697–1763, who later edited imperial antiquar-
ian albums), produced their own catalogs of calligraphy and paintings,
including model-letters compendia for calligraphers. Not surprisingly,
during the period of Han Learning's greatest strength in the eigh-
teenth century, many scholars emulated Fu Shan and particularly ad-
mired Han steles and inscriptions. The minor official and celebrated
artist Huang Yi (1744–1802), for example, felt particular excitement in
identifying inscriptions as Han texts even if there was scant evidence
for such an attribution.[91]

Huang Yi's younger friend and supporter Ruan Yuan also admired
Han Dynasty stele inscriptions and called their individual characters
"worth a thousand gold cash" apiece.[92] But under Ruan Yuan's guidance,
the fashion for epigraphic calligraphy in the nineteenth century turned
towards inscriptions produced during the Northern Wei (386–534) and
other periods when China was ruled by non-Han ethnic groups. For
centuries, this calligraphy had been considered coarse and second-rate.
Monuments produced under the Northern Wei, when North China
was controlled by the Toba ethnic group, were only grudgingly accepted

by Ouyang Xiu. Even though he admitted that "the calligraphy is often skillfully done," he complained of the "vulgarity" of Northern Wei artists, who "injected their barbarian ignorance into their learning." By including "so many Buddhist terms," for example, their inscriptions were unsuitable as calligraphy models.[93] Ouyang Xiu included some Northern Wei texts in his catalog, but Ming reprints often omitted them (and inscriptions produced during other conquest dynasties).[94]

As a consequence of greater foreign contact and interest in frontier history, however, antiquarians reconsidered calligraphy produced under non-Han regimes. In 1629, connoisseurs discovered a particularly charming stele at the Buddhist cave site in Longmen, near the Wei capital of Luoyang. Gradually, antiquarian tastes changed to appreciate what Hua Rende has characterized as the "rigid" and "sometimes monotonous" style of Northern Wei calligraphy, coming to praise its "boundless expression" and "internal sense of freedom."[95] Wang Chang even called "loathsome" the practice of copying *fatie* texts by Wang Xizhi.[96] Instead, he and Qian Daxin referenced dozens of Northern Wei steles in their catalogs. Gong Zizhen called steles created between the Han and the Sui (a period that included the Northern Wei and several other non-Han regimes) "refined and rich," and he had a seal made to reflect that preference.[97]

One of the most ardent supporters of Northern Wei–style calligraphy was Ruan Yuan. In two essays on regional variations in calligraphy, he promoted Northern Wei steles for both historical and aesthetic reasons. "Ancient stele inscriptions record the meritorious deeds of rulers, or serve as tablets inscribing the moral deeds of premiers, thus aiding in historical studies," he argued. At the same time, he praised as "clear and plain" Northern Wei inscriptions, often created for purposes of Buddhist piety. Remarkably, he argued they could express the same aesthetic and historical values as Confucian inscriptions.[98] Ruan Yuan was also a pioneer in the study of pictorial elements of stone carvings, researching the Wu Liang wall carvings after the site was rediscovered by his friend Huang Yi.[99]

Not all of Ruan Yuan's contemporaries welcomed the revival of stele-style calligraphy, however, or considered it compatible with the study of history. The proponent of Confucian ritual, Ling Tingkan (1755–1809), warned against the emerging fad of treating steles as calligraphy models. If antiquarians truly wanted to emulate Ouyang Xiu, Zhao Mingcheng, and Xue Shanggong, he cautioned, they must use inscriptions in order to "study and comprehend antiquity," and not

simply "treasure the meticulousness of their calligraphy."[100] Huang Yi's friend Weng Fanggang (1733–1818) warned that stele-style calligraphy obscured the field's emphasis on historical research. He "disliked when [calligraphers] speak only of appreciation, and do not realize that they first must ascertain if stele inscriptions accord with historical accounts."[101] Qian Daxin asserted that there had always been two types of antiquarians: those who studied inscriptions for historical purposes and those who were interested in calligraphy—implying that only the former were real scholars.[102]

Such anxieties over the continuing interplay between art and historiography prompted antiquarians to warn contemporaries not to assume a frivolous tone in discussing inscriptions, or to allow their interest in stele rubbings as aesthetic artifacts to cloud their judgment of their authenticity. As a friend wrote to the famed bibliographer Miao Quansun (1844–1919),

> People who are called antiquarians like to search for Song rubbings and colophons. Song rubbings and colophons have become treasures. Whoever finds them stores them away in private, so there's not much difference between them and playthings. Then they take them and speak of grammar and the "essence of the brush" [*biyi*]— none of this is comparable to antiquarian studies.[103]

In 1907, Liu Shipei (1884–1919) also fretted that its connection to calligraphy decreased the usefulness of *jinshi*. Although he praised mid-Qing linguistic accomplishments, "to consider the evolution of calligraphy as part of archaeology only promotes a spirit of connoisseurship, with limited usefulness."[104] Wang Guowei criticized this attitude for encouraging collectors like Duanfang to collect imitations out of a sense of admiration for their calligraphy.[105] In other words, modern practitioners still debated the relative significance to *jinshi* of art, history, philology, and politics. Yet as antiquarians engaged with reform in the late nineteenth century, the diversity of its approaches was crucial to the pastime's usefulness and enduring appeal.

2

Antiquarianism in an Age of Reform

At the beginning of the Guangxu Reign [1875–
1908], capital literati vied with each other over lit-
erature, painting and calligraphy, antiquities, and
ancient artifacts, competing to surpass Weng Fang-
gang and Ruan Yuan. At that time, Pan Zuyin and
Weng Tonghe had the most prestige of all. They took
as their protégés Shengyu and Wang Yirong, two ex-
tremely talented and bright young men, who excelled
at everything.
— Zhenjun, *Tianzhi ouwen,* 1907

IN THE NINETEENTH CENTURY, *jinshi* entered a period of remark-
able growth, with some nine hundred works produced before the end
of the dynasty.[1] This burst of enthusiasm was animatedly chronicled by
the political reformer Kang Youwei (1858–1927):

After the Jiaqing reign [1796–1821], antiquarianism was extremely
popular, with scholars referencing bronze and stone inscriptions as
evidence to verify the Classics and emend the Histories. More and
more people specialized in collecting inscriptions and published
works on them. Excavated materials were found on mountain cliffs
and inside walls, from remote and isolated areas, dug up by farmers'
hoes, or found in the kitchens of officials. Washed clean to their
original glory, they were disseminated by rubbings.[2]

This renaissance was surprising since Han Learning, the methodologi-
cal umbrella for *jinshi* in the eighteenth century, had come under attack.

Zhang Xuecheng sounded an early charge when he criticized students for "coming to the capital with notebooks in hand and with extravagant notions of making discoveries and doing research in the imperial libraries. [They] claimed to be expert in philology, text-criticism, 'phonetics,' or 'ideography,' trotting along with changing popular fashion."[3] Philology was viewed as too esoteric to meet the challenges of the globalizing world. Instead, the Statecraft School, which emphasized the need for technical training in things like river control and cartography, was seen as a more practical way to confront new political and military challenges.[4] Seeking to refute claims that China's resources were inferior to the Western powers, for example, Wei Yuan (1794–1857) hunted geographical knowledge about the nations that bordered China's frontiers and beyond, exploring their social practices, technologies, and economic systems.[5] Other writers proposed internal reforms; an influential essay by Feng Guifen (1809–1874) advocated a technologically oriented school curriculum with foreign-language training.[6] Indeed, in the last decades of the century, almost every intellectual seems to have been some kind of a reformer, whether recommending a greater acceptance of Western technologies and political practices, or (echoing Ouyang Xiu) aiming to strengthen the state through a return to ancient principles of Confucian governance.

Despite its use of Han Learning methodologies, *jinshi* was at the center of this reformist wave—the upright Confucian did not neglect the concerns of the present, as the calligrapher Zhang Yuzhao (1823–1894) advised Wu Dacheng.[7] But the political choices of late-Qing antiquarians were informed by their unique life experiences. For one, they were members of a tragic generation. Many witnessed first-hand the Taiping Rebellion (1850–1864), which tore apart scores of communities in the empire's heartland. Zhang Zhidong fought in the counterrebellion that made many refugees among the antiquarian community. Their friend, the painter Zhao Zhiqian (1829–1884), buried his wife and daughter, slaughtered when the Taipings overran Hangzhou.[8] Survivors of a devastating conflict, they admired the intellectual confidence of mid-Qing Han Learning, and their affinity for antiquarianism may have been tinged with nostalgia for a more secure and prosperous era. They also embraced the practically oriented Statecraft School, exploring frontier regions and foreign lands and striving to establish the social significance of their scholarship. *Jinshi* appealed to these intellectually curious and cosmopolitan men precisely

because it complemented their goals of political, social, and cultural transformation.

Antiquarian Learning and Qing Social Networks

The reinvigoration of *jinshi* did not take place in a social vacuum. It centered on a multigenerational network that was established in the capital by two powerful court officials, Pan Zuyin (1830–1890) and Weng Tonghe (1830–1904). Savvy politicians, they schooled their protégés in the ways of both *jinshi* and court politics. Of the dozens of young men they mentored, many went on to fill high bureaucratic posts. Others were less prominent in public affairs but became well-regarded scholars.

Like many capital social networks, their clique was cemented through *yaji*, or "elegant gatherings."[9] Pan Zuyin's parties were particularly jovial. As a Republican-period memoir recounted,

> At the end of each spring examination season, Zhang Zhidong and Pan Zuyin hosted large gatherings of high officials and famous scholars, where the feasting did not stop until their guests were happily intoxicated. Every ten days, invitations were issued to classicists, linguists, antiquarians, cartographers, astronomers, essayists, and poets from around the empire. The attendees numbered more than a hundred men. [...] Everyone was excited and focused, so elated they were almost feverish. They critiqued calligraphy and discussed paintings, played chess and chatted.[10]

These parties were described in the late-Qing novel *Niehai hua* (Flower in a sea of retribution) primarily as occasions for social climbing.[11] But Pan Zuyin's protégés remembered significant scholarly content. Guests compared artifacts and rubbings, discussed difficult inscriptions, and composed poetry, after Pan suggested topics like rubbings, ink stones, and coins.[12] These events drew together men like Zhang Zhidong's brother-in-law Wang Yirong and his colleague Wu Dacheng; the painters and rivals Zhao Zhiqian and Li Ciming (1830–1894); and the precocious Sun Yirang, who already had written an antiquarian research work, *Guzhou shiyi* (Corrected omissions of ancient script, 1873), that remedied paleographic mistakes of Xue Shanggong and Ruan Yuan. Other attendees included Yang Shoujing (1839–1915), who made his early reputation as a geographer; Wang Kaiyun (1832–1916), classicist

and poet who served as an assistant to the reform official Zeng Guofan (1811–1872); and Miao Quansun, who later served as the first director of the Jiangnan Library, established in 1907 by Duanfang, another member of their extended circle.[13]

Whether intellectually productive or occasions for opportunism, these lavish affairs captivated the imagination of a generation of young scholars, and helped spark a widespread craze for *jinshi*. Memoirists like Zhenjun (1857–1920, a Manchu) and Ye Changchi (1847–1914, a Suzhou protégé of both Feng Guifen and Pan Zuyin) noted that scores of young men in the capital wanted to emulate Ouyang Xiu and Zhao Mingcheng—in other words, become antiquarians.[14] They haunted Pan Zuyin's house on Mishi Hutong (located near Liulichang, the capital antiques district), begging to become protégés.[15] In *Niehai hua*, Pan's study is described as decorated with "countless numbers of bronzes" and other treasures, a congenial environment for discussing inscriptions, ancient roof-tiles, ink-stones, coins, and seals. Following the latest fashion, poetic couplets composed at his *yaji* festooned the walls.[16]

It is not hard to understand the appeal of Pan Zuyin's patronage. His grandfather had been a grand secretary, his father was a powerful official in the capital, and many other relatives held distinguished posts in the imperial bureaucracy. A confident man known for his literary wit, he was appointed a palace examiner when he was only twenty-six; during a long career, he served as president of the Board of Works, the Board of Punishments, and the Board of War. He first came to prominence when he defended Zeng Guofan's tactics during the Taiping Rebellion—a perhaps not surprising alliance, since Zeng Guoquan (1824–1890), Guofan's younger brother, was an antiquarian and a close friend.[17] Weng Tonghe, whose father was an imperial tutor, won first place for his 1856 examination essays. Subsequently he himself became a tutor to both the Tongzhi (r. 1861–1875) and Guangxu emperors, which placed him at the center of court politics for some four decades. In 1898, he recommended that Guangxu receive Kang Youwei and listen to the southern scholar's wide-reaching program for political reform. Until the end of the century, the two men made a formidable combination in capital politics: wealth, powerful relatives, and social charm.

Their bond was formed over a shared interest in *jinshi*. Both were from Suzhou, a city known for its cultural atmosphere; they traveled

together in 1856 to take up appointments as examination officials in Shaanxi-Gansu, a trip that afforded many *fangbei* excursions to steles in remote temples. On rainy days, they relaxed at inns, drank wine, and wrote poetry that evoked the historic towns through which they journeyed, or that praised each other's paleographic skill.[18] Pan Zuyin's diary notes the production of rubbings from inscriptions taken off monuments centuries old.[19]

The clique they assembled a decade later was not a new phenomenon; similar intellectual networks, often with political implications, had been essential features of capital life for centuries.[20] Despite their artistic and literary connotations, these cliques were considered inferior to orthodox teacher–student relationships that were structured around a communal immersion in Confucian texts.[21] But in some respects, nineteenth-century networks were novel, and uniquely orthodox. Their prevailing ethos was characteristic of an age of increased reliance on powerful officials who welcomed the idea that China's political and economic problems could best be served through their autonomy. Indeed, "China is not poor in resources, it is poor in talented men" was the watchword of Zhang Zhidong and many nineteenth-century reformers.[22] Late-Qing cliques were intended to school young men in classicism, philology, and art practice, helping them become better officials.

This kind of mentoring was particularly important because the curriculum at that time admitted a significant gap at the apex of a scholar's education. After passing county- and provincial-level examinations, young men often moved to the capital to study for the empire-wide *jinshi* (presented scholar) exam; obtaining that degree rank made them eligible for high bureaucratic service. But successfully preparing for the examinations could take years, if not decades. In the meantime, candidates required schooling of a more advanced level than could be obtained back home. As Zhang Zhidong advised them,

> From remote, rural places it is almost impossible to find examination success. Not only are there no teachers, there may be no books. Where can one find broad knowledge; what can stimulate one's ambitions? The ancients would carry their books for a thousand miles; why shirk from a similar difficulty? To abide by just any old teacher's words, is to perpetuate vulgarity; the more one learns from them, the more one is mistaken. Famous teachers are hard to find;

but friends and mentors are not scarce. Thus if you are open-minded, friends and mentors can be your teachers.[23]

Zhang's advice was essentially the credo of the antiquarian social network: friends and mentors—hopefully accomplished and generous, with extensive libraries—were essential to academic and political success. He became intimate with Weng Tonghe in part because he was a friend of his nephew Weng Zengyuan (1834–1887) and because of his reputation as a bookworm, "reading until his eyes blurred from exhaustion."[24] But by joining a patronage network, scholars did more than complete their educations: they were exposed to contemporary artistic trends, found employment, and began to flex their young political muscles.

The political orientation of Pan Zuyin and his protégés was aligned with the *qingyi* (literati opinion or remonstrance) school of political criticism, which held that low- to mid-ranking officials were justified in criticizing misguided state policies. *Qingyi* officials styled themselves as incorruptible underdogs, the bedrock of the Confucian order, fearlessly challenging corruption and incompetence. After the 1880s, many of their adherents joined the Qingliu (pure current) clique, generally seen as conservative, hawkish, and antiforeign.[25] For example, they scorned Li Hongzhang (1823–1901) for wanting to use international law to negotiate with foreign powers.[26] Yet the affiliations of Pan Zuyin's protégés were not one-sided, nor was their overall program reactionary. In the early 1870s, at the height of his involvement in Pan's coterie, Wu Dacheng went to work as a secretary for Li Hongzhang with a recommendation from the antiquarian Mo Youzhi (1811–1871).[27] Furthermore, Qingliu emerged as a vehicle of reform at the end of the century, when its members aided the Guangxu emperor in his attempts to modernize the government. By then, the clique's reputation for patriotism and conservatism provided political cover to officials who wished to modify fundamental state institutions.[28]

For an example of a young antiquarian inspired by *qingyi* discourse, we need look no farther than Wu Dacheng. In 1863, while still a *buyi* (man without a bureaucratic post), he acted forthrightly—perhaps even dangerously—to memorialize the throne on the necessity of maintaining the poetry question in the entrance examinations for the Hanlin Academy, where the court's literary projects were carried out, an institution to which he was appointed five years later. (Wu's auda-

cious act was not repeated for twenty-five years, when as a *buyi* Kang Youwei memorialized the Guangxu emperor on the need for reform.) His essay began by arguing that the training of talented men had long-term implications for how society was governed and for how evils like corruption were avoided. As he continues, it emerges that he was writing specifically in support of a Hanlin academician who was testing Sichuan students on Western knowledge and subjects like weaponry and finances.[29] The wide-ranging memorial, furthermore, echoed themes found in Feng Guifen's manifesto, including the need to eradicate corruption, lessen general poverty, and improve official morale.[30] It has been suggested that Zhang Zhidong had read Feng Guifen's essays, written in Shanghai in 1860; the contents of Wu Dacheng's memorial suggests that he might have been influenced by the famous reformer as well.

Not surprising given their political functions, social networks offered young men opportunities for networking and advancement through the imperial bureaucracy that they may not have obtained otherwise. These connections often provided substantial financial support. After Wu Dacheng passed his *jinshi* examinations (he won third place for his essays) in 1868, he was given a prestigious but poorly paid appointment at the Hanlin Academy. A few years later, he was commissioned by Pan Zuyin to draw the images of vessels for his pictorial album of ritual bronzes—with Zhao Zhiqian producing the facsimiles of seal-script inscriptions, Wang Yirong penning the standard-script texts, and Zhang Zhidong contributing to the overall linguistic research—the kind of work that helped young protégés augment their meager incomes.[31] In the 1880s, Ye Changchi assisted Pan Zuyin on several projects, including cataloging his library. Li Ciming received a considerable portion of his income from his mentors; in 1883, presents from Pan Zuyin, Weng Tonghe, and other friends—perhaps in exchange for paintings—provided him with several times the annual salary of a government clerk.[32]

But some protégés were wealthy and well connected themselves—sometimes more than their mentors. Shengyu (1850–1899) was a member of the imperial Aisin-Gioro clan and a descendent of the dynasty's founder; his mother Naxunlanbao (1825–1873, a Mongol) was a well-regarded poet.[33] For those who disliked antiquarians, their wealth and elite connections implied that their enthusiasms were insincere. Shen Yao (1798–1840) placed antiquarians in the lowest intel-

lectual stratum, as "wealthy young lords" who collected as curios things like Qin Dynasty weights, Han Dynasty roof tiles, Jin glazed tiles, and Tang stele rubbings. They "call themselves evidential scholars, but in their hearts they are greedy," he charged; he claimed that they studied antiquities only because they had no need of earning a living.[34]

Given the professional, financial, and social advantages of joining Pan's network, it is not surprising that so many young men wished to do so—or maintained their affiliations so assiduously. Until the end of his life, Wu Dacheng remained close to his early mentors; stationed on the front in the 1894–95 war with Japan he wrote to Weng Tonghe almost daily, apprising the imperial tutor of the opinions of other commanders.[35] His daughter married a son of Yuan Shikai (1859–1916)— who later became China's president after the Revolution—while his grandson Wu Hufan (1894–1968) married Pan Zuyin's talented niece Pan Jingshu (1892–1939). He also stayed good friends with Zhang Zhidong, who in the next decades emerged as one of the most powerful officials in the country. Together they established several modern academies and united to promote the Qingliu agenda—which was hawkish but also modernizing—while maintaining the pleasantries of antiquarian friends. To celebrate Zhang's sixtieth birthday, for example, Wu presented him with a lavish gift of dozens of bronzes, ink stones, seals, and other artifacts.[36] Meanwhile, emulating Pan Zuyin's promotion of young antiquarians into positions of political power, Zhang mentored young scholars like Luo Zhenyu, who joined his staff at the reformist education ministry.

Towards the end of his life, Wu Dacheng became a noted patron of calligraphers and painters. In 1895, he joined the Suzhou traditionalist painter Gu Linshi (1865–1930) in forming the Yiyuan Garden Society, which promoted literati painting styles. Their *yaji* featured promising young artists like Wu Changshi (1844–1927), once Wu Dacheng's aide and later a friend of Luo Zhenyu and the official and novelist Liu E (1857–1909), one of the first men to collect oracle bone inscriptions.[37] A number of overlapping *jinshi* networks continued to flourish in the twentieth century, preserving the field's methodological purpose while nurturing antiquarian calligraphy and related forms of art practice.

The Epigraphic School

Pan Zuyin, Weng Tonghe, and their protégés were artists as well as collectors and scholars, and were founding members of what is now

termed the *jinshihua pai* or Epigraphic School of painting and calligraphy. This was a diverse and experimental movement that emphasized a "deliberately naïve, slightly awkward manner derived ultimately from calligraphy on Han and Wei Dynasty steles unearthed during the late Qing," in Kuiyi Shen's definition.[38] Its practices help illustrate the differences between late-Qing antiquarianism and previous incarnations of *jinshi,* including eighteenth-century philology. But, like Han Learning, its popularity signaled scholarly confidence and reinforced the *qingyi* commitment to political engagement. To understand why, we can compare the Epigraphic School to poetry societies in late-Tokugawa and Meiji Japan, which encouraged a sense of national identity.[39] Like their Japanese counterparts, late-Qing artists used art and aesthetics to help define a public voice.

Both Pan Zuyin and Weng Tonghe came from families that admired antiquarian painting and calligraphy. The extensive art collection begun by Weng's father, Weng Xincun (1791–1862), passed on intact through four more generations, showcased several works from the Epigraphic School.[40] Pan's uncle Pan Zengying (1808–1878) was a well-known painter of antiquarian subjects. His meter-long handscroll *Heshuo fangbei tu* (Searching for steles north of the Yellow River), for example, was dedicated to friend and fellow antiquarian Shen Tao (c. 1792–1855), and was inscribed with a poem by Liuzhou (or Dashou, 1791–1858), a famous *jinshi seng* (antiquarian monk).[41] But its *jinshi* qualities go beyond subject matter and audience. Its brushwork and composition avoid typical characteristics of landscape painting, preferring a linear perspective to a multiperspective, monumental vista. Rather than an intricate layering of colors, the ink is laid down with distinct brush strokes, mimicking the simplicity, boldness of form, and elegant angularity of ancient inscriptions.[42] Even when painting flowers or stones, artists like Wu Changshi tried to evoke stele engravings.[43]

In their calligraphy, nineteenth-century artists were epigone of Ruan Yuan, arguing vigorously for the superiority of muscular Northern Wei calligraphy like the Longmen steles. In his *Yizhou shuangji* (Oars for the boat of art), Bao Shichen (1775–1855) praised these inscriptions for their linear arrangement and the sparseness, severity, and density of their graphs. Bao offered a detailed explanation of how to achieve similar effects with other media, encouraging scholars to use seal and clerical script in a variety of unorthodox contexts, including letters, poetic couplets, and other genres where more modern (and cursive) styles were generally seen as more appropriate.[44]

But although Bao Shichen's guide made it easier for artists to
mimic stele texts, not all antiquarians took a literal approach to this
process. They were heeding the models of earlier antiquarian callig-
raphers like Jin Nong (1687–1764), who modified the styles found on
stone engravings with elements that evoke the Tibetan writing found in
Buddhist sutras and the Manchu script featured on Qing steles and ti-
tleboards in front of court buildings.[45] Similar attempts to mix a variety
of styles while still evoking the "the fragrance of antiquity" continued
throughout the nineteenth century.[46] He Shaoji (1799–1873) practiced
cursive model-letters calligraphy as a young man, but after exposure to
Ruan Yuan and Bao Shichen came to prefer epigraphic calligraphy. He
later pioneered cursive seal script, in which seal-style graphs were writ-
ten with connecting brush strokes. The intensity of effort required to
achieve this effect was reminiscent of cursive calligraphy.[47] As he wrote,
"Whenever I copy [ancient inscriptions], I must suspend my arm with
my wrist turned inwards. The energy travels through my body to [my
fingers], and then characters can be made. When I am not yet half fin-
ished, my clothes are soaking wet with sweat!"[48] Other artists like Zhao
Zhiqian were attracted to stele-style calligraphy for its unorthodox
graphs. His playful *Liuchao biezi ji* (Record of variant character forms
from the six dynasties) repudiated the cautious calligraphy of Fu Shan,
who less than two centuries earlier avoided certain variant graphs out
of a sense of philological rigor.

The attitude of some antiquarians for inscriptions went beyond
experimental and bordered on the mystical. "Filled with restless desire,"
Chen Jieqi, for example, felt such an "interest in ancient characters was
such that sometimes I cannot relax and put them down."[49] As calligra-
phers had long known, copying ancient styles required emotional and
moral attention as well as manual skill. "Inscribing calligraphy is some-
thing that can nurture the power of one's mind," Chen wrote. "Inscrib-
ing ancient-style calligraphy, even more so."[50] Although ancient graphs
seemed awkward, their spirit or *qi* was so inimitable that it was possible
to detect forged artifacts by studying rubbings of their engravings.[51]
Furthermore, the visual qualities of inscriptions helped scholars better
appreciate their contents; through calligraphy came, eventually, analyti-
cal insight. "If you study steles because of their calligraphy," Zhang Zhi-
dong recommended, "and then use steles to understand linguistics and
research history, this is exactly what Han Yu [768–824, a famous Tang
Dynasty Confucian] meant by 'seeing the Way through literature.'"[52]
The idea of *seeing* the Way, in fact, was not entirely metaphorical. Anti-

quarians believed that *jian* (unmediated sight) was superior to *du* (reading) transcribed versions of texts, and they praised a newly discovered artifact by saying, "in antiquity and modern times, this is seldom seen." In this regard, the discourse of *jinshi* continued to reference the Song principle that visuality itself conveyed greater philosophical insight and made possible a superior connection with the values of antiquity.

In contrast to Song scholarship, however, members of the Epigraphic School were far more enthusiastic regarding bronze inscriptions, which they were also able to interpret with far greater proficiency. Previous generations of scholars focused overwhelmingly on steles. But with characteristic enthusiasm, Chen Jieqi noted, "since bronze vessels contain a form of ancient writing that is more vivid and realistic than any other kinds, how can they not resonate with the scholar's heart?"[53] He and his friends copied the contents of bronze texts verbatim, or adapted their scripts for use in composing original *duilian* (rhyming couplets) and colophons on paintings. In the ultimate expression of the "*jinshi* spirit," even their most intimate documents utilized epigraphic calligraphy.[54] Wu Dacheng, for example, wrote to friends in bronze script on stationery embellished with images of tripods and other artifacts. Pan Zuyin received so many of these letters that they filled four cases in less than six months. He initially teased his protégé for his unrelenting use in casual correspondence of this style, which may have appeared overserious. But after further consideration he changed his mind, praising Wu's calligraphy as "subtle and without comparison," and encouraged his protégé to continue using bronze script in their letters.[55]

Although created for limited circulation among peers, these paintings, works of calligraphy, letters, and poetic couplets made an important claim regarding the public role of nineteenth-century scholars. Artifacts like bronzes were political symbols; by borrowing their graphic styles, scholars imbued their own ideas and social relationships with a corresponding sense of ideological authority. It is not surprising that men who sought government reform embraced the Epigraphic School, even as their specific agendas were not always as sympathetic to other aspects of *jinshi* as one might expect.

Antiquarianism and Late-Qing Educational Reform

Among the reformist projects embraced by nineteenth-century antiquarians, the modernization of the educational system was among the

most pressing. Inspired by the *qingyi* dedication to nurture talent, Wu Dacheng and Zhang Zhidong were ruthless critics of the traditional curriculum, promoting foreign languages, science, geography, and other recently introduced fields even over their own specialization. Under their guidance, *jinshi* as part of the educational system seemed to be headed for obsolescence at any moment.

Antiquarians who became educational reformers had themselves navigated the civil examination system successfully, although not without detours. Both Wu Dacheng and Zhang Zhidong studied for their degrees during the period of disorder caused by the Taipings. A decade of warfare intervened between Zhang's triumphant first-place showing in the Zhejiang provincial exam and a mediocre pass in a special round of 1863 *jinshi* examinations. The main problem was his palace examination essay (the final stage in the process), which slammed the government for failing to ameliorate widespread poverty by scaling back on expenditures and providing tax relief. He also proposed to increase the number of licentiates by restoring the Han Dynasty recommendation system, a suggestion he may have cribbed from the outspoken critic Feng Guifen.[56]

After they had earned their degrees, both Wu Dacheng and Zhang Zhidong became educational commissioners in Shaanxi-Gansu and Sichuan, respectively, but they were not content with either their roles or their students. Wu protested that the curriculum fostered rote learning and an ignorance of Han Learning fundamentals, complaining to Chen Jieqi, "recent scholarship is all fashion and showing off."[57] Zhang also was frustrated by the inefficiencies of the system; in his 1863 examination essay, he argued that "qualifications [for office] are too inflexible, and the examination curriculum is too narrow."[58] After he accepted a post as education commissioner in Sichuan in the mid-1870s, Zhang wrote a bibliography for students at a local academy that encouraged them to read Western mathematical works, as well as a series of books published by the Jiangnan Arsenal that focused on Western military techniques.[59]

At this stage, in the 1870s, antiquarianism was still included in the curriculum. When the imperial translator college was established in 1862, for example, it offered classes in the study of artifacts and inscriptions.[60] For his Sichuan students Zhang even defined *jinshi* as a separate discipline, including a list of "bronze-and-stele experts" and artists (Jin Nong, for example) in an appendix devoted to Qing au-

thors in various fields. While promoting science and Western learning, he encouraged his students to purchase bronze vessel catalogs, studies on inscriptions and etymology, and lexicons spanning Song classics to late-eighteenth and early nineteenth century works. They were also expected to become proficient at using the *Shuowen jiezi* (Explanation of graphs and analysis of compound characters) by Xu Shen (c. 58–147). This lexicon of pre-Han characters, created to help government officials interpret the classics, was considered essential to antiquarian research.[61]

Zhang's advice for students to study *jinshi* may seem pragmatic, as at that point questions on ancient artifacts were commonly included in the imperial examinations. Both times Wang Yirong sat for the provincial degree he faced second-round questions (which typically tested knowledge of the classics) that quoted passages on ancient artifacts. In 1873, he was asked to comment on a passage from the *Rites* specifying the correct situating of two kinds of bronze vases within a temple. The problem was that the passage did not make entirely clear how to distinguish and identify the uses of these quite similar artifacts. At first, Wang's answer appears to be based on antiquarian practice: "Recent generations of scholars have traveled far and wide and obtained vessels from around the country," he wrote. Presumably, their collecting activities would have secured enough examples to identify the vases. But Wang's primary argument is philological, invoking the great phonologist Wang Niansun (1744–1832) to interpret the graphs for the vessels. Indeed, he argued that even if they "do not know the writing of the ancients" and cannot read inscriptions, scholars should be able to distinguish the two vessel types based on evidence drawn from the appropriate passages from the classics.[62]

In 1880, Wang was asked to distinguish between two types of gilded bronzes; again, both question and answer referenced only literary sources that discussed their ritual uses.[63] In neither instance was Wang Yirong asked to demonstrate familiarity with nonliterary sources, nor did he think to do so himself. Perhaps he knew the examinees would consider a discussion of actual artifacts to be extraneous, even though at least one of the men who judged his examination papers, Miao Quansun, was an antiquarian himself.

Stale questions on passages referencing the ritual use of bronze vessels were not only frustrating for antiquarians but also were symptomatic of larger flaws. As a host of students had charged since the

1860s, something needed to be done to repair the examination system: the curriculum no longer reflected current intellectual trends; test questions were repetitive and predictable; and the process offered little practical training.[64] Yet it was not until the 1880s, with the formation of several modern academies, that some of their suggestions were acted on. Perhaps surprisingly, given that so many antiquarians were pushing for reform, the status of *jinshi* in the new curriculum was shaky. Working with Wu Dacheng to establish the Guangya Academy in Canton in 1887, Zhang Zhidong crafted a curriculum that included classics, history, Neo-Confucianism, government, and other fields, while students at the Liang-Hu Academy, established in 1890, were schooled in classics, history, Neo-Confucianism, literature, mathematics, and government. Neither of these academies offered classes specifically on *jinshi;* although antiquarian studies could have been included in either classics or history, this appears not to have been the case.[65] In 1898, when Zhang Zhidong wrote *Quanxue pian* (Exhortation to study), his moderate response to calls for widespread political reform, his bibliography of essential texts makes hardly any mention of *jinshi.* His Cungu Academy, established in Hubei in 1907, offered foreign languages, geography, and mathematics, but no coursework in studying ancient artifacts or inscriptions.[66] He still encouraged students to study etymology, which he compared to learning a foreign language or translating Western texts, but he acknowledged the futility of expecting modern students to become proficient in *jinshi* as a matter of course.[67]

Perhaps Zhang Zhidong and Wu Dacheng were simply heeding the criticism of the famous translator Yan Fu (1853–1921), who attacked the traditional examination system and advocated greater Western learning. By way of contrast to modern science, Yan Fu commented specifically on the "uselessness" of antiquarians and their obsession with ancient texts, ritual, and artifacts. "If I had to choose a phrase to summarize my views [on *jinshi*], I would say: it has no use," Yan Fu wrote. "It's not that it is truly useless, but it is in keeping with 'enrich the nation to strengthen the army and afterwards, there will be material prosperity and peaceful citizenry' idea," in other words, it was typical of an earlier generation of *qingyi* reformers like Zhang Zhidong. "It is useful as a pleasant frame of mind to while away the time, not a practical program to save us from weakness and poverty today."[68]

By jettisoning *jinshi* from the curricula at his new academies,

Zhang Zhidong would appear to have conceded Yan Fu's point. Yet, in the end, he did not spurn antiquarian learning entirely, but repositioned it—as a hallmark of liberal education. He ultimately compared the educational purpose of reading the classics and histories to the Western study of Greek and Latin, which served a liberal purpose in schooling students on the fundamentals of ancient thought.[69] In creating the Cungu Academy, for example, Zhang invoked the Western emphasis on religious studies as a tool for building moral character. Similarly, absorbing the lessons offered by the legendary sage-kings of antiquity, as well as philosophers like Confucius, made students patriotic—which would ultimately advance China's economic and military development.[70] And studying things like etymology and literature were crucial to preserving China's *guocui* (national essence), an ambition that foreign academies, through their own classically oriented curricula, also respected.[71]

The idea of *guocui* (Japanese *kokutai*) devised by Japanese scholars in the late nineteenth century to balance Westernization was adopted by Chinese intellectuals like Liang Qichao to neutralize the "contempt for our own race" expressed by young students who "worshipped the foreign." Although Liang rejected the "Confucianism as a religion" discourse championed by his mentor Kang Youwei and referred to by Zhang Zhidong in his establishment of the Cungu Academy, he shared their opinion that studying ancient history and philosophy helped preserve a national identity.[72] Echoing Gong Zizhen's concerns from a century earlier, turn-of-the-century *guocui* advocates like the publisher and art collector Deng Shi (1877–1951) argued that only "if the nation preserves its learning will it survive."[73]

In agreeing that Chinese history and philosophy should remain at the heart of the modern curriculum, Zhang Zhidong left a small but important space for antiquarianism. No longer a part of basic reading lists, *jinshi* was redefined as a form of specialized knowledge for an elite cohort of advanced scholars.[74] Thereafter, the status of *jinshi* resembled even more closely the classics in Europe, whose practical application was negligible, but which conveyed enormous cachet as the apex of a liberal education well into the twentieth century.[75] In this way, Zhang preserved, and arguably made even more exclusive, the source of his intellectual prestige. This message was not lost on ambitious young men like Wang Guowei and Luo Zhenyu, who continued to cultivate the exacting methods of antiquarian research to express intellectual abil-

ity.[76] This ongoing association of *jinshi* with intelligence and erudition goes far in explaining its continuing popularity even after its role in the curriculum was reduced through educational reform.

The Role of Geography

The continued popularity of *jinshi* was not only due to elitism, however: it was closely allied with several fields that were considered of immediate, practical usefulness. Perhaps most significant of these was geography, which during the late Qing period was considered of paramount importance in allowing the state to establish and maintain diplomatic effectiveness.[77] In less concrete terms, the study of geography was also appealing to Chinese scholars hoping to situate, so to speak, their ongoing relevance in a rapidly changing world.[78] In the aggregate, the dozens of travelogues written by late-Qing diplomats and journalists overseas established the principle that Chinese intellectuals could master the wider world and its often-exotic practices.

Qing antiquarians were particularly interested in historical geography since it allowed them to locate the cities, rivers, and other features mentioned in stele texts; in turn, this research could clarify contemporary political disputes regarding national borders.[79] Some of these steles were multilanguage monuments to victory erected on faraway battle sites, communicating to subject peoples the reality of Chinese administrative control.[80] Other steles were affixed by antiquarians themselves. In the 1880s, for example, Wu Dacheng spent a number of years as an official in the Northeast, negotiating border disputes with Russia and encouraging Chinese settlement of the region. He placed his calligraphy on titleboards to commemorate new villages he founded, and commissioned a bilingual Russian–Chinese stele as a new boundary marker.[81]

Antiquarians also produced maps and travelogues. Wu Dacheng wrote a well-regarded account of frontier defenses, while Liu E completed a pictorial study of conservation methods for the Yellow River; both were included in a massive compilation of Chinese and foreign geographical materials published in the 1890s.[82] By that point, the travelogue was also put to the purpose of another *jinshi* genre, the catalog of inscriptions. These were particularly popular among members of the Qing diplomatic corps. Liu Xihai (1793–1852) and Zhao Zhiqian both wrote studies of Korean stele inscriptions, while an antiquarian catalog

by the diplomat Fu Yunlong (1840–1901) included a separate section on Japanese steles. Yang Shoujing, posted at the Qing mission in Tokyo, reprinted a Japanese catalog of steles, while befriending Japanese calligraphers and introducing them to the principles of the Epigraphic School.[83]

By including foreign texts in *jinshi* research, Qing antiquarians were beginning to apply the study of artifacts and inscriptions as a way to imagine commonalities with other countries and their cultural traditions. This cosmopolitan perspective certainly informed Kang Youwei's study of stele-style calligraphy, one of the first statements of antiquarianism's value for the study of human political and social development. Kang became interested in the Epigraphic School in the late 1880s when he was living just down the street from Pan Zuyin on the Mishi Hutong.[84] Brushing against the fringes of the Pan-Weng antiquarian circle—he was particularly close to Shen Zengzhi (1850–1922), a well-regarded poet—Kang composed a tribute to Bao Shichen that praised Northern Wei calligraphy. But Kang's cosmopolitan perspective extended even beyond non-Han dynasties to compare early Chinese calligraphy to the writing systems of ancient India, Egypt, and Mesopotamia, arguing that these languages originated from a common inspiration.[85] This was an early expression of the Sino-Babylonianism theory. This theory, which proposed that there were linguistic and cultural roots tying together China and Western civilizations, became popular among reformist intellectuals and was important to early studies of the oracle bone inscriptions.[86]

Only a few years later, Kang memorialized the emperor and demanded extensive reform of the country's educational and military systems, declaring that political change was an inevitable consequence of human development. This essay, which was scandalous in both its content and its audacity as the work of a *buyi*, was based on earlier manifestoes delivered to Pan Zuyin and Weng Tonghe, among other high officials, who initially did not dare forward it to the emperor. But Kang's views on political reform eventually did make their way to the ear of the Guangxu emperor and helped launch the Hundred Days Reform movement of 1898.

Kang's reformism emerged at the same time as his interest in antiquarian interests, which underscores the extent to which *jinshi* was compatible with progressive politics. Indeed, with his vision of a global humanism made possible through the study of ancient language, Kang

Youwei made *jinshi* appealing to even the most reform-minded schol-ars seeking greater commerce with the West and Japan. The young scholars who articulated a desire for reform through the study of *jinshi* went on to foment significant changes in the field, including collecting practices, visual representation, and artifact research.

3

A Passion for Antiquity, in Two Dimensions and in Three

Zigong said, "If you had a piece of beautiful jade here, would you put it away safely in a box or would you try to sell it for a good price?" The Master said, "Of course I would sell it. Of course I would sell it. All I am waiting for is the right offer."
—*Analects* IX.13, trans. D.C.Lau

WHAT WAS IT LIKE to be a *jinshi* expert in the late Qing? On a daily basis, the pastime entailed three activities—shopping for artifacts and rubbings, appraising them, and publishing catalogs of their inscriptions and images—all of which gave moments of extreme, if elusive, pleasure. The greatest luxury for any specialist was time. As Liu E recounted,

At most, our lifetimes only last seventy or eighty years. In our youth, we strive for official rank; in old age, our ears, eyes, hands and limbs are useless. In between are thirty or forty years when we are worn out from household cares, providing clothing and food, racing around every day on long journeys, forced to exert ourselves in quests for trifles. It is so rare that I can spend my resources on ancient texts, calligraphy, and beautiful bronzes and steles! Even when I do have resources, these things are almost as expensive as gold, pure jade, fine brocade and damask. Once I collect them, I can only fondle and appreciate them when there are no annoying personal matters, household chaos, endless official business, or idle friends about. So in an entire lifetime, there might be only a few days like today.[1]

Some scholars wrestled with the consequences of private enjoyment, particularly as museums and preservation laws became more common in other antiquity-obsessed societies. But many joined Liu E, a significant collector of coins, Buddhist sculpture, and oracle bone fragments in regarding a day spent pursuing *jinshi* as "paradise."[2]

The contours of this paradise changed significantly over the course of the nineteenth century. As ambitious young men sought expertise in the field, the antiquities market expanded to meet their demand, making available a more diverse variety of objects. On a 1905 trip to the capital, for example, Duanfang purchased "an iron ink stone from the founding of the dynasty, previously collected by Ruan Yuan, who made a rubbing of the piece; a Han Dynasty oil lamp; an inscription from a Tang Dynasty pagoda; two pieces of Song Dynasty stone sculpture; two other small stone sculptures; and more than two hundred fragments of oracle bone inscriptions."[3] Only the ink stone and the Tang inscription would have been collected a century or so earlier, and the rest would have been considered unorthodox or trivial (sculpture, almost certainly Buddhist) or taboo (the oil lamp, likely looted from a tomb); some, of course, had not yet been discovered (the oracle bone fragments). To study these materials and judge their authenticity, scholars still relied primarily on rubbings of inscriptions, using philological methodologies developed over the previous several centuries. But they also conceived of new styles of making those rubbings as well as catalog images, tending towards more three-dimensional representation. This shift encouraged the emergence of artifact studies at the turn of the century. In other words, the paradisiacal practices of *jinshi* were of significant methodological importance, determining what objects were collected by antiquarians and how they were treated in collections.

Obsession and Orthodoxy

The great *jinshi* collectors of the age amassed scores of artifacts. Chen Jieqi owned hundreds of clay seals, the specialty for which his collection was noted, as well as more than two hundred bronze vessels, including the famous Maogong tripod. Pan Zuyin possessed around five hundred artifacts, and Wang Yirong owned several hundred bronzes. By 1886, Wu Dacheng had gathered together more than a hundred bronze artifacts, as well as even more jades and seals.[4] While many scholars had far more modest collections, the size and scope of these assemblages—

not to mention the costs involved—suggest the extraordinary interest, verging on obsession, that consumed the minds of the most famous practitioners of the pastime.

Late-Qing antiquarians were fixated with the material remnants of the past. Liu Xihai's "long-time obsession for antiquity," for example, led him "stealthily to collect four to five thousand artifacts."[5] The painter Li Zuoxian (1807–1876) noted, "in my generation, men of the last fifty years, whenever we find something like a coin as small as an elm seed, we pass it around to profuse admiration, so pleased to have found something unusual. Onlookers must have a good laugh to see our cravings. Noncollectors can never really understand what it means to experience this kind of pleasure."[6] For Ye Changchi, whose passion was stele rubbings (he collected some eight thousand of them), "fondling them day and night" allowed him to "forget he was an old man."[7] So intense were these feelings of obsession that they were described using the medical term *pi* (cramp).[8]

Indeed, collecting artifacts felt a lot like falling in love, producing feelings of passion, tenderness, and loss. Liu E "loved antiquity like sex" and worked on his collection almost daily, writing poetry expressing his frustration over his inability to find the perfect piece.[9] Wang Yirong confessed that he "loved antiquity like a devil" and sought out artifacts with an "ancient spirit," which he found "quite adorable."[10] Wu Dacheng also praised bronze tripods as "adorable."[11] In 1904, Sun Yirang wrote that he "loved to play without stop" on newly discovered artifacts.[12] Like many of his fellow collectors, Ye Changchi acknowledged an obsessive interest, writing, "every time I obtain an indistinct rubbing, I gnaw at it repeatedly to determine its bones [essential structure], not caring if other amateurs disagree with me or mock my conclusions."[13] When his eldest son died, he wrote Miao Quansun of their shared love of ancient inscriptions. Even though his "son's nature was lowly," he wrote modestly, "he was a bibliophile and a good painter," who was copying an epigraphic text just before he died. Now the father "felt like a ghost ambling about—how can I bear the pain!"[14]

Such intense associations are reminiscent of other late-Qing aesthetic pursuits. Connoisseurs of the theater were enthusiastic patrons of their favorite actors, circulating elaborate guidebooks to the finest performers and scripts.[15] This emotionalism reflects late-Qing literary culture overall, where expressions of sentiment conveyed a scholar's purity and individuality.[16] Yet feelings of pleasure, however intense, were problematic for antiquarians, and became even more unpopular

after the *kaozheng* movement gained traction. In 1728, court artists presented the Yongzheng Emperor (1678–1735) with a scroll painting of brightly colored bronzes, grouped together with porcelain bowls, snuff bottles, brush holders, and other items, entitled "Picture of Ancient Playthings."[17] A century later, after the *Siku quanshu* movement made Han Learning a national orthodoxy, Pan Zuyin asserted, "scholars do not regard [bronzes] as toys" and did not regard collecting them as a mere hobby.[18] But if loving antiquity was like sex, then why should bronzes not be toys?

The feeling of high-minded austerity had complex origins, including anxieties over social status. In his work on early modern material culture, Clunas argued that possessing art and antiquities was particularly important during times of social flux. Ming elites, for example, built large art collections in order to claim they understood "the manufactured things of the material world" better than nouveaux riches.[19] There is no question that late-Qing antiquarians were also flaunting wealth and social connections by attending exclusive *yaji*, or visiting each other's homes to admire recent purchases. Less elite patrons or "social climbers" tried to "mingle with men of letters and pose as art lovers," but wound up "spending huge amounts of money purchasing art without any true knowledge or appreciation of the works," the journalist Wang Tao (1828–1897) charged.[20] But the experience of collecting artifacts offered a more varied range of social functions than status display. It required material prosperity to become a good antiquarian, but once a scholar adopted this persona, he generally tried to demonstrate a sense of high-minded responsibility. In other words, the problem was not that *jinshi* was pleasurable. The problem was that its pleasures were sensual experiences that were preferably separate from the morally serious task of interpreting Confucian texts and preserving ancient inscriptions.

Late-Qing collectors assumed the correct attitude at their *yaji*, which after all were virtually public occasions that celebrated the Confucian orthodoxy of antiquarian networks. The poems composed for Pan Zuyin's parties sound more like examination essays than expressions of *jinshi* obsessions. In "Making Rubbings of Inscriptions," Wang Yirong—who "loved antiquity like a devil"—notes primly, "Where are ritual tripods obtained? On famous mountains and fields. If characters tamped out on a rubbing are unknown, they must date from before the birth of Confucius." "Examining Calligraphy" clarifies that "Song and

Yuan artists were careful about [stele] carving, so they only used ancient characters. A thousand pieces of gold could be completely spent, and it would still be difficult to buy [a rubbing of] one of their pieces."[21] Even though Zhang Zhidong sent Wang Yirong money to purchase "amusing" artifacts on his behalf, his poem about rubbings of inscriptions began, "The excellence of ritual vessels lies in their texts. Inscriptions are primarily *tongjia* [phonetic loan characters], and can often be used to correct the meaning of the Classics"—in other words, paleography, not amusement, was the proper objective.[22]

To understand the origins of this dry approach, furthermore, we need only remember the brusque dismissal of Ming antiquarianism and its connotations of sensuality and frivolity. In the late Qing, this distaste for treating antiquities as playthings helps explain the terminologies used (or avoided) by collectors. They disdained to classify their collections as antiques—*gudong, guwan,* or *wanwu;* notably, *guwan* and *wanwu* both include the character *wan* for "toy" or "play." In this vein, Zhang Zhidong derided the late-Ming collector Hang Shijun (1696–1773) for only "dabbling in antiquity" because he specialized in modern coins.[23] A whole vocabulary to describe the colors of bronzes, common in the Ming, was eliminated from scholarship; Wu Dacheng paid extra for vessels with unique colors, but, except for a few hand-colored copies reserved for imperial use, Qing pictorial catalogs are almost exclusively black and white and virtually never mention the colors of the artifacts they depict.[24]

These affirmations of scholarly rigor veiled the intense pleasure felt in collecting artifacts. They also made the field more collaborative, however, and encouraged scholars to behave with greater generosity. When Wang Yirong offered to buy artifacts for Miao Quansun (he promised his friend, "Whatever you wish to buy—whether it's stele inscriptions or bronzes—I will exert myself on your behalf") he was honoring a vision of an intellectual community that valued these materials as shared resources rather than as objects of personal pleasure.[25] Indeed, the catalogs these scholars produced were collaborative, incorporating artifacts from the collections of dozens of friends and colleagues. Yet there were limits to this approach: communal ways to preserve and display materials, like museums, found little support. For reasons that would remain unresolved until the twentieth century, this most public of scholarly fields stubbornly remained the domain of the independent and private collector.

Private Collections versus Museums

Since the Song, antiquarian scholars insisted that inscriptions and arti-
facts constituted a common heritage. They intended for their publica-
tions to preserve for future generations the rare materials that crowded
their studios. As a consequence, they wrestled with their own prefer-
ence for enjoying artifacts within private, guarded spaces.

Well into the twentieth century, most Chinese collectors assumed
that artworks belonged in homes, not in museums and other public
spaces. The term they used to describe collections, *micang,* could be
translated literally as "private" or "secret" collection. Gong Zizhen, for
example, called his favorite Qin mirrors, Han jades, and Jin Dynasty
(265–420) calligraphy his *sanmi* (three secrets).[26] Wu Dacheng collect-
ed bronze vases secretly in order to avoid direct competition with his
mentor Pan Zuyin.[27] By associating collecting with secrecy, Qing col-
lectors were unwittingly acknowledging that expertise was generally the
result of exclusivity and concealment.[28] This was provided by the often
closely guarded study areas they constructed to house their collections,
often with the intent of preventing theft or forgery.[29] Some European
visitors were dismayed by the haphazard way these studios displayed
priceless antiquities.[30] But they were workspaces where collectors could
attend to their treasures in seclusion. They carefully scraped away oxi-
dation from bronze inscriptions, varnished or waxed them, and then
stored them in individually labeled, cloth-covered cardboard boxes
(similar to those used for scrolls), or displayed them on tables and cabi-
nets.[31] Later, these objects could be retrieved to allow collectors to share
them with friends, or to fondle them alone.

Although they preferred private spaces for enjoying artifacts, *jinshi*
scholars were aware of the development of public museums and exhibi-
tion halls in Europe and Japan. Travelers like the geographer Xu Jiyu
(1795–1873) discussed the variety of European museums and librar-
ies, which he called *guwan ku* (treasure houses) and *jiqi guan* (cabinets
of curiosities), direct translations of contemporary European terms.[32]
The *Sizhou zhi* (Gazetteer of the four continents, 1841) by Lin Zexu
(1785–1850)—the future commissioner of Canton who became no-
torious as the burner of British contraband during the first Opium
War—discussed the establishment of the British Museum and Brit-
ish Library. A visit to the Museum of Edinburgh impressed Wang
Tao deeply; he remarked on the variety of natural history materials on
display, like animal skeletons and rare minerals, and was particularly

struck by an Egyptian sarcophagus.[33] The development of museums in Japan during the 1870s and 1880s provided an even more proximate model. In 1871, pioneering Meiji historical preservation laws led just a few months later to the establishment of Japan's first museum.[34] By the 1880s and 1890s, a variety of public exhibition spaces displayed art and artifacts, natural history specimens, and other curiosities; these spaces were marketed to visitors of all genders and ages as places of pleasure and education, similar to theaters, parks, or zoos.[35]

By 1895, Kang Youwei argued that museums were necessary to "develop the people's learning" and "please the people's minds."[36] He was helping to promote the construction in Shanghai of a *bolanguan*, which Lisa Claypool glosses as a "hall for the studious and adventuring eye."[37] But given the focus of most nineteenth-century museums on natural history, their suitability as places to study things like epigraphic rubbings may not have been obvious.[38] Indeed, what became the most widely accepted Chinese term for museum, *bowuguan*, had strong connotations of natural history; *bowu* was a graphic loan word of the Japanese term for natural science, *hakubutsu*. The first museum in China— established in Shanghai in 1868 by French missionary and zoologist, Pierre Marie Heude (1836–1902)—displayed specimens of Chinese bronzes, pottery, jades, and ancient coins, but its overall purpose was not to celebrate them as aesthetic objects or to flatter Chinese notions of antiquarian value.[39] Only by the 1920s was the idea of exhibiting ancient artifacts or rubbings of their inscriptions clearly conceived, when displays of "poems, essays, calligraphy, paintings of past scholars, as well as epigraphs and ancient bronze vessels" were featured alongside "natural, historical, fine art, and educational artifacts and objects" in the museum that the industrialist Zhang Jian (1853–1926) built in Nantong, about sixty miles north of Shanghai.[40]

Before the twentieth century, in short, there were few venues— outside the scholar's private studio—to display objects of antiquarian value. Nevertheless, scholars were sensitive to the need to safeguard their country's ancient artifacts, books, and artworks, particularly after the sacking of the Summer Palace by European troops in 1860.[41] Wu Dacheng used Western photolithography to reproduce rubbings of the inscriptions on bronze tripods in order to preserve the images for the benefit of Chinese scholars.[42] He refused to sell some of his collection to foreigners, including a Japanese officer and Prince Heinrich of Prussia (1862–1929, who led German troops during the Boxer Rebellion); instead, his collection was divided among his three daughters (he had

no sons) after he died.[43] But for decades, no concerted effort was made
to establish government-funded museums or to enact legal protec-
tions against the export of antiquities. In 1908, Luo Zhenyu bemoaned
that in the absence of a historical preservation law, too many recently
discovered materials like pottery and Buddhist sculpture were being
bought by foreigners and sent overseas. "If China does not establish a
law to protect ancient artifacts," he wrote, "I am afraid that in a few de-
cades, they will all be completely swept away. How frightening!"[44] That
same year, Zhang Jian pleaded with Jiangsu gentry to contribute to his
museum in order to preserve national treasures against the specter of
looting by foreign troops.[45]

In truth, however, Chinese collectors themselves posed a far great-
er threat to the preservation of antiquities. By the early 1870s, Pan
Zuyin complained that artifacts were becoming more scarce as the an-
tiquarian craze progressed.[46] Wang Yirong found that stone statues at
a Buddhist temple in Sichuan "all had no heads, or were heads with
no bodies—there was not a single whole one," looted by collectors or
destroyed by the Taipings. He himself wanted to remove a sixth-cen-
tury stele from Longmen, and was deterred only by its size.[47] Steles
were gradually erased through the continual production of rubbings.
Ye Changchi wrote of the damage to a monument at Beilin (Forest of
Steles) in Xi'an caused by centuries of producing rubbings:

> The area surrounding the text is undamaged, but unfortunately ev-
> ery character has become like a hole. Even their outlines are un-
> clear. When you look at [rubbings of these steles] they are like a
> line of white herons, or a flock of white butterflies. Because of this,
> even if you examine them attentively, not a single brush stroke or a
> single character can be identified.[48]

It was the desire to protect artifacts from both domestic and foreign
collectors that persuaded antiquarian collectors to accept the ideas of
museums as venues for protecting and exhibiting national treasures. By
1908, Duanfang established a public gallery in the antiques market at
Liulichang, and donated a bronze vessel to Zhang Jian's proposed mu-
seum.[49] But the actual establishment of museums, for the most part,
had to wait several decades. In the meantime, whether through prefer-
ence or lack of alternatives, most collections remained private, and were
developed via the commercial antiquities markets, which were not only
places to purchase art and artifacts but also loci of activity for social and

scholarly activity; this was particularly true at the end of the nineteenth century.

Ministers and Markets

It is not surprising that the first galleries created by Chinese antiquarians were situated near antiques bazaars, since well into the twentieth century these were functionally similar to libraries and museums, supplying materials and facilitating scholarly collaboration. For most antiquarians, the most important market was located in Liulichang, whose name referred to the adjacent factory that manufactured roof tiles for the imperial palaces. Unlike many urban markets, which were seasonal or held outside, Liulichang businesses were enclosed and in operation year-round.[50] Also, they were positioned not too far from the offices of the Hanlin Academy (during the *Siku quanshu* project academicians strolled down every afternoon to look for rare books), and for more than a century the neighborhood was the epicenter of antiquarian collecting.

In the late eighteenth century, Liulichang was home to some thirty booksellers. By 1900, there were three times as many businesses specializing in books and antiques, lamps, spectacles, and blank examination papers.[51] The neighborhood served as a kind of literary pleasure quarter, where "Manchu princes and high Chinese officials used to stroll up and down looking into the shops and inspecting the old books and pictures," a Republican-era guidebook noted.[52] Scholars like Duanfang apprenticed themselves to dealers in order to learn connoisseurship skills.[53] Less-well-heeled customers were directed to open-air used bookstalls, while wealthy antiquarians shopped in places like the Debaozhai (Studio of virtuous treasures), Yueguzhai (Studio of pleasure in antiquity), or the Yongbaozhai (Studio of the everlasting treasure).[54]

One could quickly go bankrupt in these elegant emporiums, where bronzes, jades, and ceramics—the "major categories of three-dimensional antiquity," in Craig Clunas' words—were often significantly more expensive than paintings.[55] Wu Dacheng spent thousands of ounces of silver on seals, coins, roof tiles, and books of rubbings in a short period.[56] Wang Yirong pawned his clothing and generally impoverished himself to buy books, paintings, and artifacts, spending hundreds of ounces of silver on a rare Ming text alone.[57] These prices were even more remarkable given low official bureaucratic salaries (although many officials had additional income through bribery and private

sources). Wu Dacheng spent the equivalent of the annual income of a government clerk to buy a book of old rubbings; with the money he paid for a red and white piece of jade, or a single bronze vessel, he could have covered the young Luo Zhenyu's annual salary as a private tutor.[58]

Yet if collecting would seem possible only for "wealthy young lords," the popularity of less expensive items opened up the pastime to a wider group of scholars. As Li Zuoxian recounted,

> After I reached maturity I developed a liking for bronzes and stele inscriptions, paintings, and calligraphy, and among artifacts I developed a particular fondness for ancient coins. Because my family was poor I was not able to buy bronze vessels, so I had to concentrate on something more trifling. At that time I was still living in a garden tucked away by the village gates, and my understanding was unsophisticated. When I was awaiting appointment as an official, I was able to travel to Qi, Lu, Zou, and Teng,[59] and at every location I searched for artifacts and made acquisitions.
>
> After I became an official, I was brought to the capital and saw its riches, and it was bitter to have desire but no ability to buy. I was overjoyed by the opportunities but I was unable to spare the money to buy anything, and even scrimping on food and clothing brought no relief. I then became friends with several fellow connoisseurs, including Wu Dacheng....These gentlemen all gave each other presents, after which I was able to amass many more artifacts.[60]

Li succeeded as a collector—socially as well as intellectually—because he specialized in less-expensive artifacts. Indeed, so popular was this approach that an antiquarian who favored monumental bronzes, like Wu Dacheng, began to seem unusual. "Antiquarians of my generation strongly prefer portable, delicate items. I am the only one to choose large ones, and for that I am called stupid," he remarked.[61] Liulichang and other antiques markets operated as barometers of taste; what antiquarians wanted to purchase, they would provide, from bronzes and epigraphic rubbings to jades, coins, seals, ink stones, and eventually even oracle bones.

The Quest for Authenticity

With so many artifacts emerging in the market, an old problem lingered: the need to determine authenticity. Behind their genteel facades,

Liulichang dealers were notoriously unscrupulous. "The most difficult thing is to distinguish real and fake," guidebooks warned sojourning examination candidates; dealers could "pass off fish eyes as pearls," recounted another visitor.[62] As the American Sinologist Herrlee Creel (1905–1994) complained in 1937,

> The situation [of buying antiquities in China] is very perplexing to the archaeologist of Western training, who has learned to distrust all materials which have not been excavated under scientific conditions by men whose reputations he knows and respects. It is impossible to maintain such an attitude in working with Chinese materials. One sees a beautiful and most interesting piece of bronze. One asks, "where did it come from?" "Who knows?" is often the only answer. "It turned up on the Beiping market."[63]

But in fact such blithe disregard for the origins of the materials was not characteristic of *jinshi* scholars, or Chinese collectors in general. Indeed, authenticity of artwork and antiquities was of paramount concern— witness centuries of debate over the identification of seals, brushwork, and other hallmarks of genuineness in Chinese connoisseurship. The frustrations Creel experienced, in fact, were unfortunately familiar to many of his Chinese counterparts.

What Chinese antiquarians learned to do in response was to utilize *fangbei* journeys as journeys of authentication as well as of reflection. Indeed, at least since Gu Yanwu took advantage of his posting in the northwest to hunt for steles, Qing antiquarians looked forward to hinterland assignments. "When one loves antiquity and can travel to ancient places, that is true happiness," Chen Jieqi remarked.[64] Attended by personal secretaries and servants, with the imperial postal service at his disposal, an official might easily travel with artifacts, books, and rubbings. Returning to the capital after his appointment as Shaanxi-Gansu Educational Commissioner, Wu Dacheng bought so many artifacts that he had to lug them back in horse-carts.[65] But the approach of Wu Dacheng and his contemporaries to collecting artifacts on journeys was different from that of Gu Yanwu. Although earlier generations of antiquarians "did not speak about excavation conditions," he appeared to share with Luo Zhenyu the assumption that "the place where ancient objects are unearthed is of crucial importance to archaeology."[66]

In Xi'an, Wu sought out Su Yinian (fl. 1850–1875), who owned the Yonghe antiques store and was renowned for having brokered the

sale of the Maogong *ding*, which contains the longest inscription found
on any bronze to date. Excavated in the northwest in the 1840s, the
tripod was sold to Chen Jieqi for a princely sum in 1852, and Sun was
thereafter famous for obtaining rare artifacts.[67] Wu also frequently
traveled to villages himself (or sent servants) in order to bypass even
local dealers. As Chen counseled, he noted carefully where an artifact
was excavated and recorded the names of any other collectors.[68] The
freshness of an excavated piece increased its value; "newly excavated
pieces are not fake," Wu Dacheng wrote, although villagers lacked a
"clear understanding" of the importance of excavation and did not pro-
tect the land where objects were found.[69] This was not necessarily a
nascent archaeology—there was no attempt to contextualize their finds
with other site-specific information, for example—but late-Qing an-
tiquarians were certainly perceptive enough to know that they could
eliminate a lot of authentication problems if they could obtain objects
straight from the ground.

But despite their best efforts to buy freshly excavated artifacts,
forgeries remained common, particularly when objects were brokered
by dealers. When it came to bronze vessels, sometimes the top and
bottom halves of separate pieces were welded together, confusing an
analysis of a vessel's shape. Or a modern vessel's patina was artificially
accelerated through chemical treatments.[70] In these cases of tampering,
antiquarians turned to inscriptions to assess authenticity. For one, it was
not difficult to see if an inscription was forged on the vessel at the time
of creation—the hallmark of an authentic piece—or had been tinkered
with afterwards.[71] "If illiterate metalworkers can tell a real excavated
vessel from a fake," Chen asked rhetorically, "then shouldn't schol-
ars be able to as well?"[72] For another, most antiquarians believed they
could rely on textual clues to determine if an inscription was a genu-
ine period text. Wu Dacheng rejected old vessels with new inscriptions,
pieces whose original texts were lengthened, or vessels with inscriptions
cribbed directly from the classics.[73] Because of this feeling that inscrip-
tions were easier to assess than other parts of an artifact, *jinshi* scholars
developed a particular respect and fascination for the principal technol-
ogy of reproducing inscriptions, namely epigraphic rubbings.

Rubbings

Of all the ways to interpret antiquities, pictorial and philological, rub-
bings were the paramount *jinshi* technique. Indeed, they were not

simply tools to reproduce inscriptions; they were important aesthetic objects in themselves.[74] Ye Changchi conceded that it was not simply research but connoisseurship that compelled him to examine scrolls of rubbings "from head to tail," discussing calligraphy and whether the inscription was mentioned in Song catalogs.[75] Li Zuoxian and his friends "lent each other rubbings of unusual coins, sometimes mounted on scrolls with sumptuous paper and ink," that were as intoxicating as the artifacts themselves. "Every time I settle myself in my study, unroll the scrolls and gently stroke them, I feel like the ancient colors and scents have spilled out over the ink stone," he wrote. "They are fascinating. It is enough to affect any aficionado, they are so overwhelmingly fragrant like wine."[76]

But antiquarian delight aside, rubbings were treated as important tools that allowed antiquarians to identify, authenticate, and interpret inscriptions, even if they had no other access to the physical artifact. Indeed, most antiquarians conducted at least a good part of their research using nothing but images, either line-drawn pictures or rubbings of inscriptions.[77] Scholars like Chen Jieqi who sold rubbings commercially might limit the circulation of the rarest pieces, like the Maogong *ding*, but in general the scholarly code required men to share rubbings fairly freely—as Wu Dacheng wrote, "If my friends want to see a piece, they need rubbings."[78] Well into the twentieth century, antiquarians felt a particular sense of accomplishment if they could identify inscriptions in the form of rubbings.[79] Hence, almost as much as the artifacts themselves, rubbings were the principal currency of antiquarian collecting practices and visuality.

But relying on rubbings had obvious pitfalls, particularly for scholars who overestimated their abilities. In one turn-of-the-century joke, some famous *jinshi* scholars were castigated for their arrogance in believing they could identify ancient coins based only on a rubbing:

> In the beginning of the Guangxu Reign, men like Pan Zuyin, Weng Tonghe, and Shengyu researched bronze inscriptions, seal script, and clerical script inscriptions. Their letters were frequently written in seal script. Accordingly, they were known as antiquarians.
>
> Pan had a younger brother named Mosheng, who was skeptical of their research. Sometimes when he walked down the street, he would see a bakery selling "horse-hoof sesame cakes," which had an indentation on the bottom that looked like the hole in ancient coins. So he bought a sesame cake and dipped it in ink, then

stamped it on paper. He showed it to Pan, saying, "Old coins are really expensive and I couldn't buy one, so I could only get this ink rubbing for you. Please identify it for me."

Pan nodded and looked at the stamp a long time. He finally said, "This is a coin from the Shang Dynasty, it is really a rare treasure!" Mosheng gave a big laugh, and took out the horse-hoof sesame cake, telling Pan what he had done. Pan was speechless, and from that day forward was not so boastful.[80]

This story is surely apocryphal; it is hard to imagine Pan Zuyin seriously believing his brother had chanced on such an improbable object as a coin from the Shang Dynasty. Yet the humor of the tale reflects a profound anxiety that rubbings, the paramount *jinshi* mode of representing and researching artifacts, were vulnerable to fraud and amateurism. With these pratfalls in mind, Wu Dacheng cautioned Chen against relying too heavily on rubbings as tools for authentication, writing, "When talking of ancient characters on rubbings, to seek similarities is easy, to seek quality is also easy, but to seek with effectiveness is very difficult."[81]

Nonetheless, the widespread production of rubbings remained a critical marker of the popularity of *jinshi* and its simultaneous appeal as an artistic movement and component of philology. The production of rubbings constituted "a regular industry" with "shops being found in almost any Chinese city whose business is the making or selling of 'rubbings,'" as the Health Official and Honorary Curator of the Shanghai Museum, Arthur Stanley, commented in 1917.[82] Chen Jieqi employed two artisans to make rubbings, which he sold to other collectors.[83] Other specialists were hired to travel to well-known sites like Buddhist temples, where they stood on racks or hung from ropes to position themselves.[84]

The techniques to make rubbings were sophisticated and various. In the simplest procedure, to create a rubbing of a stele for instance, a paste made from saltwater algae was used to glue a piece of bamboo or mulberry paper onto the stone. Then, with special two-ended brushes, an artisan gently pushed the soft paper into the recessed characters of the inscription. After the paper dried, he used a round inkpad, made of silk with wool faces, and lightly tamped the ink onto the raised areas.[85] Connoisseurs had different preferences for the colors and styles of these rubbings, styles that were achieved using different inks and other effects. A light-colored ink resulted in a rubbing with a delicate

appearance, called a *chanyi ta* (cicada-wing rubbing); an oil-based ink produced a darker, shinier color with sharper contrasts, called a *wujin ta* (black-gold rubbing).[86] The specific terminologies alone indicate the extent to which rubbings were regarded as aesthetic objects as well as sources of scholarly data.

These processes were developed for two-dimensional artifacts like steles, however. When used on objects like bronze vessels, the result was a considerable degree of distortion—a round surface appeared crescent-shaped, making it harder to read an inscription or determine a vessel's shape. Furthermore, it was difficult to create rubbings of vessel inscriptions without the paper tearing, or the ink clumping or pooling.[87]

By the early nineteenth century, a new process, the *quanxing ta* (three-dimensional rubbing), helped eliminate these problems. This process relied on a technique that was developed in the early nineteenth-century by a Zhejiang antiquarian named Ma Fuyan (fl. c. 1820s–1850s). To make these rubbings, an artisan first measured an artifact's dimensions and placed faint reference points on a piece of paper. This perspectival sketch was then affixed to the object plane by plane so that a rubbing could be made of small individual sections.[88] The style became famous after the antiquarian monk Liuzhou presented Ruan Yuan with a scroll depicting more than one hundred bronzes in the great scholar's collection, each created using the three-dimensional style.[89]

Three-dimensional rubbings were praised by Chen Jieqi for their more exact depiction of vessel shape and dimensions, since they were the result of actually touching the object.[90] Indeed, they were a visual analogue to the tactile delight that scholars experienced when they handled artifacts; their three-dimensionality as well as their blurriness reflected the difficulty of handling ornate, often highly corroded artifacts. Just as two-dimensional rubbings allowed antiquarians to enjoy the spirit of antiquity in a convenient and portable medium, three-dimensional rubbings conveyed the vessel's materiality—that quality of tangibility that made fondling artifacts so enjoyable.

Despite mimetic drawbacks, both two- and three-dimensional rubbings of artifacts became popular jumping-off points for other genres of pictorial art. They were prominent in *bapo* (collage art), where rubbings were depicted scattered among scraps of calligraphy, pages torn from books, and snippets of paintings, to produce a charmingly haphazard effect. *Bapo* images were considered auspicious because "assemblage" rhymes with "luck" in Chinese, but surely the inclusion of

ancient artifacts also linked these collages with good fortune.[91] The idea of including rubbings of artifacts in pictorial art became even more popular in the last decades of the nineteenth century, when Wu Changshi and Ren Xun (1835–1893) gained a following for *bogu hua-hui*—ink paintings that showed brightly colored peonies and other auspicious flowers in vases represented by three-dimensional rubbings of bronze vessels (or painted facsimiles of rubbings).[92] These images resemble European still lifes in their use of perspective, shading, and composition. They may have been marketed to nouveaux riches who liked the garish, auspicious blossoms, rather than to *jinshi* specialists.[93] But not all antiquarians disliked *bogu huahui;* Wu Dacheng patron-ized several practitioners, including Wu Changshi and Huang Shiling (1849–1908).[94] The popularity of *bapo* and *bogu huahui* indicates how *jinshi* practices seeped into the Chinese art world.

With rubbings as with all *jinshi* pictures, mimetic fidelity was a minor goal. Far more important was that these images reflected the social and political values of the artifacts themselves—hence the con-tinuing popularity of idealized, corrosion-free Song-style images of bronzes. Nonetheless, three-dimensional rubbings and even photo-graphs became more prominent in antiquarian publications following changes in antiquarian practice that favored material artifacts over the philological emphasis on their inscriptions.

Pictorial Catalogs

When a wealthy collector had reached a certain threshold in the size of his collection, the extent of his antiquarian network, or both, he often decided to commission a pictorial catalog of his collection. The idea of pictorial albums of antiquities, as we have seen, originated in the Song. The genre became newly popular after the publication of Qianlong's artifact catalogs in the second half of the eighteenth century. As Ruan Yuan observed, the Qianlong catalogs inspired a generation of schol-ars to produce their own. For a century, their privately printed cata-logs of bronzes, jades, and other artifacts constituted a popular genre, still under production in the first decades of the twentieth century.[95] Liu Tizhi (1879–1963), a Qing official before joining the board of the China Industrial Bank, assembled his collection "by all means possible" for several decades. He was "completely absorbed and did not tire. In thirty years of collecting I discarded coarse objects and kept the ones to see. After fondling them myself, I did not wish to keep them private,

and thus I have displayed these bronzes in a catalog."[96] But their expectations were changing as a consequence of new visual techniques in other areas of *jinshi* practice, and began to include images that showed a greater degree of depth and mimetic attention to the surface qualities of artifacts, including damage. These albums presaged the illustrated books and serials, often using a greater sense of depth and Western-inspired forms of scientific illustration that became popular in China in the nineteenth century.[97]

To be sure, many *jinshi* catalogs remained faithful to the visual standards established by Song albums. Well into the twentieth century, they continued to use line-drawn images to represent a vessel's shape and basic decorative features. Since these artifacts were depicted as free from any sign of age, wear, or damage, the images were themselves a declaration of orthodoxy, emphasizing the permanence and ritual significance of the vessels. (See Figure 1.1, Duanfang's collection of Shaanxi bronzes, for an example of this style in the twentieth century.) These drawings remained popular in the early twentieth century as a conscious expression of Confucian ideology. Ye Changchi argued, "We should learn from the example" of Song catalogs like the *Xuanhe bogutu*, which "depicted the forms of vessels," advising scholars to "make rubbings of vessel inscriptions, and carefully note their measurements. First show the drawing, then the text," just like Song catalogs. He further argued that these illustrations "require skill to produce" and "cannot be produced by a common laborer."[98] In other words, continuing the visual style of Song catalogs was another way to demonstrate an elite sensibility towards the collection and study of artifacts.

Yet just as rubbings were showing signs of three-dimensionality, so were catalog images. In fact, Qianlong's pictorial albums of antiquities were produced by court artists trained in styles then current in Western pictorial art, such as vanishing-point perspective and cross-hatch shading.[99] Among them was Ding Guanhe (fl. 1740–1780s), whose brother Ding Guanpeng (c. 1708–1771) studied with the resident Italian painter Giuseppe Castiglione (1688–1766) and could have been exposed to the French copper-plate engravings of Qianlong's military victories produced under the direction of Charles-Nicolas Cochin (1715–1790).[100] Ding Guanhe contributed to Qianlong's 1778 catalog of ink stones, which employs finely rendered shading effects that suggest the depth and texture of the materials used (stone, clay, etc.), while revealing cracks, chips, and other imperfections (Figure 3.1).[101] These novel effects suggest the influence of European etchings and engrav-

Figure 3.1. Song Dynasty ink stone included in Qianlong's 1778 catalog *Xiqing yanpu* (Record of ink stones from the Xiqing pavillion). Note the depiction of volume, as well as the inclusion of details that suggest damage and texture.

ings, and indicate a changing antiquarian culture that increasingly valued mimetic faithfulness and an acceptance of imperfections and damage in artifacts rather than a pristine rendering. Nonetheless, similar imperfections are not apparent in Qianlong catalogs of ritual artifacts like bronzes, indicating the veneration still expressed towards ceremonial vessels and other symbols of Confucian orthodoxy.

Gradually, the European-influenced styles made popular by court artists began to influence antiquarians like Weng Fanggang and Ruan Yuan.[102] And guided by these new forms of illustration, antiquarian albums gradually abandoned the Song style and began to show even ritual artifacts with cracks, chips, and other imperfections. In his album of jade artifacts, for example, Wu Dacheng depicted jade batons and tubes from the Zhou Dynasty—symbols of exalted political power—

with signs of age and damage. Hence, in many respects, line-drawn images were beginning to look like three-dimensional rubbings. Soon, three-dimensional rubbings themselves were also included in antiquarian catalogs, like the album of artifacts collected by Zhang Tingji (1768–1848), a close associate of Ruan Yuan and a noted calligrapher (Figure 3.2). At first, it was only practical to paste three-dimensional rubbings onto the pages of one-of-a-kind scrapbooks. But with the introduction of photolithography, rubbings could be reproduced much more easily using copperplate lithography, as Wu Dacheng did in his second bronze catalog.[103] For several decades thereafter, antiquarians reproduced rubbings with photolithography for their artifact catalogs.

Still, until the 1920s, actual plate photographs of artifacts were still unusual. There were practical limitations: photographic work necessitated expensive equipment and trained practitioners, and was generally only available in large cities, and not in the hinterland where so much of antiquarianism was practiced. It also required extensive time with actual objects, another handicap for scholars whose collections were geographically diffuse. But there were aesthetic drawbacks to the technology as well. The images are sometimes less distinct, and certainly more static, than in multiperspective, line-drawn engravings, with their sharply contrasting decorative motifs. Also, rubbings remained the preferred means to represent inscriptions, either on bronzes or on other artifacts, including oracle bones.

Photography became more widespread in *jinshi* as it became more common to other forms of visual culture. In the 1890s, photography was first used in China to reproduce paintings, and within a few years photographic images began to influence the production of paintings, as well.[104] By the next decade, the technology was used to reproduce ink-squeeze rubbings of inscribed oracle bones, and then finally to photograph objects like ceremonial vessels.[105] Some early examples of photographic artifact catalogs include the series of albums produced by Rong Geng (Figure 3.3). These photographs show strikingly detailed and three-dimensional depictions of textural features like corrosion. Because they eschewed the representation of surface perfection typical of most artifact catalogs, they represented a significant shift from the visual idiom established by medieval albums and maintained, with only a few exceptions, through the end of the Qing.

But in general, photographic albums were less novel than one might imagine. For one, their composition often mirrored more traditional *jinshi* formats, for example by using black borders around ar-

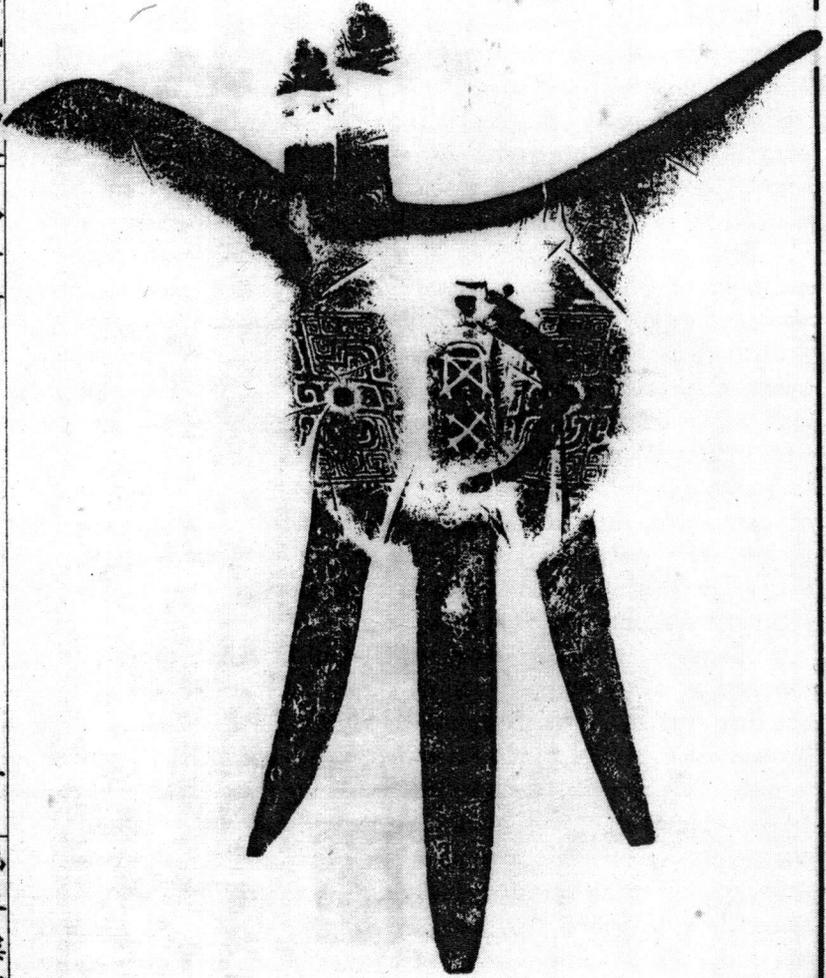

Figure 3.2. A three-dimensional rubbing of a *jue* (wine cup) collected by Zhang Tingji in the early nineteenth century and printed via photolithography. From *Qingyige suocang gu qi wu wen*, 1925.

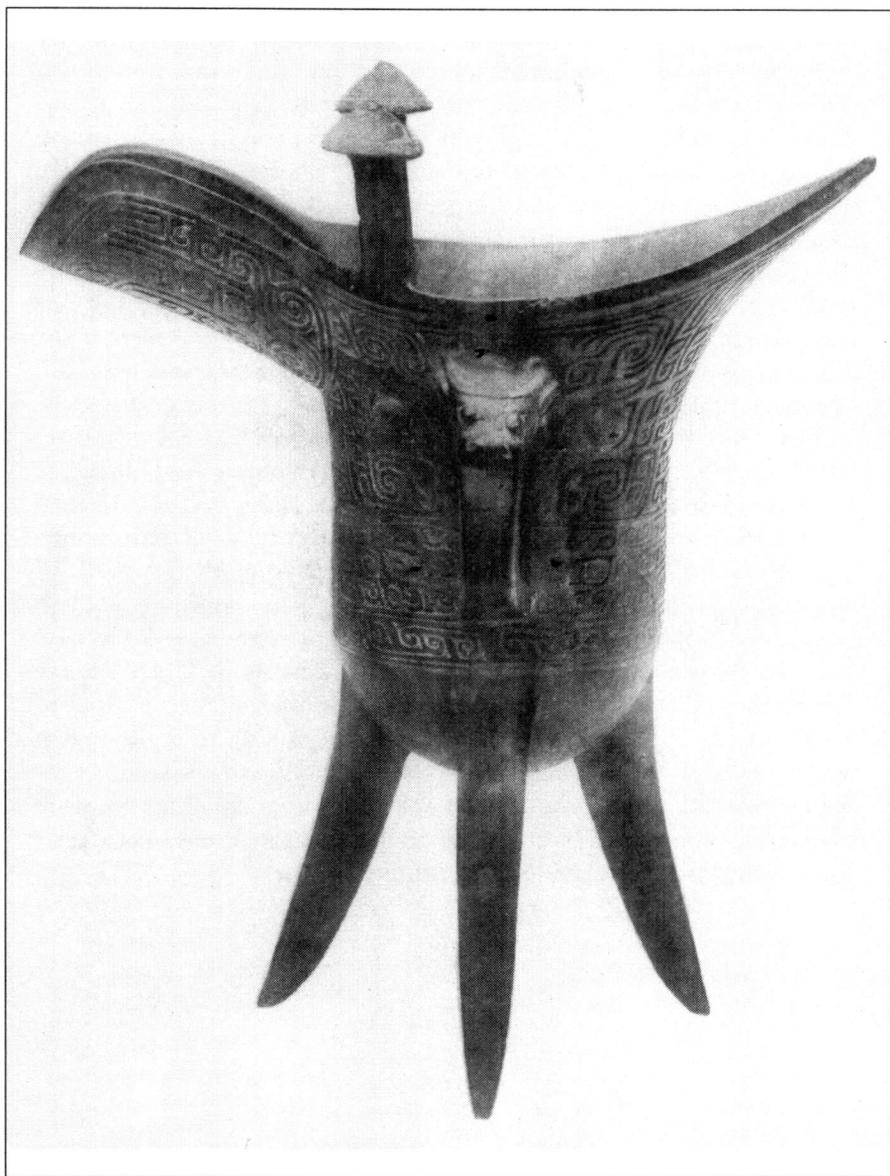

Figure 3.3. A photograph of a *jue* from the collection of Liu Tizhi. Included in *Shanzhai yiqi tulu,* compiled by Rong Geng in 1936.

tifacts like woodblock-printed catalogs. In addition, the depiction of surface corrosion was arguably not only a nod to the verisimilitude made possible by photographic technology but also a complement to the emphasis on surface texture that had been made possible by three-dimensional rubbings since the early decades of the nineteenth century. Hence, photography, by itself, did not signal an entirely new attitude regarding the materiality of artifacts, but rather a sharpening of an attitude that had been maturing for almost a century.

Nonetheless, this attitude—namely, a greater emphasis on the materiality of artifacts—was emerging. Its ultimate consequence was that antiquarians began to minimize images altogether. By the turn of the century, antiquarians still believed that pictures and rubbings were still extremely important to *jinshi* practice, but there was a far greater consciousness of their limited effectiveness in research. As Kang Youwei noted in 1895, supporting the proposal to build a museum in Shanghai, "Pictures make clear the physical aspect of the thing that they depict, but still there are things about pictures which prevent a full understanding, which can only be achieved by [looking at] the artifact itself."[106] Unmediated sight remained a principal value. "I love antiquity enough to take the trouble of seeing objects"—not just rubbings—"otherwise I do not dare to collect them," Wu Dacheng wrote to Chen Jieqi.[107] Even stele inscriptions, he believed, "must be seen in the original to dispel doubts."[108] Late-Qing scholars were beginning to argue that it was not enough to study representations: material artifacts were essential for research. But in the context of late-Qing antiquarianism, what exactly could be gained by studying the material properties of artifacts? In other words, what would artifact studies be like?

4

Wu Dacheng's Paleography and Artifact Studies

A millennium and several hundred years after the Qin
Dynasty burning [of the Classics], how can we under-
stand characters from the Three Dynasties? Luckily,
there are inscriptions on bronze bells, tripods, and
sacrificial vessels, all materials from before the Qin.
— Wu Dacheng, *Kezhai jigulu,* 1897

THE DAILY ACTIVITIES of late-Qing antiquarianism focused on col-
lection practices and the production and appreciation of visual culture,
but one more ingredient was essential to the pastime—the method-
ologies used to interpret inscriptions. As *jinshi* techniques in general
evolved in the late nineteenth century, so too did paleography. We see
this particularly clearly in the work of Wu Dacheng, one of the most
widely admired *jinshi* scholars of the period, whose efforts impressed
scholars both within China and in the international community.

Wu Dacheng's research illuminates the degree to which *jinshi*
studies remained supple, responsive to contemporary political and in-
tellectual trends, and appreciative of foreign insights throughout the
last decades of the nineteenth century. Over the course of several dec-
ades, he focused on several critical areas of the field. One was lexicog-
raphy. As a relatively young scholar, he used his calligraphic expertise
in seal script, developed in part through his imaginative recreations
of Confucian texts like the *Analects,* to revise one of the most trusted
lexicons of the language, the *Shuowen jiezi.* His work on etymology
gave him particular confidence in transcribing and interpreting difficult
bronze inscriptions of a kind that had eluded scholars for centuries,

including the Maogong *ding* inscription. Then, after he established his reputation as a paleographer of bronze inscriptions, Wu began to focus on a very different set of artifacts—uninscribed jades—which he used to recreate ancient systems of measurement. Influenced by the Western natural sciences, Wu's work on jade represented virtually the first time that a *jinshi* scholar utilized antiquities without texts in order to comment on the ancient past. This inaugurated a new era of research on material objects and established Wu Dacheng's international standing as an audacious and exacting scholar.

Calligraphy and the Old Text–New Text Debate

Wu Dacheng's reputation is hard to overstate. In one history of antiquarianism, he ranks only behind Ruan Yuan and Pan Zuyin as a collector of bronzes (Chen Jieqi is fourth), while Liang Qichao praised the "excellent quality" of his research.[1] He also was a gifted artist from an antiquarian family who compulsively made rubbings or sketches of any artifact he saw.[2] Over the course of a forty-year interest in *jinshi*, his artistic proficiency in bronze-script calligraphy continually informed his paleography.

Wu Dacheng became an antiquarian as a young man. He was already painting by the age of thirteen, and developed a particular talent for antiquarian themes. Recuperating from an illness in 1877, he wrote to Wang Yirong that he was laboring hard, and—while giving himself blisters—was producing an ambitious series of thirty-two *fangbei* paintings, each with an accompanying memoir.[3] His seal-script calligraphy, which he pursued with meditative attention, was admired even more than his painting.[4] When he was seventeen, he began studying calligraphy with Chen Huan (1786–1863), a disciple of the famous philologist Duan Yucai (1735–1815).[5] One twentieth-century critic judged his brushwork as fine as that of other Epigraphic School masters, writing, "When speaking of Qing calligraphers, after He Shaoji there was only one other. […] Wu's use of brush and ink was both precise and suitable. His strokes could be as thin as a fraction of an inch, or big enough for a door plaque, in either case without losing delicacy or cleverness, which made him a master at seal script."[6]

Calligraphy remained a primary commitment even when he studied ancient inscriptions as philosophical texts. Indeed, for Wu Dacheng calligraphy was an expression of Confucian ideology. "Taking the writing styles of antiquity as one's teacher" enabled him to "break the low

practices of us moderns."[7] Although epigraphic studies and calligraphic talent were closely related, for scholars like Wu Dacheng, art practice preceded paleographic research—both chronologically and, perhaps, even in importance.

Unfortunately, his obsession with antiquity was sometimes a political liability. He was governor-general of Hunan-Hubei in 1894 when the Qing went to war with Japan to determine supremacy in the northeast. He volunteered to help defend the Liao Peninsula, where he had been stationed ten years earlier, but his forces were routed at Niuzhuang in one of the fiercest battles of the First Sino-Japanese War. Deeply ashamed that his defeat allowed the Japanese to capture the nearby city of Yingkou and claim victory not long thereafter, Wu first tried to commit suicide—he was prevented from doing so by an aide—and then resigned his position.[8] He was not necessarily any more inadequate than his wartime colleagues, but his antiquarian obsessions gave critics a concrete explanation for his defeat. In a poem for Liang Qichao's *Xinmin congbao* (New citizen's journal, published in Yokohama after 1902), the diplomat and political reformer Huang Zunxian (1848–1905) satirized Wu's unseemly obsession with a certain Han Dynasty seal, whose inscription ironically referred to Chinese dominance of the region. "The General of Manchuria" depicts Wu Dacheng as a man who "catalogues antique jades and publishes drawings of bronze vessels / Digs deep into his wallet to buy a collection worth millions." After the war is over, he "takes out his Han seal and strokes it over and over," crying out, "Oh! My seal! My seal! What can I do now?"[9] Huang's critique was not limited to Wu Dacheng: it indicted many late-Qing officials for their old-fashioned loyalty to Confucian culture. Yet even if Huang criticized Wu for letting *jinshi* distract him from politics, the truth is that all of his research had artistic content, a scholarly purpose, and a political message, although not necessarily in equal measure.

His first *jinshi* project was inspired by his calligraphic specialty in seal script. In the 1860s, while he was preparing for the examinations and frequenting Pan Zuyin's library, he became intrigued by the three dozen references in Xu Shen's *Shuowen jiezi* to a seal-script *Analects*. Building on his technical skills as a calligrapher, he decided to rewrite the entire *Analects* in seal script, a project that, working intermittently, took almost ten years.[10] This meant trying to envision what the *Analects* would have looked like at its moment of creation. And from the perspective of late-Qing philologists, this kind of interpretation was pure politics.

Since well before the beginning of the dynasty, scholars had tried to authenticate versions of the classics, which had been destroyed by the Qin emperor and then rewritten by Han Dynasty scholars in their own script. Halfway through the Han, however, more materials were discovered—supposedly in the walls of the Confucius family home—that were written in an "old script"—or, in other words, a style that predated the Han. These so-called Old Text versions were presented to the court and integrated into the preexisting classics. Later scholars, however, used philological argumentation to demonstrate that the Han Dynasty or New Text versions were more reliable, as we saw with Yan Ruoqu's research on the *Documents*. By the late Qing, New Text adherents tended to be reformist in their political views, reinterpreting the classics to justify changing government institutions. The New Text scholar Kang Youwei, for example, became famous in the 1890s for deploying the claim, "Confucius was a reformer" in support of comprehensive reform of the Qing state.

By recreating a seal-script version of the *Analects*, Wu Dacheng would appear to declare himself a Old Text literalist and hence a political conservative by the standards of the day. But Wu's project actually tried to redefine the debate. Yan Ruoqu and many philologists only briefly considered the history of script forms, since they drew their conclusions largely based on an internal analysis of literary sources.[11] In contrast, Wu's attempt to match artifact inscriptions to the classics implied that internal textual clues were no longer sufficient. And although Kang Youwei's research on the classics was largely philological, he and his contemporaries began to draw on *jinshi* research. Liu Shipei, for example, argued that New Text versions of the classics were verified by Han Dynasty steles.[12] Hence, Wu Dacheng's attempt to recreate the classics in ancient script styles cannot be interpreted as an entirely conservative moment, if only because it encouraged other political thinkers to reconsider *jinshi* for new primary sources. A project that began as calligraphic practice, in other words, ended up making an important statement that even the future general of Manchuria was not necessarily opposed to innovation, particularly when it came to *jinshi* practices.

Inscriptions and the Shuowen jiezi

The use of new primary sources was one of the most significant of Wu Dacheng's and his contemporaries' accomplishments. As we have seen, in contrast to eighteenth-century philologists, members of the

Epigraphic School were particularly interested in bronze inscriptions, which Chen Jieqi claimed were older and hence "more important than the Six Classics."[13] After Wu Dacheng finished his *Analects* project, he decided to use bronze inscriptions to add more characters to the *Shuowen jiezi*. This resulted in his *Shuowen guzhou bu* (Ancient and zhou script supplement to the *Shuowen,* or simply the *Supplement*), an astonishing achievement that made thousands of new graphical variants available for paleographers. Its scope and accuracy demonstrated that nineteenth-century antiquarians, unlike centuries of predecessors, were finally able to decipher even the most complex bronze texts.

The inspiration for the *Supplement* came during Wu's *Analects* project, when he determined that he knew many graphs unfamiliar to Xu Shen. Indeed, he decided that the *Shuowen jiezi* was of limited usefulness in understanding the certain script forms—called *guwen* (ancient script) or *zhouwen* (zhou script, not to be confused with the Zhou Dynasty), or in combination, *guzhou*—that were thought to predate the small seal script analyzed by Xu Shen. Out of thousands of graphs discussed in the *Shuowen jiezie,* there are only some two hundred examples that include *zhouwen* equivalents, and a few more than five hundred *guwen*. This relative paucity was explained by philologists like Duan Yucai as the consequence of Xu Shen's decision to skip over some examples if they were indistinguishable from seal-script graphs. But Wu Dacheng felt the omission might be due to Xu Shen's ignorance of some examples of these early script forms, particularly since Xu Shen relied primarily on literary sources.[14] In Wu Dacheng's view, so many artifacts like bronzes were coming to light in the Qing that he and his colleagues were in a better position than even a Han scholar to determine etymology.[15]

By tackling the *Shuowen jiezi,* Wu Dacheng contributed to a significant current in Qing scholarship. Starting in the early years of the dynasty, scholars revised the dictionary, hoping to compensate for the inaccurate corrections made by medieval editors.[16] The next step was to add to the lexicon. Gong Zizhen predicted that it would someday be possible to do this with bronze inscriptions, after Zhuang Shuzu (1751–1816), Yan Kejun (1762–1843), and Wang Yun (1784–1854) referenced a few bronze characters in their well-regarded *Shuowen* studies.[17] But this kind of scholarship was perceived as very difficult (and dry). "When one first looks at the *Shuowen,* it is flavorless," Zhang Zhidong conceded, "but when one can understand a couple of entries, it is increasingly, endlessly wonderful."[18] It took a scholar like Wu

Dacheng, with both skill in bronze inscriptions and patience with Xu Shen, to make Gong Zizhen's prediction a reality.

In order to remedy Xu Shen's limited access to ancient and zhou script, Wu Dacheng decided to focus on graphs that were used from the end of the Spring and Autumn Period to the beginning of the Warring States. This entailed rewriting almost half of Xu Shen's thousands of entries. He did this by culling graphs from recently discovered bronzes, particularly those with lengthy inscriptions, including the Maogong *ding* (497 graphs). He also included graphs found on coins, pottery, and the stone drum inscriptions, which previous studies of the *Shuowen jiezi* did not reference.[19] He was extremely cautious and only referenced inscriptions that he had examined personally, at least in the form of rubbings.[20] The result was a profound challenge to the role of Xu Shen's dictionary in antiquarian research: No longer was it the most trustworthy reference for understanding early texts—artifact inscriptions were. Indeed, by using bronze inscriptions to rewrite the lexicon, Wu Dacheng demonstrated that it was now possible to begin other forms of philosophical and historical research on texts that had exceeded the paleographic capacity of *jinshi* scholars for centuries.

Wu's contribution to "Xu Studies" drew extreme praise. Pan Zuyin called him the equal of Xue Shanggong and Zhao Mingcheng.[21] The archaeologist Dong Zuobin (1895–1963) referred to the *Supplement* as "the first systematic effort of a Chinese classical scholar of the Ch'ing [Qing] dynasty to point out, on the basis of his study of ancient bronze and stone inscriptions, the errors of Hsü Shen's [Xu Shen's] dictionary."[22] He was soon an acknowledged expert on the *Shuowen jiezi*, corresponding with contemporaries like the painter Zhang Shizeng (fl. 1880s), who finished his own study of the lexicon in 1889.[23] Now that he had demonstrated his expertise as a paleographer, he began to apply his skills to interpret bronze inscriptions, including the infamous Maogong *ding*.

Vessels and Politics

The Maogong *ding*, a tripod cast during the reign of the Zhou King Xuan (Xuanwang) in the ninth century BC, has been controversial since its discovery. In the 1960s, for example, the Australian archaeologist Noel Barnard created a stir when he declared the tripod to be a forgery. Although Barnard's claims were subsequently disproved, even in the nineteenth century there were debates over the artifact. Zhang

Zhidong claimed that "out of some five hundred characters" in the inscription, "not one thing, one place, or one person is expressed in a conventional phrase," and that by "using a thousand ounces of silver to buy this tripod," Chen jeopardized the reputation of his entire collection.[24]

The authenticity of the vessel now seems certain. But when Wu Dacheng began his research, only Chen Jieqi and perhaps one other scholar had attempted to transcribe its text. Not surprising given his Qingliu priorities, his studies of the Maogong *ding* related to his views of Confucian governance. Indeed, this tripod is particularly relevant because its inscription begins with a prominent statement of the Zhou theory of the Mandate of Heaven, which assumed that only virtuous rulers are legitimate. Virtue, of course, can be defined in numerous ways, and hence Wu Dacheng's transcription reflected his views of what constituted good government.

The text relates the appointment of King Xuan's uncle, the Duke of Mao (Maogong), as prime minister. It contains a large section describing the elaborate gifts given to the duke by his nephew—jade implements, clothing, elaborate armor, and chariots.[25] Its invocation consists of a speech by King Xuan. "August Heaven is profoundly satisfied with the virtues of the glorious Kings Wen and Wu," King Xuan intones, praising the founders of the dynasty, "which makes us, the rulers of Zhou, acceptable to Heaven, so that we have received the Great Mandate to cherish all."[26]

This is Wu Dacheng's interpretation. When Chen Jieqi transcribed the text, he thought it read, "August Heaven greatly cherishes the virtue of the glorious Kings Wen and Wu."[27] But Wu replaced "cherish" with "satisfied" *(chong)*, glossing it as pleasing to the spirit of Heaven.[28] To justify this reading, Wu Dacheng drew on sources from the *Documents* and the *Guoyu* (Discourses of the states, a Warring States text with numerous Zhou speeches) that used *chong* to convey a feeling of satiation, metaphorically derived from the eating of food. In Wu Dacheng's interpretation, this meant that the virtuous king was like food, satisfying Heaven's appetite. By implication, he was not an exalted being but was simply an ingredient, so to speak, to balance the cosmological metabolism.

In the context of nineteenth-century *jinshi*, Wu Dacheng's methods were distinctive. He preferred to utilize semantic clues rather than etymology, interpreting bronze inscriptions by comparing their contents to literary sources. This method, called *tuikan* (literally "infer and collate") may sound commonsensical, but most Qing paleographers

disliked it. They preferred to identify unknown characters by citing evidence according to the Six Scripts, or Xu Shen's categories to explain the historical evolution of graphs. The eminent paleographer Tang Lan (1901–1979) was skeptical of *tuikan*'s reliability, but Wu Dacheng's application of this method proved influential among his contemporaries, particularly when dealing with the earliest graphs that seemed to be formed according to principles not consistent with Xu Shen's classification system and that hence resisted etymology.[29] Sun Yirang, for example, used *tuikan* analysis in his studies of oracle bone inscriptions.[30]

But the real value of *tuikan*'s context-driven approach may have been that it helped Wu Dacheng make political statements in his readings of ancient inscriptions, as we see repeatedly in the Maogong *ding* inscription. King Xuan's speech continues, "We still welcome even those neighboring kingdoms which did not come and have personal audiences with Kings Wen and Wu, to bask in their magnificence." Wu glossed "magnificence" as kingly virtue instead of wealth or grandeur, hence emphasizing the responsibility of the ruler to promote the well-being of society.[31] While not a revolutionary statement by any means, Wu Dacheng's comment regarding the role of government and society was made more forceful by his references to other literary sources, implying that these values permeated the entire canon.

Even more, by correlating a very difficult and very old primary-source text with the philosophical canon, Wu Dacheng was beginning to put into practice the long-standing, if rarely realized, claim that bronze inscriptions were valuable to explain the classics. (As we have seen, *jinshi* scholars often suggested this was possible but, for the most part, preferred philological analysis of the classics themselves with few references to vessel inscriptions.) From using *inscribed* artifacts to illuminate literary sources it was a short—but momentous—step to utilize *uninscribed* artifacts to do something similar. But first this required a new appreciation for the value of artifacts without texts, an appreciation suggested in particular by nineteenth-century approaches to the study of human geology.

The Idea of Artifacts

Wu Dacheng's most original research was his work on ancient systems of linear measurement. He collected and studied a variety of jade pieces and used them to determine the basic standards of Zhou lengths, one of the first research projects to intentionally focus on uninscribed mate-

rials. Indeed, before the late Qing, "artifacts without characters received no attention," as Luo Zhenyu observed, partly because dating and identification was difficult without textual clues.[32] Indeed, there were complaints that Chinese antiquarians were still so obsessed by ritual artifacts and stele inscriptions in the early twentieth century that astute foreigners had no competition in snapping up jades and ceramics.[33]

But this attitude was beginning to change, partly under the influence of European geographical works. Charles Lyell (1797–1875), for example, used fossil evidence to support the idea that the Earth gradually evolved over the millennia, rather than in bursts of divine cataclysm like the Great Flood—inspiring Darwin's search for fossils during his voyage on the *Beagle*. Both Lyell's *Principles of Geology* (1830) and his *Geological Evidence of the Antiquity of Man* (1863) made striking claims as to the length of human habitation on the earth.[34] He also discussed the usefulness of studying things like "flint hatchets and arrow heads" for clues to human prehistory.[35] *Jinshi* scholars were exposed to this approach as early as 1860, when John Anderson (1833–1900), director of the Calcutta Museum, came to Yunnan to collect ancient stone implements.[36] Three decades later, the diplomat Xue Fucheng (1838–1894) was impressed by the collection of ancient, uninscribed materials found in Siberia that were destined for Russian museums.[37] And when Duanfang presented a piece of inscribed Tang Dynasty Daoist sculpture to the Field Museum in Chicago in 1908, he was given an assortment of Native American pottery and basketry in return.[38]

For Chinese antiquarians, the distinctiveness of artifacts was that they had little value from a traditional antiquarian perspective—because they contained no inscriptions. They were intrigued by the idea that these artifacts could explain human history and social development. Tan Sitong (1865–1898) was inspired by how "geologists are examining fossils and other material artifacts," which made it possible to "explain the origins of the earth and its living things, how they evolved from mollusks, to fish, to reptiles, to birds, and then at last to humans."[39] The idea of correlating geology with human history particularly appealed to Chinese scholars hoping to prove the longevity of their civilization. In an example of how "increasing contact with Western natural history did not necessarily damage the authority of ancient texts," in Fa-ti Fan's phrase, Zhang Taiyan (1869–1936), for example, correlated the Stone, Bronze, and Iron ages derived from European geology with historical accounts in pre-Qin texts like the *Guanzi* (Writings of Master Guan).[40]

For some Asian scholars, artifacts were exciting not because they explained human prehistory, but because they explained the early history of their own nations. Under the influence of *kokutai* ideology, Meiji antiquarians began to spurn Chinese art and publish artifact catalogs to showcase their own material culture. In 1876, for example, the education ministry official Ninagawa Noritane (1835–1882) produced a superb pictorial catalog of antique pottery and ceramics. His work was illustrated with hand-colored lithographs showing artifacts in virtually photographic perspective, accompanied by lengthy essays on the artifacts' significance to local history and culture.[41] The idea was that antiquity was not only to be found in China: Japan could have its own distinctive history, symbolized by the sophistication of its early material culture.

The two implications of artifact studies, therefore, was the idea that inscriptions were not necessary to antiquarian research, but that they could in fact be utilized towards a narrative of national and social development. Whether these ideas were conveyed to Wu Dacheng via European geography or Japanese antiquarianism, he was certainly impressed by the idea of using uninscribed artifacts to research early Chinese dynasties. His two works on jade implements, *Guyu tukao* (Illustrated researches on ancient jade, 1889) and the unfinished *Quanheng duliang shiyan kao* (Experimental investigations into weight, length and capacity measures, preface dated 1892), used these artifacts to provide evidence for Zhou Dynasty measurement systems. Together these works represent one of the first attempts by Chinese scholars to use uninscribed artifacts to provide material evidence for the workings of ancient society.

Experimental Antiquarianism

Wu Dacheng's interest in uninscribed jades was surprising, given his early fascination with paleography and the *Shuowen jiezi*. Jades were commonly described as *wanwu* (curios) and hence were not subjects for rigorous *jinshi* research. But it was important to remember that this was a recent trend. In antiquity, jades "were safeguarded as [symbols of] regulations and institutions," he wrote. "They were used in ancestral temples, to send envoys, and in sacrifices, hence they were utilitarian. They were ornaments for royal crowns and swords, and officials high and low recognized their prestige, hence they were attractive."[42] Each kind of jade piece had unique physical dimensions and decora-

tions. They had particular functions for communication and adornment, as well. By recovering the measurement standards that created them, therefore, antiquarians could better understand the institutions of Zhou government.

Yet in recent decades scholars paid little attention to the artifacts. "Was it because they lack inscriptions for research? Or because after the Tang and Song Dynasties, there were so many imitations, and it was impossible to tell which jades were truly ancient?" Wu Dacheng wondered.[43] But even if the pieces themselves lacked inscriptions, there was no paucity of literary sources. Chapters in the *Rites* describe the manufacture of various jade tablets, tubes, and discs; poems in the *Shijing* (Odes) refer to their uses and appearance; and passages in the *Shuowen jiezi* and other lexicons explain their names and functions.[44] Antiquarians were particularly interested in the purportedly Zhou period *Kaogong ji* (Records of the examination of artisans), which contains a chapter specifically describing the manufacture of jades.[45]

Jinshi scholars had identified antiquities according to size since the Song Dynasty—every artifact catalog contained copious and precise measurements—but these dimensions were given according to contemporary systems of measurement, which said little about the standards of their manufacture.[46] In the eighteenth century, Qianlong's bronze catalog included an inscribed Han Dynasty measuring vessel, which allowed the editors to determine the length of a Han foot.[47] But even a Han standard was of limited usefulness when it came to identifying artifacts created centuries earlier. And what could be done if no ancient measuring devices were available for reference?

Initially, Wu Dacheng lacked confidence in his ability to piece together enough information to determine ancient measurement standards, or even to understand the often-confusing literary sources that described the artifacts.[48] Gradually, though, the size of his collection gave him confidence. During the 1880s, he became convinced that it was no accident that so many of the pieces he owned, particularly jade scepters and tubes, were the same length. According to the *Kaogong ji*, a common kind of scepter should be twelve inches in length, and so he used that piece to establish rulers that were featured in the introductory matter to his jade catalog *Guyu tukao*, published in 1889[49] (Figure 4.1). This method of determining the length of rulers to use in measuring artifacts was adapted by Duanfang, who featured a similar ruler calculated according to a Han Dynasty mirror in his 1908 bronze catalog *Taozhai jijin lu*, the one that featured the group of Shaanxi bronzes.

Figure 4.1. Rulers for ancient jades featured in Wu Dacheng's 1889 catalog *Guyu tukao*.

Although the rulers themselves appear rather simple and self-evident, in fact they represent an entirely new attitude towards the purpose of measurement in antiquarian learning. No longer would artifacts be described according to measurements garnered from descriptions in the literary sources; instead, the measurements used in antiquarian catalogs would be based on evidence gathered from the artifacts included inside.

Wu Dacheng was not satisfied, however, with the rulers he created for *Guyu tukao*, which referenced the artifacts in that particular catalog. He wanted now to determine all Zhou measurement standards, including volume and weight (topics that were never completed). This was an experimental as well as investigative project in the sense that material evidence was used repeatedly to test and verify Wu's hypotheses.[50] Indeed, his invocation of scientific discourse was not accidental, since his friends like Liu E were then incorporating technologies like telescopes in their fiction.[51] Wu Dacheng's approach may have also been indebted to the late-Qing interest in mechanics, which led some scholars to study early texts for evidence of an awareness of the principles of

physics.[52] To accomplish his experiments, Wu Dacheng worked closely with the Debaozhai emporium in Liulichang and purchased a number of unusually large artifacts, including jade discs with arched decorations and jade medicine spoons. "Right now in the capital no one else is vying to buy these items," he specified, "But if any shops in the market have old medicine spoons, no matter how expensive, please hold them for me."[53] These artifacts then became the raw data for his continuing research on Zhou measurement systems.

Experimental Investigations begins with a sequence of ten rulers, similar to the ones he created for his jade catalog. These were created by comparing jade discs, tables, and tubes in his collection, whose measurements were described in the *Kaogong ji*.[54] Another ruler was determined using a more specialized artifact—a *lüguan* (measuring tube), which a friend acquired for him in 1890. Wu believed this was in fact a *huangzhong lüguan*, the pitch-pipe created by the Zhou to establish the *huangzhong* (yellow bell) note, the basis for their twelve-tone musical system.[55] The measurement of this tube corresponded correctly and exactly with literary sources, this time detailing the number of grains of black millet that would fill the tube.[56] This was an exciting discovery, since the recovery of the yellow bell note would make it possible to imitate Zhou ritual. Wu then used the tube to come up with a new ruler, which he correlated to another twenty-nine artifacts.[57] In total, he created several tens of rulers, correlating to different kinds of artifacts and different periods within the Zhou. Such diversity can seem bewildering, but it satisfied his purpose of understanding the changing historical standards in the manufacture of these highly symbolic instruments of Zhou political authority.

His approach was particularly relevant to scholars seeking greater usefulness in antiquarian learning, by which they meant social significance. When Liu Shipei discussed the purpose of antiquarianism in 1906, for example, he cited specific innovations that Wu made possible. Indeed, "By researching the manufacture [of ancient artifacts], and inspecting the institutions [for which they were created], it is possible to both peek at ancient industry and reconstruct the inscription process," he wrote. That was the essential usefulness of *jinshi*, "which is helpful for more than [literary] scholarship."[58] In other words, a decade after Yan Fu criticized the field for lacking relevance, *jinshi* scholars were praised by reformers. Indeed, Liang Qichao's friend Jiang Zhiyou (1866–1929) noted in 1903 that archaeology had the "practical benefit" of allowing scholars to understand the roots of contemporary problems,

since "everything that happens in a later generation has its cause in earlier times."[59]

This research represented one of the first attempts by a Chinese scholar to use uninscribed artifacts to provide material evidence for the workings of ancient society, which led Luo Zhenyu to praise him as the founder of Chinese artifact studies.[60] But did his research count as archaeology? The Field Museum anthropologist Berthold Laufer (1874–1934) thought so. In his 1912 study of Chinese jades, Laufer complemented *Guyu tukao* (the pictorial album where Wu Dacheng first used artifacts to create rulers) as of "great archaeological importance." Laufer called the catalog "widely different" from its predecessors, "a truly archaeological collection, explained with great erudition and acumen," which "reflects the highest credit on the modern school of Chinese archaeologists."[61] Alongside Laufer's praise, Wu's interest in measurement soon sparked similar research among Chinese and foreign contemporaries, including Wang Xianqian (1842–1917) and the Presbyterian missionary Frank Herring Chalfant (1862–1914), who investigated Qin Dynasty weights and measures based on artifacts bought from antiques dealers in Shandong and the capital.[62] Luo Zhenyu's son Luo Fuyi (1905–1981) published an extensive work on rulers based on excavated materials, while Wang Guowei wrote an essay regarding China's historical systems of measurement.[63] All traditional and modern Chinese scholars admired him, Wang wrote, particularly for having taken advantage of all the new discoveries of texts and artifacts during his generation.[64] He also influenced a future generation of scholars like Rong Geng, who first encountered paleography through Wu's work on the *Shuowen jiezi*.[65]

Indeed, whether or not his work counted as archaeology is less important than the fact that it inspired his contemporaries and successors to search for previously underappreciated artifacts, and to apply their findings systematically to studies of ancient politics and society. These practices were the hallmark of late-Qing *jinshi* studies. By 1899, the new emphasis on artifact studies and the thirst for physical evidence of ancient script forms helped facilitate the discovery of the oracle bone inscriptions. Within two decades, furthermore, discussions of political philosophy, grounded in the empirical evidence of artifact inscriptions, was considered a benchmark for innovative historical research. Wu Dacheng's innovations thus laid the groundwork for many of the developments that are now considered the hallmarks of modern historiography.

5

The Discovery of the Oracle Bone Inscriptions

Have you found any unusual materials lately?
—Wang Yirong, undated letter to Miao Quansun

ORACLE BONE INSCRIPTIONS are among the oldest Chinese histori-
cal sources.[1] Up to some four millennia old, they predate the earliest
bronze texts by centuries. Carved onto a variety of surfaces—the bot-
tom shells (plastrons) of tortoises, the scapulae of cows or sheep, and
occasionally human skulls—they record the results of divination cer-
emonies conducted at the behest of the Shang kings. Given turn-of-
the-century debates—including accusations by Japanese scholars that
ancient Chinese historiography was largely myth—they had the poten-
tial to become peerless documentation of the ancient period. For Wang
Guowei, their discovery was comparable to the emergence of the Old
Text classics, disinterred from the walls of Confucius' house during the
Han Dynasty.[2] Yet the artifacts and their inscriptions were dogged by
controversy from the first. We are still not entirely sure how they were
identified or by whom. And when scholars began to research the ma-
terials, they interpreted them in wildly different ways. For Sun Yirang,
they helped document China's similarities with other ancient societ-
ies and justify political reform, while Luo Zhenyu used them to revere
the dynastic tradition. For all these reasons, the discovery of the oracle
bone inscriptions highlights the state of the *jinshi* field at the very mo-
ment when artifact studies was beginning to take root and historians
were beginning to take notice.

Who Discovered the Oracle Bones?

Scholars still debate precisely how the oracle bone inscriptions were discovered, principally because their detection by Wang Yirong (as related in the Introduction to this volume) seems so fantastic. While we may never know if pieces of inscribed bone were present in his malarial treatment, we are fairly certain that they would have originated in the village of Xiaotun (Anyang County, Hebei). In that region, peasants dug up fossilized bones, calling them *longgu* (dragon bones) or *longchi* (dragon teeth) and sold them as ingredients for traditional medicines.[3] Any inscriptions were usually scraped off or crushed during pharmacological preparation.[4] What were the odds that someone could find an intact text in powdered medicine?

Perhaps the least surprising thing about their detection was the scholar involved. Wang Yirong was admired by his colleagues for his curiosity, unconventional collecting habits, and keen eye for inscriptions. According to his son Wang Hanzhang (1892–?), he immediately recognized that the oracle bone characters "were neither seal-script nor ancient seal-script," but even older.[5] He was certainly among the first *jinshi* scholars to collect the bones, although for reasons that were known to him alone he collected them secretly—the custom of many connoisseurs.[6]

What we do know is that the bones are priceless. In their divination rites, the Shang kings asked their ancestors what actions (like sacrifices and battles) would be favored with success, or whether events like royal childbirth would proceed safely. They then heated the bones—although there are different theories as to how that was done. The resulting cracks (perhaps just the sound of the cracking) indicated the responses of the spirits. These responses were then written alongside the cracks, together with information regarding the date when prognostication occurred, the spirits who were approached, the questions asked by the king, and other details. A kind of recordkeeping of the ritual, the bones are tremendously valuable for their information on Shang politics, ritual, and royal genealogies, among other topics. Some of the richest excavation grounds for their recovery have clustered in Anyang, north of the Yellow River. This was the Shang heartland, near a city established by the dynasty in the fourteenth century BC, called Yin, their capital for several hundred years (the dynasty was renamed Yin-Shang to reflect the new seat of the dynasty). When the Shang

was conquered by the Zhou, their capital was destroyed, and the city was subsequently referred to as Yinxu, or the "Wastes of Yin."

The discovery of the oracle bones was unexpected, but not because scholars were unaware of their existence. Several literary sources describe Shang prognostication, including the *Records of the Historian*. In fact, Sima Qian wrote a treatise on Shang divination that describes rituals where tortoiseshells were burnt by yarrow, a thorny, tough-stemmed shrub.[7] But Sima Qian's emphasis on tortoiseshell left scholars unprepared for the quantities of inscribed cow bones unearthed in Henan; according to Luo Zhenyu, their coarseness seemed more typical of the rites of "Eastern barbarians."[8] Furthermore, the quantity and sophistication of the written inscriptions was also unexpected. To be sure, antiquarians like the Ming scholar Ma Sanheng had claimed that diviners first used ink before making their marks.[9] But as Wu Changshi pointed out, Qing classicists did not assume these marks would be writing.[10] Although Luo Zhenyu and Wu Changshi were surprised that these engravings were obviously texts, they were gratified that their knowledge of early script forms prepared them to decipher their meaning almost immediately.

We do not know if these issues were of concern to Wang Yirong. He died in 1900, leaving behind no memoir of how he discovered the materials. The earliest firsthand accounts were written by his close friend Liu E. In the preface to his 1903 catalog of oracle bone inscriptions, *Tieyun canggui* (Tieyun's collection of plastrons), Liu wrote,

> The plastrons were unearthed in 1899, in Henan, Tangyin County, in a part of Youli City. It is believed that local people saw that a grave had opened up, dug it out, and extracted some bones. They were first stuck together with mud in clumps, but after soaking them in water for a while they gradually came apart. Afterwards they put them in washbasins and scoured them. Two to three months later, it was easier to see characters. Other things that were extracted at the same time include rather stout cow tibia.
>
> Soon after they were excavated, [the bones] were obtained by tradesmen, who understood their value. They began to search for more and put a price on them. In 1900, a man named Fan brought around a hundred fragments to the capital. When Wang Mingong [Yirong] of Fushan saw them he was insanely happy, and paid for them generously. Afterwards, the Weixian [antiques dealer] Mr.

Zhao Zhizhai obtained several hundred fragments, and sold them
to Mingong.[11]

If this account is accurate, Wang Yirong never discovered the bones in
medicine, but simply bought them from antiques dealers. Indeed, both
dealers mentioned in Liu's account were well-known turn-of-the-cen-
tury specialists in antiquities. The "man named Fan" is almost certainly
Fan Weiqing (or Shouxuan), who, according to some accounts, found
the oracle bone inscriptions while traveling the region looking for an-
tiquities at Duanfang's behest.[12] Fan Weiqing also may have sold oracle
bones to the Tianjin scholar Wang Xiang (1876–1965) a year before
Wang Yirong saw them.[13] Another regular client was Luo Zhenyu.

Fan's first sale to Wang Yirong only numbered a dozen fragments,
but a few months later he sold the scholar some eight hundred pieces,
including a complete bone with an inscription of fifty-two characters.[14]
Within a year or two, Liu E had caught on to the discovery, and he and
his friends started vying to buy the most (and largest) fragments. As he
recorded in his diary,

> November 19, 1902. Zhao Zhizhai from Weixian arrived, carrying
> a box each of plastrons and Han Dynasty seals. He had over seven
> hundred seals, as well as a large Taihe era [477–499] sculpture, and
> a scale from Shaanxi. There were only a few large plastrons. [...]
> In the evening he returned with thirteen hundred plastrons and
> bones—they're apparently quite plentiful.
>
> November 27. In the afternoon I went over to Wang Xiaoyu's
> [1847–after 1913] place to chat over wine, and to find out the
> whole story behind the tortoise shells, which accorded with what
> Zhao said. This morning Wang Duanshi [fl. c. 1900] came by, and
> what he said agreed with Zhao. Duanshi said that Wenmin [Wang
> Yirong] actually bought bones twice: the first time he bought two
> hundred dollars [*yuan*] worth, the second time over one hundred
> dollars worth. Xiaoyu says that Wang Yirong's biggest pieces are no
> more than two inches wide, and he didn't have any whole plastrons.
> The Debao[-zhai antiques store] says it has more than ten whole
> plastrons, for a total price of seventy ounces of silver [*liang*], but
> that seems unbelievable.[15]

By the time these entries were recorded, Wang Yirong had been dead
for more than a year. Liu E may have been interested in establishing

the provenance of his collection (which numbered perhaps 1,500 fragments) because he intended to buy it from Wang's family.[16] Once he bought out Wang Yirong's collection, he owned more than five thousand fragments.[17]

Soon the competition to collect the artifacts expanded. The British consular official Lionel Charles Hopkins (1854–1952, Gerard Manly Hopkins' younger brother) and the Presbyterian missionary James Mellon Menzies (1885–1957) purchased bones for themselves and for museums overseas. Menzies, who toured the region in 1914, claimed he was "the first foreign or Chinese archaeologist to visit the Waste of Yin with a purely scientific interest in these objects."[18] For that matter, Samuel Couling (1859–1922), a British member of the Royal Asiatic Society, described himself as a discoverer of the bones, since he was among those who "introduced these objects to the notice of the learned world."[19] The Japanese scholar Hayashi Taisuke (1854–1922) acquired a hundred bones in 1905 from an antiquarian bookstore in Tokyo, while Mitsui Gen'emon (1867–1945, of the prominent Gen'emon *zaibatsu*) built a collection of some three thousand fragments.[20] And oracle bone studies elevated the scholarly reputations of Luo Zhenyu and Wang Guowei, who were named two of the *sitang* (four venerables) who established the academic field of oracle bone studies.[21]

With so much interest from collectors, an industry to excavate bones quickly began to take shape in Xiaotun, especially since dealers like Fan Weiqing traveled there every year, encouraging the peasants to keep digging.[22] Pits were dug some twenty feet deep, which then were refilled for farmland once a cache was exhausted.[23] When Luo Zhenyu's brother Luo Zhenchang (1875–1942) visited the area in 1910, one site was almost exhausted after decades of excavations—at first for dragon bones to sell as pharmacologia, and then for oracle bones to sell to antiquarians.[24] Villagers sold fragments one by one while alternating more- and less-desirable pieces. In some areas, they worked together to unearth artifacts and then split the profits. Otherwise, the landowners excavated the fields and denied them any compensation.[25] These small-scale, locally run excavations continued for decades, resulting in perhaps seven large finds between 1909 and 1928.[26]

The market matured so rapidly that within just a few years, visiting strangers—Chinese or foreign—were immediately offered bones by local people, even by children. In 1914, when Menzies was riding through the region, he noticed pieces of pottery tossed on the edges of fields. Local children then approached.

"What are you doing?" said the leader, "Examining some broken potsherds," said I. "What for?" said he; "Because they please me," I replied. "Do bones please you?" he ventured. "Well, that depends," I answered. "But I can show you some dragon bones with characters on them." Upon which I said that I was very much interested, and off we went around the bend and up over a barren, sandy waste to a little hollow on the western slope white with powdered particles of bone. This was the Waste of Yin, the ancient capital of Wu I [Wu Yi, fl. twelfth c. BC] of the Yin Dynasty.[27]

The eagerness of local peasants and dealers to sell bones only increased after the Boxer Rebellion swept through the region, forcing local missionaries to flee to the coast. When the Presbyterian minister Frank Herring Chalfant returned to Weixian in 1901, he was offered by an itinerant dealer a cache of fragments left behind in the chaos of the Boxers.[28] He and Couling later donated, together, four hundred fragments to the museum established by the China branch of the Royal Asiatic Society in Shanghai.[29]

All these collectors certainly knew that the bones were valuable. But their inscriptions were so different from other sources that it was a rather wide-open field to determine their significance. The first attempt by a *jinshi* scholar to study them systematically came soon after Liu E published his catalog of the inscriptions, when the Zhejiang scholar Sun Yirang, a specialist on the *Rites of Zhou*, became intrigued by their contents. As a political reformer, however, he was interested to apply their contents to the issues he was most concerned with, namely the "evolution" of Chinese politics and society.

Oracle Bones and Political Evolution

As one of Pan Zuyin's protégés, Sun Yirang had researched ancient characters for some four decades before the oracle bones were discovered. The son of a well-known official, Sun had a varied career. He never reached the highest degree rank that could have led to powerful appointments in the bureaucracy, and for most of his life he concentrated instead on scholarly activities. He composed well-regarded studies on *Mencius* and the *Documents,* and edited a compendium of annotations to Han Dynasty texts. But, like many reform-minded antiquarians, he embraced progressive education and was an advocate of technological studies in the modern curriculum. The last decade of his life was spent

administering and teaching in the new academies, and he was offered (although he declined) a position at Yanjing University, as well as the directorship of his friend Zhang Zhidong's Cungu Xuetang.[30]

Like Zhang, Sun tried to reconcile classical learning and political reform. He studied the *Rites of Zhou*, for example, to "explain the ancient in order to inspire the present, and empower us in order to shut the mouths of the conservatives."[31] His first lengthy work, *Zhouli zhengyi* (Correct meaning of the *Rites of Zhou*, 1899), compared Chinese and Western political systems, and praised the latter for making possible "the strength of European nations today," even though Europeans "have no inkling of the records and laws of the Duke of Zhou and Chengwang [King Wu's son and the nephew and ward of the Duke, fl. eleventh c. BC]." However, the study of Confucian philosophy was necessary to make China "rich and strong," and its principles could still be implemented in the modern world.[32] A second study on the *Rites of Zhou*, *Zhouli zhengyao* (Political essentials of the *Rites of Zhou*) reflected contemporary political events even more explicitly. The text was completed in 1899, at the close of the Hundred Days Reforms that briefly gave voice to Kang Youwei. *Zhouli zhengyao* emphasized the inevitability of political and cultural change, hence supporting Kang's argument that Confucian principles were not incompatible with a progressive agenda.[33]

Just a few years later, Sun Yirang had the opportunity to put into practice his ideas regarding political reform. As he recalled, "in 1909 the emperor encouraged reform and self-strengthening, calling for representatives [to the new provincial assemblies]. Some friends and I were included in the assemblies, so we took the *Rites of Zhou* as our guiding principle and Western politics as our objective."[34] He joined the Zhejiang assembly and supported a progressive agenda that included women's education.[35]

In 1903, Sun was introduced to oracle bone inscriptions by Liu E's pictorial album. Completed with help from Luo Zhenyu and Wu Changshi, the catalog contained more than a thousand photolithographed rubbings of inscribed bones, as well as transcriptions of some forty graphs into modern equivalents, including the *ganzhi* (stembranch) dating system.[36] At that point, not all scholars were sure that the materials were really Shang. But in a lengthy preface, Luo Zhenyu laid out the case for their extreme age. First, he explained how the inscriptions helped correct earlier commentators on ancient ritual, specifically regarding prognostication.[37] He also argued that Sima Qian was

mistaken in asserting that certain *ganzhi* dates were taboo in Zhou inscriptions—unless the inscriptions did not date from the Zhou at all, but were even older.[38] Then he concluded that the types of graphs in the inscriptions and the physical traces of divination ceremonies on their surfaces, in combination with evidence from literary sources, suggested that the oracle bones were from the Shang Dynasty or even earlier.[39]

Not surprisingly given his scholarly interests, Sun Yirang was particularly excited by the bones, since previously he had "never obtained a glimpse of true Shang characters."[40] The age of their inscriptions, as well as the fact that they contained significant clues to politics and ritual, made them highly relevant to his research. As we have seen, he already looked to antiquity to articulate a reformist ideology. Now he was eager to apply a politically progressive approach to the study of these new materials. In this regard, his combination of philological studies and political reformism placed him within the category of "activist philologists," to use Meng Yue's phrase. For these men, studies of language and programs for political reform were intimately connected—as indeed, they had been for *kaozheng* proponents for at least two centuries. The scholars who came of age in the last decades of the Qing were well respected in fields of traditional learning like antiquarianism, but they also embraced recently introduced concepts in the natural sciences, politics, economics, and philosophy.[41]

Among the new ideas circulating just as Sun Yirang began his oracle bone studies was the concept of evolution. The idea was particularly attractive to Qing intellectuals in search for a cure for the empire's weakness relative to Europe and Japan. Yan Fu's translation of Huxley's *Evolution and Ethics* was published in 1898, introducing to China the concept of natural selection, followed four years later by his editions of Spencer's *The Study of Sociology,* Adam Smith's *The Wealth of Nations,* and Mill's *On Liberty.*[42] It was Yan Fu's hope that his translations would inspire his compatriots to more-effective political reform since these works supposedly explained the natural laws that promoted development in politics, society, and the economy. The exploration of these concepts through the study of antiquities, on the other hand, might have surprised Yan Fu. As we have seen, he criticized *jinshi* for its inability to illuminate historical development usefully, or, in other words, for its lack of practical application. It took a progressive like Sun Yirang to demonstrate that this was not necessarily the case—that *jinshi* could contribute to the discourse of evolution, for example, and hence justify political reform.

Like his studies of the *Rites of Zhou,* Sun Yirang approached

oracle bone inscriptions as a way to theorize political and cultural transformation. Simply by referring to oracle bone inscriptions as *qi-wen*—literally, simple notches on bamboo and wood markers that were thought to predate the earliest graphs—he made it clear that there was a developmental process at stake. Furthermore, he argued that oracle bone inscriptions were pictographic—derived from natural forms like the knotted cords that were used for counting before written numerals were invented.[43] In other words, they were essentially ancient drawings.[44] By studying these early scripts, he argued, it was possible to map the evolution of Chinese writing.[45]

His conclusion that oracle bone inscriptions were close to pictorial representation resonated for many late-Qing antiquarians. In his research on stele calligraphy, as we have seen, Kang Youwei had argued that Chinese graphs were similar to Egyptian hieroglyphics; his reasoning was that they both imitated concrete objects.[46] Tze-ki Hon argues that theories connecting China to other early civilizations were particularly attractive to anti-Qing revolutionaries like Zhang Taiyan, who "opposed the Manchu dynasty on the grounds of Han nationalism" and welcomed the idea of China's cultural links to other prominent early civilizations.[47] But in fact many late-Qing officials, not just revolutionaries, were interested in such cross-cultural comparisons. Pan Zuyin conferred with Wang Yirong and Ye Changchi about whether the ideographic qualities of Egyptian hieroglyphics could help them better understand the development of Chinese script. Pan even tried to import a hieroglyphic stele from England, but was deterred by antiquities preservation laws.[48] Sun Yirang studied other ancient Western script forms as well. In 1903, he claimed that Western reproductions of Egyptian hieroglyphics and Babylonian cuneiform lagged far behind the clarity of Chinese methods.[49] Still, his views on the usefulness of comparative paleography were evolving. By 1907, when Duanfang sent him a book of rubbings of hieroglyphics that he had obtained on a recent trip abroad, Sun wrote several poems of commemoration, noting that they inspired his new thinking regarding early writing.[50]

According to the reasoning of the period, if written languages were similar, then there could be other cultural commonalities. Sun Yirang organized his oracle bone studies according to topics like official titles, kingdoms, and rituals, rather than according to linguistic categories like graphic classifiers, which would have been more typical of *jinshi* studies of the period. By doing so, he made it easier to compare ancient Chinese politics with other civilizations, which he later argued were of equal stature and mutual influence.[51] Indeed, he predicted a

more just world in the future, when a global civilization would allow for the unified development of all nations. In the short term, however, the goal of his scholarship was the *guocui* preservation of Chinese language and culture.[52] By unifying these two ideas—the positioning of China in global historical discourse, while championing its historical and cultural distinctiveness—Sun's studies of the oracle bone inscriptions share many elements with late-Qing history textbooks, which also addressed the evolution of Chinese civilization and its origins in the most ancient dynasties, almost always to a patriotic purpose of exalting the nation's distinctiveness and antiquity.[53]

Yet although Sun Yirang may have been reading contemporary historical writing, no history textbooks written during the first decade of the century appear to have mentioned the oracle bone inscriptions. This may be due to the relative unavailability of his research; after private publication, his oracle bone studies reached only a small audience. He sent handwritten copies of his research to Liu E, Duanfang, and to Luo Zhenyu, whom he met around 1907.[54] His first study of the inscriptions was not in wide circulation until after it was discovered by Wang Guowei in a Shanghai bookstall, however.[55] Wang's fortunate intercession enabled Sun's oracle bone research to survive. But Wang and Luo were sharply critical of his conclusions. Luo derided the senior scholar for being "unable to understand problems analytically" and "unable to reveal the larger meaning" of the inscriptions.[56] Wang concurred, and wrote, "there's nothing to get out of the book"; the "first volume which analyzes the political system of the Shang has absolutely no method."[57] Wang later claimed that Luo was the first scholar to research divination inscriptions carefully.[58]

By the 1910s, Wang Guowei and Luo Zhenyu had a particular stake in the inscriptions. Their reputation depended on it, as they were beginning to focus their research on the study of ancient artifacts. As political conservatives, furthermore, they may have been dissatisfied by Sun Yirang's use of the materials to draw reformist conclusions. The only way to refute his interpretations was to develop their own. To start, however, they had to demonstrate the reliability of the bones as historical sources, as a growing circle of scholars—Chinese and foreign—was beginning to doubt that the miraculous materials were actually genuine.

Oracle Bones and the Sage Kings

Sun Yirang's studies of the oracle bone inscriptions complemented his progressive politics. Yet other reformist scholars, like his friend Zhang

Taiyan, were dubious of their authenticity.[59] In an essay called "Lihuo lun" (Discourse on confused truth), Zhang compared the unearthing of the oracle bone inscriptions to other finds, like the Tang Dynasty discovery of the stone drum script. But whereas scholars overcame their skepticism in that earlier case, the oracle bone inscriptions were still problematic. Zhang pointed out the many ways in which they defied conventional expectations. He compared their graphs to marks left by birds and insects, and noted the lack of specific reference to the inscriptions in literary sources like the *Rites of Zhou*. More important, Zhang's suspicions were aroused by the way in which they were presented to a credulous public by just a handful of scholars. "Some people have cheated the world and prepared rascally buyers beforehand," he charged. "Except that one or two virtuous Confucians believed them to be genuine, this was unworthy of gentlemen. [...] The discoverers are not trustworthy people. But still the masses believe that [the oracle bones] are legitimate materials."[60]

After almost a century of further research on the materials, including thousands of fragments that had been scientifically excavated, Zhang Taiyan's criticisms may appear simply misguided. At the time, however, they represented a not uncommon view that the oracle bones, or at least most of the pieces in circulation, might simply be a sophisticated fraud perpetuated by unscrupulous art dealers and their associates. Indeed, only a year or two after their discovery, forged bones streamed onto the market, including pieces of genuinely ancient bones that were newly inscribed with purportedly original script.[61] Some sources claimed that bones were even being faked at the source—Xiaotun itself.[62] Others pointed to Weixian, the home base for many dealers, which had a "notoriety for the faking of antiques," according to Chalfant. As he wrote to Lionel Hopkins, "My good wife and certain colleagues...declare that there is a bone-factory in Weihsien [Weixian] city!"[63] The situation was even more delicate because, for a decade, collectors had no idea where the bones were coming from. "Almost all artifacts are obtained in the capital after they had been passed around by dealers," Luo Zhenyu grieved, "so the buyer has no idea where they were found, particularly if there was craftiness or deceit involved."[64]

These concerns over authenticity were forcefully echoed by a Japanese scholar, Hayashi Taisuke. For years, Hayashi, along with the famed historian Naka Michiyo (1851–1908), taught Chinese literature and philosophy at Tokyo Higher Normal University. Both men belonged to an older generation of *kangaku* (Chinese learning) scholars who emphasized the indebtedness of their own linguistic and cultural practices

to that of China. From the standpoint of early history, they were interested in utilizing new theories of historical development to interpret the pattern of China's ancient past. Hayashi was intrigued by concepts of evolutionary change, and argued that understanding Chinese characters, including their "origins" in bronze and stone inscriptions, laid a foundation for a study of East Asian civilization.[65] For his part, Naka Michiyo was interested in applying to China one of the new three-part structures then popular in European historiography, namely defining ancient, medieval, and modern periods and explaining how China fit into specific development paradigms.[66] This scheme also appealed to Liang Qichao, who in 1901 introduced Christian Jürgensen Thomsen's (1788–1865) concept of dividing the ancient past into the Stone Age, Bronze Age, and Iron Age, which he gleaned from accounts of a European conference on archaeology.[67] Liang's friend Xia Zengyou then popularized it via his middle school textbook on Chinese history.[68]

For these scholars, however, the question remained of when Chinese history began—or how to account for the appearance of the Chinese and their civilization. Zhang Taiyan and Liu Shipei believed it originated with the Baks, a Mesopotamian tribe from which the Yellow Emperor, the supposed progenitor of the race, descended.[69] Some accounts utilized creation myths featuring the Three Sovereigns beginning with Fuxi, a semihuman deity who, together with his sister Nüwa, engendered the Chinese race.[70] Naka Michiyo began his textbook with Yao and Shun, the last of the Five Emperors or sage rulers who invented Chinese civilization. (Their successor Yu established the Xia.) In 1897, though, Kang Youwei's essay "Confucius as a Reformer" questioned the ability of literary sources to adequately verify the sage kings. It was not that Kang disputed the historicity of Yao and Shun, but he could find no reliable evidence. The accounts of their reigns hence fell into the category of oral history—although not necessarily false history or myth.[71] Respecting Kang's skepticism, Xia Zengyou's history textbook opened with the Zhou, conceding that there were no reliable earlier sources.[72]

Within a few years, Chinese debates about the origins of their nation and the historicity of its legendary founders were picked up by Japanese scholars, who seized on the controversy as an opportunity to dislodge the notion of Chinese cultural superiority. One of the most prominent skeptics was Shiratori Kurakichi (1865–1942), who claimed that Yao, Shun, and Yu were a "shamanistic" formulation or primitive metaphors for "heaven, earth, and man." As Stefan Tanaka explains,

"Kangaku scholars labeled this theory the 'Murder of Yao, Shun, and Yu' because this hypothesis undermined the base on which Confucianism and existing Chinese historiography rested."[73] Zhang Taiyan dismissed Shiratori's views as "so mistaken they do not even reach mediocrity," but many Chinese and *kangaku* scholars viewed his theories as a significant challenge.[74]

The oracle bone inscriptions promised to provide contemporary evidence to corroborate literary accounts of the ancient past. As Hayashi Taisuke announced in a 1909 article (the first Japanese-language introduction to the new materials), their contents strengthened the historical record of the early dynasties, counterbalancing Shiratori's suggestion that there was no factual basis to ancient Chinese history. Still, even after reading Liu E's catalog and Sun Yirang's studies, there were unanswered questions regarding the bones. One issue for many Japanese scholars was Liu E's claim that the materials were found in Tangyin County.[75] This seemed to be an unlikely location for the Wastes of Yin, since, according to Sima Qian, the last Shang capital should have been located south of the Yellow River.[76] In a series of articles and letters exchanged with Luo Zhenyu and Wang Guowei, Hayashi Taisuke astutely grilled them on some of their early conclusions regarding the oracle bone inscriptions and suggested that they needed to do further research in order to justify their conclusions regarding their provenance and the significance of the inscriptions.[77]

Hayashi's suspicions prompted Luo Zhenyu to renew his interest in the oracle bones after a hiatus of several years.[78] His subsequent research did not focus on the "murder of the sage kings" directly, but ultimately the debate led him to address other important issues regarding the value of the artifacts for the study of ancient China, including their point of origin, their age, and their significance as evidence for the continuity of Chinese political culture.

The first question was the origins of the fragments—were they really coming from Tangyin? Luo Zhenyu found the answer, naturally enough, by asking Fan Weiqing.[79] Threatened with scholarly disbelief and the potential loss of a lucrative market, the dealer revealed that the source was really Xiaotun, a rich antiquarian hunting ground from which many bronzes and other antiquities had previously been excavated.[80] (Indeed, Wang Hanzhang wrote that his father was first approached by dealers with Xiaotun bronzes, and bones only later.[81]) The discovery of the true source of the artifacts, however, was more valuable to Luo than simply ending a scholarly dispute; he used the information

to circumvent rising prices in Liulichang. When a dealer visited him
in 1911 with very expensive bones for sale, Luo Zhenyu expressed the
desire to go to Henan in person and find bones directly.[82] Indeed, for
a time he fantasized about purchasing land in Xiaotun, excavating his
own fragments, and retiring there to study them in peace. Alas, Luo's
plans were disrupted when the "country faced difficulties"—the 1911
revolution that overthrew the Qing Dynasty and sent both him and
Wang Guowei into exile in Kyoto.[83]

Unable to leave the capital himself, he dispatched to Xiaotun his
brother-in-law Fan Zhaochang (fl. c. 1910), who returned with several
negligible fragments.[84] In 1911, he sent Fan and Luo Zhenchang back
to Henan together, with instructions to bring back oracle bones and
other antiquities. They set out that winter, resting at inns where "capital
dealers stay, and scholars who want to obtain [antiquities] come specifi-
cally to discuss purchases."[85] After dinner their first night, Fan inquired
whether any local people had come recently to sell bones. Even before
they arrived at the county seat, they dispatched messengers to Xiaotun,
hoping to lure local people and their wares.[86] Almost every day they
were offered things like oracle bone fragments and pottery vessels, al-
though "discussing prices was very difficult," and bones with unusual
characters fetched high prices.[87] Once Luo Zhenyu had sent personal
representatives to Xiaotun, he had significant control over the circula-
tion of the oracle bone inscriptions. Indeed, as early as 1911 he owned
some twenty thousand fragments, about half of what his bone collec-
tion would ultimately number.[88] In 1915, he traveled to the region in
person and was able to add stone knives, ivory artifacts, and jades to his
collection, in addition to more oracle bones.[89]

During the next few years, he completed four large-scale studies of
what he described as the "primitive graphs," with the goal of "correcting
historical omissions, explicating phonological origins, and explaining
ancient divination practices."[90] His first work, *Yin-Shang zhenbu wenzi
kao* (Studies on Shang oracle bone inscriptions, 1910) offers readings of
almost three hundred characters. His two most important conclusions
were the theory that the names of Shang royalty were related to their
dates of birth, and his explanation of their forms of animal sacrifice.[91]
He also maintained that Xiaotun, even though it was north of the Yel-
low River, could still have been Yinxu.[92] Yet although it purports to be
a study of the oracle bone inscriptions, the work drew more evidence
from literary sources than from the inscriptions. Luo referred to the
inscriptions more directly in a section on the names of the Shang kings,

trying to resolve discrepancies with the royal genealogies specified in the *Records of the Historian*. This was in fact one of Luo's most significant arguments—namely that the *Records* genealogies were largely corroborated by evidence from the oracle bone inscriptions.[93]

It took only a few months for Luo to complete this first study, and later he feared that he had made many mistakes.[94] By 1915, he had published a much more ambitious work on the inscriptions, *Yinxu shuqi kaoshi* (Studies on oracle bone inscriptions from the Wastes of Yin, 1915), which contained eight chapters on topics like the Shang capitals and other features of historical geography, the names of the Shang kings and other historical figures, and studies of ritual and etymology. For all of these topics he relied heavily on the *Shuowen*, seeking to trace the *fanbian* (evolution) of graphs from oracle bones to bronze inscriptions.[95] Although Luo Zhenyu claimed not to have been influenced by Sun Yirang, it seems hardly coincidental that this language evokes the discourse of etymology and evolution present in Sun Yirang's research a decade earlier.

Luo could feel pleased with his research contributions. He had proved, he felt, that the bones were genuine Shang artifacts, therefore establishing the first contemporary sources regarding the dynasty and helping to refute claims that the legendary early rulers were simply mythic archetypes. He also had demonstrated that their contents addressed ancient ritual, historical geography, and etymology, among other important issues. But Chen Mengjia (1911–1966) disparaged Luo for ignoring semantic clues and relying too much on the *Shuowen* for evidence.[96] Fu Sinian (1896–1950) even went so far as to claim that Luo was not talented enough to have produced *Yinxu shuqi kaoshi*, and that Wang Guowei was the study's actual author.[97] This last accusation can probably be put to rest, but there were certainly other reasons for Luo Zhenyu's poor reputation when it came to oracle bone inscriptions.[98] The problem was the very source of his success—his extraordinarily large (and growing) private collection of artifacts. When it came to oracle bones, his virtual monopoly severely limited the opportunities of his contemporaries.[99]

Just before he died, Zhang Taiyan corresponded with the archaeologist Jin Zutong (1914–1955) to explain why he doubted the materials long after the early debates, like the controversy over Yao, Shun, and Yu, had receded.[100] For one, it was difficult to tell if inscriptions were genuine or false since there were so few verifiably real ones. For another, the graphs were difficult to read and the contents

often lacked corroborating literary sources. If they could not be identified by using the *Shuowen*, stele inscriptions, or the classics, then "how can Luo Zhenyu tell by himself" what the graphs represented, Zhang complained. Most of the bronzes studied by eminent scholars such as Chen Jieqi and Wu Dacheng were probably fake, Zhang argued, and their inscriptions could not be trusted. Hence, even more so when it came to oracle bone inscriptions, "authentic and fake pieces still cannot be determined, so it is virtually impossible to know how to interpret their inscriptions."[101] Zhang Taiyan was also distressed by Luo's close collaboration with Japanese scholars, including Hayashi Taisuke, whom he described in a letter to Luo as "not very clever." Indeed, Zhang considered Japanese Sinologists to be "sloppy and superficial." Even though Hayashi Taisuke was "the most careful scholar of his generation," Zhang wrote, his scholarship on the oracle bone inscriptions "has absolutely no insight."[102]

Finally, Luo's studies on the oracle bone inscriptions reached conclusions that may have seemed misguided to Zhang Taiyan, an anti-Qing revolutionary. Regarding the genealogies of the Shang kings, for example, Luo emphasized the significance of dynastic histories and cultural continuities instead of political transformation.[103] And in contrast to both Sun Yirang and Kang Youwei, whose theories of global development and cultural connections helped fuel reformist politics, Luo curtly dismissed the idea that Egyptian hieroglyphics and Chinese graphs came from anything like a common source.[104]

That the same artifacts and similar methodologies underlay radically different conclusions suggests the complexity of *jinshi* at the turn of the century. Studying unusual materials like the oracle bone inscriptions was becoming more customary, as was the use of concepts like evolution. But as these debates over the discovery and interpretation of the bones reveal, antiquarian research, and the men who conducted it, were pulled in very different directions—some towards a skeptical or unconventional attitude towards the past and its sources, others towards validation of more customary interpretations. Meanwhile, the tug-of-war between scholars with large artifact collections and those who wanted ancient materials to be in greater public circulation was also heating up. For both these reasons—the fracturing of the field between skeptics and traditionalists, and the problem of public versus private ownership—Luo Zhenyu was becoming a highly polarizing figure in the world of Chinese history and antiquarianism.

6

Luo Zhenyu and the Dilemmas
of the Private Scholar

Three hundred years of Qing philology began with
Gu Yanwu, and culminated in Luo Zhenyu.
—Wang Guowei, afterward to *Yinxu shuqi kaoshi*, 1915

AFTER THE ABDICATION of the last Qing emperor Puyi (1906–1967)
in 1912, many talented scholar-officials lost their professional identi-
ties. For every former bureaucrat who made a fortune in banking or was
admitted into bureaucratic service of the new Republic, scores more
found work as editors, in the trades, or even as managers of rickshaw
companies. The capital was soon teeming with impoverished Man-
chus, whose pathos was captured by the writer Lao She (1899–1966).
Jinshi scholars like Luo Zhenyu were among those who had to find
new careers. With his expertise in ancient artifacts admired by even
political opposites like Hu Shi (1891–1962), he was invited to join re-
search institutions and to lecture on archaeology and other topics.[1] But
having become frustrated with the inadequacies of state museums and
schools as a Qing official, and identifying himself as an *yilao* (loyalist),
he preferred to remain a private scholar until virtually the end of his
life, when he died in Puyi's service in Manchukuo. This political choice
placed him far to the right of mainstream intellectual life in the late
1920s and 1930s. His contemporaries recognized that his form of pro-
fessionalized *jinshi* encouraged systematic studies (particularly on new
classes of artifacts), preserved rare research materials, and made them
available to the public through publication. But his commercial activi-
ties made them deeply uncomfortable, particularly since they seemed
unpatriotic—many of his best clients were Japanese—and because they
compromised his reputation as a disinterested scholar.

Luo Zhenyu's work as an art dealer, publisher, and scholar in the post-1911 period raises a number of interesting questions over the evolution of antiquarian practices. We can interpret his insistence on his rights as a private scholar, with virtually no formal institutional affiliations for the most active decades of his professional life, in two contradictory ways. On the one hand, his stance was a logical extension of traditional *jinshi* practices, which were always dependent on the commercial market in antiquities and favored the activities of individual scholars over corporate institutions like museums. On the other hand, in an age when the power of state sponsorship for historical and archaeological research appeared to be growing, this attitude placed him at variance with many of his colleagues and left him open to criticism of commercialism and intellectual dishonesty. His biography, therefore, raises interesting questions about the modern legacies of *jinshi*. In the Republican world, could an antiquarian be an entrepreneur and private scholar? And if so, what were the consequences for scholarship?

The Educational Reformer

Luo Zhenyu never intended to become an art dealer or publisher. A talented young student, he hoped to ascend the Qing bureaucratic ladder and pursue *jinshi* as a genteel pastime. But his early opportunities, particularly his access to the education that would make examination success possible, were hampered by his humble birth. He finally became a bureaucrat after attracting attention for his entrepreneurial zeal in his first area of professional specialization, namely educational reform in the last decades of the Qing.

Huai'an, the city in Jiangsu where Luo Zhenyu was born, was esteemed in the Qing for its classical academies and cultured residents. But it had nothing near the cultural cachet of more cosmopolitan cities of the province like Hangzhou and Suzhou, where Pan Zuyin, Wu Dacheng, and Ye Changchi all came from. His father Luo Shuxun (1842–1905) served three times as district magistrate, but also once worked, unprofitably, as manager of a friend's pawnshop. Burdened by helping to pay off his father's debts, Luo stayed home and supported the family rather than joining his brothers in Hangzhou to study for the imperial examinations. Even though he entered the county school as the seventh-highest ranked candidate, he never progressed beyond the lowest degree.[2]

Like many young men in the late Qing, he initially embraced *jin-*

shi as a counterpart to the examination curriculum and the hallmark of a serious scholar. But he had no access to antiquities or even a family library, a luxury that scholars like Wang Yirong (who reminisced about studying in the "long halls of my grandfather's house") took for granted.[3] Instead, his book learning came from the rental stalls of Hangzhou. He recalled,

> My family did not have a library, and Huai'an had no book market. Every school sent students to the examinations [in Hangzhou], and most of the bookmakers of Jiangnan were located in front of the examination halls. I was unable to buy anything, and just spent my time inside the market reading. People commonly rented books, to be returned after they were read, and every day I went in and out clutching books under my arms.[4]

But despite his relative poverty, Luo Zhenyu heeded Zhang Zhidong's recommendation to pursue antiquarian learning in order to be better prepared for the examinations. Visiting the West Lake with an older brother and a tutor, he saw ancient steles and examined an inspiring work by Ruan Yuan. When he entered the county academy at sixteen, he splurged on some rubbings of inscriptions.[5]

His cultivation of antiquarian interests helped his career almost immediately. Admired in local circles as a scholar, he met Liu E's brother, who recommended him for a job as a tutor. In 1894, he made contact with the novelist himself, then working as an assistant to the Shandong provincial governor and struggling with the perennially flooded Yellow River. Luo had written an essay on the subject and sent it to Liu E, who responded with a copy of his own work on river conservation.[6] Later the two friends shared their antiquarian interests and collaborated on *jinshi* projects, notably when Luo helped create Liu E's catalog of oracle bone inscriptions. But despite Liu E's patronage, failing to win higher examination degrees meant Luo could not easily enter the ranks of officialdom. Hence, in the mid-1890s, he decided to pursue another career. As he recalled, "When I was young I knew I was not stupid or incompetent, and I hoped to be an official. I decided that if the world of officialdom could not use me, I would start my own business to support myself."[7]

His first business enterprises revolved around educational reform, the introduction of foreign ideas, and the establishment of new journals—in many respects, familiar goals for late-Qing reformers. In the

spring of 1896, he left Huai'an and moved to Shanghai to embark on a new career in reformist education and technical publishing. Together with his friend Jiang Fu (1866–1911), he founded the Xuenongshe (Agricultural Study Society) and started publishing *Nongxue bao* (Agricultural bulletin) and *Jiaoyu shijie* (Education world).[8] Although these serials included some European and American articles, they primarily featured translations from Japanese sources; Luo inaugurated *Jiaoyu shijie* by calling Japanese textbooks, geographies, and histories a "blueprint" for Chinese scholars to copy.[9] He also established a language academy called the Dongwen Xueshe (Japanese Language Institute), whose students hoped to become translators themselves. For faculty he hired the journalist and conservative social critic Taoka Reiun (1870–1912), who taught English, and Fujita Toyohachi (1869–1929), who lectured in Japanese on Chinese and Western scholarship. Friends with the eminent Kyoto Sinologist Kano Naoki (1868–1947), Fujita later taught Chinese history at Tokyo University and became the first chair of the Division of Arts and Political Science at Taihoku Imperial University in Taiwan.

The Japanese Language Institute closed down during the Boxer Rebellion, but Luo's successes in starting these new journals and his language academy were noticed by some of the highest officials and educational reformers. Indeed, soon after Luo's academy closed, Zhang Zhidong chose him to help run a new agricultural academy in Hubei. Over the next few years, Zhang solicited Luo Zhenyu's help on a number of projects related to agriculture, education, and translation. In 1905, Zhang invited Luo to the capital to work at the new education ministry, appointing him as an inspector for schools in Shanxi and Zhili.[10] At the age of thirty-nine, he had found a foothold on the Qing bureaucratic ladder; although his tenure as an official was brief, it remained a critical component of his scholarly identity for the rest of his life.

Archaeology and the Failings of State Conservation

Luo Zhenyu entered the capital an ambitious bureaucrat, and left an art dealer and publisher of books related to ancient artifacts, inscriptions, and rare texts. Of course, the 1911 Revolution was the proximate cause for this transformation, but the disappointments he experienced as a Qing official were factors as well. He was successful in his advocacy of artifact studies, which he promoted with the goal of persuading his peers to take seriously a greater variety of research materials. But

aspirations of this period to help establish government-run museums and research institutions were never realized to his satisfaction and may have disillusioned him permanently as to the effectiveness of large research institutions in general.

When Luo arrived in the capital in 1908, he found that his work responsibilities were slight, leaving plenty of time for scholarly interests. He was decades past the heyday of the antiquarian social networks that embraced Wu Dacheng and Wang Yirong, but during these years he became friends with several men of their circle, including Yang Shoujing, Miao Quansun, and Shen Zengzhi, a colleague at the education ministry. The Liulichang market was, if anything, more robust than before, and Luo Zhenyu visited it often. As he recounted,

> I lived in the capital for three years, but it was not what I imagined. Official business was very slow, and to fill the time I revisited my old studies, occupying myself by discussing bronzes and steles, calligraphy and painting with two or three friends. In Liulichang I was known for my antiquarian interests, and every time I went to buy ritual vessels, old artifacts, famous inscriptions, or rare editions, my fingers flew [in negotiating prices]. But my salary was meager, and even though I saw not a few things, what I could get was very modest.[11]

But on another occasion he remarked that changing tastes made it possible for him to collect antiquarian materials relatively cheaply:

> When I was asked to "make up the numbers" at the Education Ministry, fashions had changed from the era of Pan Zuyin and Wang Yirong. Scholars disregarded old coins and ritual vessels, and there were few buyers for these items. But whenever I had extra money from my salary, I would go take a look around Liulichang, and inquire if there were any rare editions of books. Referring to prices in the Suzhou and Shanghai book markets, I was usually able to acquire them [more cheaply].[12]

Whichever account is more accurate, from the evidence of his writings during this period and subsequent artifact catalogs, Luo's collecting appetites appear to have been quite robust. As Wang Guowei remarked, "Luo Zhenyu was destined to be a scholar. Ancient artifacts and texts nourish his physical being. He needs these in order to survive, like or-

dinary people need to feed their mouths and bellies."[13] Luo admired great bronzes, but in practice sought out less-expensive items like coins. By 1908, he had collected more than a thousand coins and asked Fan Zhaochang to make rubbings of them, which he bound into two volumes. These pictorial catalogs—not just the collection of coins itself— made him feel that he was "not poor in antiquity"—in other words, that he was becoming the kind of scholar-official he most admired: an antiquarian collector as well as a bureaucrat. In this vein, he was particularly interested in artifacts once collected or studied by Pan Zuyin, Wu Dacheng, and Wang Yirong. His writings during this period reveal an endless fascination with the artifacts and rubbings that had circulated within their exalted circles just a few decades before.[14]

But Luo Zhenyu did not simply mimic the collecting appetites of Pan Zuyin and his protégés. Instead, he was committed to the idea of *guqiwu xue* or artifact studies.[15] The discourse of artifact studies encouraged scholars like Wu Dacheng to study jades in new ways; Luo was emboldened to pursue previously taboo or unfashionable materials. For example, starting in 1907 he began to collect funerary objects. It shocked friends to see them in his capital study, but he declared confidently, "all grave goods can be used in archaeology [*kaogu*]."[16] He was proud of promoting the idea of ancient artifact studies among his colleagues—in other words, the collection of materials primarily for their historical and art-historical value, regardless of societal taboos.[17]

Luo's interest in artifact studies was apparent during his first trip to Japan, when he visited the Tokyo National Museum in Ueno Park and was impressed by its holdings of Han Dynasty wall paintings and steles, Jin Dynasty bricks, ancient lamps, porcelain wine cups, and other Chinese antiquities. He was also struck by the numerous examples of "ancient fossils, pottery, and knives" in the museum's exhibits.[18] Japanese scholars, probably not coincidentally, were also studying Chinese funerary objects. In 1907, Takahashi Taika (1863–1947) visited Luoyang and was told by local dealers that he was the first scholar to collect clay figurines unearthed by nearby railroad construction.[19] The archaeologist Hamada Kōsaku (1881–1938) published a collection of essays on Chinese tomb figurines during this period.[20]

As Luo embraced the category of artifact studies and began to collect unorthodox items like funerary objects, he increasingly referred to his scholarship as archaeology, another neologism of the period. For several decades, Japanese scholars had used *kobutsugaku* (Chinese *guwuxue*, or the study of ancient materials) to denote archaeology. But

by the turn of the century, both Chinese and Japanese scholars were using *kaoguxue* (Japanese *kōkogaku*), a neologism created by adding the modern suffice *-xue* (Japanese *-gaku,* to study), which denoted an academic discipline, to the Chinese term meaning the study of antiquity.[21] *Kaoguxue* connoted a modern field, like sociology, and implied the empirical study of human cultures and their material remains.[22] In the early years of the century, several Chinese scholars began to describe the practices of Western archaeology, praising its usefulness for historians who wanted to understand the level of sophistication among early societies and their patterns of evolution.[23]

Luo Zhenyu associated the term with progress in modern education, including the establishment of institutions like museums, libraries, and technical schools to teach drafting and scientific illustration, which he encountered for the first time in Japan.[24] He tried to implement these ideals when he joined the education ministry. In 1907, Zhang Zhidong asked Luo for his opinion regarding the Cungu Academy, and he replied that in order to promote national studies the curriculum needed to reflect modern, scientific trends. Not only did the school require a library and a museum in addition to a research institute but also the museum would need to provide ancient artifacts in order to facilitate the study of archaeology and preserve rare materials.[25]

Luo's views on the importance of museums and libraries as preservation facilities were echoed a decade later by Liang Qichao, who wrote,

> When it comes to private libraries, if sons and grandsons cannot protect family property, or treat it carelessly, these will be lost, reduced to ashes instead of preserved to be read. Where are [the great private libraries] today? In modern times our transportation system is developing, our country is emerging in the world, all kinds of culture is produced, but even though we ask our provinces and cities, still they do not establish one library, one museum, one art gallery. Without question, it is a disgrace and a humiliation for our people.[26]

In other words, for many intellectuals during this period, the establishment of museums and libraries was not only needed for scholarship—it was also a sign of modernity and an indication of the effectiveness of the government in taking responsibility for stewardship of important literary and historical artifacts.

As an official in the education ministry, Luo tried to implement these arguments regarding the importance of research and historical preservation institutions, hoping to help staunch the flow of Chinese artifacts overseas.[27] For example, it was arguably state inaction that allowed the Dunhuang materials to leave China, or to remain within China but in private hands. These materials, discovered in 1907 in the Mogao cave temple by the Hungarian-British explorer Marc Aurel Stein (1862–1943), consisted of tens of thousands of Tang Dynasty books and manuscripts, including the earliest dated, printed book in the world: a ninth-century copy of the Diamond Sutra, which Stein gave to the British Library. The French Sinologist Paul Pelliot (1878–1945) traveled to Dunhuang soon thereafter and obtained some five thousand items, which he shipped to Paris. Thus, within just a few years of the cave's discovery, many of its most valuable contents had already been removed to Europe, unbeknownst to many Chinese scholars. (Luo was only informed of the discovery in the summer of 1909, when Fujita Toyohachi sent him an article on Stein from an English geographical journal.[28]) Pelliot tried to ameliorate this somewhat by providing Chinese colleagues with photographic reproductions of some of the materials; these formed the basis of Luo Zhenyu's earliest publications on Dunhuang.[29] But it was insulting that Zhang Yuanji (1867–1959), director of the Commercial Press and a respected scholar, was denied permission by French authorities to view the manuscripts when he visited Paris.[30]

Luo maintained cordial relations with Pelliot, but he was bitter that such a large portion of the manuscripts had been taken out of the country by foreign scholars so soon after their discovery. He was even more aghast when the education ministry, after finally yielding to his entreaties to purchase and safeguard some thousand items of Dunhuang texts, allowed a highly placed official, Li Shengduo (1859–1934), to abscond with much of the material after it had been taken safely back to the capital—Li simply added it to his collection of antiquities.[31] Not long thereafter, the Harvard professor Langdon Warner (1881–1955) removed priceless frescoes from the Dunhuang caves; gouged out of the rock walls of Buddhist temples, the paintings are now in the collection of the Fogg Museum.[32]

Another event from this time illustrates Luo Zhenyu's disappointing experiences regarding government conservation. In 1909, the Qing court ordered its Grand Secretariat archives to clear space in their warehouses by burning thousands of old government papers. Luo

Zhenyu heard of the order and persuaded Zhang Zhidong to save the materials. But under the ministry's lackadaisical custodianship, sacks of the papers sat rotting in the Guozijian (Imperial College), where they were occasionally pillaged by returning foreign students.[33]

Luo Zhenyu's chance to save the Grand Secretariat archives was not over, however. In 1921, the documents were given to the new Historical Museum. But within a year, the cash-strapped museum off-loaded the sacks to a capital pulp factory, which resold some of the items to Liulichang dealers, where they were rediscovered by Luo in 1922. Horrified that the Historical Museum had discarded the documents so rashly, he bought as many as he could—thousands of bags full of disorganized materials—and published their most valuable contents.[34] He doubted that "private historians" would be able to do an adequate job of writing the history of the Qing Dynasty, but he congratulated himself for his foresight and responsibility to future generations, commenting, "Regarding these materials, what if I had not saved them from being burned [in 1909]? If I do not circulate them now, then after I die, who will be accountable for their survival?"[35] Wang Guowei rejoined that the case illustrated the important preservation functions fulfilled by personal collections. Indeed, Wang Guowei argued that when public institutions like the "so-called" Historical Museum are inadequate, then *sijia* (private individuals) must take responsibility for safeguarding antiquities.[36] In this vein, Wang Guowei argued a few years later that the rise of antiquarianism in the Song was largely the result of individual scholarly interest and initiative in publishing artifact catalogs.[37]

The meaning of the terms "public" versus "private," in the context of late-Qing politics, has been debated for some time. Most recently, scholars have emphasized that the two arenas were felt to be complementary, but that even in the modern age the virtues of the public—with its implications of a shared ethical community as well as a common goal of reform—held sway over the private.[38] But Luo and Wang were not alone in arguing that private collecting and book collections could be the expression of a patriotic desire to safeguard China's national heritage against the threat of destruction or pillaging. As Meng Yue has described, many of their contemporaries in publishing circles were active in the first decade of the twentieth century to collect and republish rare Chinese books. Zhang Yuanji's experience of "unspeakable agony" when foreign collectors took books abroad (as with Pelliot's removal of the Dunhuang manuscripts from China), for example, motivated him to use modern printing technology as a tool to increase

the copies of classical texts in circulation and hence preserve Chinese culture, while at the same time resisting the seemingly overwhelming wealth and appetite of foreign collectors.[39] In the face of government indifference or inadequacy, patriotism was well served by private action.

Hence, Luo Zhenyu was not unique in expressing skepticism over the effectiveness of government agencies or large institutions as shepherds of rare materials, or even promoters of scholarly research. In 1919, when he returned to China from a decade in Kyoto, his reputation as an archaeologist had grown to the point where Cai Yuanpei (1868–1940) invited him to lecture at Peking University—but he declined, just as Wang Guowei had earlier refused a similar position.[40] Instead, he emphasized the contributions of individual scholars and their methods of studying ancient artifacts.[41] But he continued to argue that publications, particularly pictorial albums, could fulfill a function comparable to museums in disseminating research materials.[42] After 1911, when Luo opted for a career as a publisher and art dealer, this rationale justified his private stewardship of ancient books and artifacts, even when he was their exclusive financial beneficiary, or when his partners were foreign colleagues and clients.

The Publisher

After 1911, Luo Zhenyu lost his imperial sinecure and had to reinvent his professional identity once again. Shortly after the Revolution, he was encouraged to relocate to Kyoto by several Japanese Sinologists, including Kano Naoki and the famous medievalist Naitō Konan (1866–1934). Count Ōtani Kōzui (1876–1948), abbot of the Nishi Honganji Temple and a collector of Chinese and Central Asian antiquities including Dunhuang manuscripts, even offered to reimburse him for his shipping expenses.[43] And he was invited to teach at Kyoto University, which for a time housed his book collection (and may have been hoping to acquire it permanently).[44] In making this journey, Luo would be leaving his homeland but he would also be joining the thousands of other Chinese students, intellectuals, and reformists who for decades had found their Eastern neighbors to be welcoming hosts.[45] In Luo's case, his principal work in Japan would be to collaborate with fellow antiquarians to republish rare Chinese works, fulfilling the goal of many of his contemporaries to safeguard the national patrimony while also working as a publisher in a highly lucrative area of the profession.

Even before Luo Zhenyu moved to Kyoto, he had already estab-

lished important contacts with Japanese scholars and antiquarians. His first trip there was sponsored by Zhang Zhidong, who sent Luo on an inspection tour of the Japanese educational system in 1901.[46] In addition to visiting schools, post offices, and other modern institutions, he discussed antiquarianism with Wu Changshi's student Kawai Senro (1871–1945), a noted seal-carver, and met the calligrapher Kusakabe Meikaku (1838–1922), who showed him some of his collection of rare Chinese books and rubbings.[47] On his second trip in 1909, again sponsored by the education ministry, Luo visited Kyoto Imperial University and met several of its Sinologists, including Kano Naoki and the oracle bone scholar Tomioka Kenzō (1873–1918), and was reunited with Naitō Konan, whom he had met a decade earlier in Shanghai.[48]

These contacts were particularly important after Luo Zhenyu expatriated, since his personal responsibilities were considerable. He brought with him some twenty people, including Wang Guowei and his wife, children, and family servants. And apparently Wang Guowei was correct when he remarked that Luo Zhenyu required ancient artifacts and texts "like ordinary people need to feed their mouths and bellies," because he also brought to Kyoto one hundred crates of possessions, including more than thirty thousand volumes of books as well as bronzes, jades, ancient seals, rubbings, and oracle bones, carrying the most precious materials, like Song Dynasty editions, by hand.[49] He purchased land in the Jōdoji neighborhood and built a spacious library to hold his books and artifacts.[50] It was during his Kyoto decade that Luo's reputation as an antiquarian scholar was established, first through his studies of oracle bone inscriptions and Dunhuang manuscripts, and then through his collaborative projects with several Japanese scholars to republish rare Chinese texts.

These projects were not only scholarly endeavors but also enabled Luo Zhenyu to support himself and his entourage in Kyoto, a difficult task since he did not speak Japanese.[51] As he recalled, "Once I moved to Japan, I had no income, and gradually had to change professions. I am not a natural at making a living, and until the Revolution, I thought it was unnecessary, so how much more strange was it to open a business? Whatever energy I had, I devoted to publications."[52] He continued to produce the journal *Guoxue congkan* (National studies serial), which he started with Wang Guowei's help just before he left China, and then produced a series of reprints of rare texts, either purchased in China or held in the collections of Japanese friends. (His publishing projects also provided financial support for Wang Guowei during his years in Japan,

as Luo paid him a monthly salary to edit *Guoxue congkan.*[53]) When Luo
returned to China in 1919, publishing remained at the forefront of his
private business empire.[54] On the grounds of his house in the French
Concession of Tianjin, he established a bookstore to sell his own works,
a store managed by his eldest son. After he moved to Lüshun in 1928,
he established both a bookstore and a collotype printing press so that
the books he sold were not only written or compiled by him (and his
family) but also were produced in-house.[55]

During his Kyoto decade, oracle bone catalogs were some of Luo
Zhenyu's first and most lavish publication projects. Produced in coop-
eration with the Kyoto photographer and publisher Kobayashi Chūjirō
(1869–1951), they featured both photographs of bones and collo-
types of ink-squeeze rubbings of the bones' inscriptions.[56] They were
printed on rigid, cream-colored folio paper, with typeset captions in-
stead of handwritten woodblock texts. A single Kobayashi catalog cost
three times more than the expense of an entire print run for one of
Luo's Chinese journals.[57] Their circulation was not extensive—Samuel
Couling called them "rather hard to get"—but Luo's catalogs eventu-
ally included reproductions of more than four thousand oracle bone
fragments.[58]

It was in the course of publishing these catalogs that Luo Zhenyu
encountered some of his earliest criticism over his business ventures.
More than one hundred of the bone fragments he included in his cata-
logs were not actually his but were instead owned by Hayashi Taisuke,
Kawai Senro, and other Japanese scholars.[59] Even though the albums
produced by Wu Dacheng, Chen Jieqie, and their contemporaries fre-
quently included rubbings or drawings of artifacts belonging to their
friends, this kind of borrowing was now considered theft, not camara-
derie. Japanese collectors like Hayashi Taisuke were infuriated by his
decision to include these materials without attribution or permission.[60]

But other Japanese scholars, particularly collectors of ancient ar-
tifacts and Buddhist texts, remained pleased to lend their materials to
his publication projects. Luo reissued several rare editions owned by
Tomioka Kenzō and multiple items from the collection of the art-
ist Kanda Kōgan (1854–1918), whose grandson, the famous Sinolo-
gist Kanda Kiichirō (1897–1983), later eulogized Wang Guowei. Luo
republished materials owned by Ōtani Kōzui and the naval officer
Tachibana Zuichō (1890–1968), a collector of Dunhuang materials
and an author of works on the Buddhist Tripitaka and China's North-
west. Another reprint was a Dunhuang edition of the *Laozi* owned by

the great Buddhist specialist Matsumoto Bunzaburō (1869–1944). Finally, two of Luo's publications featured items owned by the infamous Miura Goro (1847–1926), a Japanese official who has been implicated in the assassination of Queen Min, which paved the way for the Japanese colonization of Korea.

Luo Zhenyu did not neglect texts by Chinese antiquarians, either, particularly works by Pan Zuyin and his protégés. In 1914, he republished Pan's 1872 bronze catalog, with a preface by Wang Guowei. He reissued Wu Dacheng's bronze and jade catalogs as well as the unfinished *Experimental Investigations*. During this period, he also printed Sun Yirang's work on the oracle bone inscriptions, along with Wang Yirong's catalog of Han Dynasty stele inscriptions. These projects enabled many of these works—which had existed only in hand-copied drafts or in a few privately published versions—to survive into the twentieth century.

As business ventures, his imprints were likely profitable; even modernist scholars like the fiction writer Lu Xun (1881–1936) avidly collected rubbings. New editions of classic antiquarian texts could be purchased from several commercial printing companies. Along with the Commercial Press, which reproduced dozens of antiquarian works under the editorship of Wang Yunwu (1888–1979), another significant publisher of antiquarian materials was Youzheng shuju, established by Di Baoxian (1875–1921, proprietor of the famous Shanghai newspaper *Shibao*). Using collotype printing to reproduce stele rubbings and other antiquarian works was more lucrative than publishing newspapers.[61] In other words, Luo Zhenyu was not alone in sensing a financial opportunity in the public's continuing appetite for *jinshi*.

These projects enabled Luo Zhenyu to support himself financially in exile, but Wang Guowei maintained that they were also important scholarly contributions. "For modern scholarship to flourish, then putting together publishing projects is a necessary service," he argued.[62] Speaking of a set of Yinxu relics he was including in a catalog, Luo wrote, "I am responsible for whether they survive or perish. If I don't publish a catalog of them today, later there won't be anyone who has knowledge of them, and I would not be able to suppress my feelings of regret."[63] Just as his appetite for collecting was voracious, so was his energy for publication; over the course of several decades, he issued literally hundreds of titles, many included in his serial and compilation projects, as well as his massive multivolume artifact catalogs. Wang Guowei was amazed at Luo's productivity not only in writing and edit-

ing books but also in publishing them—"aficionados or ordinary anti-
quarians could never compete with him," he marveled.[64]

But as successful as these projects appeared to be, they were only
one part of Luo Zhenyu's post-1911 entrepreneurial empire. He also
was an art dealer, specializing in ancient artifacts and Song and Yuan
paintings. His role in circulating materials overseas may seem merely
ironic given his earlier criticism of the unchecked flow of rare artifacts
abroad, but in fact his art dealing activities had serious consequences
for his scholarly reputation.

The Art Dealer

Art dealing became one of Luo's primary sources of income soon after
he arrived in Kyoto. During a visit back to Shanghai in 1914, for ex-
ample, he purchased too many books and paintings and complained to
Wang, "I do not have any experience, and antiques dealers are cliquish.
There are many good paintings, but I am broke and can only buy one
in ten. In this profession one must take on debts. What to do, what to
do."[65] But he quickly learned the secrets of the profession, sometimes
borrowing money to buy paintings and other antiques.[66] As a measure
of the volume of his activities, during his decade-long stay in Japan
he sold some five thousand oracle bone fragments to Japanese research
institutes, museums, and private collectors.[67] His activities had a sig-
nificant impact on prices on the Shanghai art market, according to the
artist Huang Binhong (1865–1955).[68]

The origins of Luo's work as an art dealer were perhaps not that
remarkable for a turn-of-the-century collector. He started purchasing
paintings and antiquities while living in Shanghai in the 1890s, when
he befriended a number of prominent artists, including Wu Chang-
shi. At that time, the Shanghai art world was remarkably frank about
commerce, with young painters and calligraphers issuing price lists and
marketing their wares directly to collectors, or through fan shops and
other stores.[69] Many members of this professionalizing coterie were
particularly close to Japanese patrons.[70] Indeed, at this time several
dealers opened shops in Shanghai in order to satisfy the demand for
Chinese art and antiquities. (The United States was the largest overseas
market for Chinese art works, however.)[71] Not surprising given Luo's
role in Japanese-language education, he was acquainted with several
Japanese collectors residing in Shanghai, including Kawai Senro, Naitō
Konan, and the traditionalist painter Tomioka Tessai (1837–1924, To-

mioka Kenzō's father), as well as Matsuzaki Tsūruo (1867–1949), who later became a close associate in Manchukuo. From having served as an intermediary between Japanese expatriates and Chinese artists in Shanghai, it was not too great a leap for Luo to bring Chinese artworks directly to Japan to sell, in some cases cultivating as clients the same collectors he had known in Shanghai two decades earlier.

Luo had the advantage of familiarity with the major Chinese antiques markets. Items that were once popular in China were now less popular, and Luo could purchase them for low prices in order to sell them to an eager Japanese clientele. He quite inexpensively obtained pieces by Wu Dacheng and his friends, like the antiquarians Wu Yun (1811–1883) and Shen Bingcheng (1823–1895). Indeed, precisely because they wanted to buy antique paintings, Japanese collectors expressed disappointment with the preponderance of Qing materials.[72] The real coup was the chance to buy ancient artifacts cheaply.[73] Still, he complained that although "China is very big and has many artifacts and treasures, unfortunately one cannot have them all, and almost every day things get more expensive."[74]

Luo Zhenyu's transactions with his Japanese clients were fairly explicit. On one instance, a Japanese collector admired a painting hanging on the wall of Luo's Kyoto home. The visitor offered to buy the work, but Luo refused. He did mention, however, that the painting would soon be included in a catalog. The visitor left unhappy, but Luo wrote to Wang Guowei, "Selling materials now, one cannot avoid complications," a comment that suggests that the visitor was not incorrect to presume the painting was for sale.[75] Within a few years of moving to Japan, Luo began to market his own artworks. A 1917 item in *Shibao* advertised a hundred pieces of his epigraphic calligraphy, available through his brother's publishing house Tanyinlu as a fundraiser to help flood victims.[76]

By the time Luo Zhenyu was promoting his wares, the commercial aspects of his art dealing trade were no longer private. But the extent to which Wang Guowei assisted Luo Zhenyu in his art dealing activities is still surprising, particularly because Wang had earlier criticized bibliophiles who collected rare books, artworks, and curios simply to demonstrate superior taste.[77] Now he was helping to disperse materials to elite collectors, perhaps facilitating the same kind of empty showmanship.

The pace of Luo Zhenyu's art dealing activities grew after Wang Guowei returned to Shanghai in 1916. Wang began to teach at a small

private college established by the Sino-French antiquarian patron Liza Hardoon (or Luo Jialing, 1864–1941) and her husband, the Jewish-Iraqi real-estate tycoon Silas Aaron Hardoon (1851–1931). Despite being employed by the Hardoons and continuing to do editing work for Luo, Wang earned only 150 Chinese dollars a month, about the same as his son's annual school fees, and lived in a humble basement apartment.[78] When the linguist Morohashi Tetsuji (1883–1982) accompanied Hayashi Taisuke on a visit to Wang in 1918, he was struck by the famous scholar's obvious poverty.[79]

Not surprisingly, Wang did not hesitate to become Luo's local business partner. Aided primarily by Shen Zengzhi, Wang visited dealers (often former Qing officials), negotiated the prices of rare books and paintings, rolled them up in oilcloth, and posted them to Japan.[80] Luo tried to rein in his expenditures—"this year I can only sell paintings, I can't buy any paintings" he told Wang Guowei in 1916—but as his letters reveal, he made purchases steadily. A bronze tripod for two hundred dollars. Two paintings for five hundred dollars. Two paintings for seven hundred dollars. He authorized Wang to spend up to a thousand dollars for a particular painting, but a few months later, he advised spending up to three thousand dollars, saying that he could sell it for five thousand to a Japanese collector.[81] Two weeks later, Wang negotiated the purchase of a painting for 5,400 dollars—three times his annual salary.[82]

Luo Zhenyu apologized for busying his protégé with these transactions, saying, "You do not enjoy business—you do it for me."[83] But with his growing family, Wang was apparently eager to increase his income with his own side deals. In 1916 he wrote to Luo,

> I have just sold my commercial stocks, and in addition to this year's interest I have made a profit. My plan is to leave the money in the bank temporarily, but there are disadvantages to this plan. [...] I am thinking of buying several books and paintings, and am making preparations towards that goal, but since it is difficult to decide what to buy, I haven't yet dared to make a decision. Even though I could ask Shen Zengzhi for instruction, his discrepancies in judgment are very great. If you have a use for this money, you could invest it temporarily, or if you are in Shanghai in the future you could buy some books and paintings for me. This would be safer than buying them myself.[84]

On another occasion, he wrote to Luo Zhenyu, "Dealing in books and paintings is not easy. The difficulty is not only in determining the quality and authenticity [of materials], but negotiating prices is also very difficult."[85] From these comments, we may assume that Wang Guowei's ventures were less robust, and although he continued to help his patron sell paintings and artifacts for at least two more years, his entrepreneurial energies never rivaled Luo's.

Probably because the extent of his participation in the art dealing trade was minor compared to his mentor's activities, Wang Guowei's scholarly reputation was not compromised by these transactions. Luo's work as an art dealer, however, was extremely controversial. Several of his contemporaries believed he was forging materials, including oracle bones and paintings, in order to inflate prices.[86] Puyi, for example, accused him of having "built himself up as an 'authority' on antiques through various underhanded means" to become a "forger of ancient books and seals, willing to 'authenticate' fake paintings and pieces of calligraphy for a fee."[87] When Luo claimed to discover medieval Chinese texts and paintings in Japan, Zhang Taiyan countered that these were not lost masterworks at all, but modern pieces to which Luo added forged seals and other devices to make them appear old.[88] And Guo Moruo (1892–1978) called Luo Zhenyu "an extremely false gentleman" who cheated Japanese clients.[89] These charges continue to reverberate, and there are still questions regarding the authenticity or attribution of paintings and other materials sold by Luo Zhenyu to Japanese clients.[90]

But even if he never fabricated or misrepresented artifacts intentionally, his dual roles of scholar and art dealer amounted to a conflict of interest. What did it mean for the world expert on the oracle bone inscriptions, for example, to market them to clients? Were his assurances of the authenticity or historical value of materials colored by his commercial interests?[91] Even his publication projects came under attack. Lu Xun referred sarcastically to *shangren yilaomen* (loyalist merchants) who reprinted old books, often with traditional butterfly bindings, simply as antiquarian curios. He scorned Luo's pictorial albums as "advertisements," while their "peddler's flavor" reminded his brother Zhou Zuoren (1885–1967) of auction house catalogs.[92]

Luo Zhenyu's work as an art dealer compromised his scholarly reputation, but it is noteworthy that some of his most strident critics were men who disliked his increasing conservatism and prominent identity as a Qing loyalist. To be sure, in maintaining a traditional de-

meanor despite the rapid modernization of other elements of Chinese life in the early twentieth century, he was in good company. Many artists, art dealers, and scholars found it appropriate (and profitable) to cultivate an image of the literatus.[93] But the real reason for Luo's increasing marginalization within the Republican intellectual world was that his scholarly methodologies remained somewhat limited. Although he was respected as a collector and philologist, his research made few contributions to some of the major debates about ancient history beginning to rage in the 1920s. For *jinshi* to remain relevant to modern historiography, it was left to a younger scholar, Wang Guowei, who was able to articulate how artifacts were useful to theorize the ancient past.

7

Wang Guowei—From Antiquarianism to History

Don't let three hundred years of Qing scholarship
snap like a thread.
—Luo Zhenyu letter to Wang Guowei, 1916

WHEN WANG GUOWEI returned from Kyoto, he entered a contentious
intellectual world. On May 4, 1919, students took to the streets to pro-
test the pro-Japan provisions of the Treaty of Versailles and to demand
political liberalization. They also called for a critical reexamination of
the country's philosophical, historical, and artistic traditions, and this
broad program, referred to as the New Culture Movement, advocated
Western science and philosophy as crucial to national development.
Traditional learning seemed so much in decline that the historian
Chen Yinke (1890–1969) appeared almost comically out of step when
he composed an entrance exam to Qinghua University that required
students to be familiar with Ming novels and Song poetry.[1]

One of the most important outcomes of the New Culture Move-
ment was its influence on the *yigu* or "doubting antiquity" trend in his-
torical research. *Yigu* historians were extremely skeptical of traditional
history in several respects. They questioned the veracity of the earliest
Chinese dynasties like the Xia and Shang, and, like their Japanese con-
temporaries, were inclined to describe as myth any fantastic or unprov-
en elements of the historical literature. They also hesitated to use many
traditional methodologies of textual criticism, which they considered to
be unscientific. Indeed, they expressed particular disdain for Qing phi-
lologists and their supposedly outmoded methods of interpreting texts
and artifacts. In this way, the antiquity that was in doubt included at

least three elements: the facts of the ancient past, traditional literature that described that past, and traditional modes of historical scholarship, particularly that from the Qing period.

But not all scholars embraced this spirit of radical iconoclasm. Despite the fame of the *yigu* critique, historical studies of the period were arguably dominated by the *xin kaoju* (new exegetical research), inspired by eighteenth- and nineteenth-century techniques of studying ancient texts and artifacts. In fact, by the 1930s, *kaoju* auxiliaries like etymology and bibliography seemed on the verge of eclipsing Western-style historical and literary criticism in university curricula, to the consternation of modernists.[2]

The divergence between the supporters of tradition and the iconoclasts was profound. For a time it appeared that scholars who trusted antiquity—who relied on traditional literary sources as well as Qing methodologies—could never win the respect of the doubters, whose goal was to introduce Western historiography to China. In this fractious terrain, significant middle ground was achieved by Wang Guowei. An expert in the scrupulous documentation and logical argument of *kaoju,* he deployed its methods to craft historical studies of ethnic or national identity, make global comparisons, and examine the impact of society on the individual—all of which clearly reflected the preferences of Western scholarship. He also confidently utilized material artifacts in order to argue for the continuing significance of ancient history, using a method referred to as the *erchong zhengju fa,* or double-proof method of judging literary sources against material artifacts. Indeed, his enviable flair for studying antiquities like ancient bronzes and oracle bone inscriptions, along with his scrupulous use of literary sources and his sophisticated application of the latest foreign terminologies, all helped persuade members of the doubting antiquity clique that they could continue to research ancient history, and should do so in ways that utilized, at least to some degree, philological methodologies. In this way, he both preserved and irrevocably transformed Qing antiquarianism.

The Appeal of Western Learning

Wang Guowei became proficient in Western learning early. He was a member of that turn-of-the-century generation enamored of European literature and philosophy, perceived as the essence of Western civilization. He admired European philosophy for its universal and timeless concepts. Its Chinese counterpart seemed too narrowly political, or too

empirical—unable to resolve what he termed the "natural doubts of humanity and society," namely, "What is our value for each other? Why do we exist? What is the relationship of mind and matter? How do we know the external world? And how can we determine truth from falsity?"[3]

Shanghai in the late 1890s welcomed many ambitious, dissatisfied young men like Wang Guowei. A promising student from a lower-gentry Jiangnan family (just like his mentor Luo Zhenyu), he was skilled at philology, but he was unable to overcome his distaste for the rigid essay format required for examination success.[4] As a friend recalled, the shy man could appear "unsociable and unfeeling," but this masked a profound intellectual curiosity, and "with people he knew well he loved to talk the whole day, whether it was about scholarship or domestic and international affairs."[5] In 1898, having given up on winning a higher imperial degree, Wang was fortunate to have a friend find him a position as a proofreader at *Shiwu bao* (Current affairs), the reform journal cofounded by Liang Qichao. Given his politics, the position would have seemed ideal, but the pay was low and the duties mostly clerical.[6] To fill up his days, Wang enrolled at Luo Zhenyu's Japanese Language Institute and began to study not only Japanese and English but also mathematics, physics, and chemistry. Like many of his contemporaries, he hoped that the study of science—not simply technical knowledge but also the human sciences—could help remedy China's seemingly intractable poverty and diplomatic weakness.

The study of the natural sciences prompted Wang to develop his understanding of the human sciences as well; indeed, in nineteenth-century scholarship these were closely aligned fields. He began to read works like the 1896 *Introduction to Sociology* by Arthur Fairbanks (1864–1944) and *Outlines of Psychology* by Harald Høffding (1843–1931).[7] Between 1902 and 1908, he translated almost twenty philosophy texts from English and Japanese, including adaptations of *Tetsugaku gairon* (Outline of philosophy, 1900) by the Neo-Kantian Kuwaki Genyoku (1874–1946) and the 1886 *Outlines of the History of Ethics for English Readers* by Henry Sidgwick (1838–1900). In 1908, he published excerpts of *Primer of Logic* by William Stanley Jevons (1835–1882), first translated into Chinese in 1886 by Joseph Edkins and translated again by Yan Fu in 1909. Like Yan Fu's renderings of Huxley, Spencer, and Mill, which aimed for literary stylishness and readability, Wang Guowei's translations were not necessarily valued for their literalness, but for making their contents relevant to other Chinese scholars.[8]

Wang's philosophy studies soon focused on German thought, beginning with his attempt at Immanuel Kant's (1724–1804) *Critique of Pure Reason* in 1903. Although he published an enthusiastic short essay on Kant almost immediately in Luo Zhenyu's journal *Education World*, truthfully he was unable to make much headway. But he found he "loved" Arthur Schopenhauer (1788–1860), whose works remained "constantly at my side."[9] What attracted him to Schopenhauer was the idea that literature ameliorates suffering by awakening readers to alternative realities. After immersing themselves in tragedy's themes of suffering and despair, for example, readers could imagine a world free of injustice, "convinced that life is a bad dream from which we have to awake."[10] By implication, literature might improve society more than science.[11] When Wang applied Schopenhauer's theories to *A Dream of Red Mansions*, he declared that the message of the novel is the hero's struggle to achieve personal happiness by suppressing his sensual desires.[12] A few years later, he used this insight in an essay on opium addiction to argue that personal happiness and social stability both depend on self-control.[13]

Wang was beginning to achieve his self-declared goal in studying what he called "international learning," which he contrasted with "shallow Confucian learning," namely its applicability to both scholarship and social critique.[14] With his success in interpreting *A Dream of Red Mansions* and applying its meaning to contemporary social issues, he began to devote more time to literary studies. Between 1904 and 1907, Wang published several examinations of European fiction and drama, including pieces on Francis Bacon (1561–1626) and the German playwright and poet Christian Friedrich Hebbel (1813–1863). He also published several essays on Johann Wolfgang von Goethe (1749–1842), whose writings introduced him to the idea of *Weltliteratur* (world literature). For Wang Guowei, world literature offered a way to situate novels and drama within a national context without losing sight of qualities shared among literary traditions.[15]

Wang's *Weltliteratur*-influenced studies of fiction and drama led to a reconsideration of the Chinese literary tradition, beginning with drama. When he moved to the capital in 1906 (Luo Zhenyu had secured a position for him at the education ministry), he gained access to the libraries of Miao Quansun and other prominent bibliophiles, among them several drama specialists who generously opened their libraries of rare scripts.[16] Even though he earlier dismissed Yuan drama as "childish" and "crass," he became convinced of its significance in the history

of Chinese literature.[17] After expatriating to Kyoto, he was further encouraged to study Chinese drama by Japanese experts, who admired his interpretive skills.[18] His newfound respect for the textual tradition of his own country placed his engagement with Western literature in a secondary position. Although he still bemoaned his country's lack of an indigenous concept for "aesthetics," he now praised its artistic heritage, including sculpture and architecture; Yuan painting, for example, had an elegance about which "Westerners could only dream."[19]

However, studying Chinese literature was not a methodological homecoming. His drama studies continued to employ foreign concepts, starting with the very idea of literature itself.[20] Indeed, for the remainder of his scholarly career his theoretical vocabulary featured neologisms like psychology, society, revolution, freedom and equality, progress and evolution, and human development.[21] In a lengthy essay on Confucius, for example, Wang framed his discussion by concepts of "man and society, society and the nation," arguing that individual benevolence is an extension of the benevolence of society.[22] His youthful immersion in the late-Qing discourse of science, internationalism, and concern for social and political institutions informed his work for the rest of his life, and he remained convinced that scientific approaches could be fruitfully applied to a broad category of scholarship, including research on ancient Chinese history and language.

Antiquarianism and Conservative Politics

Wang experienced tremendous success as a specialist in literature and European philosophy. The historian Fu Sinian praised his Song and Yuan drama studies, while the Beida chancellor Cai Yuanpei, who earned a *jinshi* degree before studying in Europe, believed that none of his contemporaries could have interpreted German thought so adeptly.[23] After 1911, however, Wang concentrated on studies of history, ancient artifacts, and philology. Because he remained a Qing loyalist after the 1911 Revolution, it is tempting to hypothesize a relationship between his scholarly and political choices. Was he a loyalist who happened to become interested in history, or did he turn towards history in order to give voice to conservatism?

Of Wang's political views, there is no doubt. He remained a Qing loyalist until his death; like Luo Zhenyu, he never cut his queue, even after Puyi lopped his own braid.[24] He was horrified by the 1917 Russian Revolution; two years later, he may have thought the May Fourth

demonstrations might lead to something similar in China, as he responded to the student rallies in Shanghai with feelings of "panic," calling the marches down Nanjing Road "most frightening" and fretting over the closure of restaurants and markets and the calling in of troops by the government.[25] He wrote to Kano Naoki that, "with the continual surges of new, global currents, unfortunately heaven has been overturned and the earth has cracked. But the harm caused by Western utilitarianism over the past few centuries can still be rooted out, and government based on Oriental ethics can still flourish in the world."[26]

And what better way to preserve "Oriental ethics," perhaps, than by studying ancient history and language? Indeed, by "returning to the Classics and trusting antiquity," as Luo Zhenyu urged, it might be possible to "rescue China from the unruly currents" of modern Western thought.[27] Thus began Wang's schooling, as an exile in Kyoto, in Qing antiquarianism. As he wrote to Miao Quansun, his post-1911 access to Luo's antiquarian library granted him new exposure to both Song Dynasty and nineteenth-century *jinshi*, including the work of Wu Dacheng and his contemporaries. In addition, he benefited from his patron's tutelage in helping him learn ancient scripts. This nurtured his budding interest in pre-Han history.[28] When he tackled projects that required extensive use of oracle bone inscriptions, as in his studies of the Shang genealogies, he was particularly grateful for Luo's expertise.[29] His turn towards antiquarianism might have been an opportunistic reflection of his status as Luo's assistant in Japan, but his interest in Chinese language and history also clearly reflected his emerging preference, apparent before 1911, for pre-modern and non-Western texts.

At first, Wang Guowei's antiquarian research took the form of annotated lists of artifacts and texts to accompany Luo's sumptuous pictorial albums. But soon his patron's influence waned, and he began to pursue independent projects related to artifacts and inscriptions. Leaving his employment with the Hardoons reduced Luo Zhenyu's influence even more. He moved to the capital to enter Puyi's entourage as a Companion of the Southern Study (Nan shufang), collaborating with other Qing loyalists on projects like cataloging the imperial library and art collection.[30] Despite his dismay over the treatment of Puyi—when Feng Yuxiang (1882–1948) overran the capital in 1924, he forced the deposed emperor to sign away most of his remaining rights, and chased him out of the Forbidden City to asylum at the Japanese Legation—Wang's confidence in his intellectual capabilities and autonomy increased.[31] At one time writing to Luo Zhenyu almost every day, by the

time of his tenure in the capital they corresponded only a few times a year.[32]

After Puyi's removal and the disbanding of the Southern Study, Wang joined the Qinghua faculty and crammed an on-campus house full of books.[33] Outside of his research, he had no interests, no hobbies—"he did not travel, did not exercise, did not drink, but only smoked Hatamen cigarettes," his daughter recalled—but his wife gave him extra spending money to shop for books in Liulichang.[34] He lectured on the Old and New Text versions of the classics, the *Documents*, and etymology, among other topics. At hand to discuss literature, history, and philosophy were friends like Liang Qichao and Chen Yinke, who shared many of Wang's attitudes towards history and literature. He nurtured a cohort of talented students, among them Xu Zhongshu (1898–1991), who became a famous historian of ancient China in his own right.

By focusing on historical research in his last decade, Wang indeed found a way to express his politics through scholarship. History allowed him to articulate the ongoing value of tradition, in several guises—as an object of research, as a suite of methodologies, and as an attitude towards traditional philosophy and culture. But Wang was sympathetic to some *yigu* concerns. Like them, he wanted to maintain the standard of scientific history and verify literary sources; he also wanted to use empirical research to explore questions related to history and the nation. He addressed these issues using the interpretive discourse shaped by his earlier studies of philosophy and literature. In this way, he preserved the intellectual interests of his younger years and continued to express political and social critiques, albeit in the service of conservatism.

Historical Science and National Origins

For scholars of ancient history, much had changed since the debates over the murder of the sage kings that had animated early research on the oracle bone inscriptions. The new techniques advocated by Liang Qichao at the turn of the century, namely the use of empirical evidence and socially applicable argumentation, were now almost universally accepted.[35] Indeed, almost all historians agreed that their field set an empirical standard for other disciplines by establishing "the reason for the existence of facts and theories, and the reasons for their evolution."[36] Many historians hoped the social sciences could provide a new foundation for Chinese historiography.[37]

Wang Guowei applied this perspective in some of his earliest historical research, such as "Yin-Zhou zhidu lun" (On Shang and Zhou institutions, 1917), which drew primarily on evidence from oracle bone inscriptions. This essay deals with Shang lineage systems of naming and worshipping ancestors (which contributed to the taboo of intermarriage between surnames), as well as the differences between the Shang and Zhou in their selection of heirs, their religious beliefs, and their systems of feudal nobility.[38] Although he discussed the contributions of the Duke of Zhou and other leaders, he focused less on kings and conquerors and emphasized changes in culture and political system between the dynasties, a perspective more in keeping with the demand of modern history to interpret impersonal social trends. Furthermore, reminiscent of Kang Youwei's theory that Confucius was a reformer, Wang Guowei praised Zhou leaders for their political innovations.[39] The implication was that institutional reform was virtually inscribed in the national character. This refuted a vision of Chinese history as eternal, unchanging, and static—a common stereotype by nineteenth-century social critics, most notoriously Marx.[40]

It was Wang's interest in social and political history that distinguished his work from that of his patron most clearly. In 1913, Luo Zhenyu gave Wang a set of rubbings of official seals from Shandong, which resulted in Wang's work *Qi-Lu fengni jicun* (Collection of surviving clay seals from Shandong). While Luo's introduction related his procedures for collecting the seals, Wang explained how their contents answered questions regarding Han Dynasty political institutions and clarified Shandong's historical geography.[41] In collaborative projects like their first study of the Dunhuang manuscripts, Luo Zhenyu focused on questions of language and Wang wrote about the historical issues raised by the works' contents.[42]

While addressing problems of cultural and political change, Wang confronted the other significant change in historiography since the turn of the century, namely the importance of nationalism in historical discourse. Whereas Liang Qichao had to urge his contemporaries to consider the significance of a national identity, most scholars had adopted this approach by the 1910s and 1920s. For Wang Guowei, however, the recourse to the nation was not so matter-of-fact. He was, after all, a Qing loyalist, and disagreed fundamentally with many of the premises of a polity based on an unbroken line of ethnic Han descent, for example. Not for him the theory of the Baks (that the Yellow Emperor, the founder of Chinese civilization, was a Mesopotamian wayfarer), which

reflected the desire to show both the longevity and continuity of an ethnic Chinese identity, albeit one with ultimately foreign origins.

Wang addressed these issues in some of his earliest essays on the Shang and Zhou, which focus in particular on the period of transition between the two dynasties. "Yin-Zhou zhidu lun" contained one of his most famous theories, namely that the two dynasties originated in distant geographical regions and, by implication, had significant cultural differences, a direct refutation of the claim that the Zhou had largely preserved Shang ritual.[43] Furthermore, rather than claiming significant influence between the two eras, Wang Guowei asserted, "the transformation of Chinese politics and culture occurred largely in the interval between the Shang and Zhou," highlighting the differences between the two dynasties and the importance of radical change, rather than continuities, in creating what we now think of as Chinese civilization.[44] The plural origins theory, as it is now described, became both famous and widely influential. Wang's student Xu Zhongshu expressed the theory in terms of racial difference and argued that the Shang and the Zhou were actually different ethnicities, a remarkable assertion given the goal of many historians at the time to find a unifying national origin point. Another essay argued that the ancient script forms discussed by Wu Dacheng—*guwen* and *zhouwen*—did not develop successively, as most philologists assumed, but emerged in separate geographical regions.[45] This theory also highlighted the distinctiveness of different ancient kingdoms, as opposed to assuming temporal sequence and cultural continuities.

With his interest in the origins of Chinese civilization growing, Wang Guowei began to address issues related to what European scholars, following the phrase coined in 1877 by Ferdinand von Richtofen (1833–1905), were beginning to refer to as the Seidenstrasse. To be sure, at least since the Statecraft studies of the early nineteenth century, antiquarian scholars like Qian Daxin had been fascinated by the cultures and languages of the Northwestern frontier. But a century later, this region was becoming even more significant as a location of historical research, as foreign archaeologists and adventurers, from Marc Aurel Stein to Ōtani Kōzui and his associates, plied the Silk Road in search of rare antiquities and evidence of early Western contact. Wang Guowei, along with Chen Yinke, began to investigate the history of the region, focusing, for example, on the origins of the Xiongnu and their interactions with the Han and Tang. Their research was premised on the need to understand the history of the region within the framework

of Chinese politics, as well as to recognize the role of intercultural and interracial exchange in determining the events of some of the most pivotal eras in Chinese history.

Wang Guowei's theories regarding the legacies of Silk Road exchanges and ethnic and cultural groups in early China found an audience among some of the most ardent nationalists of the historical community. The plural origins theory, for example, became an exciting point of departure for Fu Sinian's research as he attempted to refute the theory of the Baks. Although Wang Guowei argued that the Zhou originated in Western China and the Shang came from the east, to Fu Sinian it was more important that both groups were recognizably Chinese, despite the geographical distance between their centers of power.[46] Meanwhile, the idea of a Chinese nation arising from its own soil seemed to be substantiated by discovery of the early hominid known as Peking Man.[47] Wang's implicit support for a polity made up of multiple languages and nations was even consistent with the ethnic pluralism promoted in the 1920s by national leaders like Sun Yat-sen.[48] Hence even his non-nationalistic scholarship appealed to members of the New Culture generation, including the *yigu* proponent Gu Jiegang (1893–1980), particularly when it was useful to refute increasingly unpopular theories that located China as a kind of auxiliary to Western civilization.

The Problem with Antiquity

In the spring of 1922, Wang Guowei received a visit in Shanghai from a student of Hu Shi, the Columbia University Ph.D. who held the chair in Chinese Philosophy at Beida. This was Gu Jiegang, who was on vacation in his hometown of Suzhou. Their meeting deeply impressed the young scholar, who complimented Wang's scholarship and thanked him profusely for his generosity in receiving him.[49] Wang replied graciously and commented that there was no need to thank a friend for intellectual conversation.[50] A few months later, Wang corresponded with the Beida professor Ma Heng (1881–1955, an associate of Luo Zhenyu), praising Gu's "gentle demeanor."[51] He also told Luo Zhenyu that Gu was a talented scholar.[52]

Soon afterwards, however, Wang registered a more negative view, namely that Gu's topics were too fixed and his methods were too literal.[53] But this criticism may actually have seemed flattering. Approaching a topic with precise methodology was exactly the kind of research

that Hu Shi encouraged in his students. A devotee of John Dewey (1859–1952), Hu Shi's goal was to interpret Chinese philosophical and historical literature according to scientific methods, which he characterized by "boldness in setting up hypotheses and minuteness in seeking evidence."[54] He advocated extreme skepticism towards literary sources, particularly those from the earliest dynasties. Gu Jiegang and his classmates marveled that Hu's history lectures began with the ninth century BC, halfway through the Zhou, and ignored the Xia and Shang altogether.[55] Gu ultimately adopted Hu Shi's skeptical attitude, and the *yigu* movement commenced in a series of letters between Gu, Hu Shi, and Qian Xuantong (1887–1939), another Beida professor.

Although Wang Guowei enjoyed the meeting, he was alarmed by Gu's skeptical attitude, which was uncomfortably similar to Shiratori's murder of the sage kings; indeed, Gu reminded him of a Japanese scholar.[56] As Wang noted,

> Research on ancient Chinese history concerns the most quarrelsome of topics. In ancient history, legend and historical facts are mixed together and impossible to separate. Among historical facts, it is impossible to avoid the fringes, which are no different from legend; and among legends, there are always elements of historical fact. The two are not easy to distinguish, and in this all nations are the same. In ancient China, this was always attended to. Confucius said, "Believe and love antiquity." But he also said, "What the gentleman does not know, he can be wrong about." [...] It is excessive to doubt antiquity, and to dispute the personages of Yao, Shun, and Yu. Such a skeptical attitude and critical spirit is unacceptable.[57]

Of course, the *yigu* movement was just the latest salvo in a battle, ongoing at least since the late nineteenth century, over the status of the ancient period in modern historiography. As we have seen, since the turn of the century and Kang Youwei's disputes over the validity of literary sources, the idea of writing the history of ancient China without contemporary sources was viewed with distaste. Even after paleographers like Sun Yirang and Luo Zhenyu began to use oracle bone inscriptions to study ancient language, their fellow antiquarians spoke the language of history haltingly, and historians lacked training in antiquarian materials.

This was the juncture in which Wang Guowei made one of his greatest contributions to historical methodologies, namely the persua-

sive use of nonliterary sources in historical research. As early as 1913, he and Luo Zhenyu completed a study of the bamboo strips collected by Marc Aurel Stein and published by Éduard Chavannes (1865–1918), perhaps the first time Chinese scholars used artifacts excavated by archaeologists.[58] For the next fifteen years, Wang Guowei continued to emphasize the importance to his research of "recently discovered" materials like the oracle bone inscriptions, the bamboo books, Six Dynasties and Tang Dynasty materials from Dunhuang, and rare editions held in the imperial collections.[59] He was particularly proud of his ability to use artifacts to "achieve certainty out of doubt" and to denounce *yigu* claims.[60] In fact, it was his training as a scholar of antiquities that provided him with the strongest evidence to refute Gu Jiegang.

For example, in a 1923 letter to Qian Xuantong, Gu Jiegang alleged that Yu the Great, supposedly the founder of the Xia Dynasty, was almost certainly not a historical figure. Much of his argument was based on information in the *Shuowen* suggesting that the character for Yu was derived from a graph meaning worm, hence was unlikely to denote a king.[61] The references to Yu must refer not to a human ruler, he decided, but to some kind of mythical being, and therefore the historical existence of the Xia was in even greater dispute. This pugnacious claim aroused the ire of philologists like Liu Yizheng (1880–1956) who criticized Gu for an inept reading of the *Shuowen* that overstated the significance of the genetic linkage of Yu to the graph for "worm."[62]

In his refutation, one might expect Wang Guowei to rely principally on philological argumentation as well. Instead, though, his chief tactic was to cite bronze inscriptions that mentioned Yu as ruler. By "consulting two artifacts, which are known to be from the Spring and Autumn Period," he observed, it was possible to disprove "people today who doubt the existence of the Xia." Indeed, those bronze inscriptions demonstrated, "there was no one in the Eastern and Western States who did not believe that Yu was an ancient king, or that Tang [the founder of the Shang] controlled all under heaven."[63] As he wrote in a letter to Rong Geng, if *yigu* historians like Gu Jiegang and Qian Xuantong had problems with the *Shuowen*, it was because they failed to understand that the scripts in the dictionary were not as old as the texts on bronzes and other artifacts.[64] In other words, not only was Gu's philology insufficient, as Liu Yizheng claimed but also, more damningly, he was unable to use ancient artifacts as primary sources.

Gradually the idea of using nonliterary sources began to appear more empiricist, and hence scientific, than the *yigu* camp's skepti-

cal and sometimes inexpert readings of early texts and lexicons. Liang Qichao, for example, encouraged his students to consider in their "objective organization of data" not only well-accepted historical materials like dynastic records but also the activities of Shanghai commercial associations as well as material culture like paintings, weapons, and coins.[65] A few years later, Chen Yinke built a reputation on his studies of "excavated" materials like the Dunhuang manuscripts, whose late discovery made them more similar in many ways to artifacts than to literary sources.[66] All these materials were identified as *shiliao* or "historical materials," a neologism that married the idea of history to materialist notions of physical supplies.[67] The idea of *shiliao* was particularly attractive to Fu Sinian, who built an entire credo of historical science that entailed treating historical materials with precision and impartiality, rather than "the construction of art, the circulation of [ideas], or supporting or overturning this movement or that '-ism.'"[68]

To be sure, *yigu* historians were quickly convinced as to the necessity of including archaeological materials in their research. "At present, ancient history only extends to two or three thousand years [into the past]," Hu Shi wrote to Gu Jiegang in 1921. But "in the future, after scientific conventions have been established through *jinshi* and archaeology, we can use excavated historical materials to gradually extend ancient history back before the Eastern Zhou."[69] In 1924, Gu Jiegang began teaching a course entitled "Ancient Artifact Studies." Although he acknowledged that Chinese scholars had been studying artifacts for a long time, and even the phrase "ancient artifacts studies" had been used for several years, he still felt that there was a need to correct earlier mistakes in dating and attribution.[70] In 1927, when Fu Sinian and Gu Jiegang (then his colleague at Zhongshan University in Guangzhou) began to plan an institute for the study of history and philology—which would become the core research organ of the Academia Sinica—their goal was to "establish many new research fields" by collecting material related to local dialects, social customs, and excavated artifacts.[71]

Was this new respect for material objects the result of the prestige of antiquarians like Wang Guowei, or the foreign archaeologists whose electrifying discoveries were particularly influential in the 1920s? Surely, both were important influences. Returning Western-trained scholars like Li Ji (1896–1979)—who completed a Ph.D. in anthropology at Harvard before returning to work with the Swedish geologist Johan Gunnar Andersson (1874–1960), the discoverer of Peking Man—introduced to their contemporaries archaeological fieldwork methods.

Together with foreign colleagues, they unearthed a number of important Neolithic sites.[72] But activities related to Western archaeology were not the only sources of inspiration for the *yigu* camp, who increasingly praised Wang Guowei and other Chinese scholars trained in native antiquarian methods.[73] Gu Jiegang, for example, decided not to limit himself to "the destruction of the spurious system of ancient historiography" once his "field of vision" was enlarged after seeing how Wang and Luo Zhenyu used ancient artifacts. Their influence persuaded him that "a recollection of genuine ancient history could only be successful if one proceeded from the real objects [of antiquity]."[74]

In other words, the focus on material artifacts persuaded Gu Jiegang to modify his previously extreme skepticism. He also gradually softened his attitude towards other elements of antiquity, including *jinshi* traditions. When Gu Jiegang attended an exhibit of recently excavated stone and pottery artifacts in 1923, he was inspired to travel to Henan, where he visited Luoyang and examined newly unearthed bronzes. After the trip, Gu classified *jinshi* materials as archaeological artifacts, noting, "jade tablets and ornaments evolved from stone knives, jade rings evolved from stone rings, and ritual bronze tripods and cooking vessels evolved from pottery tripods and cooking vessels."[75] This signaled a remarkable acceptance of Qing methodologies by a scholar who had previously built a reputation for bold rejection of traditional scholarship.

Preserving Literary Sources, Perpetuating Qing Legacies

The turn towards material artifacts and *shiliao* suggests Wang Guowei's authority in another regard, namely his influence in persuading historians to trust literary materials, as well as the Qing methodologies that evolved to analyze them. This was the fundamental premise of Wang's *erchong zhengju fa* (double-proof method), which required that material artifacts and literary sources be used in combination, preferably with *kaoju* methodologies. Indeed, there was no contradiction between a scientific approach and respect for literary sources in Wang's view: both were necessary to good historical research.[76] The idea of using material artifacts and literary sources in combination may sound intuitive, but it was characteristic of the extreme stances of historical research during the 1910s and 1920s that Wang's goal of using material artifacts and inscriptions to "verify the facts contained in ancient texts" required justification.[77]

Initially, Wang Guowei may not have felt that his method was that unique. He began to feel more aware of its significance, however, in one of his first and most impressive studies of the oracle bone inscriptions, dating from 1917, which pitted the oracle bone inscriptions against Sima Qian's *Records of the Historian.* In this article, Wang tried to identify five predynastic rulers mentioned in the inscriptions that either were not present in Sima Qian's genealogies or not specifically identified.[78] As a consequence of his corrections and elaborations on Sima Qian's "Yinben ji" (Basic annals of the Shang) chapter, Wang Guowei affirmed the value of the *Records of the Historian* but also demonstrated its limitations. On the one hand, Sima Qian's facts were shown to be incomplete or false in some respects. On the other hand, because the Shang genealogies were largely correct, scholars could assume that the Xia genealogies were also fairly reliable, even though there was no corroborating material evidence. Indeed, Wang concluded that even the "ancient legends" that informed Sima Qian's scholarship "are not completely without reliability."[79] Hence, an essay that began as a study of oracle bone inscriptions ended with a surprising statement about the trustworthiness of a literary source.

As Wang Guowei grew more confident in his application of the double-proof method, he insisted on its novelty, even though in some ways his use of written and inscribed materials to counterbalance each other was not too far from *tuikan.*[80] But whether the technique was new or old, not everyone was immediately convinced of Wang's conclusions. Fu Sinian admired Wang's precise examination of the Shang genealogies in the *Records of the Historian,* but claimed Sima Qian's history was more valuable for its information regarding Han Dynasty politics, as well as its literary style.[81] Nonetheless, over the next decade, Wang Guowei's adeptness in using literary sources in combination with excavated artifacts gathered increasing praise. Also described as a contextualizing or explaining history approach, his method was admired for extracting value from literary works of questionable attribution.[82] For example, he proposed that historians rely on the pre-Han Dynasty geography text, the *Shanhaijing* (Classic of mountains and rivers), as well as the poetry collection called the *Chuci* (Elegies of Chu), which were often discounted because their age and origins were so unclear. Books that were discovered after the Han, such as the purportedly Warring States–era *Zhushu jinian* (Bamboo annals), also had "some degree of reliability." Even though Wang lacked archaeological material to subject these and other texts to his double-proof method, when it came

to their accounts of ancient history, these books "should not be wholly expunged."[83]

By the late period of his career, Wang Guowei appeared to rely more significantly on literary sources than on material artifacts. His discussion of the Maogong *ding* inscription, for example, hinged on passages in the *Odes* and the *Documents* that clarified Zhou social order; these sources helped resolve paleographic questions, rather than the other way around.[84] In his final years, he assured students of the primacy of philology and *kaoju* rather than material artifacts, arguing, "the authenticity of Old Text and New Text sources cannot be distinguished only through physical evidence, but through the meaning of the texts themselves."[85] His Qinghua University colleague Chen Yinke emphasized, "it is the obligation of modern historians to eliminate, layer by layer, any false material" from the histories, but it was still assumed that much of their contents could be preserved.[86]

As Wang Guowei embraced *kaoju* in historical research, his attitude towards Qing scholarship became more complimentary. Whereas his drama studies highlighted his invention of a new scholarly field, by 1925 he was insisting, "Chinese scholarship composed on paper but based on excavated materials did not start recently."[87] Like his friend Liang Qichao, whose works of intellectual history particularly praised eighteenth-century innovations, Wang was increasingly complimentary of Qing scholars. Several short pieces written in the 1920s extol the contributions of Wu Dacheng and his contemporaries. He admired their discernment, finding no fakes in Pan Zuyin's collection of three hundred bronzes, and only three or four in Wu Dacheng's collection.[88] Although Wu Dacheng was unable to devote himself to paleography "due to the cares of being an official," his integrity was confirmed when he refused offers to sell his collection to foreigners.[89]

Wang Guowei's rediscovery of *kaoju* came at a moment when Qing philology was enjoying a national revival. Scholars from Chen Yinke to Fu Sinian praised Han Learning adherents like Qian Daxin as models of empiricist historiography, while Hu Shi wrote that the spirit of scientific enquiry—verifying sources and reading them closely—was a valuable legacy of *kaozheng*.[90] In other words, Qing scholarship was admired because it offered a native legacy of scientific thought. Nonetheless, they considered the new philology to be an improvement on the old because it utilized a more interpretive approach—hence the excitement over Naitō Konan's discovery of the relatively obscure writers Zhang Xuecheng and Cui Shu (1740–1816), who were believed to em-

phasize analytical sophistication more than their contemporaries did.[91] The Qinghua philosopher Feng Youlan (1895–1990) complimented Zhang Xuecheng for "explaining antiquity": in other words, placing literary sources in historical context without expressing either too much skepticism or too much gullibility.[92] The goal was to be as erudite and as rigorous as the philologists were when it came to questions of language while making arguments that reflected the priorities of twentieth-century social and political critique.

Not accidentally, this was precisely the approach modeled by Feng's senior colleague Wang Guowei. But Wang's application of *kaoju* was not innovative in all respects. For one, its political orientation was still recognizably conservative, reaffirming rather than questioning the judgments of traditional historiography. Echoing centuries of Confucian histories, for example, he praised the civilizing practices of the Zhou, like its benevolent government and attention to ritual, in contrast with Fu Sinian, who disputed the received criticism of the supposedly barbaric Shang.[93] But Fu praised Wang Guowei's unusual respect for unorthodox literary sources like the *Shanhaijing* and *Chuci*, which challenged the primacy of Confucian literature.[94]

There were problems with the double-proof method. As Luo Zhitian has pointed out, Wang's formulation—to save literary sources with at least some degree of validity—elided the precise extent to which they were reliable, and how exactly they could be used.[95] It could also appear elitist to emphasize the value of the major tradition at a time when folksongs and vernacular novels were more fashionable. Indeed, in a criticism that could have been aimed at Luo Zhenyu and Wang Guowei specifically, Hu Shi slammed people who "cannot escape the habits of antiques dealers" and were only interested in the elite literary tradition.[96]

Despite this criticism, Wang succeeded in convincing many of his contemporaries that literary sources should not be discounted, particularly in light of new material evidence. Fu Sinian expressed hope that the archaeological excavation of large numbers of artifacts could resolve debates over the accuracy of literary sources.[97] Gu Jiegang's friend Liu Shanli (fl. 1920s–1930s) claimed that he could already rigorously apply sources like the *Rites, Documents,* and *Records of the Historian* to his research of ancient politics, while Gu declared that his goal in researching ancient artifacts was to "eliminate a number of mistakes" when "we compare their dates to the textual Classics."[98]

And, however elitist Wang's literary tastes appeared, his use of

Qing methodologies began to appear not so much conservative as patriotic. Indeed, for many of his contemporaries, the idea of using not only indigenous sources but also a native methodology in studying them—particularly one that was difficult to master without prolonged immersion in the classical tradition—was attractive. It allowed them to reclaim primacy in the world of Sinology, whose center of gravity seemed to have receded either to Europe or to Japan. Historians like Chen Yuan (1880–1971) complained, "when foreign and Chinese scholars discuss Sinology, if they're not talking of what's going on in Paris, they're talking of what's going on in Kyoto. They don't even mention China. We have to take the center of Sinology and bring it back to China, back to Beijing."[99] Other appraisals of Wang and his mentor appeared to reflect this same preference for native scholars. The famous Marxist historian Guo Moruo, for example—who once castigated Luo for his dealings with Japanese art collectors—ultimately asserted that Luo Zhenyu's studies were so important that "if one speaks of oracle bones, one must start with these; if one speaks of Chinese antiquity, one must start with these."[100]

This interpretation, however, can go too far. By championing literary sources and Qing *kaoju*, both areas where Chinese scholars excelled, Wang Guowei (like Luo Zhenyu) became a standard-bearer for native scholarly practices, and this was unquestionably part of his appeal. But his scholarly contributions were far more significant than this suggests. In the end, along with Luo Zhenyu, Dong Zuobin, and Guo Moruo, he was accorded the moniker of one of the "four venerables" who established oracle bone studies.[101] His standing as a historian has, if anything, steadily increased in the eight decades since his suicide.

Death of a Scholar

Despite the success of Wang's approach to historical research and the congeniality of his position at Qinghua, three years after joining its faculty he committed suicide, drowning himself in the lake at the Summer Palace after extinguishing a final Hatamen cigarette. Some commentators blamed a recent quarrel with Luo Zhenyu, and others pointed to Wang's anxiety over the escalating political turmoil in Beijing.[102] Chen Yinke believed his despair was a consequence of his traditionalism, since "whenever a culture is in decline, anyone who has received benefits from this culture will necessarily suffer; the more a person embodies this culture, the deeper will be his suffering."[103] At a memorial ser-

vice on campus, Chen and his students performed the *ketou,* kneeling and bowing before Wang Guowei's grave. Some onlookers expressed surprise at the observance of this custom, but others noted that it was consistent with Chen's eulogy, which commended his colleague's strong Confucian feelings.[104] Yet on Wang's memorial stele for the Qinghua campus (designed by Liang Qichao's son Liang Sicheng, 1901–1972), Chen Yinke invoked the "independent spirit" and "free ideas" represented by his colleague's scholarship—no doubt with an eye to the need to preserve academic freedom under the newly established Nationalist government, which was already starting to censor intellectuals.[105] Liang Qichao wrote to his daughter that Wang Guowei's methodologies were "new and profound," and that there would have been no limits to his scholarly contributions if he had only lived another decade.[106]

Wang Guowei's closest colleagues at Qinghua articulated a nearly universal opinion of their friend—that he was a profound cultural conservative whose research, nonetheless, impressed contemporaries with its innovation and brilliance. For them, Wang was concurrently a historian, a literary critic, and an antiquarian. Wang Guohua (1887–1980) summarized his brother's appeal as a consequence of his mastery of Qing argumentation in combination with his willingness to use excavated materials to challenge literary sources, all with the benefit of his training in the "meticulousness" of Western empiricism.[107] Wu Qichang (1904–1944) declined to characterize his mentor as simply a philologist, philosopher, or literature specialist, but rather a combination of all three—a "specialist in the 'new historiography,' or a philologist of cultural history."[108] But Rong Geng simply labeled him an expert in *jinshi.*[109]

These tributes suggest the significance of his accomplishment as a historian of antiquity, which effectively transformed antiquarianism into history. In the late Qing, Wu Dacheng and Sun Yirang used inscriptions to discuss ancient politics and philosophy. But *jinshi* specialists did not often think of themselves as historians, and their studies of artifacts and texts—generally one item or inscription at a time, like Sima Qian's case histories—made only limited, discrete claims regarding ancient politics and society. At the same time, late-Qing historians hesitated to make detailed arguments concerning the early dynasties: lacking sufficient evidence according to their methodological standards, they acknowledged that much of early Chinese history was dependent on myth and legend. History as a field, for all intents and purposes, ventured with extreme caution into the period before the Han, search-

ing anxiously for trustworthy sources according to new benchmarks of reliability.

By the 1910s and 1920s, there were some scholars who considered themselves experts on ancient China, whose goal was to interpret its history in terms of emerging theories of political and social development. But in the face of skeptical attitudes regarding the fragility of literary sources, the field still appeared stymied. Wang Guowei channeled the artifact studies of late-Qing *jinshi* in the service of the new historiography. He could access material evidence and inscriptions like an antiquarian, but his purpose was to write theoretically complex and analytical accounts like a modern historian. There was hardly anyone before Wang Guowei who was capable of doing this. There were many who followed, however—and they were all his intellectual heirs.

Epilogue

The Future of a Pastime

ON OCTOBER 13, 1928—a little over a year after Wang Guowei's sui-
cide—Dong Zuobin and other members of the Academia Sinica began
to excavate a site northwest of Xiaotun village, hoping to find any ora-
cle bones that might have eluded decades of peasant excavators. They
were unsuccessful. But after Li Ji took over the digs the following year,
the team unearthed quantities of artifacts as well as the remains of tem-
ples and royal tombs that suggested the site was indeed Yinxu, the last
Shang city. This moment marked the triumphant arrival of a patriotic
archaeology, whose purpose was to substantiate the great age of Chi-
nese civilization and undermine the less Nationalistic implications of
the "doubting antiquity" movement.[1] Indeed, after impressing contem-
poraries with the audacity of his views, Gu Jiegang and his supporters
were increasingly marginalized by the newly constituted archaeological
community. Under the leadership of Fu Sinian, who courted govern-
ment patronage of the Institute of History and Philology, scholars ral-
lied around the idea that preserving Chinese prehistory would contrib-
ute to national solidarity.[2]

The decision to begin the new institute's excavations in Anyang
were a nod to the powerful significance of the Shang in the national
imaginary.[3] It also was a logical starting point since there had been
antiquarian attention to the location for years—like the visits by Luo
Zhenyu and his brother less than two decades earlier. In fact, one might
argue that many of the activities of the new Institute were designed to
try to catch up with Luo. Not only did Fu Sinian seek to build a collec-
tion of Yinxu relics, including oracle bones, but he also tried to retrieve
as many Qing court documents as possible.[4] The kind of historical and
archaeological research he promoted, in other words, had striking over-

laps with precisely the areas of scholarship pioneered by Luo Zhenyu and Wang Guowei.

The influence of these twentieth-century antiquarians was felt in other ways as well. Several of their close associates gained prominent positions in universities, museums, and research institutes. When Fu Sinian divided the Institute of History and Philology into separate departments, he put them under the direction of two of Wang Guowei's Qinghua colleagues: Li Ji assumed control of the departments of archaeology and anthropology, and Chen Yinke was placed in charge of the department of history. After the establishment of the People's Republic in 1949, Chen was asked to direct the new Institute of History and Philology in the Chinese Academy of Sciences (replacing the Academia Sinica, which moved to Taiwan), but he refused and ended his career at Zhongshan University in Guangzhou. Ma Heng became head of the National Palace Museum in 1934 and helmed that institution until his retirement two decades later.

Given these overlaps of personnel between history and archaeology, it is not surprising that the two fields developed in tandem. Fu Sinian asserted that even though it stood apart from other subfields, "archaeology is a part of history," while the Marxist archaeologist Yin Da (1906–1983), who participated in the Anyang excavations, affirmed, "archaeology is structurally a part of history, since it uses material artifacts as historical resources for research, in order to understand human history."[5] Li Ji believed that even archaeological fieldwork is a form of historical studies, using "natural science methodologies" to "collect the historical materials of human history."[6] As a summation of these viewpoints, the account of the development of Chinese archaeology by Wei Juxian (1898–1990), a 1927 Qinghua graduate, begins by noting its relationship to history.[7] Indeed, Lothar von Falkenhausen argues, "nowhere else in the world is archaeology as closely enmeshed in a millennia-old living tradition of national history" as in China.[8] One of the causes of this overlap is surely the fact that both fields share a common genetic link in their indebtedness to *jinshi* practices. When scientific archaeology was introduced to China, historians could already claim expertise in studying bronzes, jades, and other materials—precisely the legacy of artifact studies.

As the generation of historians trained in the early twentieth century assumed leadership roles in new state institutions, their accounts of antiquarianism emphasized its scientific legacies. Ma Heng defined antiquarianism as the process of conducting historical research on

"the textual patrimony of ancient humanity," a category that included bronzes and steles "or any other kind of material that has been directly transmitted to the present day."[9] In his 1937 appraisal of the field, *jinshi* was described as independent and scientific, capable of explaining ancient ideologies and distinguishing between religious groups, as well as describing social and economic conditions.[10] Indeed, the purpose of antiquarianism was "to understand more completely our ancestors and their lives and work," not "to resurrect antiquity."[11] Where once *jinshi* was criticized as too philological to contribute to history, now it was defined as historical studies all along.

In order to substantiate this claim, however, the links between *jinshi* and art practice, ritual studies, and other elements of the traditional pastime had to be downplayed, although among art historians the connoisseurship of rubbings, particularly of stele inscriptions, remained an admired skill.[12] Modern chroniclers also did not always acknowledge the complex changes that altered *jinshi* in the decades just before it became so important to historical studies, preferring to write more-linear genealogies that attributed the field's accommodation of twentieth-century empiricism to its earliest origins in the Northern Song. Yet the fact that so many modern scholars cared about the development of the field at all attests to the significance of its late-Qing transformations. Republican historians could have disavowed *jinshi* and derided it as an obsolete form of scholarship. Instead, they embraced its practices of artifact studies, were grateful that its insights allowed them to use literary sources more effectively, and in many respects identified themselves as its practitioners.

These positive assessments of *jinshi* gained a heightened poignancy as China entered the wartime period. A 1938 history of the field, alluding to the fighting already engulfing much of the country, praised antiquarians for safeguarding ancient artifacts and texts despite a thousand years of "corrosive hardships," and "the destructiveness of warfare."[13] Over the centuries, the field changed tremendously from its earliest beginnings; calligraphers and philologists from before the nineteenth century might not comprehend the twentieth-century pursuit of uninscribed archaeological artifacts and narrative accounts of Shang and Zhou society. Still, they would surely agree that the paramount rationale of *jinshi* was the perpetuation of the Chinese nation and its history. As long as this remains the case, the pastime has a future.

Glossary

Italics are used if an entry refers to the title of a book or painting.

Bao Shichen 包世臣
bapo 八破
Beilin 碑林
beitie 碑帖
biyi 筆意
bogu huahui 博古花卉
bolanguan 博覽舘
bowu (J. hakubutsu) 博物
bowuguan 博物館
buci 卜辭
buyi 布衣

Cai Yuanpei 蔡元培
Cao Zhao 曹昭
chanyi ta 蟬翼拓
Chen Huan 陳奐
Chen Jieqi 陳介祺
Chen Mengjia 陳夢家
Chen Yinke 陳寅恪
Chen Yuan 陳垣
Cheng Ji 程濟
Chengwang 成王
chong 寵
Chuci 楚辭
Cui Shu 崔述

Dai Zhen 戴震
dao 道
Debaozhai 德寶齋
Deng Shi 鄧實
Di Baoxian 狄葆賢
ding 鼎
Ding Guanhe 丁觀鶴
Ding Guanpeng 丁觀鵬
Dong Zuobin 董作賓
Dongwen xueshe 東文學社
du 讀
Duan Yucai 段玉裁
Duanfang 端方
dui 敦
duilian 對聯

erchong zhengju fa 二重證據法

Fan Weiqing 范維卿 (Shouxuan 壽軒)
Fan Zhaochang 范兆昌
fanbian 蕃變
fangbei 訪碑
fatie 法帖
fengjian 封建

145

Feng Guifen 馮桂芬
Feng Youlan 馮友蘭
Feng Yuxiang 馮玉祥
Fu Shan 傅山
Fu Sinian 傅斯年
Fu Yunlong 傅雲龍
fugu 復古
Fujita Toyohachi 藤田豊八
Fuxi 伏羲

ganzhi 干支
Gao Lian 高濂
Gegu yaolun 格古要論
Gong Zizhen 龔自珍
gu 古
Gu Jiegang 顧頡剛
Gu Linshi 顧麟士
Gu Yanwu 顧炎武
Guanzi 管子
gudong 古董 / 骨董
guijia 龜甲
Guke congchao 古刻叢鈔
Guo Moruo 郭沫若
Guo Zongchang 郭宗昌
guocui (J. kokutai) 國粹
Guoxue congkan 國學叢刊
Guozijian 國子監
guqiwu xue 古器物學
guwan 古玩
guwan ku 古玩庫
guwen 古文
Guyu tu 古玉圖
guzhou 古籀
Guzhou shiyi 古籀拾遺
Hamada Kōsaku 濱田耕作
Han Chong 韓崇
Han Yu 韓愈
Hang Shijun 杭世駿
haogu 好古
Hayashi Taisuke 林泰輔

He Shaoji 何紹基
Heshuo fangbei tu 河朔訪碑圖
Hou Hanshu 後漢書
Hu Shi 胡適
Huang Binhong 黃賓虹
Huang Shiling 黃士陵
Huang Yi 黃易
Huang Zongxi 黃宗羲
Huang Zunxian 黃遵憲
huangzhong lüguan 黃鐘律琯
Huizong 徽宗
Huyan 呼衍

Indu fengsu ji 印度風俗記

jiagu 甲骨
jiaguwen 甲骨文
jian 見
Jiang Fu 蔣黼
Jiang jin jiu 將進酒
Jiang Zhiyou 蔣智由
Jiaoyu shijie 教育世界
jiapian 甲片
Jigulu 集古錄
Jin Nong 金農
Jin Zutong 金祖同
Jingdian shiwen 經典釋文
jinshi (antiquarianism) 金石
jinshi (presented scholar) 進士
jinshi seng 金石僧
jinshihua pai 金石畫派
jinshixue 金石學
Jinsi lu 近思錄
jiqi guan 集奇舘
jue 爵

kaishu 楷書
Kanda Kiichirō 神田喜一郎
Kanda Kōgan 神田香巖
Kang Youwei 康有為

kangaku 漢學

Kano Naoki 狩野直喜

Kaogong ji 考工記

kaogu 考古

Kaogu tu 考古圖

kaoguxue (J. kōkogaku) 考古學

kaoju 考據

kaozheng 考證

Kawai Senro 河井荃廬

keci 刻辭

ketou 磕頭

kikkō gyūkotsu (C. guijia niugu) 龜甲牛骨

Kobayashi Chūjirō 小林忠治郎

kobutsugaku (C. guwuxue) 古物學

Kong Anguo 孔安國

Kusakabe Meikaku 日下部鳴鶴

Kuwaki Gen'yoku 桑木嚴翼

Lao She 老舍

Laozi 老子

Li Bai 李白

Li Ciming 李慈銘

Li Gonglin 李公麟

Li Hongzhang 李鴻章

Li Ji 李濟

Li Qingzhao 李清照

Li Shengduo 李盛鐸

Li Yuanyi 李元懿

Li Zuoxian 李佐賢

liang 兩

Liang Qichao 梁啟超

Liang Shizheng 梁詩正

Liang Sicheng 梁思成

Lidai zhongding yiqi kuanshi fatie 歷代鐘鼎彝器款識法帖

Liji 禮記

Lin Zexu 林則徐

Ling Tingkan 凌廷堪

lishu 隸書

Liu Chang 劉敞

Liu Chenggan 劉承幹

Liu E 劉鶚

Liu Shanli 劉挍藜

Liu Shipei 劉師培

Liu Tizhi 劉體智

Liu Xihai 劉喜海

Liu Yizheng 柳詒徵

Liuchao biezi ji 六朝別字記

Liulichang 琉璃廠

Liuzhou 六舟 (Dashou 達受)

longchi 龍齒

longgu 龍骨

Lü Dalin 呂大臨

Lu Deming 陸德明

Lu Hejiu 陸和九

Lu Wenchao 盧文弨

Lu Xun 魯迅

lüguan 律琯

Luo Fuyi 羅福頤

Luo Jialing 羅迦陵

Luo Shuxun 羅樹勛

Luo Xiaochun 羅孝純

Luo Zhenchang 羅振常

Luo Zhenyu 羅振玉

Ma Fuyan 馬傅岩

Ma Heng 馬衡

Ma Sanheng 麻三衡

Maobai dui 毛伯敦

Maogong ding 毛公鼎

Matsumoto Bunzaburō 松本文三郎

Matsuzaki Tsūruo 松崎鶴雄

Mei Ze 梅賾

Miao Quansun 繆荃孫

micang 秘藏

Mitsui Genemon 三井源右衛門

Miura Goro 三浦梧樓

Mo Youzhi 莫友芝
Morohashi Tetsuji 諸橋轍次
Mozi 墨子

Naitō Konan 內藤湖南
Naka Michiyo 那珂通世
Naxunlanbao 那遜蘭保
Ni Wenwei 倪文蔚
Nie Chongyi 聶崇義
Ni Zan 倪瓚
Niehai hua 孽海花
Ninagawa Noritane 蜷川式胤
Nongxue bao 農學報
Nüwa 女媧

Okamoto Kansuke 岡本監輔
Ōtani Kōzui 大谷光瑞
Ouyang Xiu 歐陽修

Pan Jingshu 潘靜淑
Pan Zengying 潘曾瑩
Pan Zuyin 潘祖蔭
pi 癖
Puyi 溥儀

qi (material) 器
qi (spirit) 氣
Qi-Lu fengni jicun 齊魯封泥集存
Qian Daxin 錢大昕
Qian Xuantong 錢玄同
Qianlong 乾隆
Qingliu 清流
qingyi 清議
qiwen 契文
quanxing ta 全形拓

Ren Xun 任薰
Rong Geng 容庚
Rong Yuan 容媛

Ru 儒
Ruan Yuan 阮元

sanmi 三秘
shangren yilaomen 商人遺老们
Shangshu 尚書
Shangshu guwen shuzheng 尚書古文疏証
Shanhaijing 山海經
Shen Bingcheng 沈秉成
Shen Tao 沈濤
Shen Yao 沈垚
Shen Zengzhi 沈曾植
Shen Zhou 沈周
Shengyu 盛昱
Shi Bin 史彬
Shibao 時報
Shiji 史記
Shijing 詩經
shiliao 史料
Shiratori Kurakichi 白鳥庫吉
Shiwu bao 時務報
shiyan 試驗
Shun 舜
Shuowen buque 說文補缺
Shuowen jiezi 說文解字
Shuowen yizi 說文逸字
shuqi 書契
sibu 四部
sijia 私家
Siku quanshu 四庫全書
Sima Guang 司馬光
Sima Qian 司馬遷
Sizhou zhi 四州志
Su Yinian 蘇億年
Sun Yirang 孫詒讓

Tachibana Zuichō 橘瑞超
Takahashi Taika 高橋太華
Tan Sitong 譚嗣同

Tang 湯
Tang Lan 唐蘭
Tangyin 湯陰
Tanyinlu 蟬隱廬
Tao Zongyi 陶宗儀
Taoka Reiun 田岡嶺雲
taotie 饕餮
Tetsugaku gairon 哲學概論
Toktoghan (C. Tuoketuo) 托克托
Tomioka Kenzō 富岡謙蔵
Tomioka Tessai 富岡鉄斎
tongjia 通假
tuikan 推勘

wan 玩
Wang Chang 王昶
Wang Duanshi 王端士
Wang Fu 王黼
Wang Guohua 王國華
Wang Guowei 王國維
Wang Hanzhang 王漢章
Wang Kaiyun 王闓運
Wang Lü 王履
Wang Niansun 王念孫
Wang Qian'gang 王潛剛
Wang Qianming 王潛明
Wang Shizhen 王世貞
Wang Tao 王韜
Wang Xiang 王襄
Wang Xianqian 王先謙
Wang Xiaoyu 王孝禹
Wang Xiqi 王錫祺
Wang Xizhi 王羲之
Wang Yirong 王懿榮
Wang Yun 王筠
Wang Yunwu 王雲五
wanwu 玩物
Wei Juxian 衛聚賢
Wei Yuan 魏源
Weng Fanggang 翁方綱

Weng Tonghe 翁同龢
Weng Xincun 翁心存
Weng Zengyuan 翁曾源
Wu Changshi 吳昌碩
Wu Dacheng 吳大澂
Wu Hufan 吳湖帆
Wu Qichang 吳其昌
Wu Qiuyan 吾丘衍
Wu Qizhen 吳其真
Wu Yi 武乙
Wu Yun 吳雲
wujin ta 烏金拓

Xia 夏
Xia Zengyou 夏曾佑
Xian-Qin guqi tu 先秦古器圖
Xiao fanghu zhai yudi congchao 小
　方壺齋輿地叢鈔
Xiaojing 孝經
xin kaoju 新考據
Xinmin congbao 新民叢報
Xiongnu 匈奴
Xixue Zhongyuan 西學中源
Xu Jiyu 徐繼畬
Xu Shen 許慎
Xu Zhongshu 徐中舒
Xuanhe bogu tu 宣和博古圖
Xuanwang 宣王
-xue (J. -gaku) 學
Xue Fucheng 薛福成
Xue Shanggong 薛尚功
Xuegu bian 學古編
Xuenongshe 學農社

yaji 雅集
Yan Fu 嚴復
Yan Kejun 嚴可均
Yan Ruoqu 閻若璩
Yan Zhenqing 顏真卿
Yang Shen 楊愼

Yang Shoujing 楊守敬
Yang Shu 楊樞
Yao 堯
Ye Changchi 葉昌熾
Ye Mengde 葉夢得
Yi Bingshou 伊秉綬
yigu 疑古
yilao 遺老
Yin Da 尹達
Yin-Shang 殷商
Yin-Shang zhenbu wenzi 殷商真
卜文字
Yinben ji 殷本紀
Yinshi 印史
Yinxu 殷虛
Yizhou shuangji 藝舟雙楫
Yongbaozhai 永寶齋
Youzheng shuju 有正書局
Yu 禹
yuan 元
Yuan Shikai 袁世凱
Yuan Wen 袁文
Yuan Xie 袁燮
Yueguzhai 悅古齋

Zeng Guofan 曾國藩
Zeng Guoquan 曾國荃
Zhai Qinian 翟耆年

Zhang Jian 張謇
Zhang Shizeng 張式曾
Zhang Taiyan 章太炎
Zhang Tingji 張廷濟
Zhang Xuecheng 章學誠
Zhang Yuanji 張元濟
Zhang Yuzhao 張裕釗
Zhang Zhidong 張之洞
Zhao Mengfu 趙孟頫
Zhao Mingcheng 趙明誠
Zhao Xigu 趙希鵠
Zhao Zhiqian 趙之謙
Zhao Zhizhai 趙執齋
zhenbu wenzi 貞卜文字
Zheng He 鄭和
Zheng Zhen 鄭珍
Zhenjun 震鈞
Zhou Mi 周密
Zhou Zuoren 周作人
Zhouli 周禮
zhouwen 籀文
Zhu Derun 朱德潤
Zhu Xi 朱熹
Zhu Yixin 朱一新
Zhu Yun 朱筠
Zhuang Shuzu 莊述祖
zhuanshu 篆書
Zhushu jinian 竹書紀年

Notes

Introduction

1. Cao Xueqin, *Dream of Red Mansions*, 5.
2. Dong Zuobin, *Jiagu nianbiao*, 1a–1b.
3. Keightley, *Sources of Shang History*, 57.
4. Zhu Jianxin, *Jinshixue*, 2–3. Stele inscriptions of Confucian texts were preserved at the Forest of Steles (Beilin) in Xi'an and the Confucius Temple in Qufu. Rubbings of these inscriptions were highly valued, but were not generally labeled *jinshi*, so they are not included in this project.
5. Zhu Jianxin, *Jinshixue*, 2–3.
6. Ouyang Xiu, *Jigulu bawei*, 1211.
7. Wang Guowei, "Renjian shihao zhi yanjiu," 1796–1797; Bonner, *Wang Kuo-wei*, 101.
8. K.C.Chang, "Archaeology and Chinese Historiography," 156.
9. Zhu Jianxin, *Jinshixue*, 203.
10. Liang Qichao, *Intellectual Trends*, xxxiii.
11. Ma Heng, "Xulun," 1.
12. Throughout this book, I use antiquarianism to refer to a range of practices, including the collection of ancient artifacts, research on inscriptions, and publication of paleographic or philological research. However, when appropriate I do use "bronze-and-stele studies" to translate *jinshi*, particularly when the term is found in book titles that refer specifically to bronze vessels and stone steles, or research on those materials.
13. Momigliano, "Ancient History and the Antiquarian," 288.
14. Swann, *Curiosities and Texts*, 5–7.
15. Swann, *Curiosities and Texts*, 107–108.
16. Momigliano, "Ancient History and the Antiquarian," 290–291, 293, and passim.
17. For studies of Ming commercial culture, see Clunas, *Superfluous Things*, and Brook, *Confusions of Pleasure*.

18. For a discussion of humanism and its relationship to the European sciences, see Grafton, *Defenders of the Text*, 4–5 and *passim*.

19. Bai, *Fu Shan's World*, 15–20.

20. Because of the proximity between the study of artifacts and ritual, philologists never regarded their research as wholly empirical; their goal was to recover the moral and aesthetic insights of antiquity. Their attitude was similar to the European humanists or ancients. See Levine, *Battle of the Books* for a discussion of this attitude.

21. Clunas, *Superfluous Things*, 81.

22. Nivison, *The Literary and Historical Thought of Chang Hsüeh-ch'eng*, 303.

23. Zhu Yixin, "Wuxietang dawen," 436–437.

24. Pang, *Distorting Mirror*, 10. Other recent studies of late nineteenth-century visual culture in China include Vinograd, *Boundaries of the Self;* Hay, "Chinese Photography and Advertising"; and Ye, *Dianshizhai Pictorial.*

25. See Fan, *British Nationalists,* and Heinrich, *Afterlife of Images.*

26. The idea of Weltbild is from Heidegger's essay "The Age of the World Picture," where it refers to a concept or image of the world; the relationship of visuality to the experience of modernity is discussed in Jay, "Scopic Regimes of Modernity"; Pinney, *Camera Indica;* and Stafford, *Good Looking.*

27. Elman, *From Philosophy to Philology*, 197, 191.

28. Li Ji, "Zhongguo guqiwuxue de xin jichu," 60–61.

29. Liang Qichao, *Intellectual Trends*, 121–123, xxxi–xxxv.

30. My understanding of the relationship between visual culture and the physical and natural sciences is particularly informed by Galison, *Image and Logic,* and the essays in Jones, ed., *Picturing Science.*

31. Wang, "Beyond East and West," 490.

32. For the relationship between collecting practices and the development of the sciences, see Findlen, *Possessing Nature.*

33. For a recent discussion of the need for more varied approaches to early twentieth-century literature and history that engage critically with proponents of modernism, see Kai-wing Chow, Hon, Ip, and Price, "Introduction," esp. 3–5.

34. Chow, *Writing Diaspora*, 12.

35. Foucault, *Power/Knowledge*, 86.

36. K.C. Chang discusses the distaste for case histories in "Archaeology and Chinese Historiography," 157.

37. Tang, *Global Space*, 62–63.

Chapter 1: Antiquarianism and its Genealogies

1. Ruan Yuan, "Shang-Zhou tongqi lun," 3–5.

2. De Pee, *Writing of Weddings*, 44.

3. Ouyang Xiu, "Li-Yue zhi diyi," 1a. For a discussion of Ouyang Xiu's ideas related to rites and music, see Bol, *"This Culture of Ours,"* 195–196.

4. Bol, *"This Culture of Ours,"* 152–155.

5. De Pee, *Writing of Weddings,* 267, n. 85.

6. Nie Chongyi, *Xinding sanli tu,* 13:1a–2a; De Pee, *Writing of Weddings,* 69.

7. Harrist, "Artist as Antiquarian," 241; Sena, *Pursuing Antiquity,* 90–91.

8. Liu Chang, "Xian-Qin gu qi ji," 15b.

9. Ebrey, *Accumulating Culture,* 181.

10. Cited in He Fang, "Qinggong shoucang yanjiu," 97.

11. Cao Zhao, *Chinese Connoisseurship,* 10.

12. Harrist, "Artist as Antiquarian," 240. Sena discusses these paintings in *Pursuing Antiquity,* 100–104.

13. Poor, *Sung Albums,* 11; Rudolph, "Preliminary Notes," 171.

14. Liu Chang, for example, was able to decipher only "fifty to sixty percent" of the inscriptions he collected off bronze vessels. See De Pee, *Writing of Weddings,* 46. For Ouyang Xiu's similar difficulty, see Sena, *Pursuing Antiquity,* 68.

15. Poor, "Notes on the Sung Dynasty Archaeology Catalogs," 33, 37; Shaughnessy discusses these albums in *Sources of Western Zhou History,* 8–11.

16. Zheng Qiao, "Jinshi lüe," 1a.

17. De Pee, *Writing of Weddings,* 48.

18. Wu Hung, *Monumentality,* esp. 17–24.

19. Ebrey, *Accumulating Culture,* 159–166.

20. Rong Geng, "Songdai jijin shuji shuping," 5–6.

21. Rong Geng, "Songdai jijin shuji shuping," 5–6.

22. De Pee, *Writing of Weddings,* 25.

23. Ebrey, *Accumulating Culture,* 166–174.

24. Ebrey, *Accumulating Culture,* 196–203.

25. Liang Shizheng, ed., *Xiqing gujian,* 1:1a–1b.

26. Zito, *Of Body & Brush,* 160–163.

27. Duanfang, *Taozhai jijin lu,* 1:2b.

28. Duanfang, *Taozhai jijinlu,* 1:1a; Lawton, *Time of Transition,* 22.

29. For a discussion of the political uses of Chinese art and artifacts, see Elliott, *Odyssey of China's Imperial Art Treasures,* esp. Chapters 5 and 6, "Relocating and Rebuilding the Palace Museum on Taiwan," and "The Gugong in Beijing."

30. Poor, *Sung Albums,* 5 n. 1.

31. Li Qingzhao, *"Jinshilu ba,"* 1a.

32. Harrist, "Reading Chinese Calligraphy," 9.

33. McNair, "Engraved Calligraphy in China," 109. *Zhuanshu* literally means "decorative engraving script," but by the Qing the style was used almost exclusively for carving seals, hence its English translation.

34. McNair, *Upright Brush*, 127–128. As Peter Bol notes, this "preference for ancient models over modern practice and for the substantial, simple, and moral over the refined, brilliantly crafted, and sensuous" was not a new aesthetic judgment, but had been invoked by *fugu* scholars for centuries. See Bol, *"This Culture of Ours,"* 23.

35. Wu Hung, *Wu Liang Shrine*, 39–40.

36. Sena, *Pursuing Antiquity*, 67.

37. McNair, *Upright Brush*, 15.

38. Ouyang Xiu, *Jigulu bawei*, 1156.

39. Ouyang Xiu, *Jigulu bawei*, 1154–1155, 1167.

40. Davis, "Chaste and Filial Women," 204.

41. Zhao Mingcheng, *Jinshilu*, 1:1b.

42. Sena, *Pursuing Antiquity*, 46–49.

43. Sena, *Pursuing Antiquity*, 63–75 discusses Ouyang Xiu's view of using bronze inscriptions as historical records.

44. Li Qingzhao, "*Jinshilu* ba," 1a.

45. Cited in Kerr, *Later Chinese Bronzes*, 22.

46. Cao Zhao, *Chinese Connoisseurship*, 9.

47. Cao Zhao, *Chinese Connoisseurship*, 12–13.

48. Bai, *Fu Shan's World*, 50–51.

49. Wu Gongzheng, "Mingdai shangwan," 114.

50. Clunas, *Superfluous Things*, 100.

51. Clunas, *Superfluous Things*, 107.

52. Cited in Zhang Changhong, "Jiangnan yishu shichang," 24.

53. Clunas, *Superfluous Things*, 104.

54. Wang Shizhen (1526–1590), an aficionado of Northern Song art, criticized this turn towards the modern. He wrote, "Song painting used to be preferred, but in the past thirty years suddenly Yuan painters are emphasized. From Ni Zan [1301–1374] up to the Ming painter Shen Zhou [1427–1509], their price has suddenly increased tenfold. In ceramics, we used to prize [Song period] Ru ware, but fifteen years ago we suddenly emphasized pieces from the Xuande [1426–1435] to the Yongle [1402–1424] periods, and their prices have already increased tenfold." Cited in Shen Zhenhui, "Yuan-Ming shou-cangxue luelun," 68.

55. Clunas, *Superfluous Things*, 98–100.

56. Ouyang Xiu, "*Jigulu mu* xu," 1087.

57. Harrist, "Artist as Antiquarian," 240.

58. Cited in Harrist, "Artist as Antiquarian," 242.

59. Lü Dalin, *Kaogu tu*, 8.

60. Ma Sanheng, *Mozhi*, 1a.

61. Qian Daxin, "Zhongke *Sun Mingfu xiao ji* xu," 380.

62. Ji Yun et al., *Siku quanshu zongmu*, 3:1734.

63. Zhu Jianxin, *Jinshixue*, 33.

64. Li Yusun, *Jinshixue lu,* 6–10.

65. Rong Yuan, *Jinshi shulumu,* 1–24.

66. Cited in Lu Cao, "Lun jindai wenren de jinshi zhi pi," 82.

67. Dai Zhen, "*Gujing jiegou chen* xu," 146.

68. De Pee, *Writing of Weddings,* 47.

69. Lu Wenchao, "Jiujing guyi xu," 19a–19b.

70. Elman, *From Philosophy to Philology,* 31.

71. Zhang Zhidong, "Youxuan yu," 9781.

72. Chow, *Confucian Ritualism,* 162–163. For a discussion of this less reverent approach to the Classics, see Elman, "Historicization of Classical Learning"; Elman, *From Philosophy to Philology,* 76–79; and Wang, "Beyond East and West," 499.

73. Cited in Elman, *From Philosophy to Philology,* 61.

74. Elman, *From Philosophy to Philology,* 30–31.

75. Bai, *Fu Shan's World,* 167–168.

76. Wang Lü was primarily interested in steles that depicted the natural scenery of the mountain, rather than inscriptions. Liscomb, *Learning from Mount Hua,* 119.

77. Bai, *Fu Shan's World,* 174–178.

78. Gu Yanwu, "Jianwen bei," 39b–40a.

79. Bai, *Fu Shan's World,* 180–181.

80. Wang Zhongmin, ed., *Banli siku quanshu dang'an,* 3b–4a.

81. Often included in gazetteers, stele inscriptions from particular locales were particularly prized by officials in the south like Ruan Yuan, whose Guandong academy printed several catalogs of local stone inscriptions and artifacts. For a discussion of localism and antiquarianism, see Miles, "Celebrating the Yan Fu Shrine."

82. Yao Mingda, *Zhongguo muluxue shi,* 359. There was also another school of antiquarian learning in the Qing, epitomized by the work of the philosopher Huang Zongxi (1610–1695), which focused on using inscriptions as rhetorical models for literary composition, but these works were not generally considered part of *jinshi* studies. See Liang Qichao, *Intellectual Trends,* xxxii.

83. Qian Daxin, "*Guanzhong jinshi ji* xu," 367.

84. Wang, "Beyond East and West," 495.

85. Qian Daxin, *Qianyantang jinshiwen bawei,* 1: 8a–9a.

86. Qian Daxin, *Zhushi shiyi,* 207.

87. Wang Chang, *Jinshi cuibian,* 1: 1a.

88. Chu, "Grand Tradition," 200, 206–207.

89. Du Weiyun, *Qingdai shixue yu shijia,* 300; Wang, "Beyond East and West," 510.

90. Gong Zizhen, "Gushi goushen lun er," 21, 22.

91. Hsu, "Huang Yi's *Fangbei* Painting," 245.

92. Hsu, "Huang Yi's *Fangbei* Painting," 243.

93. McNair, "Engraved Calligraphy," 111.
94. McNair, "Engraved Calligraphy," 112.
95. Hua, "History and Revival," 117.
96. Wang Chang, *Jinshi cuibian,* 1: 1a.
97. Gong Zizhen, "Yulu," 437.
98. Ruan Yuan, *Nan-Bei shupai lun,* 39.
99. Wu Hung, *Wu Liang Shrine,* 42–44.
100. Ling Tingkan, "Da Niu Ciyuan Xiaolian shu," 196.
101. Weng Fanggang, "Kaoding lunshang zhi san," 302.
102. Qian Daxin, "Guo Yunbo *Jinshishi* xu," 366.
103. Gu Tinglong, ed., *Yifengtang youpeng shuzha,* 1: 1.
104. Liu Shipei, "Lun kaoguxue," 464.
105. Wang Guowei, "*Guochao jinwen zhulu biao* xu," 311.

Chapter 2: Antiquarianism in an Age of Reform

1. Rong Yuan, *Jinshi shulumu,* 1–24.
2. Kang Youwei, *Guang yizhou shuangji,* 201–202.
3. Nivison, *Life and Thought of Chang Hsüeh-ch'eng,* 51.
4. Benjamin Elman argues that concerns with Statecraft far predate the nineteenth century, but in the first decades of that century, they gained renewed popularity as a counterweight to *kaozheng* and as a remedy for China's perceived military and political weakness. For a discussion of Statecraft and its relationship with reform and *kaozheng,* see Elman, *Classicism,* 76–78 and 298–300; and Cheng, "Nationalism," 62.
5. Polachek, *Inner Opium War,* 195–200; Millward, "Coming Onto the Map," 85–86.
6. Feng Guifen, "Gai keju yi," 37–39; Elman, *Civil Examinations,* 578–580.
7. Zhang Yuzhao, "Zeng Wu Qingqing shuchang xu," 7a.
8. Hummel, *Eminent Chinese,* 2: 677; Brown, "Thunderous Events," 30.
9. Duanfang was a member of a similar network cultivated by Yuan Shikai in the 1890s, which also met for *yaji,* composed celebratory poems, and (to a lesser degree than Pan and Weng's clique) celebrated antiquarian interests. Asahara Tatsurō, "Netchū' no hito," 58–59.
10. Yi Zongkui, "Pilou," 20a.
11. Zeng Pu, *Niehai hua,* 118.
12. Sun Yirang, "Houxu," *Guzhou yulun,* 2a.
13. The invitees to one *yaji* are listed in letters from Zhang Zhidong to Pan Zuyin. See Zhang Zhidong, *Zhang Zhidong quanji,* 10103–10104.
14. Ye Changchi, *Yushi,* 36.
15. Zhenjun, *Tianzhi ouwen,* 483.
16. Zeng Pu, *Niehai hua,* 118.

17. Zhi Weicheng, *Qingdai puxue dashi liezhuan,* 345–346; Polachek, "Gentry Hegemony," 238. For mentions of Zeng Guoquan and his antiquarian activities, see Pan Zuyin, *Qinyou riji,* 42–43 and passim.

18. Weng Tonghe, "Ti Pan Bohuang cang yi he ming jing taben," 14a; Pan Zuyin, *Qinyou riji,* 71.

19. Pan Zuyin, *Qinyou riji,* 16–17.

20. Guy, *Emperor's Four Treasuries,* 39.

21. Polachek, *Inner Opium War,* 26.

22. Zhang Zhidong, *Zhang Wenxiang gong zhi E ji,* 18. To be sure, the idea that talented men were more important to good government than perfect laws was itself venerable; the *Xunzi* argues, "if you find talented men, the state will survive; without them, the state is lost." Xunzi, "Jundao," 209.

23. Zhang Zhidong, *Youxuan yu,* 9773.

24. Yi Zongkui, "Rongzhi," 32a–32b.

25. Ayers, *Chang Chih-tung,* 65–66.

26. Eastman, "Ch'ing-i and Chinese Policy Formation," 599.

27. Gu Tinglong, *Wu Kezhai xiansheng nianpu,* 30, 39, 45.

28. Zarrow, *China in War and Revolution,* 22; Rankin, "'Public Opinion' and Political Power," 456.

29. Gu Tinglong, *Wu Kezhai xiansheng nianpu,* 14–21.

30. Elman, *Civil Examinations,* 578–579.

31. Pan Zuyin, *Pangulou yiqi kuanzhi,* 2.

32. Zhang Dechang, *Qingji yige jingguan de shenghuo,* 94.

33. Gao Xingfan, "Aixin Jueluo Shengyu," 37.

34. Shen Yao, "Yu Zhang Qiushui," 23a–23b.

35. "Wu Dacheng zhi Weng Tonghe," 5–6.

36. Gu Tinglong, *Wu Kezhai xiansheng nianpu,* 253.

37. Shen, "Traditional Painting," 84; Andrews, "Traditionalist Response," 80–82.

38. Shen, "Traditional Painting," 80.

39. For a discussion of these groups and their political significance, see Ikegami, *Bonds of Civility.*

40. Sheng, "Through Six Generations"; Bai, "From Composite Rubbing," esp. 52–53.

41. Cai Xingyi, "Dao-Xian jinshixue," 41.

42. Little, *New Songs,* 106–107.

43. Shen, *Wu Changshi and the Shanghai Art World,* 172.

44. For a discussion of Bao's technical elaboration of Ruan Yuan's treatises, see Bai, "Chinese Calligraphy," 74.

45. Hay, "Culture, Ethnicity, and Empire," 204–205.

46. Ledderose, "Calligraphy at the Close of China's Empire," 191, discusses the example of the eccentric epigraphic calligraphy of Yi Bingshou (1754–1815), for example.

47. Little, *New Songs*, 118.

48. Cited in Liu, "Calligraphic Couplets," 370.

49. Wu Min'gui, *Wan Qing renwu yu jinshi shuhua*, 48.

50. Chen Jieqi, *Chen Fuzhai zhang biji*, 4b.

51. See Chen Jieqi's 1874 letter to Wang Yirong in Chang Kuang-yuan, "Xizhou zhongqi Maogong ding," 55. Wu Min'gui discusses Chen Jieqi's confidence in assessing the *qi* of inscriptions in *Wan Qing renwu yu jinshi shuhua*, 48, 51.

52. Zhang Zhidong, *Youxuan yu*, 9811.

53. Cited in Wu Min'gui, *Wan Qing renwu yu jinshi shuhua*, 48.

54. Bai, "Chinese Letters," 393–394.

55. Yi Zongkui, "Qiaoyi," 15b.

56. Ayers, *Chang Chih-tung*, 29, 32–36, 37; Elman, *Civil Examinations*, 578–580.

57. Wu Dacheng, *Wu Kezhai (Dacheng) chidu*, 18.

58. Zhang Zhidong, "Dianshi duice," 10044.

59. Zhang Zhidong, *Shumu dawen*, 9918, 9915.

60. Feng Jun, "Yangwu pai," 149.

61. Zhang Zhidong, *Shumu dawen*, 9985; Zha Xiaoying, "'Jinshixue' zai xiandai xueke," 85; Bai, *Fu Shan's World*, 260.

62. Wang Yirong, "Shiwen," 337.

63. Wang Yirong, "Shiwen," 421–422.

64. Elman, *Civil Examinations*, 578–584.

65. Zha Xiaoying, *Wenwu de bianqian*, 33

66. Zhou Hanguan, *Zhang Zhidong yu Guangya shuyuan*, 232–234.

67. Zhang Zhidong, *Quanxue pian*, 9731.

68. Yan Fu, "Jiuwang juelun," 44.

69. Zhang Zhidong, *Quanxue pian*, 9725.

70. This general approach was popular for at least another decade, as with Xia Zengyou's (1863–1924) comparison of the centrality of ancient Greece to the West with the significance of the Zhou Dynasty to Chinese civilization. Hon, "Educating the Citizens," 92.

71. Zhou Hanguang, *Zhang Zhidong yu Guangya shuyuan*, 231.

72. For a discussion of Liang Qichao's emphasis on racial pride in the adoption of *guocui*, see Sang Bing, "Japan and Liang Qichao's Research in the Field of National Learning." See also Zarrow, "Late-Qing Reformism."

73. Cited in Luo Zhitian, "Qingji baocun guocui," 32.

74. Zhang Zhidong, *Quanxue pian*, 9726–9727.

75. Even Wang Guowei, who was critical of Zhang's educational reform program in many respects, advocated more specialized educational opportunities. Bonner, *Wang Kuo-wei*, 39–40.

76. Yue, *Shanghai and the Edges of Empire*, 39–40.

77. For a discussion of the use of maps as elements of Qing political con-

trols, see Millward, "Coming Onto the Map," 62–65; Perdue, *China Marches West*, 442–461; Hostetler, *Qing Colonial Enterprise*, 76–80.

78. As Fa-ti Fan remarks, especially in the first years of the twentieth century, "Geography was an essential component of the *guocui* writers' national narrative, which sought to define the space of the nation. What was the homeland of the nation? What are the boundaries of the nation? And what are the relationships between the local and the nation? These were questions of paramount importance at a time that witnessed the disintegration of the Qing empire and growing regionalism." Fan, "Nature and Nation," 427.

79. Sun Xingyan, *Jingji jinshi kao*, 1a.

80. Perdue, *China Marches West*, 429–435. See also Zarrow, "Imperial Word in Stone."

81. Gao Yan, "Wu Dacheng," 43–44; Zhao Erxun, *Qingshi gao*, 457: 10552.

82. The *Xiao fanghu zhai yudi congchao* (Collected geographical works from the Small Square Vase Studio) by Wang Xiqi (1855–1913) included foreign studies of human geography like *Indu fengsu ji* (Record of Indian customs) by Okamoto Kansuke (1839–1904), but the majority of the works were Qing travelogues, including texts on Russia, Mongolia, Manchuria, Korea, Annam, and Japan, as well as hundreds of texts providing a comprehensive survey of the eighteen provinces. See Ai Suzhen, "Qingmo renwen dilixue," 29.

83. Yang Shoujing, "Nihon kinseki nenpyō xu," 2a; Sugimura Kunihiko, "Yang Shoujing yu Riben shuxue yanjiu," 61.

84. Kang Youwei, *Kang Nanhai zibian nianpu*, 15–16.

85. Kang Youwei, *Guang yizhou shuangji*, 181–182, 202; Bai, "Chinese Calligraphy," 74–75.

86. These theories were inspired by Albert Terrien de Lacouperie (1845–1894) and the British missionary Joseph Edkins (1823–1905), among other sources. In 1871, Edkins published *China's Place in Philology*, intending "to show that the languages of Europe and Asia may be conveniently referred to one origin in the Mesopotamian and Armenian region." This universality was attractive for a missionary, since "scripture…asserts the unity of the human race…and declares that all men once spoke a common language." In 1903, Liang Qichao's journal *Xinmin congbao* published an article discussing Lacouperie's theories that Chinese civilization originated in Babylon. See Edkins, *China's Place in Philology*, xi–xii; Ge Zhaoguang, "Xin shixue," 85; Hon, "Sino-Babylonianism," 140–142.

Chapter 3: A Passion for Antiquity, in Two Dimensions and in Three

1. Liu E, "Liu E riji," 188.
2. Liu E, "Liu E riji," 188.
3. Duanfang, "Taozhi (Duanfang) cundu," 201.

4. Chen Xiaobo, "Guobao Maogong ding," 23; Zhu Jieqin, "Qingdai jin-shuxue shuyao," 108.

5. Cited in Lu Cao, "Lun jindai wenren de jinshi zhi pi," 82.

6. Li Zuoxian, *Guquan hui*, 11–12.

7. Ye Changchi, *Yushi*, 21.

8. Zeitlin, "Petrified Heart," 10–11.

9. Qi Luqing, "Bu qiao de shoucang dajia Liu E," 30–31. The phrase "to love something like sex" is from the *Analects*, when Confucius reflects that he "has never met anyone who loves virtue as much as sex" (rendered by D.C.Lau as "beauty in a woman"). Lau, *Analects*, 98.

10. Wang Yirong, "Bing qi ji shi shu shi tongren bing suhe shi," 111; "Yu Miao Yanzhi," 145.

11. Wu Dacheng, *Wu Kezhai (Dacheng) chidu*, 42.

12. Sun Yirang, *Qiwen juli*, 1b.

13. Ye Changchi, *Yushi*, 21.

14. Gu Tinglong, ed., *Yifengtang youpeng shuzha*, 1: 405.

15. Goldman, "The Nun Who Wouldn't Be," 76–77, 110–115.

16. Song, *Fragile Scholar*, 104–108.

17. Bai, "From Composite Rubbing," 57.

18. Pan Zuyin, *Pangulou yiqi kuanzhi*, 1a.

19. Clunas, *Superfluous Things*, 8.

20. Cited in Shen, "Patronage and the Beginning of a Modern Art World," 14.

21. Wang Yirong, "Xiaoxia liu yong he Pan Zun'an Shilang shi," 104–105. "A thousand pieces of gold could be completely spent" alludes to "Jiang jin jiu" (Bring in the wine) by Li Bai (701–762).

22. Zhang Zhidong, "Shuzha yi," 10126; Zhang Zhidong, "He Pan Boyin renshen xiaoxia liu yong," 10488.

23. Zhang Zhidong, "He Pan Boyin renshen xiaoxia liu yong," 10489.

24. Shen, "Ming Antiquarianism," 66; Gu Tinglong, *Wu Kezhai xiansheng nianpu*, 58.

25. Wu Dacheng, *Wu Kezhai (Dacheng) chidu*, 31; Wang Yirong, "Tian-rangge zaji," 261, 264; Wang Yirong, "Yu Miao Yanzhi," 153.

26. Sun Yanzhao, *Fuzi nianpu*, 162.

27. Wu Dacheng, *Wu Kezhai (Dacheng) chidu*, 19.

28. Ink sketches that were used as references for artists or their appren-tices were also kept closely guarded and secret. Hay, "Painters and Publishing in Shanghai," 173.

29. Attempts at forgery seem to have been made against several of the ar-tifacts in Chen Jieqi's collection, including the Maogong *ding*. Chang Kuang-yuan, "Maogong ding," 54–55.

30. Beurdeley, *Chinese Collector*, 189–190.

31. Wu Dacheng, *Wu Kezhai (Dacheng) chidu*, 7, 10; Lawton, "An Impe-rial Legacy Revisited," 56; Lawton, *Time of Transition*, 41.

32. Xu Ben, "Quanqiuhua," 45.

33. Kong Lingwei, "Bowuxue yu bowuguan," 66.

34. Suzuki Hiroyuki, *Kōkokatachi no 19-seiki;* Yoshiaki Kanayama, *Nihon no hakubutsukan shi,* 49–57.

35. Suzuki Hiroyuki, *Kōkokatachi no 19-seiki,* 91–93.

36. Xu Ben, "Quanqiuhua," 45.

37. Claypool, "Zhang Jian," 568.

38. For a discussion of the conception of natural history materials included in early Chinese museums, see Claypool, "Zhang Jian," 580–587.

39. Kong Lingwei, "Bowuxue yu bowuguan," 66–67.

40. Claypool, "Zhang Jian," 571.

41. For a discussion of the looting of the palace, see Claypool, "Zhang Jian," 569, and Hevia, "Looting Beijing."

42. Wu Dacheng, *Kezhai jigulu,* 4: 11a–11b.

43. Wang Guowei, "Wu Qingqing," 147.

44. Luo Zhenyu, *Yonglu rizha,* 324.

45. Claypool, "Zhang Jian," 570.

46. Pan Zuyin, *Pangulou yiqi kuanzhi,* 1: 1b.

47. Wang Yirong, "Tianrangge zaji," 264, 266.

48. Cited in Gulik, *Chinese Pictorial Art,* 92–93.

49. Zhang Hanrui, "Liulichang yan'ge kao," 3; Claypool, "Zhang Jian," 588.

50. Dong, *Republican Beijing,* 147

51. Sun Dianqi, *Liulichang xiaozhi,* 38–44; Zhou Zhaoxiang, *Liulichang zaji,* 1. By 1932, the city as a whole had 240 antiques shops. See Dong, *Republican Beijing,* 138.

52. Arlington, *In Search of Old Peking,* 217.

53. Duanfang built a superb collection of bronze and jade artifacts, but was criticized for relying too much on the advice of personal assistants. In 1886, he is supposed to have begun studying informally with a Liulichang antiques dealer. Wang Zhiqiu, *Liulichang shihua,* 28; Chen Zhongyuan, *Wenwu hua chunchiu,* 258–259.

54. Zhang Hanrui, "Liulichang yange kao," 4–5; Sun Dianqi, *Liulichang xiaozhi,* 38–44.

55. Clunas, *Superfluous Things,* 126.

56. Wang Ermin, *Sheng Xuanhuai zhencang shudu,* 9: 3828.

57. Wang Yirong, "Tianrangge zaji," 260; Zhi Weicheng, *Qingdai puxue dashi liezhuan,* 282.

58. Wang Ermin, ed., *Sheng Xuanhuai zhencang shudu,* 9: 3828; Bradley W. Reed, *Talons and Teeth,* 207; Luo Kun, *Luo Zhenyu pingzhuan,* 16.

59. Small states during the Spring and Autumn Period, corresponding to modern-day Shandong.

60. Li Zuoxian, *Guquan hui,* 1: 18–20.

61. Gu Tinglong, *Wu Kezhai xiansheng nianpu,* 190.

62. Yang Jingting, *Dumen jilüe*, 5: 218a; Sun Dianqi, *Liulichang xiaozhi*, 328.
63. Creel, *Birth of China*, 29.
64. Gu Tinglong, *Wu Kezhai xiansheng nianpu*, 45–46.
65. Zhi Weicheng, *Qingdai puxue dashi lie zhuan*, 279.
66. Luo Zhenyu, "Wushiri menghenlu," 101.
67. Chang Kuang-yuan, "Maogong ding," 51–52.
68. Chen Jieqi, *Chen Fuzhai zhang biji*, 2b.
69. Wu Dacheng, *Wu Kezhai (Dacheng) chidu*, 50, 58, 71–72, 86–87, 114–115.
70. Wu Dacheng, *Wu Kezhai (Dacheng) chidu*, 6–7, 118, 148, 157. The artificial patination of bronze is discussed in Rong Geng, *Shang-Zhou yiqi tongkao*, 195–196; Barnard, *Bronze Casting*, 204–209.
71. Chang Kuang-yuan, "Maogong ding," 55.
72. Chang Kuang-yuan, "Maogong ding," 55.
73. Wu Dacheng, *Wu Kezhai (Dacheng) chidu*, 14, 21, 25.
74. As Wu Hung notes, "the material and visual properties of a rubbing include not only the imprint it bears but also its material, its mounting style, its colophons and seals, and, if the rubbing is an old one, the physical changes it undergoes during transmission." Wu Hung, "On Rubbings," 45–46.
75. Ye Changchi, *Yushi*, 21–22.
76. Li Zuoxian, *Guquan hui*, 1: 21.
77. Sena, *Pursuing Antiquity*, 60–61 argues that rubbings often outlasted artifacts, making them often more reliable sources.
78. Chang Kuang-yuan, "Maogong ding," 52; Wu Dacheng, *Wu Kezhai (Dacheng) chidu*, 49.
79. Wu Hung, "On Rubbings," 53.
80. Bai Ling, ed., *Zhongguo xiaohua ku*, 1050.
81. Wu Dacheng, *Wu Kezhai (Dacheng) chidu*, 146.
82. Stanley, "The Method of Making Ink Rubbings," 83.
83. Chang Kuang-yuan, "Maogong ding," 56; Lu Hejiu, *Zhongguo jinshixue zhengbian*, 252.
84. Wu Dacheng, *Wu Kezhai (Dacheng) chidu*, 64–65. Wu Dacheng, *Wu Qingqing lin Huang Xiaosong fangbei tu ce*, 32, shows images of what this looked like.
85. Stanley, "The Method of Making Ink Rubbings," 83–84.
86. Wu Hung, "On Rubbings," 58–59; Lu Hejiu, *Zhongguo jinshixue zhengbian*, 208–209.
87. Lu Hejiu, *Zhongguo jinshixue zhengbian*, 336–337.
88. Wu Dacheng discusses making rubbings of entire objects in *Wu Kezhai (Dacheng) chidu*, 158–159. See also Hu, *Visible Traces*, 107–108.
89. Sang Shen, "Quanxingta," 52; Sang Shen, "Qingtongqi," 33–34.
90. Sang Shen, "Qingtongqi," 35.
91. Berliner, "The 'Eight Brokens,'" 62–63.

92. Ledderose, "Aesthetic Appropriations," 234–237.

93. Bai, "From Composite Rubbing," 56–57; Erickson, "Uncommon Themes," 40–41; Shen, *Wu Changshi and the Shanghai Art World,* 70–71. Lawton believes the earliest such images may date to 1814; see "Rubbings of Chinese Bronzes," 11.

94. Bai, "From Composite Rubbing," 60.

95. Ruan Yuan, *Jiguzhai zhongding yiqi kuanzhi,* 1:1a. These catalogs were often collaborative efforts, with groups of scholars (and their secretaries and artisans) working together to find materials, provide images, and arrange for production. The greatest difficulty was preparing characters for engraving; unskilled (or illiterate) artisans could have difficulty producing the "negative" texts that mimicked the effect of rubbings. Wu Dacheng, *Wu Kezhai (Dacheng) chidu,* 27–30, 59–60; Gu Tinglong, *Wu Kezhai xiansheng nianpu,* 265.

96. Liu Tizhi, *Shanzhai jijin lu,* 2: 1a–1b.

97. Fan, *British Naturalists,* 41–42, 47. For a discussion of illustrated publications at the end of the century, see Hay, "Painters and Publishing in Shanghai."

98. Ye Changchi, *Yushi,* 322.

99. Berger, *Empire of Emptiness,* 125–126.

100. Xie Xiaohua, "Qianlong nianjian," 5.

101. The first ink stone in the *Xiqing yanpu,* made from a roof tile, is depicted with shading techniques to imply recessed surfaces as well as chips along its edges. Yu Minzhong, ed., *Xiqing yanpu,* 1: 2a–2b.

102. Bai, "From Composite Rubbing," 57; Berliner, "The 'Eight Brokens,'" 66.

103. Wu Dacheng, *Kezhai jigulu,* 1: 6a, 4: 11a–11b.

104. Berliner, "The 'Eight Brokens,'" 70.

105. Von Spee, *Wu Hufan,* 114–115.

106. Cited in Claypool, "Zhang Jian," 595.

107. Wu Dacheng, *Wu Kezhai (Dacheng) chidu,* 148.

108. Wu Dacheng, *Wu Kezhai (Dacheng) chidu,* 146.

Chapter 4: Wu Dacheng's Paleography and Artifact Studies

1. Lu Hejiu, *Zhongguo jinshixue jiangyi,* 249–252; Liang Qichao, *Intellectual Trends,* xxxiii.

2. His maternal grandfather Han Chong (fl. 1830s) composed a catalog of inscriptions that was later reprinted by Pan Zuyin. For an account of Wu Dacheng and his compulsive sketching, see Zhi Weicheng, *Qingdai puxue dashi liezhuan,* 279.

3. "Wu Dacheng zhi Weng Tonghe," 2. He particularly admired a *fangbei* album by Huang Yi that commemorated a search for monuments in a region that included the Longmen grottoes; the album was inscribed by Wang

Niansun and several other well-known antiquarians. He was finally able to see the album that he "dreamed of for so long" after his friend Ni Wenwei (1823–1890) procured a copy. He then made his own version, duplicating Huang Yi's images and colophons almost exactly—celebrating antiquarian social networks, but also perpetuating the album's meditative sense of immersion in antiquity. Duanfang also obtained a copy of Huang Yi's album in 1905, and admired it for Weng Fanggang's extensive notes. See Tseng, "Retrieving the Past," 47–48; "Wu Dacheng zhi Weng Tonghe," 4; Duanfang, "Taozhi (Duanfang) cundu," 201; and Hsu, "Huang Yi's *Fangbei* Painting," 253.

4. In his early twenties, he read Zhu Xi's *Jinsi lu* (Reflections on things at hand), an anthology of edifying sayings that encouraged students to ponder the concrete things of the material world. Inspired by this approach, Wu Dacheng conceived of his calligraphy as a form of meditative concentration. Gu Tinglong, *Wu Kezhai xiansheng nianpu,* 6.

5. Even Wu Dacheng's earliest pieces of painting and calligraphy found collectors. Gu Tinglong, *Wu Kezhai xiansheng nianpu,* 4–5.

6. Wang Qian'gang, *Qingren shuping,* 833.

7. Wu Dacheng, *Wu Kezhai (Dacheng) chidu,* 16.

8. Zhao Erxun, *Qingshi gao,* 457: 10552.

9. Schmidt, *Within the Human Realm,* 290–291; Bai, "From Wu Dacheng to Mao Zedong," 253–255.

10. Pan Zuyin's library also included a Japanese edition of an ancient script *Xiaojing* (Classic of filiality), which Wu also rewrote in seal script. Pan Zuyin, *Pangxizhai cangshu ji,* 1b.

11. Yan Ruoqu believed that ancient scripts were no longer in common use during the Eastern Jin (317–420), when Mei Ze (fl. 317–322) rediscovered the Old Text version of the *Documents.* Yang Shanqun, "Guwen *Shangshu* liuchuan guocheng tantao," 119–121.

12. Liu Shipei, "Lun kaoguxue," 466–467.

13. Cited in Wu Min'gui, *Wan Qing renwu yu jinshi shuhua,* 48.

14. Qi, "A Discourse on Chinese Epigraphy," 20–22.

15. Wu Dacheng, *Wu zhuan* Lunyü, 1b–2a.

16. Boltz, "Shuo wen chieh tzu," 430.

17. Tang Lan, *Gu wenzixue daolun,* 2: 23b; Gong Zizhen, "*Shang-Zhou yiqi wen lu* xu," 267.

18. Zhang Zhidong, *Youxuan yu,* 9779. Dozens of *Shuowen* projects were published in the nineteenth century, including several projects by members of Pan Zuyin's scholarly circle. Mo Youzhi edited a fragmentary Tang Dynasty *Shuowen,* while Wang Yirong published the ambitious *Shuowen yizi* (Characters omitted by the Shuowen) by Zheng Zhen (1806–1864), which aimed to restore graphs from New Text classics to the dictionary.

19. Wu Dacheng, Shuowen *guzhou bu,* 1: 3b; Luo Zhenyu, "Shuowen *guzhou bu* ba," 488.

20. Wu Dacheng, Shuowen *guzhou bu*, 1: 3b.

21. Pan Zuyin, "*Shuowen guzhou bu* xu," 2a; Chen Jieqi, "*Shuowen guzhou bu* xu," 2b.

22. Li Ji, *Anyang*, 6.

23. Gu Tinglong, *Wu Kezhai xiansheng nianpu*, 189.

24. Zhang Zhidong, "Maogong ding," 10373.

25. Dobson, *Early Archaic Chinese*, 218; Shaughnessy, *Sources of Western Zhou History*, 81.

26. Dobson, *Early Archaic Chinese*, 218.

27. Based on Chang, "Xizhou zhongqi Maogong ding," plate 15.

28. Wu Dacheng, *Kezhai jigulu*, 4: 5a.

29. The inspiration for this technique may have been the *Jingdian shiwen* (Explanation of graphs in the Classics) by Lu Deming (556–627), a lexicon that includes not only single-character listings but also multicharacter phrases culled from ancient texts, some of which did not survive the Tang Dynasty. Tang Lan discusses Wu's use of the technique in *Gu wenzixue daolun*, 2: 19b–22a.

30. Sun Yirang, *Qiwen juli*, 2: 1b. Sun's second work on the inscriptions, *Mingyuan* (Origin of language), includes a chapter entitled "Shuowen *buque*" (Correcting deficiencies in the *Shuowen*), which also uses *tuikan* analysis.

31. Wu Dacheng, *Kezhai jigulu*, 4: 5a.

32. Luo Zhenyu, "Guqiwu zhi xiao lu xu," 25.

33. Zha Xiaoying, "'Jinshixue' zai xiandai xueke tizhi xia," 88.

34. Lyell, *Principles of Geology*, 739.

35. Lyell, *Principles of Geology*, 739.

36. Su, "The Reception of 'Archaeology' and 'Prehistory,'" 430.

37. Xue Fucheng, "Eluosi jinsou gubei ji," 1067–1068.

38. Lawton, *Time of Transition*, 8.

39. Tan Sitong, "Shijuyinglu bizhi," 252.

40. Fan, "Nature and Nation," 421; Zha Xiaoying, "Dizhixue," 96.

41. Ninagawa Noritane, *Kwan-ko-dzu-setsu*, 1: 1–4. Edward S. Morse (1838–1925), for two years a zoology professor at Tokyo University, praised Ninagawa's illustrations as "far more characteristic of the pottery than the more perfectly chromolithographed ones one sees in English and French publications on similar subjects." Morse, *Japan Day by Day*, 106; Ikawa-Smith, "Co-Traditions in Japanese Archaeology," 297–298.

42. Wu Dacheng, *Guyu tukao*, 1: 1a–1b.

43. Wu Dacheng, *Guyu tukao*, 1: 2a.

44. Wu Dacheng, *Guyu tukao*, 1: 1b.

45. Keightley, "Measure of Man," 35.

46. Harrist, "Artist as Antiquarian," 262.

47. Liang Shizheng, *Xiqing gujian*, 34:3a–b. The length they came up with, twenty-three centimeters is corroborated by David Keightley ("Measure of Man," 19, 23) in his study of Neolithic jades.

48. Wu Dacheng, *Quanheng duliang shiyan kao,* 2a.

49. Wu Dacheng, *Guyu tukao,* 1: 2a–4a.

50. Although the term *shiyan* (experiment) means to verify or demonstrate in classical Chinese, by 1889 it meant attempt or trial, and by 1903 it referred specifically to scientific experimentation. Xianggang Zhongguo yuwen xuehui, *Jin Xiandai Hanyu xinci ciyuan cidian,* 235. See also Liu, *Translingual,* Appendix A, 270.

51. Liu E, *Travels of Lao Can,* 15.

52. Amelung, "Weights and Forces," 214–218.

53. Gu Tinglong, *Wu Kezhai xiansheng nianpu,* 189–190.

54. Wu Dacheng, *Quanheng duliang shiyan kao,* 2a.

55. DeWoskin, *Song for One or Two,* 63–64. Significant to both governance and science, the nature of the *huangzhong lüguan* was a favorite topic of late-Ming civil examinations. Elman, *Civil Examinations,* 479–481.

56. In the *Hou Hanshu* (History of the Former Han), the *huangzhong lüguan* is specified as nine inches long, filled perfectly by 1,200 grains of black millet. Wu tested his own *lüguan* by filling it with grain. Finding that the tube accommodated that amount of grain precisely, he felt confident that "this tube was without doubt the measuring tube for Zhou Dynasty bells." Needham, *Science,* 199–200; Wu Dacheng, *Quanheng duliang shiyankao,* 2a.

57. Wu Dacheng, *Quanheng duliang shiyankao,* 21a, 22b–23a.

58. Liu Shipei, "Jinshi zhi," 265–266.

59. Su, "Reception of 'Archaeology' and 'Prehistory,'" 440.

60. Luo Zhenyu, "*Quanheng duliang shiyan kao* xu," 410. For a general discussion of artifact studies and Luo Zhenyu's role, see Lu Xixing, "Cong jinshixue, kaoguxue dao gudai qiwu xue," 67–68.

61. Laufer, *Jade,* 13.

62. Gu Tinglong, *Wu Kezhai xiansheng nianpu,* 217; Chalfant, "Weights and Measures," 21–22.

63. Luo Fuyi, *Chuanshi lidai guchi tulu;* Wang Guowei, "Zhongguo lidai zhi chidu."

64. Wang Guowei, "Guantang jilin xu," 284.

65. Rong Geng, "Wang Guowei xiansheng kaoguxue shang zhi gongxian," 7340.

Chapter 5: The Discovery of the Oracle Bone Inscriptions

1. The English phrase "oracle bones" probably originated in 1914 with Samuel Couling's "The Oracle-Bones from Honan." Chinese scholars called them *guijia* (tortoiseshell) and *jiapian* (shell fragments) before Hayashi Taisuke pioneered *kikkō gyūkotsu* (C. *guijia niugu,* plastrons and bones) in his 1909 article "Kikkō gyūkotsu ni tsukite." The abbreviated form, *jiagu,* is now the most common Chinese term. Luo Zhenyu emphasized inscriptions with

shuqi (engraved text), *zhenbu wenzi* (divination script), *keci* (engraved texts), and *buci* (divination texts).

2. Wang Guowei, "*Yinxu shuqi kaoshi* xu," 1130.

3. Luo Zhenchang, *Huan-Luo*, 1: 11a–11b; Dong Zuobin, *Jiagu nianbiao*, 1a. "Dragon bones" and "teeth" were also of interest to the European paleontologists who discovered Peking Man. See Schmalzer, *People's Peking Man*, 35–36.

4. Dong Zuobin, *Jiagu nianbiao*, 1a.

5. Chen Mengjia, *Yinxu buci zongshu*, 648.

6. Chen Mengjia, *Yinxu buci zongshu*, 647.

7. Sima Qian, "Gui ci liezhuan," 1b.

8. Luo Zhenyu, "*Tieyun canggui* xu," 9.

9. Ma Sanheng, *Mozhi*, 1a.

10. Wu Changshi, "*Tieyun canggui* xu," 16.

11. Liu E, *Tieyun canggui*, 19–20.

12. Dong Zuobin, *Jiagu nianbiao*, 1b.

13. Luo Zhenchang, *Huan-Luo*, 12a–12b; Wang Yuxin, *Jiaguxue yibainian*, 32–33.

14. Chen Mengjia, *Yinxu buci zongshu*, 647.

15. Liu E, "Liu E riji," 203–204, 205.

16. Chen Mengjia, *Yinxu buci zongshu*, 647.

17. Wang Yuxin, *Jiaguxue tonglun*, 74.

18. Menzies, *Oracle Records*, 3.

19. Couling, "The Oracle-Bones from Honan," 65.

20. Lefeuvre, "Les inscriptions des Shang," 32.

21. Based on the literary names of Luo Zhenyu (Xuetang), Wang Guowei (Guantang), Dong Zuobin (Yantang), and Guo Moruo (Dingtang).

22. Luo Zhenchang, *Huan-Luo*, 1: 12a–12b.

23. Luo Zhenyu, "Wushiri menghenlu," 104.

24. Luo Zhenchang, *Huan-Luo*, 1: 10a–10b.

25. Luo Zhenchang, *Huan-Luo*, 1: 4a.

26. Wang Yuxin, *Jiaguxue yibainian*, 34–37.

27. Menzies, *Oracle Records*, 1–2.

28. Yetts, "Memoir of the Translator," xviii–xix.

29. Couling, "The Oracle-Bones from Honan," 66.

30. Sun Yanzhao, *Fuzi nianpu*, 309–310, 321, 346–347.

31. Sun Yanzhao, *Fuzi nianpu*, 297.

32. Sun Yirang, *Zhouli zhengyi*, 1: 5–6.

33. Sun Yirang, *Zhouli zhengyi*, 1: 7–8.

34. Sun Yanzhao, *Fuzi nianpu*, 297.

35. Sun Yanzhao, *Fuzi nianpu*, 305–306.

36. Liu E, *Tieyun canggui*, 22–26.

37. Luo Zhenyu, "*Tieyun canggui* xu," 3–6.

38. Luo Zhenyu, "*Tieyun canggui* xu," 8–9.

39. Luo Zhenyu, "*Tieyun canggui* xu," 9–13.

40. Sun Yirang, *Qiwen juli,* 1a–1c.

41. Yue, *Shanghai and the Edges of Empire,* 39–40.

42. Wright, "Yan Fu and the Tasks of the Translator," 237.

43. Sun Yirang, *Mingyuan,* 1a.

44. Sun Yirang, *Qiwen juli,* 1: 2a; *Mingyuan,* 3a.

45. Sun Yirang, *Mingyuan,* 1b.

46. Kang Youwei, *Guang yizhou shuangji,* 181–182, 202; Bai, "Chinese Calligraphy," 74–75.

47. Hon, "Sino-Babylonianism," 140–142.

48. Zha Xiaoying, *Wenwu de bianqian,* 12, 28–29; Luo Zhenyu, "*Aiji bei-shi* xu," 514.

49. Sun Yirang, *Guzhou yulun,* 1:3a.

50. Sun Yanzhao, *Fuzi nianpu,* 343.

51. Sun's goals were complimentary of the ideologies espoused by contemporaries like Liang Qichao, who urged historians to establish universal standards of human development in order to provide a context for China's future progress. For a discussion of this view, see Wang, *Inventing China Through History,* 49.

52. Sun Yanzhao, *Fuzi nianpu,* 351.

53. Zarrow, "New Schools," 34–39.

54. Luo Zhenyu acknowledged receiving "a letter and notes" from Sun Yirang, but not the entire *Qiwen juli.* Chen Mengjia, however, states that he did receive a full copy, along with Duanfang and Liu E. Luo Zhenyu "Jiliao-bian," 30–31; Chen Mengjia, *Yinxu buci zongshu,* 55. The controversy is discussed in Bonner, "Lo Chen-yü's Research," 164–165.

55. In 1927, the Tanyinlu publishing house (which employed Luo Zhenyu's brother Luo Zhenchang and his son-in-law Liu Dashen, Liu E's son) reprinted a copy. Luo Zhenyu, *Yinxu shuqi qianbian,* 1: 1a.

56. Luo Zhenyu, *Yinxu shuqi qianbian,* 1: 1a–1b. Guo Moruo also criticized Sun Yirang; see *Buci tongzuan,* 3.

57. Wang Qingxiang, *Luo Zhenyu, Wang Guowei wanglai shuxin,* 217–218.

58. Wang Guowei, "Zuijin er, sanshi nian zhong Zhongguo xin faxian zhi xuewen," 1918.

59. Sun Yanzhao, *Fuzi nianpu,* 348–349.

60. Zhang Taiyan, "Lihuo lun," 59.

61. Similar concerns have been raised about the authenticity of some Dunhuang manuscripts (discussed in Chapter Six), since many expert copies of original Dunhuang texts were successfully passed off as original antiquities. See the discussion in Rong, "Li Shengduo Collection."

62. Menzies, *Oracle Records,* 4.

63. Yetts, "Memoir of the Translator," xix.

64. Luo Zhenyu, "Wushiri menghenlu," 105.
65. Hayashi Taisuke, "*Kanji no kenkyū* jo," 3.
66. Mazur, "Discontinuous Continuity," 128.
67. Liang Qichao, *Zhongguo shi xulun*, 9.
68. Mazur, "Discontinuous Continuity," 128.
69. Zarrow, "New Schools," 33.
70. Zarrow, "New Schools," 32–36.
71. Lu Xinsheng, *Yigu sichao yanjiu*, 490–491.
72. Mazur, "Discontinuous Continuity," 130.
73. Tanaka, *Japan's Orient*, 117.
74. Zhang Taiyan, *Zhang Taiyan shuxin ji*, 284–285.
75. He Yin, *Guowai Hanxueshi*, 323–325.
76. Hayashi Taisuke, "Kikkō gyūkotsu ni tsukite," 131–133.
77. Brown, "What Is Chinese About Ancient Artifacts?," *passim*.
78. Luo Zhenyu, "Jiliaobian," 42; Luo Zhenyu, *Yin-Shang zhenbu wenzi kao*, 1: 1a.
79. Luo Zhenyu, "Yinxu guqiwu tulu xu," 67.
80. Luo Zhenyu, "Wushiri menghenlu," 104.
81. Chen Mengjia, *Yinxu buci zongshu*, 648.
82. Rudolph, "Lo Chen-yü Visits the Waste of Yin," 7–8.
83. Luo Zhenyu, *Yinxu shuqi qianbian*, 1: 2a.
84. Luo Zhenchang, *Huan-Luo*, 1: 1b.
85. Luo Zhenchang, *Huan-Luo*, 1: 12a.
86. Luo Zhenchang, *Huan-Luo*, 1: 3a.
87. Luo Zhenchang, *Huan-Luo*, 1: 4b–6b.
88. This collection may ultimately have reached forty thousand fragments. According to Jean Lefeuvre, half of the collection was lost in transit to Japan, but Luo made further purchases. Wang Yuxin, more conservatively, estimates Luo's final collection at thirty thousand pieces. See Lefeuvre, "Les inscriptions des Shang," 40–41, 55; Wang Yuxin, *Jiaguxue tonglun*, 74.
89. Luo Zhenyu, "Wushiri menghenlu," 104.
90. Luo Zhenyu, *Yin-Shang zhenbu wenzi kao*, 1: 1a–1b.
91. Luo Zhenyu, *Yin-Shang zhenbu wenzi kao*, 1: 4b–5a.
92. Luo Zhenyu, *Yin-Shang zhenbu wenzi kao*, 1: 2a–2b.
93. Luo Zhenyu, *Yin-Shang zhenbu wenzi kao*, 1: 4a–5a.
94. Luo Zhenyu, *Yin-Shang zhenbu wenzi kao*, 1: 1b.
95. Luo Zhenyu, *Yinxu shuqi kaoshi*, 1: 1a–1b. The use of *fanbian* for evolution is also found in Yan Fu's translation of Huxley's *Evolution and Ethics*.
96. Chen Mengjia, *Yinxu buci zongshu*, 59.
97. Peng Yuping, "Guanyu *Yinxu shuqi kaoshi* de yizhuang gong'an," 199. Guo Moruo claimed that Wang Guowei voluntarily offered Luo Zhenyu his research out of gratitude for his patron's support. Guo Moruo, "Lu Xun yu Wang Guowei," 175.

98. According to Joey Bonner, Wang Guowei and Luo Zhenyu disagreed about the locations of the last Shang capital, making it unlikely that the work was collaborative. At the same time, their research in Kyoto cannot easily be separated. Their source materials overlapped, they shared ideas and debated the meaning of inscriptions intensely, and frequently borrowed each other's conclusions. After Wang Guowei left Kyoto and established a more independent scholarly identity, Luo increasingly acknowledged the distinctiveness of his protégé's scholarship, particularly regarding studies of the oracle bone inscriptions. See Bonner, *Wang Kuo-wei,* 175; Peng Yuping, "Guanyu *Yinxu shuqi kaoshi* de yizhuang gong'an," 204–205; and for an example of Luo Zhenyu's growing appreciation for Wang Guowei's, see Luo's praise for his protégé in *Zengding yinxu shuqi kaoshi,* 1: 5a and *passim.*

99. For example, regarding one study of ancient artifacts, he boasted to Wang Guowei, "I am the only one who could have compiled this book since I am the only person who has collected all of several kinds of pieces." See Wang Qingxiang, *Luo Zhenyu, Wang Guowei wanglai shuxin,* 88.

100. Jin Zutong studied with Luo Zhenyu, who wrote a preface for one of Jin's works on the oracle bone inscriptions. Guo Chengmei, "Huizu xuezhe Jin Zutong," 140.

101. Zhang Taiyan, *Zhang Taiyan shuxin ji,* 960.

102. Zhang Taiyan, *Zhang Taiyan shuxin ji,* 284–285. Li Ji claimed that Zhang Taiyan was finally persuaded that the oracle bone inscriptions were real at the end of his life, and even kept a set of Luo's oracle bone catalogs by his bedside. See Li Ji, *Anyang,* 37.

103. In fact, his perspective was very similar to many late-Qing history textbooks, which focused on the dynastic state as a narrative structure and source of national identity. See Zarrow, "New Schools," 39–43.

104. Luo Zhenyu, "Jiliaobian," 32.

Chapter 6: Luo Zhenyu and the Dilemmas of the Private Scholar

1. Sang Bing, "Chen Yinke yu Qinghua yanjiuyuan," 131.

2. Luo Kun, *Luo Zhenyu pingzhuan,* 2–3, 10–13. Foreign contemporaries apparently believed Luo Zhenyu attained the *jinshi* degree. Ferguson, "Recent Works," 125.

3. Wang Yirong, "Tianrangge zaji," 259.

4. Luo Zhenyu, "Jiliaobian," 6.

5. Gan Ru, *Yongfeng xiangren xingnian lu,* 5.

6. Luo Zhenyu, "Jiliaobian," 7; Luo Zhenyu, "Wushiri menghenlu," 106–107; Gan Ru, *Yongfeng xiangren xingnian lu,* 11; Luo Kun, *Luo Zhenyu pingzhuan,* 18.

7. Luo Zhenyu, "Jiliaobian," 10.

8. Both of these journals were published until 1906. Luo Kun, *Luo Zhenyu pingzhuan*, 200; Yuan Yingguang, *Wang Guowei nianpu changbian*, 10.

9. Luo Zhenyu, "*Jiaoyu shijie* xulie," 1b.

10. Gan Ru, *Yongfeng xiangren xingnian lu*, 30–31.

11. Luo Zhenyu, *Yonglu rizha*, 316.

12. Luo Zhenyu, "Jiliaobian," 45.

13. Wang Guowei, "Xuetang jiaokan qunshu xulu xu," 1137.

14. Luo Zhenyu, *Yonglu rizha*, 348–349.

15. Su, "Reception of 'Archaeology' and 'Prehistory,'" 435.

16. Luo Zhenyu, "*Gu mingqi tulu* xu," 78. On the taboo status of tomb figurines, see Clunas, *Superfluous Things*, 93.

17. Wang Qingxiang, *Luo Zhenyu, Wang Guowei wanglai shuxin*, 594.

18. Luo Zhenyu, "Fusang liangyue ji," 62–63.

19. Tomita Noboru, *Liuzhuan yu jianshang*, 247–248.

20. Tomita Noboru, *Liuzhuan yu jianshang*, 249–251.

21. Suzuki Hiroyuki, *Kōkokatachi no 19-seiki*, 62–65; Su, "Reception of 'Archaeology' and 'Prehistory,'" 424 n. 4. The *xue* or -logy suffix originated in China during the late Qing, but the "trisyllabic" nature of *kaoguxue* suggests that it was a Japanese import, or "return graphic loan-word." For discussion of these loan words, see Liu, *Translingual Practice*.

22. Xianggang Zhongguo yuwen xuehui, *Jin xiandai Hanyu xinci ciyuan cidian*, 145. Some scholars like Liu Shipei, however, continued to define *kaoguxue* as simply the "study of antiquity" and considered it a way to evaluate antiquarian materials, rather than a wholly new discipline. Liu Shipei, "Lun kaoguxue," 463–464.

23. Su, "Reception of 'Archaeology' and 'Prehistory,'" 440–442.

24. Luo Zhenyu, "Fusang liangyue ji," 84.

25. Luo Zhenyu, "Jiliaobian," 31.

26. Liang Qichao, *Zhongguo lishi yanjiu fa*, 60.

27. Luo Zhenyu, "Jiliaobian," 29–30.

28. Luo Zhenyu, "*Liusha fanggu ji* xu," 38.

29. Luo Zhenyu, "*Liusha fanggu ji* xu," 38.

30. Sang Bing, "Boxihe yu jindai Zhongguo xueshujie," 118–119.

31. Luo Zhenyu, "Jiliaobian," 36–37, and "*Yiji congcan*," 38–39. For a discussion of the case, see Rong, "Li Shengduo Collection," 62–63 and *passim*.

32. Hopkirk, *Foreign Devils on the Silk Road*, 220–222.

33. Lu Xun, "Tan suowei neige dang'an," 562–563.

34. Brown, "Archives at the Margins," 251–256.

35. Wang Qingxiang, *Luo Zhenyu, Wang Guowei wanglai shuxin*, 534.

36. Wang Guowei, "Kushulou ji," 1166; Wang Qingxiang, *Luo Zhenyu, Wang Guowei wanglai shuxin*, 532.

37. Wang Guowei, "Songdai zhi jinshixue," 1927.

38. Huters, *Bringing the World Home,* 50–52.

39. Yue, *Shanghai and the Edges of Empires,* 47–51.

40. Wang Qingxiang, *Luo Zhenyu, Wang Guowei wanglai shuxin,* 80.

41. At the same time, he never completely abandoned his support for public (or at least corporate) institutions. Just after the end of World War I, for example, he proposed to establish a library and museum in conjunction with a new international society for Chinese studies. Luo Zhenyu, "Jiliaobian," 49.

42. Luo Zhenyu, *Guqiwuxue yanjiu yi,* 4a.

43. Luo Zhenyu, "Jiliaobian," 39–40.

44. Luo Zhenyu, "Jiliaobian," 41.

45. For a discussion of Chinese expatriates in Japan at the turn of the century and after, see Harrell, *Sowing the Seeds of Change;* and Lu, *Re-Understanding Japan.*

46. Gan Ru, *Yongfeng xiangren xingnian lu,* 20–22.

47. Luo Zhenyu, "Fusang liangyue ji," 74, 76.

48. Fogel, *Politics and Sinology,* 119–120.

49. Wang Yuxin, *Jiaguxue yibainian,* 92–93.

50. Luo Zhenyu, "Jiliaobian," 41.

51. Luo Zhenyu, "Jiliaobian," 41.

52. Luo Zhenyu, "Jiliaobian," 45.

53. Wang Guowei, *Wang Guowei quanji: shuxin,* 24.

54. Luo Zhenyu, "Jiliaobian," 49.

55. Luo Jizu, *Fuji liuhen,* 114.

56. Wang Qingxiang, *Luo Zhenyu, Wang Guowei wanglai shuxin,* 11 n. 3.

57. Wang Qingxiang, *Luo Zhenyu, Wang Guowei wanglai shuxin,* 17, 56.

58. Couling, "Review of James Menzies," 216.

59. Chen Mengjia, *Yinxu buci zongshu,* 653–654.

60. Hayashi Taisuke, "Kikkō jūkotsu monji," 148. Although Hayashi's tone here is mild, the fact that he mentioned the matter so publicly in his own catalog of oracle bone inscriptions suggests his anger.

61. Judge, *Print and Politics,* 42.

62. Wang Guowei, "Xuetang jiaokan qunshu xulu xu," 1135.

63. Luo Zhenyu, "*Yinxu guqiwu tulu* xu," 68.

64. Wang Guowei, "Xuetang jiaokan qunshu xulu xu," 1137.

65. Wang Qingxiang, *Luo Zhenyu, Wang Guowei wanglai shuxin,* 16.

66. Wang Qingxiang, *Luo Zhenyu, Wang Guowei wanglai shuxin,* 45.

67. Hu Houxuan, "Guanyu Liu Tizhi, Luo Zhenyu, Mingyishi," 5–6.

68. Huang Binhong, "Hubin guwan shichang ji," 291–292.

69. See Kuiyi Shen's discussion of young Shanghai artists, their pricelists, and how they marketed their works to clients in *Wu Changshi and the Shanghai Art World,* 105–112.

70. Shen, "Patronage and the Beginning of a Modern Art World," 19–20.

71. Tomita Noboru, *Liuzhuan yu jianshang,* 75–77, 82–87.

72. Tomita Noboru, *Liuzhuan yu jianshang,* 83.

73. Luo Zhenyu, "Jiliaobian," 45.

74. Wang Qingxiang, *Luo Zhenyu, Wang Guowei wanglai shuxin,* 137.

75. Wang Qingxiang, *Luo Zhenyu, Wang Guowei wanglai shuxin,* 145.

76. Wang Zhongxiu et al., *Jin xiandai jinshi shuhuajia runli,* 96.

77. Wang Guowei, "Renjian shihao zhi yanjiu," 1799–1800.

78. Wang Qingxiang, *Luo Zhenyu, Wang Guowei wanglai shuxin,* 36, 46.

79. Morohashi Tetsuji, "Yū Shi zappitsu," 84–85.

80. Wang Qingxiang, *Luo Zhenyu, Wang Guowei wanglai shuxin, Luo Zhenyu, Wang Guowei wanglai shuxin,* 61.

81. Wang Qingxiang, *Luo Zhenyu, Wang Guowei wanglai shuxin,* 133.

82. Wang Qingxiang, *Luo Zhenyu, Wang Guowei wanglai shuxin,* 143.

83. Wang Qingxiang, *Luo Zhenyu, Wang Guowei wanglai shuxin,* 141.

84. Wang Qingxiang, *Luo Zhenyu, Wang Guowei wanglai shuxin,* 134.

85. Wang Qingxiang, *Luo Zhenyu, Wang Guowei wanglai shuxin,* 220.

86. Lefeuvre, *Collections d'inscriptions oraculaires,* 306–307.

87. Puyi, *From Emperor to Citizen,* 174.

88. Zhang Taiyan, *Zhang Taiyan shuxin ji,* 962–963. Luo was accused of forging seals and other dating characteristics of paintings during his first forays into connoisseurship in the 1890s. Gao Yang, *Qingmo si gongzi,* 130.

89. Guo Moruo, "Lu Xun yu Wang Guowei," 176.

90. Kohara Hironobu, "Zhongguo huihua shi yanjiu," 68–69.

91. Marcel Granet (1884–1940), for example, accused Luo Zhenyu of using his scholarly knowledge to pass forged bones off as genuine in order to profit from their sale. Keightley, *Sources of Shang History,* 141 n. 30.

92. Lu Xun, "Tan suowei neige dang'an," 561; Zhou Zuoren, "Lin Qinnan yu Luo Zhenyu," 625.

93. Andrews, "Traditionalist Response," esp. 79–80.

Chapter 7: Wang Guowei—From Antiquarianism to History

1. Yeh, *Alienated Academy,* 42–44.

2. Sang Bing, "Jindai Zhongguo xueshu de diyuan yu liupai," 36.

3. Wang Guowei, "Zhexue bianhuo," 3–4; Wang Guowei, "Shu jinshi jiaoyu sixiang," 9.

4. Zhang Lianke, *Wang Guowei yu Luo Zhenyu,* 16–17.

5. Yin Nan, "Wo suo zhidao de Wang Jing'an xiansheng," 7165.

6. Yuan Yingguang, *Wang Guowei nianpu changbian,* 11, 17, 22.

7. Wang Guowei, "Zixu," 1825.

8. Cai Yuanpei, for example, praised Wang for clarifying debates over "utilitarianism" in philosophy. Cai Yuanpei, "Zhongguoren yu zhexue zhi guanxi," 97–98. On Yan Fu's translations, see Wright, "Yan Fu and the Tasks of the Translator," 239–240, 242–244.

9. Wang Guowei, "*Jing'an wenji* zixu," 1547.

10. Young, *Schopenhauer*, 142–143.

11. Lu Xun also claimed he rejected medical studies and embraced litera-ture as a way to address contemporary political problems. See Lu Xun, *Selected Stories*, 3.

12. Bonner, *Wang Kuo-wei*, 85–86.

13. Wang Guowei, "Qudu pian," 1870–1871.

14. Wang Guowei, "Zouding jingxueke daxue," 1863, 1868.

15. Goethe defined world literature as works made possible by unique na-tional literary traditions; hence it was both international and country-specific. Pizer, *Idea of World Literature*, esp. 33–37.

16. He, "Wang Guowei," 143.

17. He, "Wang Guowei," 132–133; Wang Guowei, "*Qulu* xu," 273.

18. He, "Wang Guowei," 129–130, 149–150.

19. Wang Guowei, "Kongzi zhi meiyu zhuyi," 158.

20. Sieber, *Theaters of Desire*, 4–7.

21. Wang Guowei, "Lun xin xueyu zhi shuru," 1741–1742.

22. Wang Guowei, "Kongzi zhi xue shuo," 124–125.

23. Cai Yuanpei, "Zhongguoren yu zhexue zhi guanxi," 97, 100; Fu Si-nian, "Wang Guowei zhuo *Song Yuan xiqu shi*," 1429.

24. Wang Dongming, "Huainian wo de fuqin," 478.

25. Wang Qingxiang, *Luo Zhenyu, Wang Guowei wanglai shuxin*, 456; Wang Guowei, *Wang Guowei quanji: shuxin*, 230–231.

26. Wang Guowei, *Wang Guowei quanji: shuxin*, 311.

27. Luo Zhenyu, "Haining Wang Zhongque gong zhuan," 7020.

28. Wang Guowei, *Wang Guowei quanji: shuxin*, 40–41.

29. Zhang Lianke, *Wang Guowei yu Luo Zhenyu*, 247–249.

30. Wang Qingxiang, *Luo Zhenyu, Wang Guowei wanglai shuxin*, 325.

31. Bonner, *Wang Kuo-wei*, 202–204.

32. Zhang Lianke, *Wang Guowei yu Luo Zhenyu*, 238–239.

33. Wang Dongming, "Huainian wo de fuqin," 475.

34. Wang Dongming, "Zui shi renjian liu bu zhu," 456–457.

35. Wang, *Inventing China Through History*, 46–50.

36. Wang Guowei, "*Guoxue congkan* xu," 1408.

37. Wang, *Inventing China Through History*, 63–66.

38. Wang Guowei, "Yin-Zhou zhidu lun," 433. Wang Guowei's men-tion of *fengjian* (feudalism) is notable, since it is one of the earliest Chinese uses of a concept that would become the hallmark of subsequent Marxist historiography.

39. Wang Guowei, "Yin-Zhou zhidu lun," 460–462.

40. For views of "China's immobility" among nineteenth-century West-ern historians, see Cohen, *Discovering History*, 58–60.

41. Zhang Lianke, *Wang Guowei yu Luo Zhenyu*, 215.

42. Zhang Lianke, *Wang Guowei yu Luo Zhenyu*, 218–219.

43. Wang Guowei, "Yin-Zhou zhidu lun," 460–462.

44. Wang Guowei, "Yin-Zhou zhidu lun," 433.

45. Wang Guowei, "Zhanguo shi Qin yong zhouwen Liuguo yong guwen shuo," 287–288. Wang Guowei's theory has been disputed by some recent philologists. For a brief discussion, see Qi, "Discourse on Chinese Epigraphy," 20.

46. Wang Fan-Sen, *Fu Ssu-nien*, 107.

47. Schmalzer, *People's Peking Man*, 50–51.

48. Gladney, *Muslim Chinese*, 83–84.

49. "Gu Jiegang zhi Wang Guowei de san feng xin," 11.

50. "Wang Guowei zhi Gu Jiegang de san feng xin," 205.

51. Wang Guowei, *Wang Guowei quanji: shuxin*, 324.

52. Wang Qingxiang, *Luo Zhenyu, Wang Guowei wanglai shuxin*, 544.

53. Zhao Lidong, "*Gushibian* yu *Gushi xinzheng*," 109.

54. Wang, *Inventing China Through History*, 56–58.

55. Wang, *Inventing China Through History*, 58–59.

56. Wang Qingxiang, *Luo Zhenyu, Wang Guowei wanglai shuxin*, 544.

57. Wang Guowei, *Gushi xinzheng*, 2077.

58. Su, "Reception of 'Archaeology' and 'Prehistory,'" 435.

59. Wang Guowei, "Zuijin er, sanshi nian zhong Zhongguo xin faxian zhi xuewen," 1915–1916.

60. Wang Guowei, "*Guantang jilin xu*," 285.

61. Gu Jiegang, "*Gushibian* zixu," 6.

62. Hon, "Cultural Identity and Local Self-Government," 513–514.

63. Wang Guowei, *Gushi xinzheng*, 2080.

64. Wang Guowei, *Wang Guowei quanji: shuxin*, 435–437.

65. Liang Qichao, *Zhongguo lishi yanjiu fa*, 38–48. Chen Yinke and Wang Guowei also encouraged the use of paintings and sculpture in research. By appreciating these with a spirit of connoisseurship and enjoyment, Chen wrote, historians could better understand the reasons for their creation, while Wang Guowei argued—in terms similar to antiquarian critiques of using artifacts as "toys"—that paintings should not be appreciated simply as "curios." Chen Yinke, "Feng Youlan *Zhongguo zhexue shi*," 279; Wang Guowei, "Kongzi zhi meiyu zhuyi," 158.

66. Wang Guowei, "Zuijin er, sanshi nian zhong Zhongguo xin faxian zhi xuewen," 1919.

67. *Shiliao* is an abbreviation of two "return graphic loanwords" or classical Chinese phrases given new meaning by late-Tokugawa and Meiji intellectuals looking to translate Western concepts, in this case the words for "history" and "material supplies." For a discussion of these kinds of terms, see Liu, *Translingual Practice*, 319, 324.

68. Fu Sinian, *Shixue fangfa daolun*, 337.

69. Hu Shi, "Zishu gushi guan shu," 29.

70. Gu Jiegang, "Wo de yanjiu gushi de jihua," 182–183.

71. Gu Chao, *Gu Jiegang ninapu*, 145.

72. Su, "Reception of 'Archaeology' and 'Prehistory,'" 444–445.

73. Even Fu Sinian referred to collecting antiquities and paleography as "old archaeology." Fu Sinian, "Kaoguxue de xin fangfa," 1341.

74. Gu Jiegang, "How I Came to Doubt Antiquity," 153.

75. Gu Jiegang, "*Gushibian* zixu," 31–32.

76. Wang Guowei, "*Guoxue congkan* xu," 1411.

77. Wang Guowei, *Gushi xinzheng*, 2078.

78. Bonner, *Wang Kuo-wei*, 179–180.

79. Wang Guowei, "Yin buci zhong suojian xiangong xianwang kao," 399.

80. Wang Guowei, *Gushi xinzheng*, 2078.

81. Fu Sinian, "*Shiji* yanjiu cankao pinlei," 395–396.

82. Feng Youlan, *Sansongtang zixu*, 221–223.

83. Wang Guowei, *Gushi xinzheng*, 2108.

84. Wang Guowei, "*Maogong ding kaoshi* xu," 275–276.

85. Wu Qichang, *Guantang shoushu ji*, 45.

86. Chen Yinke, "*Zhangsuo zhilun*," 135.

87. Wang Guowei, "Zuijin er, sanshi nian zhong Zhongguo xin faxian zhi xuewen," 1916.

88. Wang Guowei, "Guqi zhi xue," 144.

89. Wang Guowei, "Guochao xueshu," 103; "Wu Qingqing," 147.

90. Luo Zhitian, "Xin Songxue," 22; Fu Sinian, "*Shiliao yu shixue* fakan ci," 1404.

91. Fogel, *Politics and Sinology*, 13–16.

92. Feng Youlan, *Sansongtang zixu*, 221–223.

93. Wang Fan-sen, *Fu Ssu-nien*, 119.

94. Wang Fan-sen, *Fu Ssu-nien*, 102.

95. Luo Zhitian, "Shiliao de jinliang kuochong," 157.

96. Luo Zhitian, "Shiliao de jinliang kuochong," 155.

97. Fu Sinian, "Kaoguxue de xin fangfa," 1339.

98. Ge Zhaoguang, "Xin shixue," 86; Gu Jiegang, "Wo de yanjiu gushi de jihua," 182–183.

99. Zhou Shaochuan, "Lun Chen Yuan xiansheng de minzu wenhuashi guan," 7.

100. Guo Moruo, "Buci zhong zhi gudai shehui," 149.

101. Zhu Jianxin, *Jinshixue*, 2

102. Soon after Luo's return to China in 1919, the two scholars arranged the marriage of Wang's eldest son, Qianming, to Luo Zhenyu's youngest daughter, Xiaochun. In 1926, Qianming died, and although custom dictated that Xiaochun remain with her husband's family, she returned to her father's house in Tianjin. Mortified by Xiaochun's rejection of his family, Wang Guowei sent her a gift of money; she refused it, creating a rift between the two

families. For interpretations of the break, see Bonner, *Wang Kuo-wei*, 209–210; Chen Hongxiang, *Wang Guowei zhuan*, 246–252; and Liu Xuan, *Wang Guowei pingzhuan*, 268–269. For Wang Guowei's anxieties over the Northern Expedition and politics in the capital, see Zhang Lianke, *Wang Guowei yu Luo Zhenyu*, 327–334.

103. Bonner, *Wang Kuo-wei*, 215.

104. Zhou Yiliang, "Wo suo liaojie de Chen Yinke xiansheng," 9.

105. Chen Yinke, "Wang Jing'an xiansheng jinian bei," 7168.

106. Zhang Lianke, *Wang Guowei yu Luo Zhenyu*, 339.

107. Wang Guohua, "*Wang Jing'an xiansheng yishu* xu," 2.

108. Sang Bing, "Jindai Zhongguo de xin shixue ji qi liupai," 14.

109. Rong Geng, "Wang Guowei xiansheng kaoguxue shang zhi gong-xian," 7340.

Epilogue: The Future of a Pastime

1. von Falkenhausen, "Historiographical Orientation," 842.

2. See Lai, "Digging Up China," esp. 14–15, 18–19; Wang, *Fu Ssu-nien*, 85–87.

3. Wang, *Fu Ssu-nien*, 86–87.

4. Brown, "Archives at the Margins," 261–262; Wang, *Fu Ssu-nien*, 88–90.

5. Fu Sinian, "Kaoguxue de xin fangfa," 1337; Yin Da, "Xin shiqi shidai yanjiu de huigu yu zhanwang," 285.

6. Li Ji, "Tianye kaogu baogao," 312.

7. Wei Juxian, *Zhongguo kaoguxue shi*, 1.

8. von Falkenhausen, "Historiographical Orientation," 839.

9. Ma Heng, "Xulun," 1.

10. Lu Hejiu, *Zhongguo jinshixue zhengbian*, 73, 80.

11. Cited in Chen Yiai, *Zhongguo xiandai xueshu*, 332.

12. Wu Hung, "On Rubbings," 53–59.

13. Zhu Jianxin, *Jinshixue*, 1.

Bibliography

Ai Suzhen 艾素珍. "Qingmo renwen dilixue zhuzuo de fanyi he chuban 清末人文地理學著作的翻譯和出版" [The translation and publication of works on human geography in the late Qing]. *Zhongguo keji shiliao* (1996, 1): 26–35.

Amelung, Iwo. "Weights and Forces: The Introduction of Western Mechanics into Late Qing China." In Michael Lackner et al., eds., *New Terms for New Ideas: Western Knowledge and Lexical Change in Late Imperial China*. Leiden, Netherlands: Brill, 2001: 197–232.

Andrews, Julia F., and Kuiyi Shen. "The Traditionalist Response to Modernity: The Chinese Painting Society of Shanghai." In Jason C. Kuo, ed., *Visual Culture in Shanghai, 1850s–1930s*. Washington, DC: New Academia Publishing, 2007: 79–93.

Arlington, L.C., and William Lewisohn. *In Search of Old Peking*. 1932. Reprint. Oxford: Oxford University Press, 1987.

Asahara Tatsurō 浅原達郎. " 'Netchū' no hito—Tanpō den (ni) 「熱中」の人：端方伝 (二)" [An "enthusiastic" person: A biography of Duan-fang, part two]. *Senoku hakkokan kiyō* 6 (1989): 54–81.

Ayers, William. *Chang Chih-tung and Educational Reform in China*. Cambridge, MA: Harvard University Press, 1971.

Bai Ling 白岭, ed. *Zhongguo xiaohua ku* 中國笑話庫 [A treasury of Chinese jokes]. Zhengzhou: Zhongzhou guji chubanshe, 2000.

Bai, Qingshen. "Chinese Calligraphy in the Mid to Late Qing and Republican Periods (1850–1950)." In Stephen Little, ed., *New Songs on Ancient Tunes: 19th–20th Century Chinese Paintings and Calligraphy from the Richard Fabian Collection*. Honolulu: Honolulu Academy of Arts, 2007: 66–79.

———. "Chinese Letters: Private Words Made Public." In Robert E. Harrist, Jr., and Wen C. Fong, eds., *The Embodied Image: Chinese Calligraphy from the John B. Elliott Collection*. Princeton, NJ: The Art Museum, Princeton University, 1999: 381–399.

———. "From Composite Rubbing to Pictures of Antiques and Flowers *(Bogu huahui):* The Case of Wu Yun." *Orientations* 38:3 (April 2007): 52–60.

———. "From Wu Dacheng to Mao Zedong: The Transformation of Chinese Calligraphy in the Twentieth Century." In Maxwell K. Hearn and Judith G. Smith, eds., *Chinese Art, Modern Expressions.* New York: Metropolitan Museum of Art, 2001: 246–283.

———. *Fu Shan's World: The Transformation of Chinese Calligraphy in the Seventeenth Century.* Cambridge, MA: Harvard University Asia Center, 2003.

Barnard, Noel. *Bronze Casting and Bronze Alloys in Ancient China.* Canberra: Australian National University, 1961.

Berger, Patricia. *Empire of Emptiness: Buddhist Art and Political Authority in Qing China.* Honolulu: University of Hawai'i Press, 2003.

Berliner, Nancy. "The 'Eight Brokens': Chinese Trompe-l'oeil Painting." *Orientations* 23:2 (February 1992): 61–70.

Beurdeley, Michel. *The Chinese Collector through the Centuries, from the Han to the 20th Century.* Trans. Diana Imber. Rutland, VT: C.E.Tuttle Co., 1966.

Bol, Peter K. *"This Culture of Ours": Intellectual Transitions in T'ang and Sung China.* Stanford, CA: Stanford University Press, 1992.

Boltz, William G. "Shuo wen chieh tzu." In Michael Loewe, ed., *Early Chinese Texts: A Bibliographic Guide.* Berkeley: Institute of East Asian Studies, 1993: 429–442.

Bonner, Joey. "Lo Chen-yü's Research on the Shang." *Early China* 9–10 (1983–1985): 164–168.

———. *Wang Kuo-wei: An Intellectual Biography.* Cambridge, MA: Harvard University Press, 1986.

Brook, Timothy. *The Confusions of Pleasure: Commerce and Culture in Ming China.* Berkeley: University of California Press, 1998.

Brown, Claudia. "Thunderous Events: Disruption and Continuity in Chinese Painting." In Julia Andrews, ed., *Between the Thunder and the Rain: Chinese Paintings from the Opium War through the Cultural Revolution, 1840–1979.* San Francisco: Echo Rock Ventures, 2000: 25–35.

Brown, Shana J. "Archives at the Margins: Luo Zhenyu's Qing Documents and Nationalism in Republican China." In Tze-ki Hon and Robert J. Culp, eds., *The Politics of Historical Production in Late Qing and Republican China.* Leiden, Netherlands: Brill, 2007: 249–270.

———. "What Is Chinese About Ancient Artifacts? Oracle Bones and the Transnational Collectors Hayashi Taisuke and Luo Zhenyu." In Vimalin Rujivacharakul, ed., *Collecting "China": The World, China, and a Short History of Collecting.* Newark: University of Delaware Press, 2011: 63–72.

Cai Xingyi 蔡星儀. "Dao-Xian jinshixue yu huihua—cong Pan Zengying yu

Dai Xi de liang ge huajuan tan qi 道咸金石學與繪畫—從潘曾瑩與戴熙的兩個畫卷談起" [Daoguang and Xianfeng period bronze and stele studies and painting—a discussion regarding two scrolls by Pan Zengying and Dai Xi]. *Meishushi yanjiu* (2008, 2): 31–43.

Cai Yuanpei 蔡元培. "Zuijin wushi nian Zhongguoren yu zhexue zhi guanxi 最近五十年中國人與哲學之關係" [The relationship between Chinese people and philosophy during the last fifty years]. *Cai Yuanpei yanhang lu* 蔡元培言行錄 [Record of the words and actions of Cai Yuanpei]. 6 vols. Shanghai: Guangyin shuju, 1931: 6: 84–138.

Cao Xueqin 曹雪芹. *A Dream of Red Mansions.* Trans. Yang Xianyi and Gladys Yang. Beijing: Foreign Languages Press, 1999.

Cao Zhao. *Chinese Connoisseurship: The* Ko Ku Yao Lun, *the Essential Criteria of Antiquities, a Translation Made and Edited by Sir Percival David, with a Facsimile of the Chinese Text of 1388.* New York: Praeger Publishers, 1971.

Chalfant, F.H. "Standard Weights and Measures of the Ch'in Dynasty." *Journal of the North China Branch of the Royal Asiatic Society* 35 (1903–1904): 21–25.

Chang, K.C. "Archaeology and Chinese Historiography." *World Archaeology* 13:2 (October 1981): 156–169.

Chang Kuang-yuan 張光遠. "Xizhou zhongqi Maogong ding 西周重器毛公鼎" [The important Western Zhou vessel, the Maogong *ding*]. *Gugong jikan* 7:2 (Winter 1972): 1–69, plates 1–18.

Chen Hongxiang 陳鴻祥. *Wang Guowei zhuan* 王國維傳 [Biography of Wang Guowei]. Beijing: Tuanjie chubanshe, 1998.

Chen Jieqi 陳介祺. *Chen Fuzhai zhang biji: fu shouzha* 陳簠齋丈筆記: 附手札 [Chen Jieqi's jottings, with letters]. Baibu congshu jicheng, vol. 68. Taibei: Yiwen yinshuguan, 1967.

———. "*Shuowen guzhou bu* xu 說文古籀補敘" [Comments on the Supplement in ancient and Zhou script to the Shuowen]. In Wu Dacheng, Shuowen *guzhou bu* 說文古籀補 [Supplement in ancient script to the *Shuowen*]. 14 juan. 1886. Reprint. (China), 1898: 1:1a–2a.

Chen Mengjia 陳夢家. *Yinxu buci zongshu* 殷虛卜辭綜述 [Summary discussion of oracle bone inscriptions from the wastes of Yin]. Beijing: Kexue chubanshe, 1956.

Chen Xiaobo 陳小波. "Guobao Maogong ding yu da shoucangjia Chen Jieqi 國寶毛公鼎與大收藏家陳介棋" [The national treasure the Maogong ding and the great collector Chen Jieqi]. In Tang Caiyu 楊才玉, ed., *Gujin shoucangjia* 古今收藏家 [Ancient and modern collectors]. Xi'an: Xibei daxue chubanshe, 1999: 20–28.

Chen Yiai 陳以愛. *Zhongguo xiandai xueshu yanjiu jigou de xinqi: yi Beijing daxue yanjiusuo guoxuemen wei zhongxin de tantao, 1922–1927* 中國現代學術研究機構的興起: 以北京大學研究所國學門為中心的探討, 1922–1927 [The emergence of academic research institutions in modern China:

An investigation based on Beijing University's National Studies Department, 1922–1927]. Taibei: Guoli zhengzhi daxue lishixue xi, 1999.

Chen Yinke 陳寅恪. "Feng Youlan *Zhongguo zhexue shi* shangce shencha baogao 馮友蘭中國哲學史上冊審查報告" [Report on an investigation of the first volume of Feng Youlan's *History of Chinese Philosophy*]. 1931. Reprint. *Jinming guan conggao erbian* 金明舘叢稿二編 [Writings from the Golden Moon House, vol. 2]. Beijing: Sanlian shudian, 2001: 279–281.

———. "Wang Jing'an xiansheng jinian bei 王靜安先生紀念碑" [Memorial stele for Mr. Wang Jing'an]. 1929. Reprint. In Wang Guowei, *Wang Guantang xiansheng quanji* 16: 7168.

———. "*Zhangsuo zhilun* yu *Menggu yuanliu* 章所知論與蒙古源流" [What is to be known and the origin of the Mongols]. 1931. Reprint. *Jinming guan conggao erbian* 金明舘叢稿二編 [Writings from the Golden Moon House, Vol. 2]. Beijing: Sanlian shudian, 2001: 128–139.

Chen Zhongyuan 陳重遠. *Wenwu hua chunchiu* 文物話春秋 [Annals of artifacts]. Beijing: Beijing chubanshe, 1996.

Cheng, Anne. "Nationalism, Citizenship, and the Old Text/New Text Controversy in Late Nineteenth Century China." In Joshua A. Fogel and Peter G. Zarrow, eds., *Imagining the People: Chinese Intellectuals and the Concept of Citizenship, 1890–1920*. Armonk, NY: M.E.Sharpe, 1997: 61–81.

Chow, Kai-wing. *The Rise of Confucian Ritualism in Late Imperial China: Ethics, Classics, and Lineage Discourse*. Stanford, CA: Stanford University Press, 1994.

Chow, Kai-wing, Tze-ki Hon, Hung-yok Ip, and Don C. Price. "Introduction." In Kai-wing Chow et al., eds., *Beyond the May Fourth Paradigm: In Search of Chinese Modernity*. Lanham, MD: Lexington Books, 2008: 1–23.

Chow, Rey. *Writing Diaspora: Tactics of Intervention in Contemporary Cultural Studies*. Bloomington: Indiana University Press, 1993.

Chu, Pingyi. "Remembering Our Grand Tradition: The Historical Memory of the Scientific Exchanges Between China and Europe, 1600–1800." *History of Science* 41/2:132 (June 2003): 193–215.

Claypool, Lisa. "Zhang Jian and China's First Museum." *Journal of Asian Studies* 64:3 (August 2005): 567–604.

Clunas, Craig. *Superfluous Things: Material Culture and Social Status in Early Modern China*. Urbana: University of Illinois Press, 1991.

Cohen, Paul A. *Discovering History in China: American Historical Writing on the Recent Chinese Past*. New York: Columbia University Press, 1984.

Couling, Samuel. "The Oracle-Bones from Honan." *Journal of the North China Branch of the Royal Asiatic Society* 45 (1914): 65–75.

———. (As S.C.) "Review of James Menzies's *Oracle Records from the Waste of Yin*." *North China Branch of the Royal Asiatic Society* 48 (1917): 215–217.

Creel, Herrlee Glessner. *The Birth of China: A Study of the Formative Period of Chinese Civilization.* New York: F.Ungar Pub., 1954.

Dai Zhen 戴震. "*Gujing jiegou chen* xu 古經解鈎沈序" [Preface to exploration of lost contents of ancient classics]. In Zhao Yuxin 趙玉新, ed., *Dai Zhen wenji* 戴震文集 [Collected works of Dai Zhen]. Hong Kong: Zhonghua shuju, 1974: 145–146.

Davis, Richard L. "Chaste and Filial Women in Chinese Historical Writings of the Eleventh Century." *Journal of the American Oriental Society* 121:2 (2001): 204–218.

De Pee, Christian. *The Writing of Weddings in Middle-Period China: Text and Ritual Practice in the Eighth through Fourteenth Centuries.* Albany: State University of New York Press, 2007.

DeWoskin, Kenneth J. *A Song for One or Two: Music and the Concept of Art in Early China.* Ann Arbor: Center for Chinese Studies, University of Michigan, 1982.

Dobson, W.A.H.C. *Early Archaic Chinese: A Descriptive Grammar.* Toronto: University of Toronto Press, 1962.

Dong, Linfu. *Cross Culture and Faith: The Life and Work of James Mellon Menzies.* Toronto: University of Toronto Press, 2005.

Dong, Madeleine Yue. *Republican Beijing: The City and Its Histories.* Berkeley: University of California Press, 2003.

Dong Zuobin 董作賓. *Jiagu nianbiao* 甲骨年表 [Oracle bone chronology]. Shanghai: Shangwu yinshuguan, 1937.

Du Weiyun 杜維運. *Qingdai shixue yu shijia* 清代史學與史家 [Qing Dynasty historiography and historians]. Beijing: Zhonghua shuju, 1988.

———. *Taozhai jijin lu* 陶齋吉金錄 [Record of Taozhai's ritual bronzes]. 8 juan. (China): N.p., 1908.

Duanfang 端方. "Taozhi (Duanfang) cundu 陶齋(端方)存牘" [Surviving letters of Duanfang]. *Zhongyang yanjiuyuan jindaishi yanjiusuo shiliao congkan* 30 (1996): 184–241.

Eastman, Lloyd. "Ch'ing-i and Chinese Policy Formation." *Journal of Asian Studies* 24:4 (August 1965): 595–611.

Ebrey, Patricia Buckley. *Accumulating Culture: The Collections of Emperor Huizong.* Seattle: University of Washington Press, 2006.

Edkins, Joseph. *China's Place in Philology: An Attempt to Show That the Languages of Europe and Asia Have a Common Origin.* London: Trübner & Co., 1871.

Elliott, Jeannette Shambaugh, and David Shambaugh. *The Odyssey of China's Imperial Art Treasures.* Seattle: University of Washington Press, 2005.

Elman, Benjamin A. *Classicism, Politics, and Kinship: The Chang-chou School of New Text Confucianism in Late Imperial China.* Berkeley: University of California Press, 1990.

———. *A Cultural History of Civil Examinations in Late Imperial China.* Berkeley: University of California Press, 2000.

———. *From Philosophy to Philology: Intellectual and Social Aspects of Change in Late Imperial China.* Cambridge, MA: Harvard University Press, 1984.

———. "The Historicization of Classical Learning in Ming-Ch'ing China." In Q. Edward Wang and Georg Iggers, eds., *Turning Points in Historiography: A Cross-Cultural Perspective.* Rochester, NY: University of Rochester Press (2002): 101–146.

Erickson, Britta. "Uncommon Themes and Uncommon Subject Matters in Ren Xiong's Album after Poems by Yao Xie." In Jason C. Kuo, ed., *Visual Culture in Shanghai, 1850s–1930s.* Washington, DC: New Academia Publishing, 2007: 29–54.

von Falkenhausen, Lothar. "On the Historiographical Orientation of Chinese Archaeology." *Antiquity* 67:257 (1993): 839–849.

Fan, Fa-ti. *British Naturalists in Qing China: Science, Empire, and Cultural Encounter.* Cambridge, MA: Harvard University Press, 2004.

———. "Nature and Nation in Chinese Political Thought." In Lorraine Daston and Ferdinand Vidal, eds., *The Moral Authority of Nature.* Chicago: University of Chicago Press, 2004: 409–437.

Feng Guifen 馮桂芬. "Gai keju yi 改科舉議" [Proposal for reforming the civil examinations]. *Jiaobinlu kangyi* 校邠盧抗議 [Essays of protest from Studying-the-Zhou Cottage]. Shanghai: Shanghai shudian chubanshe, 2002: 37–39.

Feng Jun 馮君. "Yangwu pai de jindai rencaiguan 洋務派的近代人才觀" [The modern talented men view of the learn-from-the-West faction]. *Guangxi shehui kexue* 12:114 (2004): 148–151.

Feng Youlan 馮友蘭. *Sansongtang zixu* 三松堂自序 [Autobiography from the Hall of Three Pines]. Beijing: Sanlian shudian, 1984.

Ferguson, John C. "Recent Works by a Chinese Scholar." *Journal of the North China Branch of the Royal Asiatic Society* 50 (1919): 122–132.

Findlen, Paula. *Possessing Nature: Museums, Collecting, and Scientific Culture in Early Modern Italy.* Berkeley: University of California Press, 1994.

Fogel, Joshua A. *Politics and Sinology: The Case of Naitō Konan, 1866–1934.* Cambridge, MA: Harvard University Press, 1984.

Foucault, Michel. "Two Lectures." *Power / Knowledge: Selected Interviews and Other Writings, 1972–1977.* New York: Pantheon Books, 1980: 78–108.

Fu Sinian 傅斯年. *Fu Sinian quanji* 傅斯年全集 [Complete works of Fu Sinian]. 7 vols. Taibei: Lianjing chuban shiye gongsi, 1980.

———. "Kaoguxue de xin fangfa 考古學的新方法" [The new archaeological methods]. 1930. Reprint. *Fu Sinian quanji* 4:1337–1347.

———. "*Shiji* yanjiu cankao pinlei 史記研究參考品類" [Research on the categories of research related to the Records of the Historian]. 1952. Reprint. *Fu Sinian quanji* 2: 395–397.

———. "*Shiliao yu shixue* fakan ci 史料與史學發刊詞" [Forward to the inaugural issue of historical materials and historiography]. 1945. Reprint. *Fu Sinian quanji* 4: 1402–1404.

———. *Shixue fangfa daolun* 史學方法導論 [Guide to historical research]. 1933. Reprint. *Fu Sinian quanji* 2: 335–392.

———. "Wang Guowei zhuo *Song Yuan xiqu shi* 王國維著宋元戲曲史" [Wang Guowei's history of Song and Yuan drama]. 1919. Reprint. *Fu Sinian quanji* 4: 1429–1432.

Galison, Peter. *Image and Logic: A Material Culture of Microphysics.* Chicago: University of Chicago Press, 1997.

Gan Ru 甘孺. *Yongfeng xiangren xingnian lu—Luo Zhenyu nianpu* 永豐鄉人行年錄: 羅振玉年譜 [Yearly record of the Man of Yongfeng—Biographical chronology of Luo Zhenyu]. In Luo Zhenyu, *Xuetang leigao* 8: 1–121.

Gao Xingfan 高興璠. "Aixin Jueluo Shengyu 愛新覺羅盛昱" [Aisin-Gioro Shengyu]. *Manzu yanjiu* 4:37 (1995): 37.

Gao Yan 高艷. "Aiguo, aimin de yidai mingchen Wu Dacheng 愛國愛民的一代名臣吳大澂" [Wu Dacheng, the patriotic and people-loving famous official]. *Heilongjiang shizhi* (2005, 4): 43–46.

Gao Yang 高陽. *Qingmo si gongzi* 清末四公子 [Four gentlemen of the late Qing]. Taibei: Nanjing chuban gongsi, 1980.

Ge Zhaoguang 葛兆光. "Xin shixue zhi hou—1929 nian de Zhongguo lishi xuejie 新史學之後—1929年的中國歷史學界" [After the new historiography: The Chinese historical world in 1929]. *Lishi yanjiu* (2003, 1): 82–97.

Gladney, Dru. *Muslim Chinese: Ethnic Nationalism in the People's Republic.* Cambridge, MA: Harvard University Asia Center, 1991.

Goldman, Andrea S. "The Nun Who Wouldn't Be: Representations of Female Desire in Two Performance Genres of 'Si fan.'" *Late Imperial China* 22.1 (June 2001): 71–138.

Gong Zizhen 龔自珍. *Gong Zizhen quanji* 龔自珍全集 [Complete works of Gong Zizhen]. Shanghai: Renmin chubanshe, 1975.

———. "Gushi goushen lun er 古史鉤沈論二" [Second investigative discussion of ancient historians]. *Gong Zizhen quanji:* 21–25.

———. "*Shang-Zhou yiqi wen lu* xu 商周彝器文錄序" [Preface to record of inscriptions from Shang and Zhou sacrificial vessels]. *Gong Zizhen quanji:* 267–268.

———. "Yulu 語錄" [Record of sayings]. *Gong Zizhen quanji:* 421–437.

Grafton, Anthony. *Defenders of the Text: The Traditions of Scholarship in an Age of Science, 1450–1800.* Cambridge, MA: Harvard University Press, 1991.

Gu Chao 顧潮. *Gu Jiegang nianpu* 顧頡剛年譜 [Chronological biography of Gu Jiegang]. Beijing: Zhongguo shehui kexue chubanshe, 1993.

Gu Jiegang 顧頡剛. "*Gushibian* zixu 古史辨自序" [Autobiographical materials related to critique of ancient history]. 1926. Reprint. *Gushi bian* 古

史辨 [Critique of ancient history]. 7 vols. Haikou: Hainan chubanshe, 2005: 1: 1–57.

———. "How I Came to Doubt Antiquity." Trans. Ursula Richter. In Wolfram Eberhard et al., eds., *Nation and Mythology*. Bremen: Simon and Megiera, 1983: 145–159.

———. "Wo de yanjiu gushi de jihua 我的研究古史的計劃" [My plans for researching ancient history]. 1924. Reprint. *Gushi bian* 古史辨 [Critique of ancient history]. 7 vols. Haikou: Hainan chubanshe, 2005: 1: 181–284.

"Gu Jiegang zhi Wang Guowei de san feng xin 顧頡剛致王國維的三封信" [Three letters from Gu Jiegang to Wang Guowei]. *Wenxian* 15 (March 1983): 11–13.

Gu Tinglong 顧廷龍. *Wu Kezhai xiansheng nianpu* 吳愙齋先生年譜 [Biographical chronology of Mr. Wu Kezhai]. Beijing: Hafo yanjing xueshe, 1935.

———, ed. *Yifengtang youpeng shuzha* 藝風堂友朋書札 [Letters from friends of the pavilion of art and style]. 2 vols. Shanghai: Shanghai guji chubanshe, 1980.

Gu Yanwu 顧炎武. "Jianwen bei 建文碑" [Jianwen stele]. *Qiugulu* 求古錄 [Record of a search for antiquity]. 1 juan. Reprint. *Tinglin yishu huiji* 亭林遺書彙輯 [Compilation of the works of the late Gu Yanwu]. Shanghai, 1889: 39b–40a.

van Gulik, R.H. *Chinese Pictorial Art, as Viewed by the Connoisseur*. Rome: Istituto Italiano per il Medio Estremo Oriente, 1958.

Guo Chengmei 郭成美. "Huizu xuezhe Jin Zutong 回族学者金祖同" [The Hui scholar Jin Zutong]. *Huizu yanjiu* 70:2 (2008): 138–144.

Guo Moruo 郭沫若. *Buci tongzuan* 卜辭通纂 [General compendium of oracle bone inscriptions]. 1933. Reprint. Beijing: Kexue chubanshe, 1983.

———. "Buci zhong zhi gudai shehui 卜辭中之古代社會" [Ancient society as seen in oracle bone inscriptions]. *Zhongguo gudai shehui yanjiu* 中國古代社會研究 [Research on ancient Chinese society]. 1930. Reprint. Shijiazhuang: Hebei jiaoyu chubanshe, 2000: 144–191.

———. "Lu Xun yu Wang Guowei 魯迅與王國維" [Lu Xun and Wang Guowei]. 1936. Reprint. In Chen Pingyuan 陳平原, Wang Feng 王楓, eds., *Zhuiyi Wang Guowei* 追憶王國維 [Recollecting Wang Guowei]. Beijing: Zhongguo guangfan dianshi chubanshe, 1996: 166–178.

Guy, R. Kent. *The Emperor's Four Treasuries: Scholars and the State in the Late Ch'ien-lung Era*. Cambridge, MA: Harvard University Press, 1987.

Harrell, Paula. *Sowing the Seeds of Change: Chinese Students, Japanese Teachers, 1895–1905*. Stanford, CA: Stanford University Press, 1992.

Harrist, Robert E. "The Artist as Antiquarian: Li Gonglin and His Study of Early Chinese Art." *Artibus Asiae* 55:3/4 (1995): 237–280.

———. "Reading Chinese Calligraphy." In Robert E. Harrist, Jr. and Wen C. Fong, eds., *The Embodied Image: Chinese Calligraphy from the John B. El-*

liott Collection. Princeton, NJ: The Art Museum, Princeton University, 1999: 3–27.

Hay, Jonathan. "Chinese Photography and Advertising in Late Nineteenth Century Shanghai." In Jason Chi-sheng Kuo, ed., *Visual Culture in Shanghai, 1850s to 1930s.* Washington, DC: New Academia Press, 2007: 95–119.

———. "Culture, Ethnicity, and Empire in the Work of Two Eighteenth-Century 'Eccentric' Artists." *Res* 35 (Spring 1999): 201–223.

———. "Painters and Publishing in Late Nineteenth-century Shanghai." In Ju-hsi Chou, ed., *Art at the Close of China's Empire.* Tempe: Arizona State University, 1998: 134–188.

Hayashi Taisuke 林泰輔. "*Kanji no kenkyū jo* 漢字ノ研究序" [Preface to research on Chinese characters]. In Adachi Tsunemasa 安達常正, *Kanji no kenkyū* 漢字ノ研究 [Research on Chinese characters]. Tokyo: Rokugō kan, 1911: 1–4.

———. "Kikkō jūkotsu monji 龜甲獸骨文字" [Characters from tortoise-shell plastrons]. *Kokotsu kanke bunken jobatsu shusei* (1917, 1): 143–148.

———. "Shinkoku Kanan-shō Tōinken hakken no kikkō gyūkotsu ni tsukite 清國河南省湯陰縣發見の龜甲牛骨に就きて" [The recent discovery of plastrons and cow bones in Tangyin County, Henan Province, China]. 1909. Reprint. *Shina jōdai no kenkyū* 支那上代之研究 [Research on ancient China]. Tokyo: Kōfūkan, 1944: 125–169.

He Fang 何芳. "Qinggong shoucang yanjiu 清宮收藏研究" [Research on Qing court collecting]. *Zhonghua wenhua luntan* 1 (2004): 95–98.

He Yin 何寅, Xu Guanghua 許光華. *Guowai Hanxueshi* 國外漢學史 [History of foreign Sinology]. Shanghai: Shanghai waiyu jiaoyu chubanshe, 2000.

He, Yuming. "Wang Guowei and the Beginnings of Modern Chinese Drama Studies." *Late Imperial China* 28:2 (March 2008): 129–56.

Heidegger, Martin. "The Age of the World Picture." In *The Question Concerning Technology and Other Essays.* Trans. and with an introduction by William Lovitt. New York: Harper and Row, 1977: 115–154.

Heinrich, Larissa N. *The Afterlife of Images: Translating the Pathological Body between China and the West.* Durham: Duke University Press, 2008.

Hevia, James. "Looting Beijing: 1860, 1900." In Lydia H. Liu, ed., *Tokens of Exchange: The Problem of Translation in Global Circulations.* Durham: Duke University Press, 1999: 192–213.

Hon, Tze-ki. "Cultural Identity and Local Self-Government: A Study of Liu Yizheng's History of Chinese Culture." *Modern China* 30:4 (2004): 506–542.

———. "Educating the Citizens: Visions of China in Late Qing History Textbooks." In Tze-ki Hon and Robert J. Culp, eds., *The Politics of Historical Production in Late Qing and Republican China.* Leiden, Netherlands: Brill, 2007: 79–105.

————. "From a Hierarchy in Time to a Hierarchy in Space: The Meanings of Sino-Babylonianism in Early Twentieth-Century China." *Modern China* 36: (2010): 139–169.

Hopkins, L.C. (Lionel Charles). "Working the Oracle." *New China Review* 1 (May 1919): 111–119, 249–261.

Hopkirk, Peter. *Foreign Devils on the Silk Road: The Search for the Lost Cities and Treasures of Chinese Central Asia.* Amherst: University of Massachusetts Press, 1984.

Hostetler, Laura. *Qing Colonial Enterprise: Ethnography and Cartography in Early Modern China.* Chicago: University of Chicago Press, 2001.

Hsu, Eileen Hsiang-Ling. "Huang Yi's *Fangbei* Painting." In Naomi Noble Richard, ed., *Rethinking Recarving: Ideals, Practices, and Problems of the "Wu Family Shrines" and Han China.* New Haven, CT: Yale University Press, 2008: 236–258.

Hu Houxuan 胡厚宣. "Guanyu Liu Tizhi, Luo Zhenyu, Mingyishi sanjia jiu-cang jiagu xianzhuang de shuoming 關於劉体智，羅振玉，明義士三家舊藏甲骨現狀的説明" [Explanation of the present conditions of the oracle bone collections of Liu Tizhi, Luo Zhenyu, and J. M. Menzies]. *Jiaguwen yu Yin-Shang wenhua yanjiu* 甲骨文與殷商文化研究. Zhengzhou: Zhongzhou guji chubanshe, 1992: 1–13.

Hu, Philip K., ed. *Visible Traces: Rare Books and Special Collections from the National Library of China.* New York: Queens Borough Public Library, 2000.

Hu Shi 胡適. "Zishu gushi guan shu 自述古史觀書" [Letter explaining my view of ancient history]. In Gu Jiegang 顧頡剛, *Gushi bian* 古史辨 [Critique of ancient history]. 7 vols. Haikou: Hainan chubanshe, 2005: 1: 29.

Hua Rende. "The History and Revival of Northern Wei Stele-Style Calligraphy." In Cary Y. Liu et al., eds., *Character and Context in Chinese Calligraphy.* Princeton, NJ: Princeton University, 1999: 104–131.

Huang Binhong 黃賓虹. "Hubin guwan shichang ji 滬濱古玩市場記" [Notes on the antiques market in Shanghai]. *Huang Binhong wenji* 黃賓虹文集 [Collected works of Huang Binhong]. 6 vols. Shanghai: Shanghai shuhua chubanshe, 1999: 1: 290–292.

Hummel, Arthur W., ed. *Eminent Chinese of the Ch'ing period (1644–1912).* 2 vols. Washington, DC: U.S. Govt. Printing Office, 1943.

Huters, Theodore. *Bringing the World Home: Appropriating the West in Late Qing and Early Republican China.* Honolulu: University of Hawai'i Press, 2005.

Ikawa-Smith, Fumiko. "Co-Traditions in Japanese Archaeology." *World Archaeology* 13:3 (February 1982): 296–309.

Ikegami, Eiko. *Bonds of Civility: Aesthetic Networks and the Political Origins of Japanese Culture.* Cambridge, UK: Cambridge University Press, 2005.

Jay, Martin. "Scopic Regimes of Modernity." In Hal Foster, ed., *Vision and Visuality.* Seattle: Bay Press, 1988: 3–27.

Ji Yun 紀昀, et al. *Siku quanshu zongmu* 四庫全書總目 [Catalog of the complete library of the four treasuries]. Reprint. Taipei: Yiwen yinshuguan, 1974.

Jones, Caroline A. and Peter Galison, ed. *Picturing Science, Producing Art.* New York: Routledge, 1998.

Judge, Joan. *Print and Politics: Shibao and the Culture of Reform in Late Qing China.* Stanford, CA: Stanford University Press, 1996.

Kang Youwei 康有爲. *Guang yizhou shuangji* 廣藝舟雙楫 [Amplification of oars for the boat of art]. 1889. Reprint. In Pan Yungao 潘運告, ed., *Wan Qing shu lun* 晚清書論 [Late-Qing calligraphy discourse]. Changsha: Hunan meishu chubanshe, 2003: 181–481.

———. *Kang Nanhai zibian nianpu* 康南海自編年譜 [Kang Youwei's self-edited chronological biography]. Beijing: Zhonghua shuju chuban, 1992.

Keightley, David. "A Measure of Man in Early China: In Search of the Neolithic Inch." *Chinese Science* 12 (1995): 16–38.

———. *Sources of Shang History.* Berkeley: University of California Press, 1978.

Kerr, Rose. *Later Chinese Bronzes.* London: Bamboo Pub. in association with the Victoria and Albert Museum, 1990.

Kohara Hironobu 古原宏伸. "Riben jin bashi nian lai de Zhongguo huihua shi yanjiu 日本近八十年來的中國繪畫史研究" [Research on the history of Chinese paintings in Japan over the last eighty years]. *Xin meishu* (1994, 1): 67–73.

Kong Lingwei 孔令偉. "Bowuxue yu bowuguan zai Zhongguo de yuanqi 博物學與博物館在中國的源起" [The origins of natural history and museums in China). *Xin meishu* 29:1 (2008): 61–67.

Lai, Guolong. "Digging Up China: Nationalism, Politics and the Yinxu Excavation, 1928–1937." Paper presented at the Association for Asian Studies Annual Meeting, Boston, MA, 1999.

Lau, D.C., trans. *Confucius: The Analects.* New York: Penguin Books, 1979.

Laufer, Berthold. *Jade: A Study in Chinese Archaeology and Religion.* 1912. Reprint. New York: Dover Publications, 1974.

Lawton, Thomas. "An Imperial Legacy Revisited: Bronze Vessels from the Qing Palace Collection." *Asian Art* I:1 (Fall/Winter 1987–1988): 51–79.

———. "Rubbings of Chinese Bronzes." *Bulletin of the Museum of Far Eastern Antiquities* 67 (1995): 7–48.

———. *A Time of Transition: Two Collectors of Chinese Art.* Lawrence: Spencer Museum of Art, University of Kansas, 1991.

Ledderose, Lothar. "Aesthetic Appropriation of Ancient Calligraphy in Modern China." In Maxwell K. Hearn and Judith G. Smith, eds., *Chinese Art, Modern Expressions.* New York: Metropolitan Museum of Art, 2001: 212–245.

———. "Calligraphy at the Close of China's Empire." In Ju-his Chou, ed.,

Art at the Close of China's Empire. Tempe: Arizona State University, 1998: 189–207.

Lefeuvre, Jean A. *Collections d'inscriptions oraculaires en France*. Taibei: Institut Ricci, 1985.

———. "Les Inscriptions des Shang sur Carapaces de Tortue et sur Os: Aperçu Historique et Bibliographique de la Découverte et des Premières Études." *T'oung Pao* (Second Series) 61:1/3 (1975): 1–82.

Levine, Joseph M. *The Battle of the Books: History and Literature in the Augustan Age*. Ithaca, NY: Cornell University Press, 1994.

Li Ji 李濟. *Anyang*. 1977. Seattle: University of Washington Press, 1977.

———. "Tianye kaogu baogao 田野考古报告" [Report on archaeological fieldwork]. 1936. Reprint. *Anyang* 安陽 [Anyang]. Shijiazhuang: Hebei jiaoyu chubanshe, 2000: 312–314.

———. "Zhongguo guqiwuxue de xin jichu 中國古器物學的新基礎" [A new basis for Chinese artifact studies]. 1950. Reprint. In Zhang Guangzhi 張光直, Li Guangmo 李光謨, eds., *Li Ji kaoguxue lunwen xuanji* 李濟考古學論文選集 [Li Ji's selected archaeological articles]. Beijng: Wenwu chubanshe, 1990: 60–70.

Li Qingzhao 李清照. "*Jinshi lu* hou ba 金石錄後跋" [Postface to the records of bronzes and steles]. In Zhao Mingcheng 趙明誠, *Jinshi lu* 金石錄 [Records of bronzes and steles]. 30 juan. Reprint. Shanghai: Shangwu yinshuguan, 1934: 30: 1a–5b.

Li Yusun 李遇孫. *Jinshixue lu* 金石學錄 [Record of bronze-and-stele studies]. Taibei: Shangwu yinshuguan, 1970.

Li Zuoxian 李佐賢. *Guquan hui* 古泉匯 [Collection of ancient coins]. 64 juan. 1864. Reprint. Zhongguo qianbi wenxian congshu, vol. 16. Shanghai: Shanghai guji chubanshe, 1992.

Liang Qichao 梁启超. *Intellectual Trends in the Ch'ing Period*. Trans. Immanuel C. Y. Hsu. Cambridge, MA: Harvard University Press, 1959.

———. *Zhongguo lishi yanjiu fa* 中國歷史研究法 [Methods of Chinese history research]. 1922. Reprint. Shijiazhuang: Hebei jiaoyu chubanshe, 2000.

———. *Zhongguo shi xulun* 中國史叙論 [Discussion of Chinese historiography]. 1901. Reprint. *Yinbingshi heji–wenji* 飲冰室合集－文集 [Collected writings from the Ice Drinker's Studio: Collected essays]. 24 vols. Shanghai: Zhonghua shuju, 1936: 6: 1–13.

Liang Shizheng 梁詩正 et al., eds. *Xiqing gujian* 西清古鑒 [Record of antiquities from the Xiqing pavilion]. 40 juan. 1749. Reprint. Beijing: Jicheng tushu gongsi, 1908.

Ling Tingkan 凌廷堪. "Da Niu Ciyuan Xiaolian shu 荅牛次原孝廉书" [Letter in answer to Niu Ciyuan, Xiaolian]. *Xiaolitang wenji* 校禮堂文集 [Collected writings from the studio for collating rituals]. Beijing: Zhonghua shuju, 1998: 196–197.

Liscomb, Kathlyn Maurean. *Learning from Mount Hua: A Chinese Physician's*

Illustrated Travel Record and Painting Theory. Cambridge, UK: Cambridge University Press, 1993.

Little, Stephen, ed. *New Songs on Ancient Tunes: 19th–20th Century Chinese Paintings and Calligraphy from the Richard Fabian Collection*. Honolulu: Honolulu Academy of Arts, 2007.

Liu, Cary Y. "Calligraphic Couplets as Manifestations of Deities and Markers of Buildings." In Robert E. Harrist, Jr., and Wen C. Fong, eds., *The Embodied Image: Chinese Calligraphy from the John B. Elliott Collection*. Princeton, NJ: The Art Museum, Princeton University, 1999: 361–379.

Liu Chang 劉敞. "Xian-Qin gu qi ji 先秦古器記" [Records of pre-Qin vessels]. *Gongshi ji* 公是集 [Collected works of Gongshi]. 54 juan. Reprint. Baibu congshu jicheng, vols. 264–268. Taibei: Shangwu yinshuguan, 1975: vol. 267: juan 36: 15a–15b.

Liu E 劉鶚. "Liu E riji 劉鶚日記" [Liu E's diary]. *Liu E ji Loacan youji ziliao* 劉鶚及老殘遊記資料 [Research materials related to Liu E and the travels of Lao Can]. Chengdu: Sichuan renmin chubanshe, 1985: 143–289.

———. *Tieyun canggui* 鐵雲藏龜 [Tieyun's collection of plastrons]. 1903. Reprint. Taibei: Yiwen yinshuguan, 1975.

———. *The Travels of Lao Can*. Trans. Yang Xianyi and Gladys Yang. Honolulu: University Press of the Pacific, 2001.

Liu, Lydia He. *Translingual Practice: Literature, National Culture, and Translated Modernity—China, 1900–1937*. Stanford, CA: Stanford University Press, 1995.

Liu Shipei 劉師培. "Bianji xiangtu zhi xulie fu: jinshi zhi 編輯鄉土志序例附：金石志" [Appendix to the compilation of prefaces from local gazetteers: Treatise on bronzes and steles]. 1906. Reprint. *Liu Shipei shixue lunzhu xuanji* 劉師培史學論著選集 [Selections of Liu Shipei's studies on historiography]. Shanghai: Shanghai guji chubanshe, 2006: 265–267.

———. "Lun kaoguxue mo bei yu jinshi 論考古學莫備於金石" [How the study of antiquity is perfected through bronzes and steles]. 1907. Reprint. *Liu Shipei shixue lunzhu xuanji* 劉師培史學論著選集 [Selections of Liu Shipei's studies on historiography]. Shanghai: Shanghai guji chubanshe, 2006: 463–467.

Liu Tizhi 劉體智. *Shanzhai jijin lu* 善齋吉金錄 [Record of ritual bronzes from the studio of virtue]. 1924. Reprint. Shanghai: Shanghai tushuguan yingyin, 1998.

Liu Xuan 劉烜. *Wang Guowei pingzhuan* 王國維評傳 [Critical biography of Wang Guowei]. Nanchang: Baihua zhouwenyi chubanshe, 1996.

Lu Cao 陸草. "Lun jindai wenren de jinshi zhi pi 論近代文人的金石之癖" [On the obsession of modern literati with antiquarianism]. *Zhongshan xuekan* (1995, 1): 82–87.

Lü Dalin 呂大臨. *Kaogu tu* 考古图 [Illustrated researches on antiquity]. Reprint. In Li Conghui 李聰慧, ed., *Songren zhuolu jinwen congkan chubian*

宋人著錄金文叢刊初便 [Collection of Song works on bronze inscriptions, first volume]. Beijing: Zhonghua shuju, 2005: 1–192.

Lu Hejiu 陸和九. *Zhongguo jinshixue qianbian* 中國金石學前編 [First edition of Chinese bronze-and-stele studies]. 1933. Reprint. *Zhongguo jinshixue jiangyi* 中國金石學講義 [Handbook of Chinese bronze-and-stele studies]. Beijing: Beijing tushuguan chubanshe, 2003: 1–72.

———. *Zhongguo jinshixue zhengbian* 中國金石學正編 [Revised edition of Chinese bronze-and-stele studies]. 1937. Reprint. *Zhongguo jinshixue jiangyi* 中國金石學講義 [Handbook of Chinese bronze-and-stele studies]. Beijing: Beijing tushuguan chubanshe, 2003: 73–702.

Lu Wenchao 盧文弨. "Jiujing guyi xu 九經古義序" [Preface to the ancient meaning of the nine classics]. *Baojingtang wenji* 抱經堂文集 [Collected essays from the hall for cherishing the classics]. 34 juan. Reprint. Sibu congkan chubian suoben, vol. 97. Taibei: Yiwen yinshuguan, 1967: 2:19a–19b.

Lu Xinsheng 路新生. *Zhongguo jin sanbai nian yigu sichao yanjiu* 中國近三百年疑古思潮研究 [Research on Chinese "doubting antiquity" theories in the last three hundred years]. Shanghai: Shanghai renmin chubanshe, 2001.

Lu Xixing 陸錫興. "Cong jinshixue, kaoguxue dao gudai qiwu xue 從金石學考古學到古代器物學" [From bronze-and-stele studies and archeology to the study of ancient artifacts]. *Nanfang wenwu* (2007, 1): 67–72.

Lu Xun 鲁迅. *Selected Stories of Lu Hsun*. Trans. Yang Hsien-yi and Gladys Yang. New York: W. W. Norton & Company, 1977.

———. "Tan suowei Neige dang'an 談所謂內閣檔案" [On the so-called grand secretariat archives]. 1928. Reprint. *Lu Xun quanji* 鲁迅全集 [Complete works of Lu Xun]. 16 vols. Beijing: Renmin wenxue chubanshe, 1981: 3: 561–569.

Lu, Yan. *Re-Understanding Japan: Chinese Perspectives, 1895–1945*. Honolulu: Association for Asian Studies and University of Hawai'i Press, 2004.

Luo Fuyi 羅福頤. *Chuanshi lidai guchi tulu* 傳世历代古尺圖录 [Pictorial record of ancient and historical rulers]. Beijing: Wenwu chubanshe, 1957.

Luo Jizu 羅繼祖. *Fuji liuhen* 蜉寄留痕 [Scars left by wasp stings]. Shanghai: Shanghai guji chubanshe, 1999.

Luo Kun 羅琨, Zhang Yongshan 張永山. *Luo Zhenyu pingzhuan* 羅振玉評傳 [Critical biography of Luo Zhenyu]. Nanchang: Baihua zhouwenyi chubanshe, 1996.

Luo Zhenchang 羅振常. *Huan-Luo fanggu youji* 洹洛訪古遊記 [Journey in search of antiquities along the Huan and Luo rivers]. 2 juan. Shanghai: Yinyinlu, 1936.

Luo Zhenyu 羅振玉. "*Aiji beishi* xu 埃及碑釋序" [Preface to explanations of Egyptian steles]. 1922. Reprint. *Xuetang leigao* 2: 514–515.

————. "Fusang liangyue ji 扶桑兩月記" [Diary of two months in Japan]. 1902. Reprint. *Xuetang zishu:* 61–86.

————. *"Gu mingqi tulu* xu 古明器圖錄序" [Preface to pictorial record of ancient grave goods]. 1916. Reprint. *Xuetang leigao* 2: 78–79.

————. *"Guqiwu zhi xiao lu* xu 古器物識小錄序" [Preface to short record of inscriptions from ancient artifacts]. 1931. Reprint. *Xuetang leigao* 2: 25–26.

————. *Guqiwuxue yanjiu yi* 古器物學研究議 [Discussion of research in ancient artifact studies]. Tianjin: Yi'antang jingji pu, n.d.

————. "Haining Wang Zhongque gong zhuan 海寧王忠慤公傳" [Biography of Wang Zhongque of Haining]. 1927. Reprint. In Wang Guowei, *Wang Guantang xiansheng quanji* 16: 7019–7022.

————. *"Jiaoyu shijie* xulie 教育世界序列" [Introduction to education world]. *Jiaoyu shijie* 1 (1901): 1a–1b.

————. "Jiliaobian 集蓼編" [Amidst bitter experiences]. 1941. Reprint. *Xuetang zishu:* 1–61.

————. *"Liusha fanggu ji* xu 流沙訪古記序" [Preface to record of journeys in search of antiquities in the inner desert]. 1909. Reprint. *Xuetang leigao* 2: 38.

————. *"Quanheng duliang shiyan kao* xu 衡度量實驗攷序 [Preface to experimental investigations into weight, length and capacity measures]. 1915. Reprint. *Xuetang leigao* 2: 409–410.

————. *"Shuowen guzhou bu* ba 說文古籀補跋" [Colophon to ancient and Zhou script supplement to the Shuowen]. 1921. Reprint. *Xuetang leigao* 2: 488–490.

————. *"Tieyun canggui* xu 鐵雲藏龜序" [Preface to Tieyun's collection of plastrons]. Liu E, *Tieyun canggui* 鐵雲藏龜 [Tieyun's collection of plastrons]. 1903. Reprint. Taibei: Yiwen yinshuguan, 1975: 1–13.

————. "Wushiri menghenlu 五十日夢痕錄" [Recorded traces of a fifty-day dream]. 1915. Reprint. *Xuetang zishu:* 87–116.

————. *Xuetang leigao* 雪堂類稿 [Xuetang's assorted manuscripts]. 8 vols. Shenyang: Liaoning chubanshe, 2003.

————. *Xuetang zishu* 雪堂自述 [Xuetang's memoirs]. Nanjing: Jiangsu renmin chubanshe, 1999.

————. *"Yiji congcan* chubian xu mu 佚籍叢殘初編序目" [Preface and contents to lost books, first volume]. 1911. Reprint. *Xuetang leigao* 2: 38–40.

————. *Yin-Shang zhenbu wenzi kao* 殷商貞卜文字考 [Studies of characters used in Shang divination]. (China): Yujianzhai, 1910.

————. *"Yinxu guqiwu tulu* xu 殷虛古器物圖錄序" [Preface to pictorial record of ancient vessels from the wastes of Yin]. 1916. Reprint. *Xuetang leigao* 2: 67–68.

————. *Yinxu shuqi kaoshi* 殷虛書契考釋 [An examination of inscriptions

from the wastes of Yin]. Kyoto: Shanyu Luo Zhenyu Yongbaoyuan ying-yinben, 1915.

———. *Yinxu shuqi qianbian* 殷虛書契前編 [Inscriptions from the wastes of Yin, first volume]. Kyoto: Shangyu Luo Zhenyu yongbaoyuan riben yingyinben, 1912.

———. *Yonglu rizha* 俑廬日札 [Daily notes from the Tomb Figurine Hut]. 1908. Reprint. *Xuetang leigao* 1: 308–403.

———. *Zengding Yinxu shuqi kaoshi* 增訂殷虛書契考釋 [Revised studies on inscriptions from the wastes of Yin]. China: Dongfang xuehui, 1927.

Luo Zhitian 羅志田. "Qingji baocun guocui de chaoye nuli ji qi guannian daotong 清季保存國粹的朝野努力及其觀念導同" [The Qing period enthusiasm for preserving the national essence and the transmission of this viewpoint]. *Jindai shi yanjiu* (2001, 2): 28–100.

———. "Shiliao de jinliang kuochong yu bu kan ershisi shi—mingguo xin shixue de yige guilun xianxiang 史料的盡量擴充與不看二十四史－民國新史學的一個詭論現象" [The maximum expansion of historical materials without looking at the twenty-four histories: A tricky phenomenon from new Republican historiography]. *Lishi yanjiu* (2000, 4): 151–167.

———. "Xin Songxue yu Minchu kaoju shixue 新宋學與民初考據史學" [The new Song studies and early Republican-era evidential historiography]. *Jindaishi yanjiu* (1998, 1): 1–36.

Lyell, Charles. *Principles of Geology; Or, the Modern Changes of the Earth and Its Inhabitants, Considered as Illustrative of Geology.* 1830. Reprint. New York: D. Appleton & Co., 1865.

Ma Heng 馬衡. "Xulun 緒論" [Introductory discussion]. *Zhongguo jinshixue jiyao* 中國金石學既要 [Essentials of Chinese antiquarianism]. 1924. Reprint. *Fanjiangzhai jinshi conggao* 凡將齋金石叢稿 [Antiquarian manuscripts from the Studio of the Fully Prepared]. Beijing: Zhonghua shuju, 1977: 1–3.

Ma Sanheng 麻三衡. *Mozhi* 墨志 [Treatise on ink]. 1 juan. Reprint. In Wu Chongyao 伍崇曜, ed., *Yueyatang congshu, di nian si ji* 粵雅堂叢書第廿四集 [Collectanea from the Hall of Cantonese Elegance, twenty-fourth series]. Vol. 310. China: Nanhai Wu shi, 1853.

Mazur, Mary G. "Discontinuous Continuity: The Beginnings of a New Synthesis of 'General History' in 20th-Century China." In Tze-ki Hon and Robert J. Culp, eds., *The Politics of Historical Production in Late Qing and Republican China.* Leiden, Netherlands: Brill, 2007: 109–142.

McNair, Amy. "Engraved Calligraphy in China: Recension and Reception." *The Art Bulletin* 77 (1995): 106–114.

———. *The Upright Brush: Yan Zhenqing's Calligraphy and Song Literati Politics.* Honolulu: University of Hawai'i Press, 1998.

Menzies, James Mellon. *Oracle Records from the Wastes of Yin.* Shanghai: Kelly and Walsh, Ltd., 1917.

Miles, Stephen B. "Celebrating the Yan Fu Shrine: Literati Networks and Local Identity in Early Nineteenth-Century Guangzhou." *Late Imperial China* 25:2 (December 2004): 33–73.

Millward, James A. "'Coming Onto the Map': 'Western Regions'—Geography and Cartographic Nomenclature in the Making of Chinese Empire in Xinjiang." *Late Imperial China* 20:2 (December 1999): 61–98.

Momigliano, Arnaldo. "Ancient History and the Antiquarian." *Journal of the Warburg and Courtauld Institutes* 13:3/4 (1950): 285–315.

Morohashi Tetsuji 諸橋轍次. "Yū Shi zappitsu 游支雜筆" [Miscellaneous notes on trips to China]. *Morohashi Tetsuji chosakushū* 諸橋轍次著作集 [Writings of Morohashi Tetsuji]. Tokyo: Tiashūkan shoten, 1977: 9: 84–85.

Morse, Edward Sylvester. *Japan Day by Day, 1877, 1878–79, 1882–1883, Volume II.* Boston: Houghton Mifflin Company, 1917.

Naka Michiyo 那珂通世. *Shina tsūshi* 支那通史 [General history of China]. 1891. Reprint. Tokyo: Iwanami Shoten, 1967.

Needham, Joseph, and Wang Ling, et al. *Science and Civilization in China, Volume 4, Part 1: Physics.* Cambridge, UK: University of Cambridge Press, 1962.

Nie Chongyi 聶崇義. *Xinding sanli tu* 新定三禮圖 [Illustrated ritual canon]. 20 juan. Shanghai: Guji chubanshe, 1984.

Ninagawa Noritane 蜷川式胤. *Kwan-ko-dzu-setsu: notice historique et descriptive sur les arts et industries japonais: art céramique* 觀古圖説：陶器三部. Tokyo: H. Ahrens & Co., 1876–1878.

———. *The Life and Thought of Chang Hsüeh-ch'eng, 1738–1801.* Stanford, CA: Stanford University Press, 1966.

Nivison, David S. *The Literary and Historical Thought of Chang Hsüeh-ch'eng, 1738–1801: A Study of his Life and Writing, with a Translation of Six Essays from the* Wen-shih t'ung-i. Ph.D. dissertation. Harvard University, Cambridge, MA, 1953.

Nylan, Michael. *The Five "Confucian" Classics.* New Haven, CT, and London: Yale University Press, 2001.

Ouyang Xiu 歐陽修. *Jigulu bawei* 集古錄跋尾 [Colophons and commentary to the record of collecting antiquities]. 1062. Reprint. *Ouyang Xiu quanji* 歐陽修全集 [Collected works of Ouyang Xiu]. 2 vols. Taipei: Shijie shuju, 1961: 2: 1089–1218.

———. "*Jigulu mu* xu 集古錄目序" [Preface to the catalog of the record of collecting antiquities]. 1069. Reprint. *Ouyang Xiu quanji* 歐陽修全集 [Collected works of Ouyang Xiu]. 2 vols. Taipei: Shijie shuju, 1961: 2: 1087.

―――. "Li-Yue zhi diyi 禮樂志第一" [First treatise on rituals and music]. *Xin Tangshu* 新唐書 [New history of the Tang]. 225 juan. Reprint. Shanghai: Zhonghua shuju, 1936: 11: 1a–8a.

Pan Zuyin 潘祖蔭. *Pangulou yiqi kuanzhi* 攀古樓彝器款識 [Engraved inscriptions on ritual vessels from the Hall of Ascending to Antiquity]. 1872. 2 juan. Reprint. Xuxiu siku quanshu, vol. 903. Shanghai: Shanghai guji chubanshe, 2002.

―――. *Pangxizhai cangshu ji* 滂喜齋藏書記 [Notes on the book collection from the Studio of Gushing Delight]. Shanghai: Chen shi shenchutang, 1914.

―――. *Qinyou riji* 秦輶日記 [Diary of a carriage ride through Shaanxi]. 1 juan. Reprint. Taipei: Guangwen shuji, 1971.

―――. "*Shuowen guzhou bu* xu 說文古籀補敘" [Comments on the supplement in ancient and zhou script to the *Shuowen*]. In Wu Dacheng, Shuowen *guzhou bu* 說文古籀補 [Supplement in ancient script to the Shuowen]. 14 juan. 1886. Reprint. (China), 1898: 1: 1a–2a.

Pang, Laikwan. *The Distorting Mirror: Visual Modernity in China.* Honolulu: University of Hawai'i Press, 2007.

Peng Yuping 彭玉平. "Guanyu *Yinxu shuqi kaoshi* de yizhuang gong'an 關於 殷虛書契考釋的一樁功按" [Set of documents concerning studies on oracle bone inscriptions from the wastes of Yin]. *Zhongzhou xuekan* 168: 6 (November 2008): 198–205.

Perdue, Peter C. *China Marches West: The Qing Conquest of Central Eurasia.* Cambridge, MA: Belknap Press of Harvard University Press, 2005.

Pinney, Christopher. *Camera Indica: The Social life of Indian Photographs.* Chicago: University of Chicago Press, 1997.

Pizer, John David. *The Idea of World Literature: History and Pedagogical Practice.* Baton Rouge: Louisiana State University Press, 2006.

Polachek, James M. "Gentry Hegemony: Soochow in the T'ung-chih Restoration." In Frederic Wakeman and Carolyn Grant, eds., *Conflict and Control in Late Imperial China.* Berkeley: University of California Press, 1976: 211–256.

―――. *The Inner Opium War.* Cambridge, MA: Council on East Asian Studies, Harvard University, 1992.

Poor, Robert. "Notes on the Sung Dynasty Archaeology Catalogs." *Archives of the Chinese Art Society of America* 19 (1965): 33–44.

―――. *Sung Albums of Antiquities and Some Ancient Chinese Bronzes.* Ph.D. dissertation. University of Chicago, Chicago, 1964.

Puyi. *From Emperor to Citizen: The Autobiography of Puyi, the Last Emperor of China.* Trans. W. J. F. Jenner. Oxford: Oxford University Press, 1987.

Qi, Gong. "A Discourse on Chinese Epigraphy." In Qi Huang, ed., *Chinese Characters Then and Now.* Zurich: Voldemeer, 2004: 9–66.

Qi Luqing 齊魯青. "Bu qiao de shoucang dajia Liu E 不巧的收藏大家劉鶚"

[The unlucky great collector Liu E]. In Tang Caiyu 糖才玉, ed., *Gujin shoucangjia* 古今收藏家 [Collectors then and now]. Xi'an: Xibei daxue chubanshe, 1999: 29–34.

Qian Daxin 錢大昕. "*Guanzhong jinshi ji* xu 關中金石記序" [Preface to the record of Guanzhong antiquities]. *Qianyantang wenji* 25: 367–368.

———. "Guo Yunbo *Jinshishi* xu 郭允伯金石史序" [Preface to Guo Yunbo's history of epigraphy]. *Qianyantang wenji* 25: 365–366.

———. *Qianyantang jinshiwen bawei* 潛研堂金石文跋尾 [Prefaces and colophons for bronze-and-stele inscriptions from the hall of devotion to studies]. 20 juan. 1799. Reprint. Taibei: Yiwen yinshuguan, 1968.

———. *Qianyantang wenji* 潛研堂文集 [Collected works of the hall of devotion to studies]. 50 juan. Preface dated 1806. Shanghai: Shangwu yinshuguan, 1935.

———. "Zhongke *Sun Mingfu xiao ji* xu 重刻孫明復小集序" [Preface to the reengraving of the shorter collected works of Sun Mingfu]. *Qianyantang wenji* 25: 380.

———. *Zhushi shiyi* 諸史拾遺 [Loose ends of various histories]. 5 juan. Reprint. Taibei: Guangwen shuju, 1978.

Rankin, Mary Backus. "'Public Opinion' and Political Power: Qingyi in Late Nineteenth Century China." *Journal of Asian Studies* 41:3 (May 1982): 453–484.

Reed, Bradley W. *Talons and Teeth: County Clerks and Runners in the Qing Dynasty.* Stanford, CA: Stanford University Press, 2000.

———. *Shang-Zhou yiqi tongkao* 商周彝器通考 [General studies on ritual vessels from the Shang and Zhou]. Beijing: Hafo Yanjing xueshe, 1941.

Rong Geng 容庚. *Shanzhai yiqi tulu* 善齋彝器圖錄 [Pictorial record of ritual implements from the studio of virtue]. Beiping: Yanjing daxue Hafo Yanjing xueshe, 1936.

———. "Songdai jijin shuji shuping 宋代吉金書籍述評" [Critical discussion of Song Dynasty works on sacred bronzes]. 1932. Reprint. In Zeng Xiantong 曾憲通, ed., *Rong Geng xuanji* 容庚選集 [Selected works of Rong Geng]. Tianjin: Renmin chubanshe, 1994: 3–73.

———. "Wang Guowei xiansheng kaoguxue shang zhi gongxian 王國維先生考古學上之貢獻" [Mr. Wang Guowei's contributions to archaeology]. 1927. Reprint. In Wang Guowei, *Wang Guantang xiansheng quanji* 16: 7340–7356.

Rong, Xinjiang. "The Li Shengduo Collection: Original or Forged Manuscripts?" In Susan Whitfield, ed., *Dunhang Manuscript Forgeries.* London: The British Library, 2002: 62–83.

Rong Yuan 容媛. *Jinshi shulumu* 金石書錄目 [Bronze-and-stele bibliography]. Beiping: Shangwu yinshuguan, 1930.

Ruan Yuan 阮元. *Jiguzhai zhongding yiqi kuanzhi* 積古齋鍾鼎彝器款識 [Inscriptions of the bronze bells, tripods, and other ritual bronzes of the stu-

dio for collecting antiquities]. 1796. Reprint. (Changshu): Baoshi houzhi buzuzhai, 1883.

———. *Nan-Bei shupai lun, Beibei Nantie lun* 南北書派論, 北碑南帖論 [Discourse of the northern and southern schools of calligraphy, discourse of northern steles and southern model letters]. 1823. Reprint. Shanghai: Shanghai shudian chubanshe, 1987.

———. "Shang-Zhou tonqi lun 商周銅器論" [On Shang and Zhou bronzes]. In Wei Juxian 衛聚賢, *Zhongguo kaogu xiaoshi* 中國考古小史 [Short history of Chinese archaeology]. Shanghai: Shangwu yinshuguan, 1933: 1–5.

Rudolph, Richard C. "Lo Chen-yü Visits the Waste of Yin." In Frederic Wakeman, Jr., ed., *"Nothing Concealed": Essays in Honor of Liu Yü-yün.* Taibei: Chungwen chubanshe, 1970: 3–19.

———. "Preliminary Notes on Sung Archaeology." *Journal of Asian Studies* 22:2 (1963): 169–177.

Sang Bing 桑兵. "Boxihe yu jindai Zhongguo xueshujie 伯希和與近代中國學術界" [Paul Pelliot and modern Chinese academia]. *Lishi yanjiu* (1997, 7): 115–130.

———. "Chen Yinke yu Qinghua yanjiuyuan 陈寅恪与清华研究院" [Chen Yinke and the Qinghua research institute]. *Lishi yanjiu* (1998, 4): 129–143.

———. "Japan and Liang Qichao's Research in the Field of National Learning." In Joshua A. Fogel, ed., *The Role of Japan in Liang Qichao's Introduction of Modern Western Civilization to China.* Berkeley: Institute of East Asian Studies, University of California, 2004: 177–202.

———. "Jindai Zhongguo de xin shixue ji qi liupai 近代中國的新史學及其流派" [Modern Chinese historiography and its schools]. *Shixue yuekan* (2007, 11): 5–28.

———. "Jindai Zhongguo xueshu de diyuan yu liupai 近代中国学术的地缘与流派" [Regions and schools in the modern Chinese scholarly world]. *Lishi yanjiu* (1999, 3): 24–41.

Sang Shen 桑椹. "Qingtongqi quanxing ta jishu fazhan de fenqi yanjiu 青銅器全形拓技術發展的分期研究" [Research on the periods of development for the technique of three-dimensional rubbings of bronze vessels]. *Dongfang bowu* (2004, 3): 32–39.

———. "Quanxing ta zhi chuancheng yu liubian 全形拓之傳承與流變" [The transmission and development of three-dimensional rubbings]. *Zizhicheng* (2006, 5): 52–55.

Schmalzer, Sigrid. *The People's Peking Man: Popular Science and Human Identity in Twentieth-Century China.* Chicago: University of Chicago Press, 2008.

Schmidt, J.D. *Within the Human Realm: The Poetry of Huang Zunxian, 1848–1905.* Cambridge, UK: Cambridge University Press, 1994.

Sena, Yun-Chiahn Chen. *Pursuing Antiquity: Chinese Antiquarianism from the*

Tenth to the Thirteenth Century. Ph.D. dissertation. University of Chicago, Chicago, 2007.

Shaughnessy, Edward L. *Sources of Western Zhou History: Inscribed Bronze Vessels*. Berkeley: University of California Press, 1991.

Shen, Chuang. "Ming Antiquarianism, an Aesthetic Approach to Archaeology." *Journal of Oriental Studies* 8:1 (January 1970): 63–78.

Shen, Kuiyi. "Patronage and the Beginning of a Modern Art World in Late Qing Shanghai." In Jason C. Kuo, ed., *Visual Culture in Shanghai, 1850s–1930s*. Washington, DC: New Academia Publishing, 2007: 13–27.

———. "Traditional Painting in a Transitional Era, 1900–1950." In Julia F. Andrews and Kuiyi Shen, eds., *A Century of Crisis: Modernity and Tradition in the Art of Twentieth-Century China*. New York: Solomon R. Guggenheim Foundation, 1998: 80–95.

———. *Wu Changshi and the Shanghai Art World in the Late Nineteenth and Early Twentieth Centuries*. Ph.D. dissertation. Ohio State University, Columbus, 2000.

Shen Yao 沈垚. "Jianzha zhicun shang—yu Zhang Qiushui 簡札摭存上—與張秋水" [Selected extant letters, part one—to Zhang Qiushui]. *Luofanlou wenji* 落帆樓文集 [Collected works from the hall of furled sails]. 8 juan. 1858. Reprint. Beijing: Wenwu chubanshe, 1987: 8: 23a–23b.

Shen Zhenhui 沈振辉. "Yuan-Ming shoucangxue luelun 元明收藏學略論" [Summary of Yuan and Ming collecting]. *Shehui kexue* (1999, 3): 66–70.

Sheng, Hao. "Through Six Generations: An Exhibition of the Weng Collection of Chinese Painting and Calligraphy at the Museum of Fine Arts, Boston." *Orientations* 38:3 (April 2007): 30–39.

Sieber, Patricia. *Theaters of Desire: Authors, Readers, and the Reproduction of Early Chinese Song-Drama, 1300–2000*. New York: Palgrave Macmillan, 2003.

Sima Qian 司馬遷. "Gui ci liezhuan 亀策列傳" [Collective biographies of tortoiseshell diviners]. *Shiji* 史記 [Records of the historian]. 130 juan. Shanghai: Shangwu yinshuguan, 1936: 128: 1a–21a.

Song, Geng. *The Fragile Scholar: Power and Masculinity in Chinese Culture*. Seattle: University of Washington Press, 2004.

Stafford, Barbara Maria. *Good Looking: Essays on the Virtue of Images*. Cambridge, MA: MIT Press, 1998.

Stanley, Arthur. "The Method of Making Ink Rubbings." *Journal of the North China Branch of the Royal Asiatic Society* 48 (1917): 82–84.

Strand, David. *Rickshaw Beijing: City People and Politics in the 1920s*. Berkeley: University of California Press, 1993.

Su, Rongyu. "The Reception of 'Archaeology' and 'Prehistory' and the Founding of Archaeology in Late Imperial China." In Michael Lackner and Natascha Vittinghoff, eds., *Mapping Meanings: The Field of New Learning in Late Qing China*. Leiden, Netherlands: Brill, 2004: 429–443.

Sugimura Kunihiko 杉村邦彦. "Yang Shoujing yu Riben shuxue yanjiu 杨守敬与日本书学研究" [Research on Yang Shoujing and Japanese calligraphy studies]. Trans. Li Hong 李红, ed. Zu Wu 祖武. In Chen Shangmin 陈上岷, ed., *Yang Shoujing yanjiu xueshu lunwen xuanji* 杨守敬研究学术论文选集 [Selected criticism and scholarship on Yang Shoujing]. Wuhan: Chongwen shuju, 2003: 50–62.

Sun Dianqi 孫殿起, ed. *Liulichang xiaozhi* 琉璃廠小志 [Short gazetteer of Liulichang]. Beijing: Beijing guji chubanshe, 1982.

Sun Xingyan 孫星衍. *Jingji jinshi kao* 京畿金石考 [Research on bronzes and steles from the capital region]. 2 juan. 1792. Reprint. Xingyinxuan congshu 惜陰軒叢書, ed. Li Xiling 李錫齡. Baibu congshu jicheng, Vol. 3, no. 3. Taipei: Yiwen yinshuguan, 1967.

Sun Yanzhao 孫延釗. *Sun Yiyan, Sun Yirang fuzi nianpu* 孫衣言孫貽讓父子年譜 [Father-son chronological biography of Sun Yiyan and Sun Yirang]. Shanghai: Shanghai shehui kexueyuan chubanshe, 2003.

Sun Yirang 孫貽讓. *Guzhou yulun* 古籀餘論 [Further discourses on ancient and zhou script]. 3 juan. 1903. Reprint. Beiping: Yanjing daxue, 1929.

———. *Mingyuan* 名原 [Origins of language]. 1905. Reprint. Jinan: Qilu shushe, 1986.

———. *Qiwen juli* 契文舉例 [Selected examples of oracle bone inscriptions]. 1904. 2 juan. Reprint. Shanghai: Yingyinlu, 1927.

———. *Zhouli zhengyi* 周禮正義 [Correct meaning of the *Rites of Zhou*]. 1899. Reprint. Wanyou wenku gaiyao, Vols. 241–244. Taibei: Shangwu yinshuguan, 1965.

Suzuki Hiroyuki 鈴木廣之. *Kōkokatachi no 19-seiki: Bakumatsu Meiji ni okeru "mono" no arukeoroji* 好古家たちの19世紀：幕末明治における《物》のアルケオロジー [The antiquarians' nineteenth century: The archeology of "things" in the late Tokugawa and Meiji eras]. Tokyo: Yoshikawa kōbunkan, 2003.

Swann, Marjorie. *Curiosities and Texts: The Culture of Collecting in Early Modern England.* Philadelphia: University of Pennsylvania Press, 2001.

Tan Sitong 譚嗣同. "Shijuyinglu bizhi—si bian 石菊影廬笔識・思篇" [Notes from the Stone Chrysanthemum Shadow Hut—thoughts section]. *Tan Sitong quanji* 譚嗣同全集 [Complete works of Tan Sitong]. Beijing: Xinhua shudian, 1954: 241–279.

Tanaka, Stefan. *Japan's Orient: Rendering Pasts into History.* Berkeley: University of California Press, 1995.

Tang Lan 唐蘭. *Gu wenzixue daolun* 古文字學導論 [Guide to the study of ancient characters]. 2 juan. Jinan: Qilu shushe, 1981.

Tang, Xiaobing. *Global Space and the Nationalist Discourse of Modernity: The Historical Thinking of Liang Qichao.* Stanford, CA: Stanford University Press, 1996.

Thorp, Robert L. "Bronze Catalogues as Cultural Artifacts." *Archives of Asian Art* 44 (1991): 84–94.

Tomita Noboru 富田升. *Jindai Riben de Zhongguo yishupin liuzhuan yu jian-shang* 近代日本的中國藝術品流轉與鑒賞 [The circulation and connoisseurship of Chinese art objects in modern Japan]. Trans. Zhao Xiumin 趙秀敏. Shanghai: Shanghai guji chubanshe, 2005.

Tseng, Lillian Lan-Ying. "Retrieving the Past, Inventing the Memorable: Huang Yi's Visits to the Song-Luo Monuments." In Robert S. Nelson and Margaret Olin, eds., *Monuments and Memory, Made and Unmade.* Chicago: University of Chicago Press, 2003: 37–58.

Vinograd, Richard. *Boundaries of the Self: Chinese Portraits, 1600–1900.* Cambridge, UK: Cambridge University Press, 1992.

Von Spee, Clarissa. *Wu Hufan: A Twentieth Century Art Connoisseur in Shanghai.* Berlin: Reimer, 2008.

Wang Chang 王昶. *Jinshi cuibian* 金石萃編 [Miscellaneous collection of bronze and stele inscriptions]. 160 juan. 1805. Reprint. (China): Jingxuntang cangban, 1872.

Wang Dongming 王東明. "Huainian wo de fuqin Wang Guowei xiansheng 懷念我的父親王國維" [Remembering my father, Mr. Wang Guowei]. 1985. Reprint. In Chen Pingyuan 陳平原 and Wang Feng 陳平原, eds., *Zhuiyi Wang Guowei* 追憶王國維 [Recollecting Wang Guowei]. Beijing: Zhongguo guangfan dianshi chubanshe, 1996: 473–493.

———. "Zui shi renjian liu bu zhu 最是人間留不住" [At the end, leaving the human realm]. 1983. Reprint. In Chen Pingyuan 陳平原 and Wang Feng 陳平原, eds., *Zhuaiyi Wang Guowei* 追憶王國維 [Recollecting Wang Guowei]. Beijing: Zhongguo guangfan dianshi chubanshe, 1996: 455–458.

Wang Ermin 王爾敏, Chen Shanwei 陳善偉, comp. *Jindai mingren shouzha zhenji: Sheng Xuanhuai zhencang shudu* 近代名人手札真蹟:盛宣懷珍藏書牘 [Letters of prominent figures in modern China from the Sheng Xuanhuai collection]. 9 vols. Hong Kong: Zhongwen daxue chubanshe, 1987.

Wang Fan-sen. *Fu Ssu-nien: A Life in Chinese History and Politics.* Cambridge, UK: Cambridge University Press, 2000.

Wang Guohua 王國華. "Wang Jing'an xiansheng yishu xu 王靜安先生遺書序" [Preface to the posthumous works of Mr. Wang Jing'an]. 1936. Reprint. In Chen Pingyuan 陳平原 and Wang Feng 陳平原, eds., *Zhuaiyi Wang Guowei* 追憶王國維 [Recollecting Wang Guowei]. Beijing: Zhongguo guangfan dianshi chubanshe, 1996: 1–2.

Wang Guowei 王國維. (As Luo Zhenyu). "*Guantang jilin* xu 觀堂集林序" [Preface to collected works of Guantang]. 1923. Reprint. In Fo Chu 佛雛, ed., *Wang Guowei xueshu wenhua suibi* 王國維學術文化隨筆 [Wang Guowei's notes on scholarship and culture]. Beijing: Zhongguo qingnian chubanshe, 1996: 283–285. On the essay's attribution, see op. cit., 283.

———. "*Guochao jinwen zhulu biao* xu 國朝金文著録表序" [Preface to Qing dynasty works on bronze inscriptions]. 1914. Reprint. *Wang Guowei yishu* 1: 310–312.

———. "Guochao xueshu 國朝學術" [Qing Dynasty scholarship]. *Wang Guowei xueshu suibi:* 103.

———. "*Guoxue congkan* xu 國學叢刊序" [Preface to national studies serial]. 1911. Reprint. *Wang Guantang xiansheng quanji* 4: 1408–1414.

———. "Guqi zhi xue 古器之學" [The study of ancient vessels]. 1914–1915. Reprint. *Wang Guowei xueshu suibi:* 144.

———. *Gushi xinzheng* 古史新証 [New evidence concerning ancient history]. 1926. Reprint. *Wang Guantang xiansheng quanji* 6: 2077–2111.

———. "*Jing'an wenji* zixu 靜安文集自序" [Author's preface to essays by Jing'an]. 1905. Reprint. In Wang Guowei, *Wang Guantang xiansheng quanji* 5: 1547–1548.

———. "Kongzi zhi meiyu zhuyi 孔子之美育主義" [Confucius' ideas on aesthetic education]. 1904. Reprint. *Wang Guowei wenji* 3: 155–158.

———. "Kongzi zhi xue shuo 孔子之學説" [On Confucian scholarship]. 1908. Reprint. *Wang Guowei wenji* 3: 107–154.

———. "Kushulou ji 庫書樓記" [Record of the archives pavilion]. 1922. Reprint. *Wang Guantang xiansheng quanji* 3: 1164–1168.

———. "Lun xin xueyu zhi shuru 論新學語之輸入" [On the importing of new scholarly language]. 1905. Reprint. In Wang Guowei, *Wang Guantang xiansheng quanji* 5: 1741–1748.

———. "*Maogong ding kaoshi* xu 毛公鼎考釋序" [Preface to research on the Maogong ding]. 1918. Reprint. In Wang Guowei, *Wang Guantang xiansheng quanji* 1: 275–277.

———. "*Qudu pian* 去毒篇" [Essay on extirpating poison]. 1906. Reprint. In Wang Guowei, *Wang Guantang xiansheng quanji* 5: 1870–1877.

———. "*Qulu* xu 曲錄序" [Preface to collected drama]. 1909. Reprint. *Wang Guowei yishu* 10: 273–275.

———. "Renjian shihao zhi yanjiu 人間嗜好之研究" [A study of human pastimes]. 1907. Reprint. In Wang Guowei, *Wang Guantang xiansheng quanji* 5: 1795–1803.

———. "Shu jinshi jiaoyu sixiang yu zhexue zhi guanxi 述近世教育思想與哲學之關係" [On the relationship between recent educational thought and philosophy]. 1906. Reprint. *Wang Guowei wenji* 3: 9–22.

———. "Songdai zhi jinshixue 宋代之金石學" [Song Dynasty bronze-and-stele studies]. 1926. Reprint. *Wang Guantang xiansheng quanji* 5: 1924–1934.

———. *Wang Guantang xiansheng quanji* 王觀堂先生全集 [Complete works of Mr. Wang Guantang]. 16 vols. Taipei: Wenhua chuban gongsi, 1968.

———. *Wang Guowei quanji: shuxin* 王國維全集書信 [Complete works of Wang Guowei: letters], ed. Wu Ze 吳澤. Beijing: Zhonghua shuju, 1984.

———. *Wang Guowei wenji* 王國維文集 [Collected works of Wang Guowei], ed. Wang Yan 王燕, Yao Ganming 姚淦銘. 4 vols. Beijing: Zhongguo wenshi chubanshe, 1997.

———. *Wang Guowei xueshu suibi* 王國維學術隨筆 [Wang Guowei's scholarly notes], ed. Zhao Lidong 趙利棟. Beijing: Shehui kexue xenxian chubanshe, 2000: 103–104.

———. *Wang Guowei yishu* 王國維遺書 [Writings of the late Wang Guowei]. 1983. Reprint. 10 vols. Shanghai: Shanghai shudian chubanshe, 1996.

———. "Wu Qingqing 吳清卿" [Wu Qingqing]. 1914–1915. Reprint. *Wang Guowei xueshu suibi:* 147.

———. "*Xuetang jiaokan qunshu xulu* xu 羅振玉校刊群書敘錄序" [Preface to descriptive catalog of works edited and printed by Luo Zhenyu]. 1918. Reprint. *Wang Guantang xiansheng quanji* 3: 1135–1137.

———. "Yin buci zhong suojian xiangong xianwang kao 殷卜辭中所見先公先王考" [Former lords and former kings of the Yin as seen in oracle bone inscriptions]. 1917. Reprint. *Wang Guantang xiansheng quanji* 2: 391–419.

———. "*Yinxu shuqi kaoshi* xu 殷虛書契考釋序" [Preface to studies on inscriptions from the wastes of Yin]. 1914–1915. Reprint. *Wang Guantang xiansheng quanji* 3: 1130–1132.

———. "Yin-Zhou zhidu lun 殷周制度論" [On Yin and Zhou institutions]. 1917. Reprint. *Wang Guantang xiansheng quanji* 2: 433–462.

———. "Zhanguo shi Qin yong zhouwen Liuguo yong guwen shuo 戰國時秦用籀文六國用古文說" [How the Qin used Zhou script and the six dynasties used ancient script during the warring states]. 1916. Reprint. *Wang Guantang xiansheng quanji* 1: 287–289.

———. "Zhexue bianhuo 哲學辯惑" [Philosophical puzzles]. 1903. Reprint. *Wang Guowei wenji* 3:3–5.

———. "Zhongguo lidai zhi chidu 中國歷代之尺度" [China's historical rulers]. 1927. Reprint. *Wang Guowei wenji* 4: 185–190.

———. "Zixu 自序" [Autobiography]. 1907. Reprint. *Wang Guantang xiansheng quanji* 5: 1822–1827.

———. "Zouding jingxueke daxue wenxueke daxue zhangcheng shuhou 奏定經學科大學文學科大學章程書後" [My views on the "Regulations concerning the establishment of departments of classical studies and literary studies in the university, as memorialized and approved"]. N.d. Reprint. *Wang Guantang xiansheng quanji* 5: 1857–1870.

———. "Zuijin er, sanshi nian zhong Zhongguo xin faxian zhi xuewen 最近二三十年中中國新發現之學問" [Scholarship on recent discoveries of the last twenty or thirty years]. 1925. Reprint. *Wang Guantang xiansheng quanji* 5: 1915–1924.

"Wang Guowei zhi Gu Jiegang de san feng xin 王國維致顧頡剛的三封信" [Three letters from Wang Guowei to Gu Jiegang]. *Wenxian* 18 (December 1983): 205–206.

———. "Beyond East and West: Antiquarianism, Evidential Learning, and Global Trends in Historical Study." *Journal of World History* 19:4 (December 2008): 489–518.

Wang, Q. Edward. *Inventing China Through History: The May Fourth Approach to Historiography.* Albany: State University of New York Press, 2001.

Wang Qian'gang 王潛剛. *Qingren shuping* 清人書評 [Critique of Qing calligraphers]. In Cui Erping 崔尔平, ed., *Lidai shufa lunwen xuan xu bian* 歷代書法論文選續編 [Selected historial discourses on calligraphy]. Shanghai: Shanghai shuhua chubanshe, 1993: 803–845.

Wang Qingxiang 王慶祥, Xiao Wenli 蕭文立, ed. *Luo Zhenyu, Wang Guowei wanglai shuxin* (WLSX) 羅振玉王國維往來書信 [Correspondence between Luo Zhenyu and Wang Guowei]. Beijing: Dongfang chubanshe, 2000.

Wang Yirong 王懿榮. "Bing qi ji shi shu shi tongren bing suhe shi 病起即事書視同人並素和詩" [Poem for comrades and laymen on becoming ill and other matters]. *Wang Yirong ji:* 111.

——. "Shiwen 時文" [Examination essays]. *Wang Yirong ji:* 323–455.

——. "Tianrangge zaji 天壤閣雜記" [Random notes from the Tianrang pavilion]. *Wang Yirong ji:* 257–267.

——. *Wang Yirong ji* 王懿榮集 [Collected works of Wang Yirong], ed. Lü Weida 呂偉達. Jinan: Jilu shushe, 1999.

——. "Xiaoxia liu yong he Pan Zun'an Shilang shi 消夏六詠和潘鄭庵侍郎師" [Summer—six lyrics for Master Pan Zheng'an Shilang]. 1872. *Wang Yirong ji:* 104–105.

——. "Yu Miao Yanzhi 與繆炎之" [To Miao Yanzhi]. "Shuzha 書札" [Letters]. *Wang Yirong ji:* 143–193.

Wang Yuxin 王宇信. *Jiaguxue tonglun* 甲骨學通論 [General survey of oracle bone studies]. 1989. Reprint. Beijing: Zhongguo shehui kexue chubanshe, 1999.

Wang Yuxin 王宇信, Yang Shengnan 楊升南, ed. *Jiaguxue yibainian* 甲骨學一百年 [One hundred years of oracle bone studies]. Beijing: Zhongguo shehui kexue chubanshe, 1999.

Wang Zhiqiu 王治秋. *Liulichang shihua* 琉璃廠史話 [Remarks on Liulichang's history]. Beijing: Sanlian shudian, 1963.

Wang Zhongmin 王重民, ed. *Banli siku quanshu dang'an* 辦理四庫全書檔案 [Archives of the compilation of the complete library of the four treasuries]. Beiping: Guoli Beiping tushuguan, 1934.

Wang Zhongxiu 王中秀 et al., eds. *Jin xiandai jinshi shuhuajia runli* 近現代金石書畫家潤例: *Renumeration Rates of Modern and Contemporary Seal-Cutters, Calligraphers, and Painters.* Shanghai: Shanghai huabao chubanshe, 2004.

Warner, Langdon. *The Long Old Road in China.* Garden City, NY: Doubleday, 1926.

Wei Juxian 衛聚賢. *Zhongguo kaoguxue shi* 中國考古學史 [History of Chinese archaeology]. Shanghai: Shangwu yinshuguan, 1937.

Weng Fanggang 翁方綱. "Kaoding lunshang zhi san 考訂論上之三" [Third

discourse on verification]. *Fuchuzhai wenji* 復初齋文集 [Literary collection from the Studio of the Return to Beginnings]. Jindai Zhongguo shiliao congkan, vol. 421. Taibei: Wenhai chubanshe, 1966: 300–302.

Weng Tonghe 翁同龢. "Ti Pan Bohuang cang yi he ming jing taben題潘伯寅藏瘞鶴銘精塌本" [On the rubbing of the Yiheming inscription collected by Pan Zuyin]. *Pinglu shigao* 瓶廬詩稿 [Pinglu's draft poems]. 8 juan. (China): 1919: 1: 14a.

Wright, David. "Yan Fu and the Tasks of the Translator." In Michael Lackner et al., eds., *New Terms for New Ideas: Western Knowledge and Lexical Change in Late Imperial China.* Leiden, Netherlands: Brill, 2001: 235–255.

Wu Changshi 吳昌碩. "Tieyun canggui xu 鐵雲藏龜序" [Preface to Tieyun's collection of plastrons]. In Liu E, *Tieyun canggui* 鐵雲藏龜 [Tieyun's collection of plastrons]. 1903. Reprint. Taibei: Yiwen yinshuguan, 1975: 15–17.

Wu Dacheng 吳大澂. *Guyu tukao* 古玉圖考 [Illustrated research on ancient jades]. Shanghai: Tongwen shuju, 1889.

———. *Kezhai jigulu* 愙齋集古錄 [Kezhai's record of collecting antiquities]. 26 juan. 1897. Reprint. Shanghai: Shangwu yinshuguan, 1918.

———. *Quanheng duliang shiyan kao* 權衡度量實驗攷 [Experimental investigations into weight, length and capacity measures], ed. Luo Zhenyu 羅振玉. (China): Shangyu Luo shi, 1915.

———. Shuowen *guzhou bu* 說文古籀補 [Ancient and Zhou script supplement to the *Shuowen*]. 14 juan. 1886. Reprint. (China), 1898.

———. *Wu Kezhai (Dacheng) chidu* 吳愙齋大澂尺牘 [Wu Kezhai (Dacheng's) informal letters]. Taipei: Wenhai chubanshe, 1971.

———. *Wu Qingqing lin Huang Xiaosong fangbei tu ce* 吳清卿臨黃小松訪碑圖冊 [Wu Dacheng's rendition of Huang Yi's pictorial album of searching for steles]. Shanghai: Shenzhou guoguangshe chuban, 1915.

———. *Wu zhuan* Lunyü 吳篆論語 [Wu Dacheng's seal-script analects]. 2 juan. 1877. Reprint. Shanghai: Dongfang shuju, 1934.

———. *Zishuo* 字說 [On graphs]. 1893. Reprint. Taibei: Yiwen yinshuguan, 1971.

"Wu Dacheng zhi Weng Tonghe, Wang Yirong deng weikan nigao xuanji 吳大澂致翁同龢、王懿荣等未刊函稿选辑" [A selection of previously unpublished letters from Wu Dacheng to Weng Tonghe, Wang Yirong and others]. *Dang'an yu lishi* (2003, 2): 2–6.

Wu Gongzheng 吳功正. "Mingdai shangwan ji qi wenhua, meixue pipan 明代賞玩及其文化、美學批判" [Ming connoisseurship and its cultural and aesthetic critique]. *Nanjing daxue xuebao (zhexue, renwen kexue, shehui kexue ban)* (2008, 3): 114–122.

Wu Hung. *Monumentality in Early Chinese Art and Architecture.* Stanford, CA: Stanford University Press, 1995.

———. "On Rubbings: Their Materiality and Historicity." In Judith T. Zeitlin

et al., eds., *Writing and Materiality in China: Essays in Honor of Patrick Hanan.* Cambridge, MA: Harvard University Asia Center, 2003: 29–72.

————. *The Wu Liang Shrine: The Ideology of Early Chinese Pictorial Art.* Stanford, CA: Stanford University Press, 1992.

Wu Min'gui 吳民貴. *Wan Qing renwu yu jinshi shuhua: Pushiju tan shi lu* 晚清人物與金石書畫: 蒲石居談史錄 [Late-Qing personages and epigraphic calligraphy and painting: Records of history talks from the Cattail-Stone Residence]. Shanghai: Shanghai shehui kexueyuan chubanshe, 2006.

Wu Qichang 吳其昌, Liu Pansui 劉盼遂, eds. *Guantang shoushu ji* 觀堂授書記 [Notes on Wang Guowei's pedagogy]. Taibei: Yiwen yinshuguan, 1975.

Xianggang Zhongguo yuwen xuehui 香港中國語文學會. *Jin xiandai Hanyu xinci ciyuan cidian* 近現代漢語新詞詞源詞典 [An etymological glossary of selected modern Chinese words]. Shanghai: Hanyu da cidian chubanshe, 2001.

Xie Xiaohua 謝小華, Liu Ruofang 劉若芳. "Qianlong nianjian Faguo daizhi deshengtu tongban shiliao 乾隆年間法國代制得勝圖銅版史料" [Historical materials on the copperplate etching of triumph, printed by France during the Qianlong period]. *Lishi dang'an* (2001, 1): 5–14.

Xu Ben 徐賁. "Quanqiuhua, bowuguan he minzu gojia 全球化，博物館和民族國家" [Globalism, museums, and the nation-state]. *Wenyi yanjiu* (2005, 5): 43–54.

Xue Fucheng 薛福成. "Eluosi jinsou gubei ji俄罗斯禁蒐古碑記" [Record of Russian expeditions to find ancient steles]. *Yong'an wenbian* 庸菴文編 [Yong'an's writings]. Jindai Zhongguo shiliao congkan, Vol. 943. 3 vols. Taibei: Wenxian chubanshe, 1973: 2: 1067–1068.

Xunzi 荀子. "Jundao 君道" [Way of the gentleman]. In Wang Xianqian 王先謙, ed., *Xunzi jijie* 荀子集解 [Collected explanations of the Xunzi]. 1891. Reprint. Taibei: Shijie shuju, 2000: 209–225.

Yan Fu 嚴復. "Jiuwang juelun 救亡決論" [Decisive words on our salvation]. 1895. Reprint. *Yan Fu ji* 嚴復集 [Collected works of Yan Fu]. 5 vols. Beijing: Zhonghua shuju, 1986: 1: 40–54.

Yang Jingting 楊靜亭. *Dumen jilüe* 都門紀略 [Short account of the capital]. 2 juan. Beijing: N.p., 1875.

Yang Shanqun 楊善群. "Guwen *Shangshu* liuchuan guocheng tantao 古文尚書流傳過程探討" [Close examination of the transmission process of the ancient script documents]. *Xuexi yu tansuo* (2003, 4): 119–123.

Yang Shoujing 楊守敬. "*Nihon kinseki nenpyō* xu 日本金石年表序" [Introduction to chronology of Japanese epigraphy]. In Nishida Naokai 西田直養, *Nihon kinseki nenpyō* 日本金石年表. [Chronology of Japanese epigraphy]. Pan Zuyin 潘祖蔭, ed., *Pangxizhai cangshu* 滂喜齋叢書 [Collectanea from the Studio of Gushing Delight]. Jingshi: Panshi, 1867–1883: 5: 2a–2b.

Yao Mingda 姚名達. *Zhongguo muluxue shi* 中國目錄學史 [History of Chinese bibliography]. 1937. Reprint. Beijing: Shangwu yinshuguan, 1998.

Ye Changchi 葉昌熾. *Yushi* 語石 [Talking about steles]. 1909. Reprint. Wanyou wenku gaiyao, vol. 635. Taibei: Taiwan shangwu yinshuguan, 1965.

Ye, Xiaoqing. *The Dianshizhai Pictorial: Shanghai Urban Life, 1884–1898.* Ann Arbor: Center for Chinese Studies, University of Michigan, 2003.

Yeh, Wen-hsin. *The Alienated Academy: Culture and Politics in Republican China, 1919–1937.* Berkeley: University of California Press, 1990.

Yetts, W. Percival. "Memoir of the Translator." In Dai Tong 戴侗, *The Six Scripts, or the Principles of Chinese Writing. A Translation by L. C. Hopkins. With a Memoir of the Translator by W. Percival Yetts.* Cambridge, UK: Cambridge University Press, 1954: vii–xxviii.

Yi Zongkui 易宗夔. "Pilou 紕漏" [Careless errors]. *Xin shi shuo* 新世说 [Tales of the new era]. 8 juan. 1918. Reprint. Shanghai: Shanghai guji chubanshe, 1982.

———. "Qiaoyi 巧藝" [Skillful artists]. *Xin shi shuo* 新世说 [Tales of the new era]. 8 juan. 1918. Reprint. Shanghai: Shanghai guji chubanshe, 1982.

———. "Rongzhi 容止" [Appearances]. *Xin shi shuo* 新世说 [Tales of the new era]. 8 juan. 1918. Reprint. Shanghai: Shanghai guji chubanshe, 1982.

Yin Da 尹達. "Xin shiqi shidai yanjiu de huigu yu zhanwang 新石器時代研究的回顧與展望" [Review and future prospects of research on the Neolithic Period]. 1963. Reprint. *Yin Da shixue lunzhu xuanji* 尹達史學論著選集 [Selection of Yin Da's historiographic works]. Beijng: Renmin chubanshe, 1989: 277–300.

Yin Nan 殷南. "Wo suo zhidao de Wang Jing'an xiansheng 我所知道的王靜安先生" [The Mr. Wang Jing'an that I knew]. 1927. Reprint. In Wang Guowei, *Wang Guantang xiansheng quanji* 16: 7165–7167.

Yoshiaki Kanayama 金山喜昭. *Nihon no hakubutsukan shi* 日本の博物館史 [History of Japanese museums]. Tokyo: Keiyūsha, 2001.

Young, Julian. *Schopenhauer.* London: Routledge, 2005.

Yu Minzhong 于敏中 et al., eds. *Xiqing yanpu* 西清硯譜 [Register of ink stones from the Xiqing pavilion]. 1778. Reprint. Shanghai: Shangwu yinshugang, 1934.

Yuan Yingguang 袁英光, Liu Yinsheng 劉寅生. *Wang Guowei nianpu changbian* 王國維年譜長編 [Expanded biographical chronology of Wang Guowei]. Tianjin: Renmin chubanshe, 1996.

Yue, Meng. *Shanghai and the Edges of Empires.* Minneapolis: University of Minnesota Press, 2006.

Zarrow, Peter Gue. *China in War and Revolution, 1895–1949.* London, New York: Routledge, 2005.

———. "The Imperial Word in Stone: Stele Inscriptions at Chengde." In James A. Millward et al., eds., *New Qing Imperial History: The Making of Inner Asian Empire at Qing Chengde.* London: RoutledgeCurzon, 2004: 146–164.

———. "Late-Qing Reformism and the Meiji Model: Kang Youwei, Liang Qichao, and the Japanese Emperor." In Joshua A. Fogel, ed., *The Role*

of Japan in Liang Qichao's Introduction of Modern Western Civilization to China. Berkeley: Institute of East Asian Studies, University of California, 2004: 40–67.

———. "The New Schools and National Identity: Chinese History Textbooks in the Late Qing." In Tze-ki Hon and Robert J. Culp, eds., *The Politics of Historical Production in Late Qing and Republican China*. Leiden, Netherlands: Brill, 2007: 21–54.

Zeitlin, Judith. "The Petrified Heart: Obsession in Chinese Literature, Art, and Medicine." *Late Imperial China* 12:1 (June 1991): 1–26.

Zeng Pu 曾朴. *Niehai hua* 孽海花 [Flowers in a sea of retribution]. 1905. Reprint. Beijing: Jiefangjun wenyi chubanshe, 2000.

Zha Xiaoying 查晓英. "Dizhixue yu xiandai kaoguxue zhishi zai Zhongguo de chuanbo 地質學與現代考古學在中國的傳播" [The spread of geology and modern archaeology in China]. *Lishi yanjiu* (2006, 4): 90–104.

———. "'Jinshixue' zai xiandai xueke tizhi xia de zhongsu "金石學"在現代的學科體制下的重塑" [The remolding of antiquarianism as a modern academic discipline]. *Zhongshan daxue xuebao (shehui kexue ban)* 3:48 (2008): 83–96.

———. *Wenwu de bianqian—Xiandai Zhongguo de kaoguxue de zaoqi lishi* 文物的變遷―現代中國的考古學的早期歷史 [The evolution of artifacts—the early history of modern Chinese archaeology]. Ph.D. dissertation. Zhongshan University, Guangzhou, 2006.

Zhang Dechang 張德昌. *Qingji yige jingguan de shenghuo* 清季一個京官的生活 [A capital official's life in the Qing period]. Hong Kong: Zhongwen daxue chuban, 1970.

Zhang Hanrui 張涵銳. "Liulichang yan'ge kao 琉璃廠沿革攷" [Research on the evolution of Liulichang]. In Sun Dianqi 孫殿起, ed., *Liulichang xiaozhi* 琉璃廠小志 [Short gazetteer of Liulichang]. Beijing: Beijing guji chubanshe, 1982.

Zhang Lianke 張連科. *Wang Guowei yu Luo Zhenyu* 王國維與羅振玉 [Wang Guowei and Luo Zhenyu]. Tianjin: Tianjin renmin chubanshe, 2002.

Zhang Taiyan 章太炎. "Lihuo lun 理惑論" [Discourse on confused truth]. *Guogu lunheng* 國故論衡 [Disquisitions on the national heritage]. Dongjing: Guoxue jiangxi hui, 1910: 57–60.

———. *Zhang Taiyan shuxin ji* 張太炎書信集 [Zhang Taiyan's collected letters]. Shijiazhuang: Hebei renmin chubanshe, 2003.

Zhang Tingji 張廷濟. *Qingyige suocang gu qi wu wen* 清儀閣所藏古器物文 [Ancient vessels and inscriptions collected in the Pavilion of Pure Ceremony]. Shanghai: Shangwu yinshuguan, 1925.

Zhang Yuzhao 張裕釗. "Zeng Wu Qingqing shuchang xu 贈吳清卿庶常序" [Presenting some advice to the Hanlin Bachelor Wu Qingqing]. *Guochao wenhui, ding ji* 國朝文匯丁集 [Compendium of Qing Dynasty literature, fourth collection]. 30 juan. Shanghai: Guoxue fulunshe, 1909: 8: 7a-7b.

Zhang Zhidong 張之洞. "Dianshi duice 殿試對策" [Palace examination essay]. *Zhang Zhidong quanji* 12: 10043–10046.

———. "He Pan Boyin renshen xiaoxia liu yong 和潘伯寅壬申消夏六詠" [Six lyrics for Pan Boyin, year renshen, summer]. 1872. Reprint. "Shiwen er 詩文二" [Collected poems, second section]. *Zhang Zhidong quanji* 12: 10488–10491.

———. "Maogong ding 毛公鼎" [The Maogong tripod]. *Zhang Zhidong quanji* 12: 10373–10374.

———. *Quanxue pian* 勸學篇 [Exhortation to study]. 1898. Reprint. *Zhang Zhidong quanji* 12: 9703–9770.

———. *Shumu dawen* 書目答問 [Questions and answers on the bibliography]. 1877. Reprint. *Zhang Zhidong quanji* 12: 9864–9987.

———. "Shuzha yi 書札一" [Letters, first section]. *Zhang Zhidong quanji* 12: 10099–10152.

———. *Youxuan yu* 輶軒語 [The commissioner's words]. 1876. Reprint. *Zhang Zhidong quanji* 12: 9771–9822.

———. *Zhang Wenxiang gong zhi E ji* 張文襄公治鄂記 [Zhang Zhidong's notes on governing Hubei]. Taibei: Taiwan kaiming shudian, 1966.

———. *Zhang Zhidong quanji* 張之洞全集 [Complete works of Zhang Zhidong], ed. Yuan Shuyi 苑書義 et al. 12 vols. Wuhan: Hebei renmin chubanshe, 1998.

Zhao Erxun 趙爾巽, et al. *Qingshi gao* 清史稿 [Draft history of the Qing]. Beijing: Zhonghua shuju, 1998.

Zhao Lidong 趙利棟. "*Gushibian* yu *Gushi xinzheng*—Gu Jiegang yu Wang Guowei shixue sixiang de yige chubu bijiao 古史辨與古史新証—顧頡剛與王國維史學思想的一個初步比較" [Debates on ancient history and new evidence concerning ancient history—A preliminary comparison of the historiographic thought of Gu Jiegang and Wang Guowei]. *Zhejiang xuekan* (2000, 6): 109–114.

Zhao Mingcheng 趙明誠. *Jinshi lu* 金石錄 [Records of bronzes and steles]. 30 juan. Reprint. Shanghai: Shangwu yinshuguan, 1934.

Zhao Zhiqian 趙之謙. *Buhuanyu fangbei lu* 補寰宇訪碑錄 [Record of searches for steles across the wide universe]. 5 juan. 1865. Reprint. Shike shiliao congshu yibian, vol. 21. Taibei: Yiwen yinshuguan, 1966.

Zheng Qiao 鄭樵. "Jinshi lüe 金石略" [Summary of bronzes and steles]. *Tongzhi* 通志 [General treatises]. 1161. Reprint. *Jiutong* 九通 [Nine treatises]. 940 juan. Zhejiang shuju, 1896: 73: 1a–49b.

Zhenjun 震鈞. *Tianzhi ouwen* 天咫偶聞 [Things heard close to heaven]. 10 juan. 1907. Reprint. Jindai Zhongguo shiliao congkan, vol. 219. Taibei: Wenhai chubanshe, 1967.

Zhi Weicheng 支偉成. *Qingdai puxue dashi liezhuan* 清代樸學大師列傳 [Biographies of famous "unadorned learning" scholars from the Qing Dynasty]. 1924. Reprint. Changsha: Yuelu shushe, 1998.

Zhou Hanguang 周漢光. *Zhang Zhidong yu Guangya shuyuan* 張之洞與廣雅書院 [Zhang Zhidong and the Guangya academy]. Taibei: Zhongguo wenhua daxue chubanshe, 1983.

Zhou Shaochuan 周少川. "Lun Chen Yuan xiansheng de minzu wenhuashi guan 論陳垣先生的民族文化史觀" [Discussion of Mr. Chen Yuan's view of ethnic and cultural history]. *Shixueshi yanjiu* (2002, 3): 1–8.

Zhou Yiliang 周一良. "Wo suo liaojie de Chen Yinke xiansheng 我所了解的陳寅恪先生" [The Mr. Chen Yinke that I knew]. In Hu Shouwei 胡壽為, ed., Liu Rushi biezhuan *yu guoxue yanjiu: jinian Chen Yinke jiaoshou xueshu taolunhui lunwen ji* 柳如是別傳與國學研究: 紀念陳寅恪教授學討論會論文集 [The biography of Liu Rushi and national studies research: Papers presented at the conference in memory of Professor Chen Yinke]. Hangzhou: Zhejiang renmin chubanshe, 1994: 8–15.

Zhou Zhaoxiang 周肇祥. *Liulichang zaji* 琉璃廠雜記 [Miscellaneous records of Liulichang]. Beijing: Beijing Yanshan chubanshe, 1995.

Zhou Zuoren 周作人. "Lin Qinnan yu Luo Zhenyu 林琴南与羅振玉" [Lin Qinnan and Luo Zhenyu]. 1924. Reprint. *Zhou Zuoren ji wai wen* 周作人集外文 [Further writings of Zhou Zuoren]. Haikou: Hainan guoji xinwen chuban zhongxin, 1995: 1: 624–625.

Zhu Jianxin 朱劍心. *Jinshixue* 金石學 [Bronze-and-stele studies]. Reprint. Hong Kong: Shangwu yinshuguan, 1964.

Zhu Jieqin 朱傑勤. "Qingdai jinshixue shuyao 清代金石學述要" [General introduction to Qing Dynasty bronze-and-stele studies]. *Dongfang zazhi* 39:1 (1943): 105–109.

Zhu Yixin 朱一新. "Wuxietang dawen 无邪堂答問" [Questions and answers from the hall of orthodoxy]. *Zhuo'an conggao* 拙盦叢稿 [Collected writings of the inelegant cauldron]. 3 vols. 1896. Reprint. Jindai Zhongguo shiliao congkan, vol. 272. Taibei: Wenhai chubanshe, 1968: 1: 21–524.

Zito, Angela. *Of Body and Brush: Grand Sacrifice as Text/Performance in Eighteenth-Century China.* Chicago: University of Chicago Press, 1998.

Index

About the Author

Shana J. Brown is an associate professor of history at the University of Hawai'i at Mānoa. A graduate of Amherst College and the University of California, Berkeley, she has lived and worked extensively in China and Taiwan. Her current research is on the history of photography in China. *Pastimes* is her first book.

Lightning Source UK Ltd.
Milton Keynes UK
UKOW02n1723270217

295440UK00002B/21/P